SYMBOLIST

ART

A Critical Anthology

THEORIES

Edited by Henri Dorra

University of

California Press

Berkeley

Los Angeles

London

The publisher gratefully acknowledges the contribution provided by the Art Book Endowment Fund of the Associates of the University of California Press, which is supported by a major gift from the Ahmanson Foundation.

University of California Press
Berkeley and Los Angeles, California
University of California Press, Ltd.
London, England
© 1994 by
The Regents of the University of California

First Paperback Printing 1995

Library of Congress Cataloging-in-Publication Data
Symbolist art theories : a critical anthology / edited by
Henri Dorra.
p. cm.
Includes bibliographical references and index.
ISBN 0-520-07768-7
1. Symbolism (Art movement)—Europe. 2. Arts.
Modern—19th century—Europe. I. Dorra, Henri.
1924–
NX542.S97 1994
700'.9'034—dc20 93-32264

Printed in the United States of America
9 8 7 6 5 4 3 2

For Mary

CONTENTS

ILLUSTRATIONS

ACKNOWLEDGMENTS

I wish to thank the many scholars and administrators who have given their advice and assistance during the preparation of this book. For years John Rewald has generously made unpublished material available and has supported this project. The late Jean Adhémar, Conservateur en Chef of the Bibliothèque Nationale's Cabinet des Estampes, was enthusiastic and helpful in numerous consultations. His successor, Laure Beaumont, has maintained his tradition of assisting scholars. François Chapon, Conservateur of the Bibliothèque littéraire Doucet of the University of Paris, allowed me to consult the Mallarmé correspondence. Monique Laurent, Conservateur Emerita of the Musée Rodin, opened up that artist's files of received correspondence. Geneviève Lacambre, Conservateur Général au Musée d'Orsay, was indefatigable and immensely generous in referring me to sources and providing information from her archives. Claire Denis opened up the Maurice Denis archives. Marie-Amélie Anquetil, Conservateur, Musée du Prieuré, Saint-Germain-en-Laye, generously placed her Museum's documentation at my disposal and gave me valuable advice. Victor Merlhès made available documents from his Gauguin archives. The late André Vasseur allowed me to consult his vast collection of turn-of-the-century literary and artistic periodicals, many of them unavailable elsewhere. In Brussels, Francine-Claire Legrand, Directeur Emerita, Archives de l'Art Moderne, Musées Royaux des Beaux-Arts; Gisèle Ollinger-Zinque, Conservateur-Chef de Section, Peinture, Art Moderne, Musées Royaux des Beaux-Arts de Belgique; and Georges Colin, Conservateur, Livres précieux, and Claudine Lemaire, Conservateur Emerita, Archives van de Velde, both of the Bibliothèque Royale Albert 1er, were always helpful. The architect Jean Delhaye of Kampendaal, Belgium, kindly provided material from his archives. In the Netherlands, G. K. Boon, Curator Emeritus of the Amsterdam Rijksprentenkabinet; the late Mrs. André Bonger; and her nephew S. Crommelin were all most generous. In Oslo, Arne Eggum, Curator of

the Munch Museum, was a cordial advisor. Jack Murray, Professor in the Department of French and Italian, University of California, Santa Barbara, read part of the text and made valuable comments. The W. T. Bandy Center for Baudelaire Studies, Vanderbilt University, helped identify verses by that poet. And there were many others!

A grant from the Guggenheim Foundation in 1978–79 made it possible for me to assemble material in Europe, and the Academic Senate Research Committee of the University of California, Santa Barbara, provided essential funds for gathering photographs and paying for reproduction rights.

I relied on fellow scholars and friends Aline Dardel and Jehanne Joly to check and gather documents in Paris. In Santa Barbara my research assistant, Brett Rothstein, and Soo Youn Kang, a doctoral candidate in the University's Art History Department, helped gather documentation and check facts for the final typescript. My students, who asked probing questions over the years, also deserve heartfelt thanks, for they helped me refine a number of concepts.

Finally, the unstinting support and thoughtful counsel of Deborah Kirshman, Fine Arts Editor of the University of California Press, and Stephanie Fay, Editor, are deeply appreciated.

My wife, Mary, and my daughters, Amy and Helen, were quietly encouraging throughout and ingenious and resourceful in helping me resolve tactical problems.

INTRODUCTION

The reader who concludes that this is not a genuine anthology but a treatise on symbolist theory parading as one should have no qualms. The texts of the anthology have been carefully selected to provide breadth as well as depth. Some are long, either because their authors conveyed their views on theory, art, or literature through detailed argumentation or because they could convey their responses to symbolism only by evoking a literary or artistic work in prose. And some are very short; indeed, some highly intuitive or articulate writers suggest complex aesthetic impressions in a few incisive statements.

As for coverage, the Prologue traces some of Charles Baudelaire's aesthetic thought to Eugène Delacroix and older sources and traditions and pays tribute to the poet himself by including the poem that best sums up his, and ultimately the symbolists', aesthetic goals. Chapter 1 provides a selection of texts on, and by, romantic-symbolist artists, among them the British Pre-Raphaelites and such immediate precursors of symbolism as Pierre Puvis de Chavannes, Gustave Moreau, Odilon Redon, and Auguste Rodin. The chapter includes passages by established mid-nineteenth-century critics, such as Théophile Gautier and Théophile Thoré; by younger critics, such as Emile Hennequin; by poets, such as Jules Laforgue; and by the artists themselves. Whistler's "Ten O'Clock" is included both because of that artist's symbolist affinities and because of his antiliterary sentiments in the lecture that made the very concept of symbolism abhorrent to a later generation of art critics.

In the spirit of the most distinguished designers of the period under study, Chapter 2 is devoted to the decorative arts and architecture and considers the work of Gustave Eiffel, a structural engineer sensitive to aesthetics, as important as that of a potter of genius, Paul Gauguin. Arranged chronologically, the excerpts start with those by the men who first promoted the Arts and Crafts movement in Britain: Owen Jones, William Morris, and

Arthur Mackmurdo—all three against a background of Ruskinian thought. The spirited and articulate proponent of art nouveau Henry van de Velde represents developments in Continental Europe; and the chapter ends, appropriately, with the American florescence of the same movement as exemplified by the thought and work of Louis Sullivan.

The close relations between poets and artists throughout the period are acknowledged in Chapter 3, on literary developments. Paul Bourget, particularly thoughtful and sensitive in this regard, opens the section with his comments on the influence Baudelaire had over the group of early symbolists who, more or less willingly, accepted the appellation "decadent." Rimbaud and Verlaine provide short and pithy professions of faith. Mallarmé receives pride of place as a theoretician of literary symbolism as well as a friend and supporter of many important artists. Texts by Teodor de Wyzewa on Wagner, Jean Moréas on his all-too-basic principles of symbolist aesthetics, and Maurice Maeterlinck on the symbolist stage illustrate the richness and variety of symbolist critical thought.

In Chapter 4 the major post-impressionists are all claimed for mature symbolism. Georges Seurat is represented by his own theoretical text, and his theories and achievements are discussed by Félix Fénéon and Gustave Kahn. Gauguin, van Gogh, and Cézanne are represented by their own writings, and articles by G.-Albert Aurier on the first two artists are also included. The Nabis are assessed in a few letters, followed by magisterial pages by Emile Verhaeren on James Ensor—notable for their foresight— and by Ferdinand Hodler's thoughtful lecture on the theoretical aspects of his work.

The *artistes de l'âme* (artists of the soul), whose style owes much to Puvis and Moreau as well as the Pre-Raphaelites, are represented in Chapter 5 by their own writings, by those of their chief mentor, Joséphin Péladan, and by one of Octave Mirbeau's scurrilous newspaper attacks on their works and all they stood for.

The Epilogue presents writings by Remy de Gourmont, a critic who made important contributions to symbolist theory as the movement was waning, and by two of his disciples and friends, Alfred Jarry and Guillaume Apollinaire, whose own writings reasserted important symbolist principles, albeit under new cloaks, for the eventual benefit of the surrealist generation. The writings of Roger Fry and Clive Bell, who in Whistler's wake fought the literary aspects of symbolism for the sake of "pure form" and "significant form," are part of the concluding discussion.

Although I have avoided turning into dogmas what are essentially loose, and by no means all-inclusive, traits, I have also attempted to highlight a theoretical framework applicable to both the plastic arts and literature. This

framework should prove useful in several ways: it can help establish a greater cohesiveness than has been thought possible between theories pertaining to the symbolist movement in literature and in the plastic arts; this, in turn, could make it easier to outline overall historical developments; finally, the specific theories, most of which pertain to content rather than to style, can bring to the study of artistic developments a clearer perspective than was obtainable solely on the basis of traditional stylistic analysis—the styles of symbolist works ranging as they do from the nearly representational to the nearly abstract.

To define such a theoretical framework, I include an introductory theoretical analysis of each text in the anthology, discuss the style and iconography of relevant works of art, and offer biographical, bibliographical, and general historical materials for each chapter and text.

NOTE TO THE READER

As far as possible the quoted texts are drawn from their original edition. When that was unavailable, a reliable more recent edition, wherever possible no longer covered by copyrights, was selected. When the text happens to have been reprinted in a recent scholarly edition, reference to that edition is made in the introduction to the passage or in the notes.

To establish the continuity of significant developments I make frequent references, in the introductions to chapters and individual excerpts and in the notes, to passages in the text dealing with relevant aspects of the symbolist movement. Because cross-referencing would have encumbered the text with a multitude of parentheses, I have chosen to make significant ideas available through exhaustive listings in the index, which, I hope, offer advantages comparable to those of cross-references with none of the inconvenience. Dates for the authors of excerpts and their subjects are given once in the text; those for other individuals can be found in the index.

The translations are mine. I took great care to respect the original intent of each author, even to the point of maintaining what appeared to be deliberate ambiguities. Occasionally a word or a clause is added in brackets to help clarify the author's intent. When ellipsis points were part of a quoted text, an indication is given in brackets. No indications are given when the ellipsis points stand for cuts I made. Minor errors in punctuation and spelling have been corrected in the texts originally published in English.

PROLOGUE: BAUDELAIRE, DELACROIX, AND THE PREMISES OF SYMBOLIST AESTHETICS

The writings of Charles Baudelaire on the arts powerfully influenced the aesthetic theories of symbolist artists and critics from 1860 to 1900—much as Baudelaire's poetics and poetry were at the root of symbolism in literature. Newspaper clippings of his Salon reviews circulated among the symbolists;[1] the poet Paul Verlaine reportedly carried one in his coat pocket and quoted from Baudelaire's 1859 Salon review, praising the older poet's imaginative play of associations: "[The imagination] is the analysis, it is the synthesis. . . . It has created . . . the analogy and the metaphor . . . it produces the sensation of the new."[2] Baudelaire's aesthetics became even more widely known following his death in 1867 with the publication of much of his literary and artistic criticism as well as much of his poetry.[3]

Baudelaire drew his principal theories from mainstream romantic aesthetics. After he had met several times with the leading romantic artist in France, Eugène Delacroix (Fig. 1; see Fig. 2), in 1846–47,[4] characteristics already discernible in his poetry crystallized in his theoretical writings. Passages in these writings are frequently attributed to Delacroix; occasionally they echo, almost word for word, texts by the artist that appeared later, some in his journal, published posthumously in 1893.[5] The poet's formulations, however, are both more articulate and more forceful than the notations of the artist.[6]

Baudelaire's sonnet "Correspondences," first published in *Flowers of Evil* in 1857, was probably conceived around the time of his first meetings with Delacroix.[7] Some of the characteristics of his thinking can be discerned in the poem: Baudelaire postulates in it a universal harmony that accounts for relationships between the intangible and the tangible; he implies that the gifted poet perceives these through bare hints provided by nature. And he stresses the evocative and expressive power of such stimulants as perfumes, colors, and sounds on the senses as well as his belief in the equivalence of their aesthetic impact.

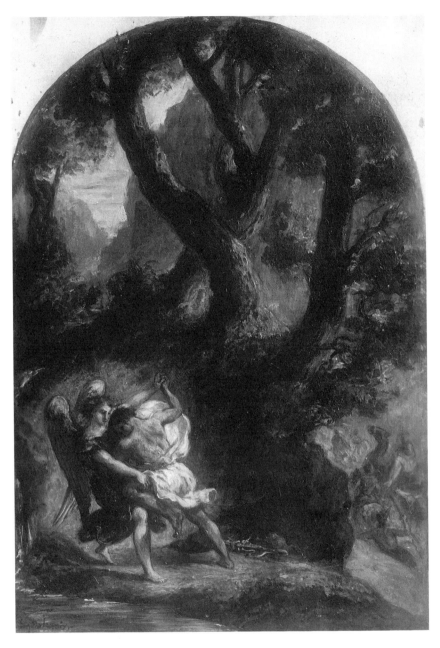

1. Eugène Delacroix, Sketch for *The Struggle of Jacob and the Angel* (small version of the picture at Saint Sulpice, Paris), 1850. Oil on canvas, 57 × 41 cm. Österreichische Galerie, Vienna.

What is this mysterious I-know-not-what that Delacroix . . . has translated better than anyone else? it is the invisible, it is the impalpable, it is the dream, it is the nerves, it is the soul.　　　　　　　　　　　　　　　　　　BAUDELAIRE

The similarities between Baudelaire's aesthetic theories and Delacroix's are evident in the passages that follow, the first from Baudelaire, the second from Delacroix:

> The appropriate way to determine whether a painting is melodious is to look at it from a distance so as to be unable to comprehend its subject or its lines. If it is melodious, it already has a meaning and has taken its place in the repertory of memories.[8]

> There is an emotion peculiar to painting, of which nothing in [literature] can give an idea. There is an impression that results from a certain arrangement of colors, lights, shadows, and so forth. It is what one might call the music of the painting. Before you even know what the painting represents, . . . when you are too far away from it, . . . you are conquered by this magical accord.[9]

Further developing Delacroix's thought, Baudelaire spelled out what has been called musicality: the artist's creation of harmonious (or deliberately discordant) as well as expressive effects by line and color, comparable to what the composer creates with rhythm and notes and the poet with prosody: "Harmony is the basis of color theory. . . . There are tones that are gay and frolicsome, others frolicsome and sad, rich and gay, rich and sad, some that are common, and some original."[10]

Baudelaire accepted—indeed, recommended—moreover, that drawing depart from the perspectival approach to nature developed by naturalistically inclined artists since the early Renaissance, so as to accentuate its element of musicality. He advocated, in particular, a return to the expressive power and harmonious effects achieved by archaic artists through abridgment and deformation:

> I want to talk of an inevitable, synthetic, childlike barbarity, which often remains visible in a perfect art (Mexican, Egyptian, or Ninevite) and which derives from the need to see things on a grand scale and to consider them primarily in their overall effect. It is not out of place to observe that many people have accused of barbarity all the painters whose vision is synthetic and abbreviated.[11]

A few years earlier Baudelaire had written of the historical-philosophical approach of such artists as Lyons-born Paul Chenavard and the German Alfred Rethel:[12] "If they were logical in their pursuit of an art serving any pedagogical purposes, they would courageously go back to the innumerable barbaric conventions of hieratic art"[13]—"hieratic" presumably referring to archaic traditions. According to Baudelaire, the deliberate abridgments and distortions of form in the art of archaic cultures—*form* in this instance encompassing line and color—were essential to the successful expression of abstract thought. Although Baudelaire never quite said so, a corollary also

holds: the simplifications and abridgments of archaic traditions for the purpose of expression or harmony are, in fact, examples of musicality.

Used in this connection, the term *synthetic* was nothing short of prophetic, for it embodied all that hieratic, even barbaric, stylization would contribute to the search for musicality and, beyond musicality, to the evocation of complex ideas and emotions by members of what was to be known as the cloisonist or synthetist school.

Like Delacroix before him, Baudelaire was aware that romantic poetic vision was characterized not so much by the mere use of metaphor (a characteristic of all relatively mature poetry) as by the richness and multiplicity of its metaphors, which, when released by a well-stocked memory and governed by an intuitive imagination, could bring forth a complex play of associations.

Delacroix believed that a fertile imagination could detect in the physical world a wealth of metaphors and even gave the unconscious its due in the process: "These figures, these objects, which seem to a certain part of your intellect the thing itself, are like a solid bridge by which the imagination penetrating them reaches the mysterious and profound sensation of which the forms are, in some way, the hieroglyph, but a hieroglyph that is far more expressive than cold representation." [14]

Elsewhere, the artist revealed the pleasure he derived from the most diverse associations, anticipating the element of surprise brought about for Baudelaire by the concatenation of his own associations and the equivalence for him of various sensory effects: "What is the point of sounding sometimes the flute, sometimes the trumpet? The first brings forth the association of a rendezvous between two lovers, the second the triumph of a warrior, and so on." [15]

Baudelaire echoed Delacroix's thought in his Salon review of 1846, placing even greater emphasis on the creative act of the artist, particularly the interplay of intuition and memory in the development of striking associations: "For Delacroix, nature is a vast dictionary, whose leaves he flips and consults with a sure and penetrating eye; and the [resulting painting], which derives primarily from memory, speaks to one's own memory. The effect produced on the soul of the spectator is commensurate with the means used by the artist." [16] In a later text, furthermore, the poet insisted on the aesthetically satisfying surprise such imaginative metaphors can bring about: "The painters who obey the imagination seek in their dictionary the elements most suited to their conception, all the while adjusting them with a certain art and so endowing them with a totally new physiognomy." [17]

The poet maintained that in certain cases the unconscious played a vital part in this process of selection: "In certain supernatural states of the soul the profundity of life reveals itself in the sight before one's eyes, however ordinary it might be. The second becomes the symbol of the first." [18]

Both artist and poet seem to have been influenced by a common romantic source: the 1831 Salon review by the German poet Heinrich Heine; Delacroix was familiar with it,[19] and Baudelaire quoted it in his review of the Salon of 1846: "In artistic matters I am a supernaturalist. I believe that the artist cannot find in nature all his types, for the most remarkable are revealed to him in his soul, as is the innate symbolism of innate ideas, and at the same time."[20]

To link associations with the unconscious implies that they reflect the conflicts, contradictions, and even absurdities that characterize its workings. The workings of the unconscious, in turn, invite the active collaboration of the reader's or viewer's imagination (and, necessarily, its subconscious springs). Baudelaire was acutely aware of this.

The romantic symbolists adopted and built on another characteristic of romanticism: the sense of mystery. Here too there are telling parallels between the thought of Baudelaire and that of Delacroix. Like other romantics, Delacroix was aware of the aesthetic potential of vagueness. After an evening stroll by the ocean he wrote: "The vagueness of obscurity adds a great deal to the impression of the sea."[21] And he noted how "the imagination takes delight in vagueness and spreads easily and encompasses vast objects on the basis of summary indications."[22]

For Baudelaire, Victor Hugo's writings convey "what I would call the *mystery of life*. . . . [Hugo] expresses with *indispensable obscurity* what is obscure and confusedly revealed."[23] But mystery did not derive solely from vagueness, obscurity, or confusion. It could also derive from apparently illogical and disturbing clashes of associations, as in the work of Edgar Allan Poe; Baudelaire suggested as much in one of his studies on the American poet, in which he linked such clashes with the vagaries of the unconscious:

> Hallucination, first allowing room for doubt, then asserting itself and becoming as convinced and argumentative as a book; the absurd taking over intelligence and governing it through a frightful logic; hysteria substituting itself for the will; contradiction establishing itself between nerves and mind; and man so disconcerted as to express pain through laughter.[24]

Demonstrating his awareness of how such inconsistencies, inasmuch as they reveal the inconsistencies of the unconscious, could give rise to startling and poetically evocative imagery, Baudelaire quoted from a novella by his friend Charles Asselineau in a review of 1859:

> What is surprising in the life of dreams is not so much to find oneself transported into fantastic regions, in which all accepted behavior has become confused, all established ideas contradicted; where frequently (and this is even more frightening) the impossible mingles with the real. What strikes me much more is the assent given these contradictions, the ease with which the most mon-

strous paralogisms are accepted as altogether natural, in such a way as to make one believe in faculties or notions of a special order, foreign to our world.[25]

Aesthetic differences pertaining to conflicting associations are readily apparent in the romantics and Baudelaire. Although the romantics made ample use of contradictory associations in their beloved antitheses, they usually reconciled these or transcended them in their poems. For Baudelaire and his symbolist successors, not only was the play of associations more complex, but the oppositions themselves were also less readily resolved or transcended, so that the meaning of the work became less definite, more mysterious, and in some ways, perhaps, more evocative of modern ambivalence.

What is the ultimate purpose of the insistence on musicality? on the play of associations and all they reveal about the life of the unconscious? on the search for mystery and what it can do to free individual imagination? It is the further probing of the self that had obsessed the romantics and, with the diffusion of the subjectivist theses of Fichte, Schopenhauer, and eventually Nietzsche, would assert itself ever more intensely during the symbolist years.

Once again Baudelaire, in his 1846 Salon review, based a theory of subjectivity on Delacroix's example: "Delacroix . . . starts out from the principle that a painting, before all else, must reproduce the intimate thought of the artist, which dominates the model as the creator dominates creation."[26] And he reiterated this theory in the article written just after the artist's death: "What is this mysterious I-know-not-what that Delacroix, for the greater glory of our century, has translated better than anyone else? it is the invisible, it is the impalpable, it is the dream, it is the nerves, it is the *soul*"[27] (see Fig. 1). Delacroix, for his part, had written in his journal: "The principal source of interest [of the work of art] derives from the soul [of the artist] and irresistibly reaches the soul of the onlooker."[28]

While the individual criteria Baudelaire developed all have their roots in romanticism and were echoed by those late romantics the Parnassians, the persistence with which he singled out particular criteria went beyond romanticism—and indeed heralded full-blown symbolism. The tendency not to reconcile or transcend conflicting oppositions has already been mentioned, as has the awareness that in the plastic arts, at least, synthetism—the distortion and abridgment ultimately linked with musicality—could lead to art forms as remote from naturalist concepts as those of archaic cultures. Another criterion of the symbolists is related to subjectivity. It seems to derive from the Parnassian poets, who combined outward impassivity with the stress on intense inner emotion characteristic of romanticism. Thus the artist tries to be an objective observer, coldly detached like a scientist; si-

multaneously, however, he seeks within himself all the passions of which humanity is capable. Baudelaire not only articulated these apparently contradictory goals fully but also claimed to derive from pursuing them the sensual excitement of a voyeur. Thus, referring to Edgar Allan Poe, he insisted on "the supernatural sensual delight man can experience at the sight of his own blood."[29] Baudelaire was so well aware of the artist's need to be at once a detached observer of the drama of his life and an active participant in it that he noted: "The artist can be an artist only on condition that he be double and not ignore any phenomenon related to his double nature."[30] I call this principle by its French name, *dédoublement,* literally the doubling of the artist's personality—in this instance the artist's capacity to be at once active and passive.

The next symbolist criterion established by Baudelaire is related to *dédoublement,* which necessarily implies an element of hypersensitivity on the part of the artist: "I have cultivated my hysteria with delight and terror," Baudelaire revealed in a posthumously published text.[31] Imperceptible in an outwardly cold demeanor, in keeping with the dogma of impassivity, this hysteria implied a state of trancelike awareness that transformed the objects of everyday life into apparitions endowed with spiritual meaning.[32]

It is not too much to say, then, that Baudelaire foresaw the visionary state the much younger symbolist poet Arthur Rimbaud was to advocate in letters to friends of 1871.

The combination in poetry of apparitions evoking trancelike moods with the impassivity called for by *dédoublement* had its pictorial equivalent in the appearance of slow motion and dreamlike detachment the symbolist artists were to give their figures, even in scenes evoking intense inner turmoil—a phenomenon that will be referred to as sleepwalking, or somnambulism.

CHARLES BAUDELAIRE

Correspondences (c. 1852–56?)

The diverse sources of this poem have been amply studied.[33] Baudelaire (1821–1867) acknowledged that the mystic Emanuel Swedenborg had advocated the principle of correspondences and the utopian socialist Charles Fourier that of analogies.[34] The sociologist-philosopher Pierre Leroux, deeply interested in the history of religions, eloquently evoked universal harmony, correspondences, and musicality in his "De la poésie de notre époque" (Pertaining to the poetry of our time) of 1831:

> Poetry is the mysterious wing that glides at will in the whole world of the soul, in that infinite sphere, one part of which is colors, another sounds, another movements, another judgments, and so forth, all vibrating simultaneously, according to certain laws, so that a vibration in one region communicates itself to another region. The privilege of art is to feel and express these relationships, which are deeply hidden in the very unity of life. From these harmonic vibrations of the diverse regions of the soul an *accord* results, and this accord is life; and when this accord is expressed, it constitutes art. And it so happens that when this accord is expressed, it is a symbol, and the form of its expression is rhythm, which itself partakes of the symbol: that is why art is the expression of life, the reverberation of life, life itself. Poetry, which chooses for its instrument the word and creates with words the symbol and the rhythm, is an accord, as is music, as is painting, as are all the other arts: so that the fundamental principle of all art is the same, and all the arts get fused into art, all the poetries into poetry.[35]

Leroux himself was unquestionably affected by the study of the history of religions in Germany. By the early nineteenth century Germany's major poets and philosophers had become fascinated both with the role of the symbol in the development of religions and with its aesthetic potential. Undoubtedly influenced by *Ideen zur Philosophie der Geschichte der Menschheit* (Ideas on the philosophy of the history of humanity), 1784–87, by Johann Gottfried von Herder, Immanuel Kant, in *The Critique of Judgment,* 1790, commented on allegorical associations, which are but a special case of sym-

bolic ones—the allegory being a universally understood symbol that is consequently devoid of mystery:

> Jupiter's eagle, with the lightning in its claws, is an attribute of the mighty king of heaven, and the peacock, his stately queen. They do not, like *logical attributes,* represent what lies in our concepts of the sublimity and majesty of creation, but rather something else—something that gives the imagination an incentive to spread its flight over a whole host of kindred representations that provoke more thought than admits of expression in a concept determined by words. They furnish an *aesthetic idea,* which serves the above rational idea as a substitute for logical presentation, but with the proper function, however, of animating the mind by opening out for it a prospect into a field of kindred representations stretching beyond its ken.[36]

Leroux is likely to have been influenced by the thought of Friedrich Creuzer, one of several historians of religion continuing the tradition initiated by Herder. Creuzer was the author of an important work on the myths and symbols of antiquity that appeared in German in 1810–12 and, much augmented, in a French translation by Joseph Guigniaut from 1825 through 1851.[37] Leroux would have read, as Guigniaut put it in notes to this work, that

> the idea of something of primitive origin, something divine, in the symbol, has no other source . . . than the set of ancient beliefs that animated the whole world, its forces, its phenomena, and placed man in a perpetual relationship with the gods made in his image. In this way, the link between the sign and the signified object, far from being arbitrary, rests on the universal laws of nature.[38]

Although he did not stress the intrinsic aesthetics of the symbol, Guigniaut waxed eloquent on the simplicity, variety, and harmony of the essentially symbolic ornamentation of Cologne cathedral.[39]

Whether the symbol or, in Kant's sense, the allegory reveals relationships "deeply hidden in the very unity of life," as Leroux put it; or opens for the mind "a prospect into a field of kindred representations stretching beyond its ken," as Kant put it; or establishes a "link between the sign and the significant object [that] rests on the universal laws of nature," as Guigniaut put it; or is associated with "long echoes that mingle in the distance in a tenebrous and profound unity," as Baudelaire put it, it constitutes a correspondence between our perception of matter and the eternal truths of a spiritual order. Both Leroux and Baudelaire, moreover, accepted the notion of correspondences between sensory perceptions—Leroux adding judgment to the rest. For him, "the wing of poetry . . . glides at will . . . in the sphere of colors, sounds, movements," and even "judgments." And for Baudelaire there was a parallelism between "perfumes, colors, and sounds."[40]

Although others in France helped spread the ideas of German historians

of religion, poets, and philosophers,[41] the names Creuzer, Guigniaut, and Leroux stand out. They transmitted to the French romantic generation the concept of the symbol and its aesthetic implications as understood by Herder, Kant, Schiller, Goethe, Moritz, W. F. Schlegel (whose student Creuzer had been), and others. It was the German poets who believed that the symbol could be drawn from everyday life. Hegel, whose work on aesthetics was translated into French between 1840 and 1851, preferred the symbol drawn from nature to that drawn from ancient religions.[42] Much influenced by German thought, the English poet Percy Bysshe Shelley noted that the objects of the world can generate a play of associations: "Poetry . . . awakens and enlarges the mind itself by rendering it the receptacle of a thousand unapprehended combinations of thought. Poetry lifts the veil of the hidden beauty of the world, and makes familiar objects be as if they were unfamiliar."[43]

It is uncertain whether Baudelaire knew the writings of Joseph Görres, a friend and colleague of Creuzer's, at the time he wrote "Correspondences." The following passage by Görres, however, may be a source for the reference to symbol-covered pillars in the first line of the poem: "Priests based the great principles of all cosmogony on [the holy books]—a great, powerful, and noble row of pillars, which keep on appearing in all myths, unchanged."[44]

Baudelaire's sonnet can be regarded as the preliminary manifesto of the French symbolist movement. It evokes nature in the metaphor of a temple whose treelike pillars are alive. The "correspondences" are links between the sensory and the spiritual that musicality further stresses through the harmony and expressiveness of the prosody.

In the verse "comme de longs échos qui de loin se confondent," for instance, the poet, aside from establishing a harmonious repetitive pattern of the French nasal "on" sounds, suggests how the vastness and "profound tenebrous unity" of the universe dulls the reflection and mingling of distant sounds; in both effects Baudelaire complies with the principle of musicality. Likewise, the sounds "frais," "verts," "doux" constitute jauntier harmonies expressing the excitement of sensuous impressions; these sounds also contribute to musicality.

As for the play of associations, Baudelaire provides an example of its effectiveness in the series of similes in which he evokes the harmonious and expressive potential of musicality:

> Some perfumes are as fresh as the flesh of children,
> Sweet as the sound of oboes, green as pastures
> —And others corrupt, rich, and triumphant.

"Confused words," furthermore, just like the "forests of symbols" and vast "profound tenebrous unity," evoke the aesthetics of mystery.

And no one can deny the subjectivity of this vision of nature.

The poem is from Charles Baudelaire, *Œuvres complètes,* ed. Jacques Crépet, 19 vols. (Paris: Connard, 1923), 1:17. For a recent annotated version, see *Charles Baudelaire: Œuvres complètes,* ed. Claude Pichois, 2 vols. (Paris: Gallimard, 1975–76), 1:11. ✦

CORRESPONDENCES

Nature is a temple in which living pillars
Sometimes emit confused words;
Man crosses it through forests of symbols
That observe him with familiar glances.

Like long echoes that mingle in the distance
In a profound tenebrous unity,
Vast as the night and vast as light,
Perfumes, sounds, and colors respond to one another.

Some perfumes are as fresh as the flesh of children,
Sweet as the sound of oboes, green as pastures
—And others corrupt, rich, and triumphant,

Having the expanse of things infinite,
Such as amber, musk, benzoin, and incense,
That sing of the flight of spirit and the senses.

CORRESPONDANCES

La nature est un temple où de vivants pilliers
Laissent parfois sortir de confuses paroles;
L'homme y passe à travers des forêts de symboles
Qui l'observent avec des regards familiers.

Comme de longs échos qui de loin se confondent
Dans une ténébreuse et profonde unité,
Vaste comme la nuit et comme la clarté,
Les parfums, les couleurs et les sons se répondent.

Il est des parfums frais comme des chairs d'enfants,
Doux comme les hautbois, verts comme les prairies,
—Et d'autres corrompus, riches et triomphants,

Ayant l'expansion des choses infinies,
Comme l'ambre, le musc, le benjoin et l'encens
Qui chantent les transports de l'esprit et des sens.

I

ROMANTIC SYMBOLISTS

"Our true fathers were Balzac and the Parnassians for the poets, Stendhal and some Mérimée or other for the analysts. . . . Zola . . . unconsciously turned art into the equivalent of the beautiful power of a motor." So wrote the Belgian symbolist poet Albert Mockel in 1887,[1] thus distancing himself from Emile Zola, the acknowledged leader of naturalism, and locating the origins of symbolism in the endeavors of the Parnassians—poets still in the mainstream of romanticism who nevertheless undertook to control the emotional exuberance of that movement in both content and style—and in romanticism itself, as Mockel acknowledged in his references to Stendhal and Prosper Mérimée.

Mockel's inclusion of Honoré de Balzac may seem surprising since that novelist, although fully in the romantic tradition in evoking passion in the various strata of society, paid so much attention to observed detail as to be a forerunner of the naturalists' cult of the here and now. But Balzac also had a mystical side, as evinced in his *Séraphita* (1832) and *Louis Lambert* (1835). These two novels were in keeping with the rejection of materialism, already apparent in mainstream romanticism, that became a central theme of both Parnassian and symbolist poetry.

The novelist Gustave Flaubert, although not mentioned by Mockel, cannot be ignored. More than Balzac he dealt—sometimes ironically—with the minutiae of life. And he succeeded in rendering even more poignant visions of grand human drama. In his *Salammbô* of 1863 he took delight in the apparently impassive evocation of barbaric myths and in the meticulous enumeration of archaeological features to compose a drama of epic proportions. Furthermore, *La Tentation de Saint Antoine* (a version was serialized in 1856–57; the definitive text appeared in 1874) presented jestingly, dramatically, and above all with sometimes painful self-revelation Flaubert's bitter disillusionment about worldly pursuits in the detailed narrative of an early Christian hermit saint's resistance to temptation.

The French Parnassians first gathered around *La Revue fantaisiste,* founded by the poet Catulle Mendès in 1859, and later published their works in the volumes of *Le Parnasse contemporain*—whence their name—which appeared from 1866 through 1876. Their leaders were Charles Leconte de Lisle, Théophile Gautier, Théodore de Banville, José-Maria de Heredia, Sully Prudhomme, and François Coppée. Baudelaire and the symbolists-to-be Paul Verlaine and Stéphane Mallarmé were also included. The first Parnassians, according to the poet, novelist, and critic Paul Bourget, had taken a stand against the "passionate and audacious curiosity about the elements of daily life" and the "unrelenting dedication to analysis" characteristic of the naturalist and positivist circles of the time. They were nevertheless idealists, who defended "the noble and deceptive chimeras of romanticism" and advocated "a renewal of faith" in it and "an effort to renew learned and sophisticated poetry."[2] Much of their work was pervaded by a gentle pessimism. Among those welcomed by the somewhat eclectic group were the artists Edouard Manet and Henri Fantin-Latour, both of whom were linked with the beginnings of impressionism, as well as a number of musicians.[3]

A decade or so later, the symbolist critic and poet Achille Delaroche explained, in writing about Leconte de Lisle, some of the differences between full-blown romantic poetry and Parnassian poetry, which his generation, incidentally, already found outmoded: "All feeling was carefully excluded from his work as parasitic. Even the gestures of humanity acquired for him the impassiveness of natural phenomena, unfolding in his verse as if they were landscapes of blood, bronze, and granite whose moral value is no more evolved than that of the flora and fauna that take part in the perpetual fantasy of universal transformism."[4] Verlaine alluded to the impassivity of the Parnassians and to the near-classical polish of their prosody in a half-jesting, half-admiring sally, according to an editor of Verlaine's poems, directed at a poem by Leconte de Lisle of 1867 named after the Graeco-Roman statue at the Louvre that it evokes: "Is it of marble or not, the Venus of Milo?"[5]

In sum, the younger generation undoubtedly saw the Parnassians as dedicated to the resonances and meter of traditional prosody, to the detriment of the freedom of form; so coldly archaeological in their treatment of ancient myths and fables as to fetter their own and their readers' flights of imagination and thus all play of associations; and so impassive as to preclude the intense subjectivity characteristic of Baudelaire and his later admirers.

The Parnassians themselves might have defended their impassivity as a reaction to romantic exuberance of form and expression, arguing that their leaders, at least, remained exalted at heart, thus announcing the *dédoublement* of the symbolist psyche. Although the Parnassians valued polished form and traditional craftsmanship in protest against the emotional and stylistic exu-

berance of the Romantics, they still attached much importance to musicality. Indeed Banville, admittedly writing in 1881, claimed that "there is no poetry and no verse outside of song."[6]

The Parnassians' attitude toward ancient myths implied a renewed awareness of their appeal. For Louis Ménard, a poet and a historian of religion as well as a distinguished scientist who was a friend of Leconte de Lisle's, ancient myths were "sets of symbols, that is, ideas expressed in concrete form." Myth, he added, has the same impact as religious instruction: it addresses itself

> not to reason, as does the teaching of philosophy, but to all faculties at once; it acts through the senses on the imagination, the heart, and the intelligence. The great mysteries of nature, light, movement, life cannot be proved; they assert themselves. Likewise symbols, which are the human expression of divine laws, cannot be proved; they merely reveal themselves, and conviction descends of its own accord in the souls that are prepared to receive them.[7]

Thus the ancient myths reaffirmed the age-old play of associations that the younger generation had adopted so willingly from romanticism; and, more important, they were potent reminders of the sacredness ascribed to that play by early prophets and poets.

Alfred, Lord Tennyson, who towered over British poetry at mid-century, was, broadly speaking, the contemporary of the Parnassians and shared some of their ideals. The succeeding generation of English poets—the Pre-Raphaelites—came to appreciate developments in France after two Francophiles and Baudelairean enthusiasts, Algernon Charles Swinburne and, later, Walter Pater, became their friends. Swinburne and Pater gave the British aesthetic movement its main impulse.

The aesthetic views of an important presymbolist group of painters and sculptors corresponded to those of the Parnassians. They too can be included among the romantic symbolists. These artists, like the Parnassian poets, were rooted in romanticism. And like the Parnassians, they reacted against the spread of naturalism, blossoming forth in the 1860s and 1870s into its most seductive offshoot, impressionism. Their stress on musicality, the play of associations, a sense of mystery, and subjectivity, furthermore, relates their aesthetic views to those of Baudelaire and Delacroix. And their works were also dominated by dreams and daydreams, frequently echoing mythical and religious themes. These works evoke the states of the soul, specifically that of the artist, in keeping with the tradition of romanticism.

Romantic-symbolist artists were as reluctant as the literary Parnassians to display the emotional turbulence of the romantics—hence a similar stress on impassivity, often verging on somnambulism. Indeed, the figures in

their works usually appear detached and self-absorbed, wrapped up in their own thoughts, however dramatic the subject of the work might be. This last trait in itself implies an element of *dédoublement,* since such figures seem at once to participate in an action and to meditate on their predicament.

In style these artists shared the Parnassians' respect for traditional form in most of their works, avoiding both Delacroix's turbulent drawing and his audacious juxtaposition of hues. Like the Parnassians, they frequently borrowed from earlier traditions; they remained essentially faithful to the simple value-modeling of masses that originated in the early Renaissance, but they occasionally emulated the elegant linear patterning and the ornate jewel-strewn surfaces of such quattrocento artists as Mantegna and Crivelli. At times decorative affectations in the handling of lines and surfaces and eerie exaggerations of light-dark contrasts point to Mannerism. But the romantic symbolists never quite abandoned the essentially naturalist handling of masses in space of the early Renaissance; and they treated light and atmosphere with the relative consistency of that period, even though their lighting could be eerie and their shadows ominous.

It is tempting to include Delacroix himself among the romantic symbolists; the only grounds on which to keep him out are stylistic. For unlike Ingres, he never attempted to emulate the manner of the *quattrocento.* What is more, his ebullient execution, which often followed baroque principles, reflected the emotional exaltation of romanticism. Aside from these characteristics, his *Sardanapalus* of 1827 (Fig. 2) meets the criteria of romantic symbolism. Its sumptuous, richly sensuous, and sometimes brutal color achieves a splendid musicality; such suggestive forms as the flamelike bodies of the women convey, by the play of associations, both intense sensuality and the promise of the ordeal by fire to come;[8] the overall confusion and the apparent conflict between indices of pleasure and intimations of pain contribute to a sense of mystery; the despot's contemplative response to a veritable onslaught on the senses echoes Delacroix's own combination of phlegm and sensuality and points to his subjective approach. Such impassivity is in keeping with Parnassian ideals; paired with the dramatic turbulence of Delacroix's subject, it constitutes a prime example of *dédoublement.* The artist's description of the work in the 1827 Salon catalogue corroborates this interpretation. The monarch—briefly mentioned in the Bible and eventually the hero of a poem by Byron—when his palace was surrounded by his enemies, ordered that "his women, pages, even his horses and favorite dogs be slain; that none of the objects that had given him pleasure survive him; [and that] his chamberlain set his bed afire and throw himself upon it."[9] Thus he takes an active part in a dramatic grand finale, quietly watching as it unfolds.

Théodore Chassériau, Ingres's pupil and a friend and follower of Dela-

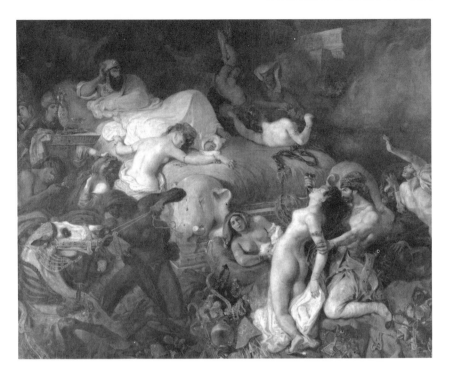

2. Eugène Delacroix, *The Death of Sardanapalus*, 1827. Oil on canvas, 395 × 495 cm. Musée du Louvre, Paris. Photo copyright R.M.N.

. . . the supernatural sensual delight man can experience at the sight of his own blood . . . BAUDELAIRE

croix, played a leading role in fostering romantic symbolism in the arts. Gustave Moreau and Pierre Puvis de Chavannes, Chassériau's friends and disciples, must have been particularly impressed by his large, complex allegorical compositions. A third major romantic symbolist, Odilon Redon, wrote effusively of the impact Delacroix had had on him.

For the sake of chronology the Pre-Raphaelites, the closest British equivalents to the romantic-symbolist artists, are discussed first.

DANTE GABRIEL ROSSETTI

Hand and Soul (1850)
On His *Beata Beatrix* (1871)

The British painter-poet Rossetti (1828–1882),[10] along with the artists William Holman Hunt and John Everett Millais, was one of the original members of the Pre-Raphaelite Brotherhood, founded in September 1848. (Ford Madox Brown shared their ideals but did not officially join them.) According to Hunt, Rossetti at one point proposed Early Christians as a name for the brethren,[11] one that would have been appropriate, given their dedication to ideals like those of the Nazarenes, young German artists who had studied together at the Vienna Art Academy and had moved to Rome in 1810.[12] The leading artists among the Nazarenes were Friedrich Overbeck, Franz Pforr, and, eventually, Peter Cornelius. Devout Catholics and Protestants, they were set on reviving the abstraction—the stress on pure line, simplified surface, and intense color—as well as the iconography and the mysticism of what was then loosely called primitive, or early Christian, or pre-Raphaelite art, whose principal luminaries, in their eyes, were Dürer, Fra Angelico, and even Raphael. They also rightly claimed that their careful linear rendering of detail, reminiscent of Dürer, brought their art closer to nature than that of their academic instructors.

The influence of the Nazarenes on the British Pre-Raphaelites is well established;[13] the early work of the British artists was, in many cases, similarly devout and characterized by roughly similar stylistic and iconographic interests. Ironically, John Ruskin stressed the "naturalism" of the young men's work, praising its "perfect truth, power and finish"; he added that "as studies both of drapery and of every minor detail, there has been nothing so earnest and so complete as these pictures since the days of Albert Dürer."[14] The young artists themselves took up the "naturalist" label with some alacrity, as evinced by the subtitle of the short-lived periodical they launched in 1850: *The Germ: Thoughts towards Nature in Poetry, Literature, and Art.*[15]

Ruskin himself had become fully attuned to the aesthetics of the Middle

Ages and the early Renaissance. He had been influenced by works on Christian art from the earliest times that reflected Nazarene attitudes, as well as by the fourteenth-century frescoes of the Campo Santo in Pisa and by much of the medieval art he saw in Florence.[16] Ruskin, however, was so smitten by the cult of direct observation that he acknowledged the Pre-Raphaelites' fondness for apparition-like imagery only in 1878: "One of the most curious, yet the most common deficiency in the modern contemplative mind [is] that these phenomena of true imagination are yet no less real, and often more vivid than the phenomena of matter." He nevertheless required that "such objects from imagination must not be prettified."[17]

Delayed though it was, Ruskin's admission appeared to justify the religious tone of both early and later Pre-Raphaelite work and the Neoplatonic awareness that became increasingly pronounced in Rossetti's work—it was to affect the work of the other Pre-Raphaelites too—that the soul alone is real.

HAND AND SOUL

By December 21, 1849, when Rossetti wrote "Hand and Soul,"[18] which was published in the first issue of the *Germ*, in January 1850, he had already produced the paintings that adhered most faithfully to Nazarene ideals.[19] The manuscript, with its unmistakable Neoplatonic overtones, presages a major development in his work and that of his fellow Pre-Raphaelites in the 1850s.

In the tale, the artistic and religious fervor of the imaginary young medieval painter Chiaro dell'Erma of Arezzo is symbolized by a Beatrice-like "mistress—his mystical lady, now hardly in her ninth year."[20] The situation is reminiscent of Dante's first sight of his own elusive Beatrice and suggests an acceptance of Dante's Neoplatonic belief in the parallelism between the highest spiritual ideals and the purest love that transcends all material contingencies, even death.[21]

Chiaro undergoes a spiritual crisis, wondering whether he has not mistaken "the worship of beauty" for "faith" in the course of his short yet successful artistic career.[22] Henceforth he would "put his hand to no works but only to such as had for their end the presentment of some moral greatness that should impress the beholder; and, in doing this, he did not choose for his medium the action and passion of human life, but cold symbolism and abstract impersonation." The reference was unquestionably to the Nazarene moral, religious, and even stylistic ideals.

The results of Chiaro's new endeavors are disappointing and he becomes despondent. He is awed by the visit of a mystic lady, none other than "the fair woman, that was his soul. . . . [H]er hair [was] the golden veil through

which he beheld his dreams." His soul urges him: "Paint me thus, as I am, to know me: weak, as I am, and in the weeds of this time." The text thus reasserts romantic individualism and subjectivity.

The soul also reminds Chiaro that art does not necessarily have to be a "presentment of some moral greatness that should impress the beholder," a conduit, that is, for religious and moral intimations. The statement is tantamount to a rejection of strictly Nazarene ideals and a tilt toward the romantics' notion of art for art's sake.

Perhaps even more important, the artist's soul urges him in humility to partake of the communal soul she refers to as "man" and so to accomplish his task as an artist: "Serve man with God,"[23] achieving meaningful communication at the soul-to-soul level, the physical envelope being relegated to the role of a symbol.

In his artistic program Rossetti endeavored to perceive other souls through his own, so to speak—projecting his own temperament and aspirations onto his models, becoming in the process a paragon of subjectivity. He was also indulging in an elaborate play of associations, for at diverse times in his career, and sometimes simultaneously, he was "communing" with the souls of a variety of feminine types—from those of seductive sinners and beguiling witches to those of beatific Beatrices.

Whatever their individual psychology, Rossetti's figures are always impassive and detached in their expressions and attitudes; their angelic mien verges on the hermaphroditic, echoing a Neoplatonic spirituality. His propensity, furthermore, for seeing his own soul through the souls of others and his ability to capture the variety of resulting effects show an aptitude for *dédoublement*.

Rossetti renders his figures in evocative, graceful linear patterns and arrangements of fairly intense hues that hark back to the Florentine quattrocento and at the same time reveal an understanding of musicality.[24] These remained attributes of Pre-Raphaelitism and affected later developments throughout Europe and the United States.

The following excerpt from Dante Gabriel Rossetti, "Hand and Soul," originally published in *The Germ,* no. 1 (January 1850): 1–31, is from *The Collected Works of Dante Gabriel Rossetti,* ed. William Michael Rossetti, 2 vols. (London: Ellis and Elvey, 1901), 1:383–98. ❧

A woman was present in his room, clad to the hands and feet with a green and grey raiment, fashioned to that time. . . .

As the woman stood, her speech was with Chiaro: not, as it were, from her mouth or in his ears; but distinctly between them.

"I am an image, Chiaro, of thine own soul within thee. See me, and know me as I am. Thou sayest that fame failed thee, and faith failed thee; but because at least thou hast not laid thy life unto riches, therefore though thus late, I am suffered to come into thy knowledge. Fame sufficed not, for that thou didst seek fame: seek thine own conscience (not thy mind's conscience, but thine heart's), and all shall approve and suffice. . . .

"Thou hast said . . . that faith failed thee. This cannot be. Either thou hadst it not, or thou hast it. But who bade thee strike the point betwixt love and faith? Wouldst thou sift the warm breeze from the sun that quickens it? Who bade thee turn upon God and say: 'Behold, my offering is of earth, and not worthy: Thy fire comes not upon it; therefore, though I slay not my brother whom Thou acceptest, I will depart before Thou smite me.' Why shouldst thou rise up and tell God He is not content? Had He, of His warrant, certified so to thee? Be not nice to seek out division; but possess thy love in sufficiency: assuredly this is faith, for the heart must believe first. What He hath set in thine heart to do, that do thou; and even though thou do it without thought of Him, it shall be well done; it is this sacrifice that He asketh of thee, and His flame is upon it for a sign. Think not of Him; but of His love and thy love. For God is no morbid exactor: He hath no hand to bow beneath, nor a foot, that thou shouldst kiss it."

And Chiaro held silence, and wept into her hair which covered his face; and the salt tears that he shed ran through her hair upon his lips; and he tasted the bitterness of shame.

Then the fair woman, that was his soul, spoke again to him, saying:

"And for this thy last purpose, and for those unprofitable truths of thy teaching,—thine heart hath already put them away, and it needs not that I lay my bidding upon thee. How is it that thou, a man, wouldst say coldly to the mind what God hath said to the heart warmly? Thy will was honest and wholesome; but look well lest this also be folly,—to say, 'I, in doing this, do strengthen God among men.' When at any time hath He cried unto thee, saying, 'My son lend Me thy shoulder, for I fall'? Deemest thou that the men who enter God's temple in malice, to the provoking of blood, and neither for His love nor for His wrath will abate their purpose,—shall afterwards stand, with thee in the porch midway between Him and themselves, to give ear unto thy thin voice, which merely the fall of their visors can drown, and to see thy hands, stretched feebly, tremble among their swords? Give thou to God no more than he asketh of thee; but to man also, that which is man's. In all that thou doest, work from thine own heart, simply; for his heart is as thine, when thine is wise and humble; and he shall have understanding of thee. One drop of rain is as another, and the sun's prism in all: and shalt thou not be as he, whose lives

are the breath of One? Only by making thyself his equal can he learn to hold communion with thee, and at last own thee above him. Not till thou lean over the water shalt thou see thine image therein: stand erect, and it shall slope from thy feet and be lost. Know that there is but this means whereby thou mayst serve God with man:—Set thine hand and thy soul to serve man with God."

And when she that spoke had said these words within Chiaro's spirit, she left his side quietly, and stood up as he had first seen her: with her fingers laid together, and her eyes steadfast, and with the breadth of her long dress covering her feet on the floor. And, speaking again, she said:

"Chiaro, servant of God, take now thine Art unto thee, and paint me thus, as I am, to know me: weak, as I am, and in the weeds of this time; only with eyes which seek out labour, and with a faith, not learned, yet jealous of prayer. Do this; so shall thy soul stand before thee always, and perplex thee no more. . . ."

ON HIS BEATA BEATRIX

In few of Rossetti's works is the Neoplatonic interaction between souls more complex or more effectively presented than in *Beata Beatrix,* "Blessed Beatrice" (Fig. 3); Rossetti began preparations for it before the suicide in 1862 of Elizabeth Siddal, whose portrait it is. Originally a milliner's assistant, she became his model and mistress and later developed slight talents as a poet and painter. Besides being prone to fits of deep depression and anger, she was tubercular and increasingly addicted to pain-killing drugs. Only when her health took a serious turn for the worse, in 1862, did Rossetti marry her. He worked on the portrait in earnest from 1864 through 1870.

Rossetti's text, in combination with the picture, confronts us with complex associations. The morbid-looking Beatrice–Elizabeth Siddal is caught "under the resemblance of a trance," already absorbed in the "consciousness of a new world" she is about to enter as she sheds material ties to become pure spirit. The figures of Dante-Rossetti and Love in the background, for their part, are even less substantial, although still in the streets of Florence and therefore of this world. Conscious as they are of Beatrice's presence, they are nonetheless visions having a vision.

The relationship becomes even more complex when one realizes that, following the advice received by Chiaro dell'Erma, Beatrice-Elizabeth is, in part at least, Rossetti's soul.[25] As his sister Christina put it in her sonnet of December 1856, "In an Artist's Studio," he repeated some of his models' features with monomaniacal insistence, as if each embodied some aspects of

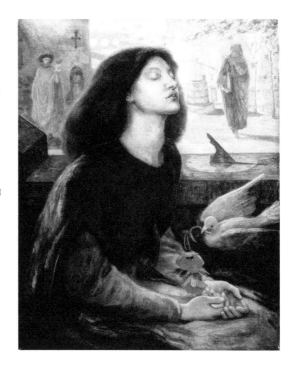

3. Dante Gabriel Rossetti, *Beata Beatrix*, 1864. Oil on canvas, 132 × 86.4 cm. Birmingham Museums and Art Gallery. Reproduced by permission.

. . . a trance, in which Beatrice, seated at the balcony overlooking the city, is suddenly rapt from Earth to Heaven. ROSSETTI

his inner life—a highly subjective approach, and one implying an element of *dédoublement:*

> One face looks out from all his canvases,
> .
> Not as she is, but as when hope shone bright
> Not as she is, but as she fills his dream.[26]

Not all of Rossetti's mature compositions are as complex, but most consist of an elaborate counterpoint of material and spiritual, real and imaginary, wholesome and morbid, conscious and oneiric. What is more, Rossetti seemed to take much greater delight in the sheer play of associations, and all the emotions they evoke, than in any moral or religious consideration.

Touches of abstraction remain in graceful linear patterns and an arrangement of fairly intense hues. The precise graceful outlines of lips, nostrils, and hands no less than the folds of the drapery and its definite, contrasting hues bring to mind the Florentine quattrocento. But on the whole, the painting is characterized by the looser, more vaporous painting technique

of Rossetti and the other Pre-Raphaelites after the 1860s. With its spectral figures and Beatrice-Elizabeth's somnambulistic attitude,[27] it seems intended to elicit dream-like associations.

The excerpt that follows is from Rossetti's letter to the picture's first owner, the Hon. Mrs. Cowper-Temple,[28] on March 26, 1871. It is reproduced from the original in The Pierpont Morgan Library, New York (MA 1650[3]). ✦

You are well acquainted with Dante's *Vita Nuova* which [the picture] illustrates, embodying symbolically the death of Beatrice as treated in that work. It must of course be remembered, in looking at the picture, that it is not intended at all to *represent* Death, but to render it under the semblance of a trance, in which Beatrice, seated at the balcony overlooking the city,[29] is suddenly rapt from Earth to Heaven. You will remember how much Dante dwells on the desolation of the city in connection with the incident of her death, and for this reason I have introduced it as my background, and made the figures of Dante and love passing through the street, and gazing ominously on one another, conscious of the event; whilst the bird, a messenger of death, drops the poppy between the hands of Beatrice. She, through her shut lids, is conscious of a new world, as expressed in the last words of the *Vita Nuova*. "—Quella beata Beatrice[,] che gloriosamente mira nella faccia di colui *qui est per omnia soecula benedictus*" [—That blessed Beatrix who gloriously gazes at the face of Him who is blessed throughout the ages].[30]

SIR EDWARD BURNE-JONES

Letters to His Family (1854)

Burne-Jones (1833–1898) entered Oxford University in 1852, intending to become a clergyman. There, however, he was exposed to Ruskin's writing and found in William Morris a fellow student equally enthusiastic about the arts and poetry.[31] In 1856 he sought out Rossetti, who was teaching at the Working Men's College in London; that year he decided to become an artist. His early work showed stylistic and iconographic affinities with that of Rossetti. In 1857 he, Morris, and others participated under Rossetti's guidance in decorating the recently completed neo-Gothic Debating Hall of the Oxford Union. He and Morris were at the forefront of the second group of Pre-Raphaelite artists that formed just as the first was losing its cohesiveness. Incidentally, George Frederic Watts, a lifelong friend of Burne-Jones's, although not strictly speaking a Pre-Raphaelite, can be regarded as belonging to this second wave. The two friends also met the future poet Algernon Swinburne, with whom they soon developed a close relationship. Both original and later Pre-Raphaelites were tied to aestheticism, particularly Rossetti.

The first of the two excerpts from Burne-Jones's letters to his family from Oxford suggests the sense of elation he experienced when daydreaming about the Middle Ages during a solitary walk. In the religious symbolism of chivalric romances he found echoes of his own spiritual fervor, and everything medieval seemed to him a counterweight to the deplorable materialism of his own time. In many ways, his escape into medieval spiritualism is comparable to Rossetti's Neoplatonic and Dantesque propensities; for Burne-Jones the forms and colors of medieval art contributed to a sense of "ecstasy," a term used by the Neoplatonists of late antiquity to refer to the state of a soul susceptible to communion with the divine.[32]

The second text recounts Burne-Jones's and Morris's excitement at reading a just-published volume by Ruskin that contained a chapter on the Pre-Raphaelites.

The excerpts that follow are from Georgiana Burne-Jones, *Memorials of Edward Burne-Jones,* 2 vols. (London: Macmillan, 1904), 1:97–98 and 1:99. ✦

MEDIEVAL VISIONS

I have just come in from my terminal pilgrimage to Godstowe ruins and the burial place of Fair Rosamond.[33] The day has gone down magnificently; all by the river's side I came back in a delirium of joy, the land was so enchanted with bright colors, blue and purple in the sky, shot over with a dust of golden shower [shower of golden dust?], and in the water a mirror'd counterpart, ruffled by a light west wind—and in my mind pictures of the old days, the abbey, and long processions of the faithful, banners of the cross, copes and crosiers, gay knights and ladies by the river bank, hawking-parties and all the pageantry of the golden age—it made me feel so wild and mad I had to throw stones into the water to break the dream. I never remember having such an unutterable ecstasy, it was quite painful with intensity, as if my forehead would burst. I get frightened of indulging now in dreams, so vivid that they seem recollections rather than imaginations, but they seldom last more than half-an-hour; and the sound of earthly bells in the distance, and presently the wreathing of steam upon the trees where the railway runs, called me back to the years I cannot convince myself of living in.

DISCOVERING THE PRE-RAPHAELITES

I was working in my room when Morris ran in one morning bringing the newly published book with him:[34] so I first saw the name of Rossetti. So everything was put aside until he read it all through to me. And there we first saw about the Pre-Raphaelites, and there I first saw the name Rossetti. So for many a day after that we talked of little else but paintings which we had never seen, and saddened the lives of our poor Pembroke [Burne-Jones's college at Oxford] friends.

Poems by William Morris (1868)

The belief that the soul's aspirations would be fulfilled in a world less tangible, purer, and more exalted than the real one—like the world Burne-Jones visualized in his dreams of medieval knights—remained important to the later Pre-Raphaelites and, indeed, had repercussions throughout Europe and America. The imagery drew on different cultures, from medieval and Nordic to Greek, Roman, and Celtic, but was always characterized by expressive and harmonious lines and colors. In the remote artificial universe they imagined, artists and poets could freely unfold the play of associations. The later Pre-Raphaelites espoused art for art's sake even more readily than the earlier brethren as the excitement of the imagery eclipsed any vestige of the Victorian moral values of their upbringing, much as in ancient myths the poetry of the narration transcended accepted morality.

Walter Pater's "Poems by William Morris" was the first significant attempt to define aestheticism, even though that word does not appear in it.[35] A little younger than Burne-Jones and Morris (1834–1896), Pater (1839–1894) also went to Oxford, and he too fell under Ruskin's spell, eventually deciding to be a writer and critic.[36] While at Oxford, he met Swinburne, soon to be the leader of aestheticism.

An avid reader of French literature, Swinburne admired such writers as Hugo, Gautier, Flaubert, and Baudelaire—all of them supporters of art for art's sake. His enthusiasm for the last three may well have steered him toward the apparent amorality, and occasional immorality, that were to become characteristic of aestheticism. He specifically linked the latter with the art of earlier eras of decadence, such as declining classical antiquity, for which he felt a special affinity. He first flaunted the pennant of art for art's sake in his *Poems and Ballads* (1866), dedicated to Burne-Jones, which included the notorious "Hermaphrodite," written in 1863 and inspired by a Roman copy of a Hellenistic marble at the Louvre of an androgynous sleeping figure of love.

The Pre-Raphaelites, who must have had similar predispositions, were painting figures that reflected—albeit with considerable restraint and decorum—a similar spirit. That is what the poet and critic Robert Buchanan singled out in attacking, in 1871, Swinburne, Rossetti, Morris, using the epithet "aesthetic" in connection with the movement: "The poet [of what Buchanan called the fleshly school of poetry] must be an intellectual hermaphrodite, to whom the very facts of day and night are lost in a whirl of aesthetic terminology."[37]

There was another side to aestheticism—one that, ironically, the artists had no difficulty conciliating with their art-for-art's-sake stance: the notion that art itself was a substitute for religion, or, more specifically, that the artist's vision was semireligious in inspiration. We have an inkling of this attitude in the ecstasy occasioned for Burne-Jones by his daydreams of the Middle Ages; the same spirit pervades the visions evoked in Morris's poetry, as Pater eloquently points out in "Poems by William Morris." Pater himself, besides admiring Swinburne, was a close friend of Simeon Solomon, who was active for a time in the later group of Pre-Raphaelites.

The general mood of Pater's text, as well as specific phrases—"artificial . . . 'paradise,'" "exotic flowers," and "a beautiful disease or disorder of the senses"—has a Baudelairean flavor.[38] The references to androgyny and to the hothouse atmosphere in which "reverie, illusion, delirium . . . are the three stages of a fatal descent," moreover, are in keeping with the aestheticism of the second wave of Pre-Raphaelitism and suggest the fascination with decadence characteristic of the contemporary French poetry from which aestheticism derives. Similar characteristics are reflected in the morbid aspects of the work of Gustave Moreau and, later, that of the artists of the soul.

Pater's reference to ecstasy clearly alludes to the most exalted state of the soul poetry can convey—one that Neoplatonists of the beginning of the Christian Era associated with the suprarational, mystical state essential to an awareness of the Supreme Being. By applying the word to an aesthetic state, he in effect makes a religion of art.

Ecstasy as a bridge between the physical and the spiritual in Pater's writing can be broadly equated with the states of the soul in Baudelaire, in which everyday persons and objects are transformed into supernatural visions fraught with spiritual meaning, and is fully in keeping with the fundamentals of romantic symbolism. Indeed, there is an element of Baudelairean pessimism both in the notion that the aesthetic experience makes the admired object "irresistibly real and attractive" for a "moment only" and in the even more saddening thought: "to save himself, it is himself [the human being] that he loses at every moment."

There are other links with the Baudelairean roots of romantic symbolism.

The "quickened, multiplied consciousness" praised by Pater is but a livened version of the play with associations. "Somnambulistic" is a term Pater himself uses, and the very notion that the creative spirit must "burn with this hard gem-like flame" implies the ability to experience the most intense passion while being able to express it with the cold precision of a gem-cutter—a form of *dédoublement*.

The aestheticist label came to be attached to Rossetti and the group of younger artists gathered around him, whose works were exhibited regularly at the Grosvenor Gallery beginning in August 1870, when it was founded. Burne-Jones and Morris were part of the group, as was Aubrey Beardsley, who was much influenced by Burne-Jones early in his career. Whistler, in his most decorative endeavors, also had affinities with the movement. Rossetti and his sister Christina, Morris, Swinburne, Oscar Wilde, and Pater himself were the movement's principal literary figures.

The excerpt that follows is from [Walter Pater,] "Art II, Poems by William Morris. *The Defense of Guinevere: And Other Poems,* 1858; *The Life and Death of Jason: A Poem,* 1867; *The Earthly Paradise: A Poem,* 1868," *Westminster and Foreign Quarterly Review,* October 1, 1868, 300–312. ✦

Greek poetry, medieval or modern poetry, projects above the realities of its time a world in which the forms of things are transfigured. Of that world this new poetry takes possession and sublimates beyond it another still fainter and more spectral, which is literally an artificial or "earthly paradise." It is a finer ideal, extracted from what in relation to any actual world is already an ideal. Like some strange second flowering after date, it renews on a more delicate type the poetry of a past age, but must not be confounded with it. The secret of the enjoyment of it is that inversion of home sickness known to some, that incurable thirst for the sense of escape, which no actual form of life satisfies, no poetry even, if it be merely simple and spontaneous. It is this which defines in these poems the temperament or personality of the workman.

. . . Here [in Provençal poetry of the Middle Ages], under this strange complex of conditions, as in some medicated air, exotic flowers of sentiment expand, among people of a remote and unaccustomed beauty, somnambulistic, frail, androgynous, the light almost shining through them, as the flame of a little taper shows through the Host. Such loves were too fragile and adventurous to last more than for a moment.

That whole religion of the middle age was but a beautiful disease or disorder of the senses; and a religion which is a disorder of the senses must

always be subject to illusions. Reverie, illusion, delirium; they are the three stages of a fatal descent both in the religion and the loves of the middle age.

[After discussing individual poems and discoursing on humanity's continuing sense of loss, derived from its endless state of flux, Pater concludes as follows:]

Struggling, as he must, to save himself, it is himself [the human being] that he loses at every moment. . . .

The service of philosophy, and of religion and culture as well, to the human spirit, is to startle it into a sharp and eager observation. Every moment some form grows perfect in hand or face; some tone on the hills or sea is choicer than the rest; some mood of passion or insight or intellectual excitement is irresistibly real and attractive for us for that moment only. Not the fruit of experience but experience itself is the end. A counted number of pulses only is given to us of a variegated, dramatic life. How may we see in them all that is to be seen in them by the finest senses? How can we pass most swiftly from point to point, and be present always at the focus where the greatest number of vital forces unite in their purest energy?

To burn always with this hard gem-like flame, to maintain this ecstasy, is success in life. Failure is to form habits; for habit is relative to a stereotyped world; meantime it is only the roughness of the eye that makes any two things, persons, situations—seem alike. While all melts under our feet, we may well catch at any exquisite passion, or any contribution to knowledge that seems by a lifted horizon to set the spirit free for a moment, or any stirring of the senses, strange dyes, strange flowers and curious odors, or work of the artist's hands, or the face of one's friend. Not to discriminate every moment some passionate attitude in those about us and in the brilliance of their gifts some tragic dividing of forces on their ways, is on this short day of frost and sun to sleep before evening.

. . . [W]e have an interval and then we cease to be. Some spend this interval in listlessness, some in high passions, the wisest in art and song. For our one chance is in expanding that interval, in getting as many pulsations as possible into the given time. High passions give one this quickened sense of life, ecstasy and sorrow of love, political or religious enthusiasm, or the enthusiasm of humanity. Only, be sure it is passion, that it does yield you this fruit of a quickened, multiplied consciousness. Of this wisdom, the poetic passion, the desire of beauty, the love of art for art's sake, has most; for art comes to you professing frankly to give nothing but the highest quality to your moments as they pass, and simply for those moments' sake.

FERNAND KHNOPFF

Memories of Burne-Jones (1898)

The Belgian artist Fernand Khnopff (1858–1921), a romantic symbolist in-fluenced first by Gustave Moreau and then by Burne-Jones, wrote an obitu-ary, published shortly after Burne-Jones's death in 1898, that reflects the ideals of aestheticism. In it he praised Burne-Jones's major works.

King Cophetua and the Beggar Maid of 1884 (Fig. 4), inspired by a poem by Tennyson, itself based on an ancient ballad,[39] tells of a love that breaks all social boundaries. *The Golden Stairs* of 1872–80 (Fig. 5), originally called *The King's Wedding,* depicts the maids of honor who have helped celebrate the union of two lovers with their musical instruments. Quiet, graceful, lost in their thoughts, almost somnambulistic, they are leaving, no doubt after taking the new bride to the bed chamber—doves nestled along the eaves symbolize conjugal bliss—and resume the bustle and conversation of daily life as they approach the bottom of the stairs.

Both the firm and elegant lines and smooth surfaces of the quattrocento and the simple richness of the setting and accoutrements attest to Burne-Jones's intention to recall the discreet ornamental opulence of Botticelli and Mantegna and the spiritual exaltation it was meant to evoke.

Khnopff reveals that he had seen *King Cophetua and the Beggar Maid* nine years earlier, at the Paris Universal Exhibition of 1889. Presumably he relied on memory in writing of both works, in each of which he detected the artist's own memory images of "the things that are no more, the things that can never be." For Khnopff, Burne-Jones's two pictures suggested the poignancy of what Pater had called the "ecstasy and sorrow of love," mak-ing it, again in Pater's words, "irresistibly real and attractive for us for [a] moment only." Khnopff echoed this poignancy in interpreting the gesture of "the last of the maidens," who "stops, and turning her head once more, sheds a smile of farewell."

Paul Bourget, who is quoted in the text, was a successful French novelist and critic.

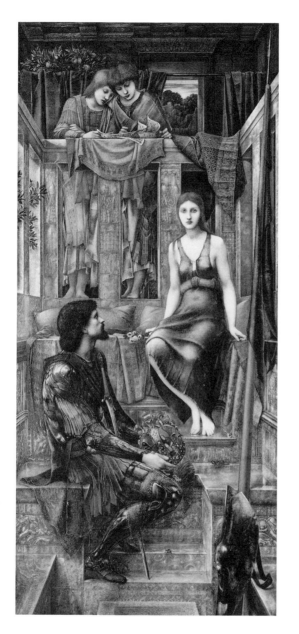

4. Sir Edward Burne-Jones, *King Cophetua and the Beggar Maid*, 1884. Oil on canvas, 293.4 × 135.9 cm. Photo copyright The Tate Gallery, London.

One by one the tender and precious memories were revived, the recondite emotions of past art and life. KHNOPFF

5. Sir Edward Burne-Jones, *The Golden Stairs*, 1872–80. Oil on canvas, 262.9 × 66 cm. Copyright The Tate Gallery, London.

As they descend the winding stair the suppressed passion of it all finds utterance in the plaint of a violin. KHNOPFF

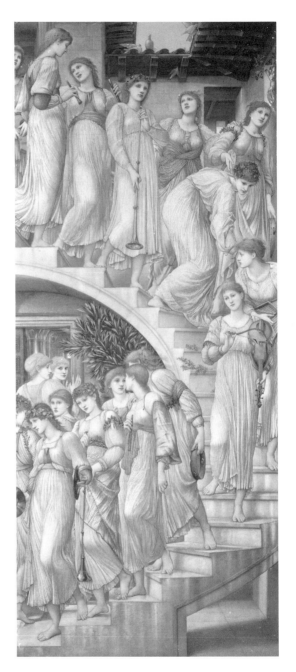

The text that follows is from Fernand Khnopff, "A Tribute from Belgium," in *The Magazine of Art* 21, (1898): 520–26. ✦

Before the pallid beggar-maid [see Fig. 4], still shivering in her little grey gown, sits the king clad in brilliant black armor, who, having surrendered to her his throne of might, has taken a lower place on the steps of the dais. He holds on his knees the finely modeled crown of dark metal lighted up with the scarlet of rubies and coral, and his face, in clear-cut profile, is raised in silent contemplation. The scene is incredibly sumptuous: costly stuffs glisten and gleam, luxurious pillows of purple brocade shine in front of the chased gold paneling, and the polished metal reflects the beggar-maid's exquisite feet, adorable feet—their ivory whiteness enhanced by contrast with the scarlet anemones that lie here and there. Two chorister-boys perched above are singing softly, and in the distance, between the hanging curtains, is seen a dream, so to speak, of an autumn landscape, its tender sky already dusk, expressing all sweet regret, all hope in vain for the things that are no more, the things that can never be. In this exquisite setting, the two figures remain motionless, isolated in their absorbed reverie, wrapped in the interior life.

How perfectly delightful were the hours spent in long contemplation of this work of intense beauty! One by one the tender and precious memories were revived, the recondite emotions of past art and life, making one more and more in love with their superb realization in this marvelous picture. The spectator was enwrapped by this living atmosphere of dream-love and of spiritualized fire, carried away to a happy intoxication of soul, a dizziness that clutched the spirit and bore it high up, far, far away, too far to be any longer conscious of the brutal presence of the crowd, the mob of sightseers amid whom the body fought its way out again through the doors. This artist's dream, deliciously bewildering, had become the real; and at this moment it was the elbowing and struggling reality that seemed a dream, or rather a nightmare.

Truly we cannot help loving with all our heart and mind the great and generous artists who can give us such an illusion of happiness, who can light up the future with such a radiance of bliss, whose spirit is powerful enough to bear up their souls to the threshold of the Absolute, whence they send us messengers of hope and angels of peace.

For are not these angels, indeed, envoys from the farthest beyond, the exquisite beings who appear in this master's work?—these knights, noble ideals of valiancy and virtue, the fine frames of heroes hidden under the shining metal of their dark armor; these legendary princesses in such sump-

tuous garments heavy with embroidery and gems, dignified or languid in gesture, their magnificent hair framing faces of perfect loveliness; these women whose goddess-like figures have a subtle fascination of grace in the long flowing lines and the pale flesh, ivory and gold; above all, these maidens, in purest robes, so finely pleated, virgin forms of delicate and pensive gesture, with light soft hair, pure and gracious and sweet of aspect, the exquisite curve of innocence on their lips, and deep loving-kindness in their limpid gaze.

And the "light that never was on sea or shore" irradiates the beautiful scenery—a light that seems to be wholly composed of subtle reflections harmonized to exquisite twilight; it shines on these legendary palaces—vast deserted courtyards, elaborate stairways, mysterious nooks; on those broad landscapes framed in walls of rock or distant hills; on those bosky woods, those shores of spreading slowly-creeping rivers, or of pools starred with myriads of tiny flowers; on those ruins, austere and silent.

. . . "'Dreams are but lies,' says an old maxim; but when our last hour is at hand, and but a few brief minutes are left to what was 'I,' pale lights before the eyes that are fast growing dim, who can tell by what mark to distinguish you, O memories of the actual life, O mirages of the dream-life?"

These words of Paul Bourget might well serve as an epigraph to the lovely picture of *The Golden Stairs*.[40] Like the array of our most tender and precious memories in the progress of life, these ideal beings of youth and beauty are coming down, down, the inevitable steps. At first heedless and smiling; then one of them, already anxious, stops with her finger the possible sound of her long and dainty silver trumpet; the others bow their heads, or hold them high, and their soft motions stir the myriad pleats of rippling crape. Down they come; as they descend the winding stair the suppressed passion of it all finds utterance in the plaint of a violin. Behind, the metallic gleam of light cymbals introduces the saddened hues of dim gold and fading purple like the low of an autumn sunset. They turn away to depart, but before going off into the great hall, through the solemn colonnade, the last of the maidens stops, and turning her head once more, sheds a smile of farewell.

THÉOPHILE GAUTIER

An Early Appraisal of
Puvis de Chavannes (1861)

Only a few years after Rossetti found inspiration in his daydreams of Arezzo
and Florence and Burne-Jones in his visions of medieval chivalry, a French-
man, Pierre Puvis de Chavannes (1824–1898), conceived vast works based
on complex allegorical thought vaguely evoking a distant, somewhat nebu-
lous golden age that could be associated alternatively with Greco-Roman
and Gallo-Roman antiquity, and even with the Middle Ages and the early
Renaissance. A keen student of earlier historical styles, he had adopted
simple linear compositions and harmonious arrangements of muted colors
that brought to mind the early Renaissance, even though the static poses
and whiteness of his figures often suggested antique statuary.

Théophile Gautier (1811–1872) was the first major critic in France to
sense the innovative character of Puvis's works, both in the inventive han-
dling of their allegorical undercurrents and in the artist's imaginative reli-
ance on earlier historical traditions to achieve his aims. It is Gautier, in fact,
who placed Puvis in the context of romantic symbolism.

Paradoxical as it may seem, however, the romantic naturalists had not
abandoned the use of symbols and allegory. Jean-François Millet's depic-
tions of the peasants of his own time often had biblical overtones. And
Gustave Courbet, the self-styled founder of the realist school in painting
who was essentially a romantic naturalist, called his most important work,
completed in 1855, *The Studio of the Artist, a Real Allegory Encompassing a
Seven-Year Phase of My Artistic and Moral Life.* But the physical component,
or signifier, of such allegories had to be drawn from everyday life. Indeed,
the critic Théophile Thoré, who had been a staunch supporter of romantic
naturalism since the early thirties, advocated that "true allegory . . . be at
once a living type and a symbol, as against these old pagan allegories, which
are nothing but dead shells." [41] Not surprisingly, Thoré was less than sym-
pathetic to the pictures by Puvis de Chavannes discussed by Gautier, *Bellum*

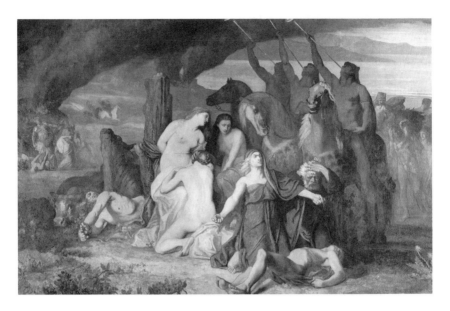

6. Pierre Puvis de Chavannes, *Bellum* (War), 1861. Oil on canvas,
340 × 555 cm. Musée de Picardie, Amiens. Photo: Bulloz.

It is the idea itself, rendered perceptible to the senses with a singular poetic power.

GAUTIER

(Fig. 6) and *Concordia* (Fig. 7).[42] He specifically complained about Puvis's
use of allegorical signifiers from earlier times:

> It would take a totally new and particularly original spirit to renew the person-
> nel and the material paraphernalia of the old allegorical theater. Greece and Italy
> have produced endless renderings and re-renderings of figures from ordinary
> life under the pretense of raising them to the level of universal myths . . . [Here]
> profound inspiration is less apparent than skillful reflection in the arrangement
> of the groups.[43]

A successful poet, novelist, playwright, and creator of ballets, Gautier
(1811–1872) had studied painting for two years as a young man; he became
an ardent romantic, eventually developing a gemlike richness and precision
in his prosody that heralded the Parnassians, whose movement he helped
found. He was Baudelaire's supporter and friend, and it was to him that the
younger poet dedicated *Flowers of Evil,* his volume of poetry, in 1857. Gau-
tier owed his success as a critic partly to his good luck in writing for *Le
Moniteur universel,* Napoleon III's semiofficial newspaper, and partly to his
eclecticism: he praised artists working in very different modes. It is signifi-

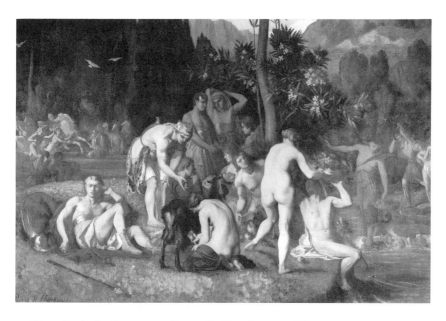

7. Pierre Puvis de Chavannes, *Concordia* (Peace), 1861. Oil on canvas,
340 × 555 cm. Musée de Picardie, Amiens. Photo: Bulloz.

One could imagine oneself in the Golden Age, such is the calm, the freshness, the
repose of a composition as tranquil as the other is furious. GAUTIER

cant, for instance, that he had written at length about the German Nazarenes
and the British Pre-Raphaelites in his review of the 1855 Paris Universal
Exhibition. He had also been a good friend of Chassériau, Puvis's friend
and mentor, who died in 1856. It is not surprising, therefore, that he was
sensitive to the originality of *Bellum* and *Concordia,* Puvis's first major
works. He understood that they constituted an intelligent departure from
works whose style and iconography were rooted in naturalism.

In his references to cartoons and tapestry Gautier connects Puvis's work
to the line and color and richness of design of earlier periods—all out of
keeping with fully developed naturalism—and his mention of the sixteenth-
century palace of Fontainebleau links Puvis to the elegant line and artifici-
ality of color characteristic of the Italian mannerist painters who decorated
it.[44] Gautier's insistence on decorative surface effects evidences a new con-
cern for musicality in the artist's handling of line and color. Furthermore,
that "forms," as the critic puts it, "give birth to ideas" implies their sugges-
tive power in giving rise to a play of associations.

In other words, Gautier discovered in Puvis's works what Baudelaire
found lacking in the historical-philosophical paintings of Chenavard and

others;[45] he even uses the word *synthetic* in discussing Puvis's compositions, implying a deliberate elimination of details of time and place. In *Bellum* and *Concordia* Puvis gave play to the expression of abstract thought. Not only did Gautier stress the unreality of the scenes, asking whether they were "cartoons, tapestries, or rather frescoes" of a distant era, but he also pointed out the impassiveness of the victors in *Bellum,* just as he stressed the quality of an Arcadian idyll of *Concordia*. On both occasions he was responding to the slow, controlled grace characteristic of Puvis's figures, whatever action they might be engaged in, and to the dreamlike atmosphere in which they existed—traits akin to the somnambulism referred to earlier.

The excerpt that follows is drawn from Théophile Gautier, *Abécédaire du Salon de 1861* (Paris: Dentu, 1861), 102–3. ✦

One may say that the real debut [of Pierre Puvis de Chavannes] dates from this year. In one stroke he has come out of the shadow; light shines on him and will never leave him. His success has been great, and that reflects well upon the public, as Puvis de Chavannes does not belong to the fastidious school. His mind dwells in the highest sphere of art, and his ambition even surpasses his talent. The very aspect of his two large compositions, *War* and *Peace,* challenges the onlooker: Are they cartoons, tapestries, or rather frescoes mysteriously removed from an unknown Fontainebleau, these immense canvases surrounded by frames bearing flowers and emblems reminding one of those of the Farnesina?[46] What medium was used? tempera? wax? oil? One can hardly tell, so strange is the gamut of hues, so far outside the usual range; these are the neutral or skillfully muted tones of mural painting of the kind that covers buildings without introducing elements of gross vulgarity and, rather than represent objects, he gives birth to the idea of them.

We must insist: at a time when so many palaces and monuments are being completed, awaiting their garment of frescoes, Puvis de Chavannes is not a painter of easel pictures; he does not require an easel but scaffolding and vast areas of wall to cover. That is his dream, and he has proved that he can fulfill it. This young artist, in a period of prose and realism, is naturally heroic, epic, and monumental, as if through the startling rebirth of the genius of earlier ages. It would seem that he has seen nothing of contemporary painting and has just come out of the workshops of Primaticcio or Rosso.[47]

The subject of *War* is conceived in the synthetic sense, outside the contingencies of time, place, or any particularity. It is the idea itself, rendered perceptible to the senses with a singular poetic power. War has swept through a country; the work of conquest has been accomplished; three

horse-borne trumpeters, impassive, similar in their poses, sound the victory fanfare, like angels sounding the call of the Last Judgment, and just as frightening. This is grandiose, disquieting, and wild, albeit with an antique twist, reminding one of certain verses of the *Nibelungenlied*.[48] [The end of the description follows:] . . . the smoke rising from the destroyed village [evokes] a call for revenge . . . trophies, palms, war machines frame this canto of a homeric poem.

Peace transports us to . . . a vale shaded by large green trees, irrigated by running water. The warriors have laid down their arms; they rest or exercise their horses. The women devote their leisure to the innocent industries of peace. . . . One could imagine oneself in the Golden Age, such is the calm, the freshness, the repose of a composition as tranquil as the other is furious. Even its color is less abstract and more human. . . . Flowers and fruit of an excellent color surround this Arcadian idyll and complete it; the ornamental and decorative sense of Puvis de Chavannes emerges even in his details.

Pierre Puvis de Chavannes (1886)

Although Puvis de Chavannes never fully embraced the name symbolist, he acknowledged in an interview that "a work of art emanates from a confused emotion in which it is contained like an animal in its egg. I meditate on the thought buried in this emotion until it appears lucidly and as distinctly as possible before my eyes. Then I search for an image that translates it with exactitude. . . . This is symbolism if you like."[49] He actually repudiated the term in another interview: "And in all this, you see, and please say so, no symbol. I have tried to tell as much as possible in as few words as possible. To get there I took the shortest path."[50]

Puvis's statements were closer to symbolist theory than he might have thought: the search for expressive simplicity in hue and color has a parallel in musicality, and confused emotion suggests the complex states of the soul a subjective artist wants to express. Even his reluctance to use obvious symbols was in keeping with the practices of the symbolists, who relied on a suggestive play of associations rather than accepted symbols and could evoke each associated image clearly, however "confused" the original sensations or emotion that gave rise to it.

Puvis's reluctance to be called a symbolist may have been caused by the eagerness of the young men calling themselves symbolists around 1885 to adopt him as one of their leaders. The poet Jean Moréas, author of "Un manifeste littéraire" (A literary manifesto) on symbolism, candidly attempted to do so, announcing "the sovereignty of the master Puvis de Chavannes, whose work soars beyond the staleness of impressionism to reach the scintillating halos of pure symbol."[51] Another young member of the symbolist group, Félix Fénéon, more restrained and more sensitive in his response to Puvis's talent, was nonetheless conscious of his musicality: "Through the closely interrelated rhythm of color and line, his nine pastels [then on exhibition] constitute an art of dream, of silence, of slow movements, of pacific beauty."[52]

At the time Fénéon wrote these lines the young poet Jules Laforgue (1860–1887), also affiliated with the symbolists, had already published his collected poems, *Les complaintes* (1886), and ranked among the pioneers in free verse. Having developed a passion for art and aesthetics, he took a stand against the positivist theory developed by Hippolyte Taine in his *Philosophie de l'art* (1865), which accounted for various artistic schools, and indeed the work of individual artists, according to materialist criteria—for example, ethnic, geographical, and historical data. In a letter of 1883 to his friend the collector, art patron, and scholar Charles Ephrussi, Laforgue claimed that he wanted to "explain spontaneous genius, something about which Taine remains silent."[53] Having read *Philosophie de l'inconscient* (1877) by Eduard von Hartmann, Laforgue allotted to the unconscious a role in the creative process like that of Baudelaire's correspondences, which linked the material and the spiritual.

According to Hartmann, in the creative mind the unconscious was like a constructive current underlying natural evolution: "For the genius who owes his conception to the unconscious, all the elements of the work of art are so closely linked, so well coordinated and associated with one another, that the perfect unity of the work bears comparison only with that of natural organisms, which also owe their unity to the unconscious."[54] Hartmann thus attributed near-divine powers to the artist engaged in unconscious or intuitive creativity. Basing himself on Schopenhauer's notion that an intuitive idea suppresses the opposition between subject and object,[55] he virtually ignored the barriers between self and nonself, thus stressing the importance of subjectivity in the intuitive processes and, by extension, in unconscious artistic creation.

Laforgue used Hartmann's views to turn Taine's rationalist criticism into criticism that focused on the vagaries of the human unconscious, nevertheless assuming an underlying harmony: "The unconscious, law of the world, is the great melodic voice resulting from the symphony of consciences, of races, and of individuals. . . . The object and the subject" are for him "irremediably moving, ungraspable, and themselves unable to grasp." As if by a miracle, however, contacts to occur, presumably at moments of great intuitive artistic insight, and they present insuperable problems to the rationalist critic: to establish "flashlike strokes of identity between subject and object, that is the proper function of genius. Trying to codify such flashes would be a childish joke."[56] Seen in the light of Baudelairean theory, however, the process becomes a particularly daring yet meaningful play of associations.

The passage that follows concerns Puvis's *Fisherman's Family,* which has since disappeared: a replica is illustrated (Fig. 8). It is precisely such a "flashlike stroke" that Laforgue perceived in the relationship between the ob-

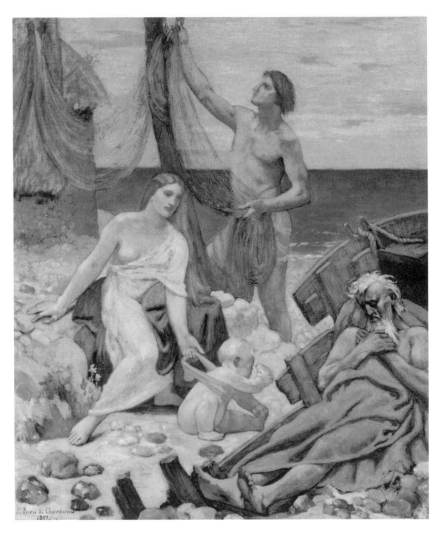

8. Pierre Puvis de Chavannes, *The Fisherman's Family*, 1887 (replica of the destroyed original of 1875). Oil on canvas, 82.5 × 71.8 cm. The Art Institute of Chicago, Mr. and Mrs. Martin A. Ryerson Collection, 1915.227. Photo: Kathleen Culbert-Aguilar, Chicago; copyright 1992 The Art Institute of Chicago. All rights reserved.

A grandly cloistered Golden Age, but one colored with nostalgia in the distant reaches of the sky. . . . LAFORGUE

ject—the fisherman's immediate concern with his family's sustenance—and the subjective element, Puvis's daydream of a golden age reflected in the harmony of the overall design, tinged by the psychological complexities Laforgue noted in the lack of empathy between husband and wife.

The "springlike techniques" to which Laforgue refers are those of impressionism.

The excerpt is from Jules Laforgue, "A propos de toiles, ça et là," *Le Symboliste* 1 (October 30–November 6, 1886). ✦

The Puvis de Chavannes of last Salon. Genius-touched ideal of an active and symphonic dream in the translucency of beautiful evenings of the Golden Age. A grandly cloistered Golden Age, but one colored with nostalgia in the distant reaches of the sky, as reflected in this young Eve whose pose is that of one of Michelangelo's *Slaves*, her feet firmly planted on her native soil, but her torso already swaying, her head just beginning to turn back, and her eyes absolutely lost, whereas, by her side, the man, who is wiser, is getting ready to cast his net so that the daydreaming Eve might have something to eat tonight. No [thought of] money, or any bachelor pettiness. Not a single muddy color, although here and there the paw of the Peasant of the Danube is made to stand out in our Parisian salons.[57] The paint is soberly applied, but always with the distinguished feeling awakened by vermilions and canary yellows here and there, without ever stepping over into the Japanese tradition [of intense uniform color areas], not even for filling in the corners. Nudes textured by means of a sculptural [yet] tender, somewhat blond clay, delimited by the bold strokes of a mural sketch. Well, in this day and age, in this time of decoration for billiard halls, [one gets from Puvis's works] an unchallengeable feeling of the sacred verging on the immortal. This master has, at a time when no one has given it a thought, re-created the pictorial decoration [of past ages for] the esoteric palaces of the future. He has found the nuances of style and content suited to their needs at the crossroads of our intimist, sickly literatures, of our great musical productions, and of springlike techniques of the modern palette attuned to ephemeral landscapes.

Gustave Moreau (1889)

Huysmans (1848–1907) had a well-established reputation as a naturalist novelist by the time his *A Rebours* [Against the grain] was published in 1884.[58] That work is a half-serious, half-ironic study of the aesthetic movement, whose followers, epitomized by Huysmans's hero, des Esseintes, pursued a near-religious dedication to art, excessive refinement, and a morbid sensitivity verging on the decadent. The novel also looks indirectly at the ideal of decadence—a significant trend in symbolist literature of the mid-1880s.

Throughout the novel, Huysmans gives captivating descriptions of the pictures assembled by des Esseintes, who is portrayed as an avid collector of works by members of the new generation of romantic symbolists, specifically Gustave Moreau and Odilon Redon; Huysmans thereby enhanced the reputation and contributed to the success of these artists.

Huysmans wrote a number of articles on artists that were collected in his book *Certains,* published in 1889. At that time, the novelist was going through an emotional crisis that would lead him to reject naturalism in favor of occultism and, eventually, a mysticism of Catholic inspiration and to respond to the spiritual aspects of romantic symbolism.

Gustave Moreau (1826–1898) had attracted considerable critical notice when his *Oedipus and the Sphinx* was shown at the 1864 Salon.[59] The naturalist critic Jules-Antoine Castagnary deplored the work as the seeming outcome of a "poetic hallucination" and chided the artist for his apparent belief that he could make tangible "a human myth, an eternal thought." "Impossible," he claimed! Indeed, to "arrive at the intelligible," Moreau had had to "pile up detail on detail—said details merely succeeding in exposing the impairment of [his] conception."[60]

Huysmans, who could be playful when referring to the details of Moreau's pictures, nevertheless realized that accumulations of detail were essential to Moreau's creation of a dreamlike vision and that the stunning color

and exquisite richness of his paintings gave rise to myriad associations. However inhuman or perverse they might be, they pertained to the world of aesthetic experience. Moreau, although he developed a visionary manner, giving each figure the appearance of having been frozen in its own dream, essentially remained faithful to the naturalist treatment of bodies that had prevailed in Western art since the early Renaissance; he stressed, however, a jewel-like linear precision going back to Mantegna as well as a preciosity of attitudes and gestures reflecting mannerist influences.

The excerpt that follows is from Joris-Karl Huysmans, *Certains* (Paris: Stock, 1889), 17–20. ✦

Away from the maddening crowd [of Salon artists], which provides us during the month of Mary [May] with the intellectual ipecac of great art, Gustave Moreau for years has kept his canvases from becoming prisoners under the drab muslin tents hanging like miserable canopies in the glassed-in structure of the Palace of Industry.[61]

He has also abstained from showing them in fashionable society exhibitions. As a result, his works, held by a few dealers, are rarely seen. In 1886, however, a series of his watercolors was exhibited by the Goupils in their galleries, rue Chaptal.[62]

There the rooms were filled with immense skies lit by the flames of an auto-da-fé;[63] squashed globes of bleeding suns, hemorrhages of heavenly bodies poured down in purple cataracts over scudding clouds.

Against the terrible bustle of such backgrounds, silent women went by, naked or dressed in gowns adorned with precious stones, like old Gospel-book bindings; women with hair of raw silk; with hard, steady gazes darting from pale blue eyes; with flesh as white and icy as the seminal fluid of fish; motionless Salomes holding in a cup the glowing head of the Precursor [Saint John the Baptist], macerated in phosphorus, under topiaries with twisted branches of green verging on black; goddesses riding hippogriffs [Fig. 9] and slicing with the lapis of their wings the swarms of agonizing clouds; feminine idols wearing tiaras, standing on thrones whose steps are awash in extraordinary flowers or else seated, in rigid poses, on elephants whose foreheads are weighted with green decorations, whose chests are cloaked in gold-embroidered chasubles, edged with pearls in the guise of jingle bells, elephants who stamp on their weighty image, reflected in the surface of the water they splash with their columnar ring-encircled legs.

An identical impression arose from these various scenes, an impression of repeated spiritual onanism in a chaste flesh; the impression of a virgin endowed with a solemnly graceful body, with a soul exhausted by solitary

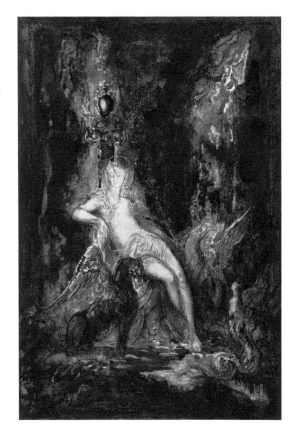

9. Gustave Moreau, *Fairy and Griffins*, c. 1880s. Watercolor and pencil on paper. Musée Gustave Moreau, Paris. Photo copyright R.M.N.

. . . the impression of a virgin endowed with a solemnly graceful body, with a soul exhausted by solitary secret thoughts . . . HUYSMANS

secret thoughts; of a woman seated, murmuring to herself, under the pretense of the sacramental rhetoric of obscure prayers, insidious appeals for sacrilege, shameful orgies, torture, and murder.

Out of that gallery, in the bleak street, the dazed memory of these works persisted, but the scenes no longer appeared in their entirety; they became unremittingly fragmented into the minutiae of their strange details. The execution of these jewels, their outlines incised in the watercolor as if with the squashed nibs of pens; the thin elegance of these plants with intertwining stalks; the partially interwoven stems, embroidered like the lace surplices once made for prelates; the sweep of these flowers pertaining through their shape both to religious vessels and to aquatic flora, to water lilies and *pyxidates,* chalices and algae, all this surprising chemistry of supershrill colors, which, having reached their ultimate stage, went to the head and intoxicated the sight, causing the departing visitor, totally blinded by what

he still saw projected along the new houses [lining the street] to grope for his way.[64]

On second thought, as I went on strolling, as my eye found a new serenity and could look at, and size up, the shame of modern taste, the street—these boulevards where trees that have been orthopedically corseted in iron and fitted by the trussers of the Department of Public Works in cast-iron wheels [railings and circular grates placed around trees in Paris to protect them]; these roadways shaken by enormous horse-drawn buses and ignoble publicity carts; these sidewalks filled with a hideous crowd in quest of money: with women degraded by successive confinements, made stupid by horrible barters; with men reading vile newspapers or dreaming of fornications or of fraudulent operations [as they walked] along the shops and offices from which the officially sanctioned crooks of business and finance spy, the better to prey on them—one understood better the work of Gustave Moreau, which stands outside time, escapes into distant realms, glides over dreams, away from the excremental ideas oozing from a whole populace.

EMILE HENNEQUIN

Fine Arts: Odilon Redon (1882)

Hennequin (1859–1888), the political correspondent of the daily newspaper *Le Temps* and the author of literary and artistic criticism in various avant-garde periodicals, was a regular guest at Mallarmé's Tuesday literary and artistic gatherings.[65] In *La Critique scientifique* (1888) he summarized his approach to criticism, proposing that criteria more scientific than those of Taine—Hennequin had been his pupil—be introduced into the objective study of artistic creation and that criticism stress the analysis of the style and content of the work itself. Even more important, he sought to study the psychology of the artist, both as an individual and as a social being, hoping to arrive at "an order of research whereby the works of art are considered the indices of the soul of the artist, of the soul of a people."[66]

"Fine Arts: Odilon Redon" was the first significant study of the work of Redon (1840–1916).[67] It appeared soon after the second individual exhibition of his work, in the office of the daily newspaper *Le Gaulois,* in 1882 (the first had taken place in 1881).

Although written some six years before Hennequin's book was published, this article nevertheless reveals the critic's attempt to analyze the work as it reflected the states of the artist's soul. He seems to succeed, thanks in part to the cooperation of Redon himself, whom he acknowledges having visited.

Hennequin stresses the mysterious character of most of Redon's works and makes it clear that his imagery reflects the unconscious workings of his mind rather than direct observation. The unconscious reveals itself in a powerful play of associations, evocative of diverse—sometimes contrasting—states of the soul that manifest themselves in the artist's imagery. Hennequin praises in particular the contrast between "the heroic" and "the vile," and he refers in a passage not excerpted to "the gay macabre." He understands, furthermore, the subjectiveness of this imagery, its "revelation of an autonomous temperament."

Hennequin makes only passing reference to traditional myths—a satyr, Beatrice—which become rarer in Redon's work with the passing of time. When they do occur, they usually constitute only one allusion among several. This aspect of the artist's development brings him closer to the symbolists than to the romantic symbolists.

The stress on plant life is not surprising. Redon in his adolescence had been a close friend of Armand Clavaud, who was to become assistant director of the botanical garden in Bordeaux, whom Redon described as "always emotionally affected by the revelations of the microscope." Clavaud had introduced Redon not only to the writings of Flaubert, Poe, and Baudelaire but also to his own botanical research, which dealt, at one point, with organisms seeming to bridge animal and vegetable life.[68]

The critic made no mention of musicality, a principle always close to Redon's heart. A childhood friend of the artist, however, had already referred to it when he wrote, in an article on Redon's 1881 exhibition, of the artist's rendering of form: "It is what [Redon] called symphonic . . . drawing and painting. . . ."[69]

Hennequin's allusion to the style of objects presumably contemporary with the archaic Greek temple of Aegina suggests his awareness of Redon's somewhat simplified and severe, occasionally mannered, linearism, although that linearism recalls the quattrocento more than the Graeco-Roman past as well as a Mannerist preciosity of gestures. Such stylistic interests, in Burne-Jones, Puvis, and Moreau as well as Redon set these artists apart from full-blown naturalism and herald the synthetist elements of post-impressionism.

The excerpts that follow are from Emile Hennequin, "Beaux-Arts: Odilon Redon," *Revue littéraire et artistique* 5 (March 4, 1882): 136–38. ❦

Odilon Redon must henceforth be regarded as one of our masters by those who praise above all what is strange, without which, according to Lord Bacon, there is no perfect beauty;[70] he is an exceptional master who, aside from Goya, has no ancestors and no disciples. Through this exhibition of twenty-two charcoal drawings Redon has just offered to the public a delight likely to surprise the most fastidious among us. He has found a way to conquer a desolate domain, at the border between the real and the fantastic, which he has peopled with formidable ghosts, monsters, monads, composite beings made up of all human perversities, all the beastly villainies, all the terrors of inert and harmful things. With a sense of the incubi and the succubi that sleep in the depths of the human soul, he has succeeded, through imperceptible degradations,[71] in creating an awesome ugliness, an insidious,

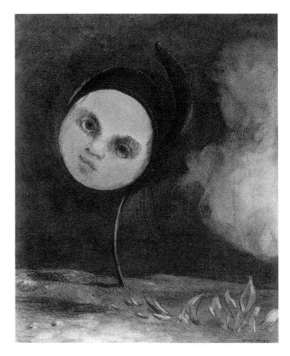

10. Odilon Redon, *A Flower with a Child's Face,* c. 1885. Charcoal on paper. 40.3 × 33 cm. The Art Institute of Chicago, David Adler Collection, 1950.1433. Photo copyright 1992 The Art Institute of Chicago. All rights reserved.

Odilon Redon deserves as much praise as Baudelaire for having created a new thrill.
HENNEQUIN

cunning profile, its forehead revealing the excrescences of all the vices and its murky eyes the wickedness of the brute without a conscience.[72] Odilon Redon deserves as much praise as Baudelaire for having created a new thrill [*frisson nouveau*].[73]

Some of his works are as upsetting as the sensation produced by a sudden contact with a viscous object—his *Animated Flower* [in all likelihood a work similar to *A Flower with a Child's Face,* Fig. 10], among others, in which a short herbaceous stem rising from black soil supports in the shade a perfectly round calyx, a large yellowish face with dead eyes and a placid smile.[74] Elsewhere, in *Muds,* infusoria—part vibrion, part aquatic cryptogram—emerge from a tenebrous background, presenting to the spectator the malevolent, malicious, perfidious, or ridiculous deformations of the human face. . . .

But Redon does not limit himself to the lower levels of life. He exhibits, in what might be called a heroic genre, *Etruscan Woman,* a large nude figure in a gauzy tunic that reveals the hard perfect forms of the archaic bronzes of Aegina, and, especially, *Martyr* [no one has established with certainty the identity of the works Hennequin mentions; *Martyr* is possibly *Martyr's Head in a Cup,* Fig. 11], a yellow head on a plate, its throat slit from the base of

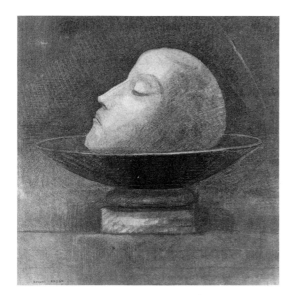

11. Odilon Redon, *Martyr's Head in a Cup*, 1877. Charcoal on paper, 37 × 36 cm. Photo copyright Rijksmuseum Kröller-Müller, Otterlo, Netherlands.

I have experienced the torments of the imagination as well as the surprises it produced for me at the tip of my pencil; but I have directed and led them, these surprises, according to the laws ruling the organism of art. REDON

the cranium to the chin. Let anyone who wishes examine these sickly curved lips; this delicate nose and its thin, sensitive nostrils; this sloping forehead and tell whether they are not those of the mystic who, beyond martyrdom, has seen the skies open up and has heard the voice of the seraphim.

Everything must be mentioned. In *Angel and Demon,* which has a vigor worthy of Michelangelo, the two figures start out side by side for the harvest of souls; *Head of a Satyr* is youthful knavery personified. A sinister and hairy spider contorts itself at the bottom of its web. . . .

All these singular, exquisite works, this revelation of an independent temperament seeking its way off the trodden path, aroused in me an intense desire to call on Redon and tender my most respectful congratulations. I found a man in his thirties, tall, thin, pale, with an intellectual and somewhat ascetic demeanor, who gave the impression that he expressed himself with the calm, precise diction of a noble and subtle mind. Redon informed me that he had published two sets of lithographic plates in very small editions, *To Edgar Poe* and *The Dream.*

As for this last work, apparently conceived in the spirit of the epigraph of Goya's *Caprichos*—"El sueño de la razón engendra monstruos" [The dream of reason produces monsters]—I can but reiterate my earlier admiration. It is a bizarre work; it pertains at once to the grandiose, the delicate, the subtle, the perverse, and the seraphic. One must visualize one of the plates as an

accumulation of shadows, enlivened by streaks of yellow light, in which stands a cyclopean wall. The formidable ghost of a Roman soldier in helmet and armor, one foot on a battlement, defends the entrance to the fortified castle; at the foot of the ramparts, an ashen sphere rolls and glides along the ground; on it the pointed profile and glassy eyes of a man-beast are sketched. This opposition between the heroic and the vile is surely overwhelming. . . .

Alone among all our artists, painters, literary figures, and composers, he seems to us to have achieved this absolute originality, which today, in a world as old as ours, also constitutes absolute artistic merit. He has succeeded in conveying, by certain symbols, through subtle syntheses, our most profound modern ideas on corruption, depravation, and ruse and on the grandiose and the beautiful. To be sure, Odilon Redon is a singular artist who has lost in comprehensibility and universality what he has gained in depth and specialization. Assuredly, he means neither to please the masses nor to depict everyday occurrences. But he must be regarded, without doubt, as the leader of the class of spirits that ardently seeks in art, not scientific certainties, but unknown beauties, the strange, the creative, the dream of new, rich, and striking means of expression. And these spirits, once called decadent, are today legion enough to affirm the perspicacity of the critic Paul Bourget, who said of their ancestor Baudelaire that "he had caught the ear of contemporary youth."[75]

Excerpts from *To Oneself*
(1898–1909)

In 1885, Redon sent Mallarmé his series of lithographs, *Homage to Goya,* and the poet sent in return a grateful letter full of praise.[76] The exchange marked the beginning of a lasting friendship and a growing appreciation of Redon by Mallarmé's admirers.

Redon consciously reshaped his public image to reflect the evolution of his art—the otherworldly and macabre aspects of his work yielded to a gentler lyricism—and dissociated himself from the spirit of decadence earlier writers had ascribed to him.[77] He prepared a carefully balanced text for the Belgian lawyer and art lover Edmond Picard to use as the basis for a lecture on his work in 1894.[78] This text, considerably reworked in 1898, was given in 1909 to the Dutch businessman André Bonger to be translated and read by him in connection with another exhibition, in the Netherlands.[79] It was reprinted three times and altered somewhat before being incorporated posthumously in the volume of Redon's writings on art,[80] from which the excerpt that follows is taken.

Redon alludes to various elements of romantic-symbolist aesthetics. Both the way his lines unfurl in space, independent of whatever form they give to specific elements, "including the human face," and the "mysterious play of shadow and rhythm in the lines" are in keeping with the concept of musicality. The play of associations is implied in his practice of combining "the most diverse elements"—in the "surprises . . . at the tip of [his] pencil," the "forms transposed or transformed, independent of any contingencies." What is more, much as Laforgue imagined a universal law of harmony governing the unconscious, Redon postulated "secret laws that have led me to fashion, as best I could and according to my dream, things in which I have totally immersed myself." He also calls them "laws ruling the organism of art," and, ultimately, an "imaginative logic," which gave his creation a physical and moral cohesiveness. This reference to a sense of order, in turn, brings up the matter of *dédoublement,* for the artist who ex-

perienced "the torments of the imagination" knew how to subordinate creation to "the laws of the plausible."

The artist's aspirations to the "equivocal" and his belief that the figures of his fantasy are not only alive but capable of "arousing in the spectator . . . all the evocative power, all the lure of the uncertain, at the very limits of thought" suggest his insistence on an element of mystery.

Redon stressed his allegiance simultaneously to "the laws of nature" and to those of the inner self. For him the two were the same; "nature," he explained, "also leads us to submit ourselves to the gifts with which it has endowed us. Mine have induced me to dream." He was thus equating external and internal nature, the objective and the subjective.

Redon's profound admiration for Rembrandt and Leonardo accounts for his own taste for the expressive, even spiritual, effects of line, light, and shadow. Finally, the almost word-for-word paraphrase of a passage of an article of 1902 by Gourmont (reproduced in the notes) is but one indication of that critic's importance in articulating symbolist concepts.

The first of the two excerpts that follow is from Odilon Redon, "Confidences d'artiste," in *A Soi-même. Journal (1867–1915). Notes sur la vie, l'art et les artistes* (Paris: Floury, 1922), 11–30. The second, from Redon's journal, is from the same volume, 97. ◆

CONFESSIONS OF AN ARTIST

I have created an art after my own heart.

I have created it with my eyes open to the wonders of the visible world and, whatever may have been said, with steadfast determination to obey the laws of nature and of life. I have also proceeded in full awareness of my love for a few masters who have drawn me to the cult of beauty. Art is the *ultimate reach,* high, wholesome, and sacred; it causes everything to blossom; it only produces in the art lover a sense of unique and delicious enjoyment; in the artist, however, it brings, with torment, the new seed for the new harvest. I believe I have yielded obediently to the secret laws that have led me to fashion, as best I could and according to my dream, things in which I have totally immersed myself. . . .

Delacroix, whose painting was still largely misunderstood, was vehemently defended by [Clavaud];[81] and I still hear [Clavaud's] account of the life and passion he felt in the vital energy radiating from Delacroix's warriors, lovers, or heroes—the life of passion, in sum, that he saw in his art. He compared Delacroix's genius to that of Shakespeare, telling me that in a single word of dialogue the English dramatist swiftly sketches a character in its entirety. Likewise, a hand, an arm perceived in a fragment of a scene by Delacroix conveys the whole personage. . . .

Suggestive art can lead nowhere without exclusive recourse to the mysterious play of shadow and rhythm in the lines an artist conceives.[82] And did these ever achieve greater results than in the work of Leonardo da Vinci, whose mystery and fertile fascination are due to them. They are the root of his language. Through perfection, excellence, reason, and docile submission to the laws of nature, moreover, this admirable and sovereign genius dominates everything in the art of forms; he dominates it right down to its very essence. "Nature," he once wrote, "is full of an infinity of causes that have never occurred in the realm of experience."[83] This was for him, as for all masters, an axiomatic necessity. What painter would think differently?

Nature also leads us to submit ourselves to the gifts with which it has endowed us. Mine have induced me to dream. I have experienced the torments of the imagination as well as the surprises it produced for me at the tip of my pencil; but I have directed and led them, these surprises, according to the laws ruling the organism of art—laws that I know and feel—with the sole purpose of arousing in the spectator, through a sudden attraction, all the evocative power, all the lure of the uncertain, at the very limits of thought. . . .

Suggestive art can be likened to the energy emitted by objects in a dream—one toward which our thought also proceeds. Decadent or not, this is the way it is. Let us say, rather, that it [suggestive art] is growth, evolution in art geared to the soaring of our own life, to [life's] expansion, to its highest point of support or moral balance, through its necessary exaltation.

This suggestive art is even more freely and radiantly encompassed by the excitatory art of music; but it also owes much to a combination of diverse elements that have been brought together, of forms transposed or transformed, independent of any contingencies, yet logical. All the critics' errors about my early work derive from their failure to see that they had to abstain from defining, understanding, or delimiting anything, from rendering anything more precise; because all that is new and sincere—like beauty itself—reflects obedience [to laws], carries its significance within itself.

The title that occasionally identifies my drawings can be superfluous. It is justified only when it is vague, indeterminate, and even equivocal. My drawings *inspire* and cannot be defined. They do not determine anything. They place us, as music does, in the world of the ambiguous and the indeterminate.

They are a kind of *metaphor*, as Remy de Gourmont put it; he placed them outside geometric art. He sees in them an imaginative logic. I believe that this writer has said in a few lines more than all that had been said earlier about my first works.

Imagine [a work in which] arabesques or diverse meanders unfurl themselves, not on a plane, but in space, and, at the same time, imagine all the possibilities that the deep and indeterminate periphery of the sky offers to

the mind; imagine the play of their lines as they are projected and combined with the most diverse elements, including the human face; if this face has the features of those we notice every day in the street, thanks to its fortuitous, immediate, and very real truthfulness, you will find [in such a work] the usual combination of many of my drawings.

They are therefore—another explanation could hardly be more precise—the reflection of a human expression, emerging according to permissible fantasy from a play of arabesques that will elicit in spectators fictions whose significance will be great or small according to their sensitivity and the ability of their imagination to magnify or diminish everything. . . .

There is a mode of drawing that the imagination has liberated from the cumbersome particularity of the real and devoted freely to the representation of conception. I have created a few fantasies based on the stem of a flower, or a human face, or elements derived from bone formations that I believe are drawn, constructed, and built as they had to be. They are what they are because they are organically cohesive. Only when the human figure gives the impression that it is, so to speak, about to emerge from its frame to walk, act, or think is the drawing truly modern. Undeniably, I invest my most unreal creations with the illusion of life. My whole originality therefore consists in making the most implausible beings live human lives according to the laws of the plausible, placing the logic of the visible, insofar as is possible, at the service of the invisible.

That kind of drawing stems naturally and simply from the vision of the mysterious world of shadows, to which Rembrandt, as he revealed it to us, gave us the key.

My most nourishing diet, however, the diet most needed for my expansion—and I have often said it—is the direct copying of reality, the attentive reproduction of the objects of external nature in her tiniest, most particular, and most accidental aspects. After making an effort to copy in minute detail a pebble, a blade of grass, a hand, a profile, or any other element, organic or inorganic, I feel a mental stimulus that makes me want to create, to allow myself to represent the imaginary. When I am so imbued, nature becomes my wellspring, my yeast, my ferment. Because such is their origins, I believe my inventions to be true. . . .

EXCERPT FROM THE JOURNAL, 1902

The sense of mystery consists in a continuous ambiguity, in double and triple aspects, hints of aspects (images within images). Forms about to exist or existing in the mind of the onlooker. All things that are more than suggestive, since they actually appear to us.[84]

ANDRÉ MELLERIO

Odilon Redon (1894)

André Mellerio (b. 1862) was a friend of Redon's and the author of both the catalogue raisonné of his graphic work (1913) and the first monograph on the artist (1923).[85] The passage that follows states clearly the spiritual transcendence that dominates all of Redon's work and singles out the sense of radiant peace that, as Redon matured, increasingly suffused even his most bizarre and terrifying visions, such as martyrdom scenes. This characteristic, which emerged gradually, eventually became dominant in his art. That Mellerio wrote as this transformation was taking place, and most likely with the artist's approval, gives the text particular relevance. For Redon, increasingly leery of critics who emphasized the supernatural and morbid aspects of his work, seems to have favored quietly lyrical subjects after 1900.[86] He wrote in the margin of an article by Emile Bernard of 1904: "The supernatural does not inspire me; I am content to contemplate the external world and life."[87]

The allusion to a scientific current in Redon's conceptions can be readily explained: Redon was a friend of the botanist Clavaud and took the entrance examination for the architectural division of the Ecole des Beaux-Arts, which he failed.[88] He had obviously received training in architectural drawing.

The excerpt is from André Mellerio, Introduction to the exhibition catalogue *Odilon Redon* (Paris: Galerie Durand-Ruel, 1894). ❧

We are able to grasp the broad lines of the artist's work, so deliberately simple in its fundamentals, so complex and varied in its expressions. . . .

What unifies Redon's works and at the same time constitutes their chief inspiration is the impression of the beyond—the beyond that Edgar [Allan] Poe delighted in pursuing, attempting to define it lucidly, mathematically,

even, through the premonition he had of it. In Redon, we subsequently find two distinct elements: a scientific education and an eminently spiritualist inspiration. These were fused in an artist's temperament, as if it were a fiery furnace from which the work emerged. . . .

The artist isolates the essential concept of the vices, the virtues, the sufferings that surround him. Then, abruptly, he rises above the real world, which presses and oppresses us from all sides, beyond banal and narrow daily contingencies. In ecstatic faces burst out gleams of a divine dream—faces of martyrs for whom the burning stake turns into roses.

But the basis of everything for Redon—ignorance, bestiality, perversity, sublimity—is suffering. The expressive intensity of some of his physiognomies, like a state of vertigo, attracts and frightens the onlooker.

EMILE VERHAEREN

A Symbolist Painter: Fernand Khnopff
(1887)

The Belgian poet, dramatist, and critic Emile Verhaeren (1855–1916) started out as a robust and biting naturalist. Later he was attracted by the grandiose visions and sonorities of the Parnassians. From 1883 on, much affected by the writings of Paul Bourget on Baudelaire, he cultivated the spirit of *décadence*. In Paris in 1886 he met Verlaine and Huysmans and was soon introduced to Mallarmé's circle. He ranks among the most powerful symbolist poets.

During the early eighties he contributed artistic and literary criticism to avant-garde Belgian periodicals, among them *Jeune Belgique* and *L'Art moderne*. He was stunned by Georges Seurat's *Sunday Afternoon on the Island of La Grande-Jatte* (see Fig. 29) when he first saw it in 1886 at the Eighth Impressionist Exhibition in Paris; probably thanks to his intercession, it was shown the following year at the Brussels exhibition Les XX (The twenty). This was an annual exhibition begun in 1884 by a group of artists and writers, among whom the lawyer Edmond Picard, an editor of *L'Art moderne*, played an active role; it was a showcase for the most recent developments in Belgium and the rest of Europe.[89]

Preliminary comments on literary symbolism are presented here rather than in Chapter 3, "Literary Symbolism," because they are pertinent to Verhaeren's text; similarities with the thinking of the literary symbolists, particularly Mallarmé, are striking.

By siding with the idealism of Kant and Fichte, and against the positivism of Auguste Comte and Emile Littré, Verhaeren upheld the idealist and spiritual aspirations as well as the subjectivity of symbolist aesthetics in opposition to the materialist and positivist aspects of naturalism.

His reference to a play of associations based on "an immense algebra the key to which was lost," suggests both Baudelaire's notion of "forests of symbols" and the literary symbolists' references to an algebra of signs.

One passage in the excerpt clearly heralds surrealist developments. When Verhaeren asserts that "the sentence must be considered as a living entity, independent, . . . its body and soul issuing from the self," he alludes to what the surrealists will call graphic automatism, a notion he will broach in his book *Ensor* (1908), where he refers to the representational element in a work—a diminutive human figure swept by a storm evoked by a sweeping graphism—as an "eddy of thought in the tumultuous rush of cosmic powers."[90]

Verhaeren defines the art of Khnopff, which is admittedly close to that of Moreau, in terms that correspond closely to the principal characteristics of romantic symbolism. The reference to an "art of thought, reflection, combination" suggests the importance Verhaeren attached to the play of associations, and his awareness that "fact and world become mere pretexts for ideas" reveals again his stress on a spiritual outlook and his subjectivity, since the poet is the great originator of ideas. The evocations of both the Queen of Sheba and the Sphinx confirm Khnopff's romantic-symbolist interest in myth and legend as well as in an aura of mystery.

Fernand Khnopff was one of the earliest participants in Les XX.[91] While questioning whether there is such a thing as plastic symbolism, Verhaeren tentatively places Moreau and Redon under that banner and rightly refers to Khnopff as marching in their footsteps. Indeed, he specifically cites Khnopff's *D'après Flaubert* (After Flaubert) in terms that recall Moreau's work. The title of the article, selected, perhaps, by an editor of *L'Art moderne* rather than by Verhaeren, is even more explicit, categorically referring to Khnopff as a symbolist painter.

The article does not mention the British Pre-Raphaelites, even though Khnopff had admired them from an early age, and the figures of his mature style are characterized by the same aloofness, hermaphroditism, overall spiritual mien, and graceful linearity of style.

Khnopff did illustrations for the novels of Joséphin Péladan, the future leader of the Rose + Croix movement, in the 1890s. Two were displayed at Les XX and are mentioned in Verhaeren's article (although not in the passages excerpted here). Khnopff, it happens, was one of Péladan's favorite artists and took part in his Rose + Croix exhibitions, thus linking the British Pre-Raphaelites and the groups around Péladan devoted to their ideals, specifically, the artistes de l'âme (artists of the soul).

The picture *Female Sphinx* (1884) mentioned by Verhaeren was acquired by the Grand Duchess Sergei of Russia in 1911 and disappeared during the Russian Revolution. The drawing *Head Study for a Female Sphinx* (Fig. 12) was executed five years after the painting. It is dedicated to Burne-Jones.

12. Fernand Khnopff, *Head Study for a Female Sphinx*, c. 1896. Crayon and white gouache on paper. 23 × 13 cm. Private Collection, Ghent. Photo courtesy of Galerie Patrick Derom, Brussels; copyright Vincent Everarts.

She is, before all else, delusive and attractive; she fascinates from afar, like a horizon entreating our comprehension.

VERHAEREN

The excerpts that follow are from Emile Verhaeren, "Un peintre symboliste," *L'Art moderne* (Brussels), April 24, 1887, 129–31. ❧

If . . . a poet evokes a mental image [of Paris] as "an immense algebra the key to which was lost,"[92] this evocation, unique of its kind, will succeed apart from any description or enumeration of facts, . . . in bringing forth luminous, tenebrous, and formidable Paris.

The symbol, therefore, purifies itself through the process of evocation as it becomes an idea; it is a sublimation of perceptions and sensations; it is not demonstrative but suggestive; it destroys any contingency, any fact, any

detail; it is the highest and most spiritual artistic expression possible. There is now only one true symbolist master in France: Stéphane Mallarmé.

. . . [N]aturalism . . . led to the fragmentation of the object through merciless description, painstaking microscopic analysis. There was no summing up, no attempt at concentration, no generalization. One studied corners,[93] anecdotes, individuals, and the whole school geared itself to the science of the day and consequently to positivist philosophy.

Symbolism will do the opposite. For whereas naturalism finds support in the French philosophy of Comte and Littré, symbolism finds it in the German philosophy of Kant and Fichte.[94] This transformation is a matter of unalloyed logic. In symbolism fact and world become mere pretexts for ideas; they are handled as appearances, ceaselessly variable, and ultimately manifest themselves only as the dreams of our brains. The idea, whether responding to them or evoking them, determines their manifestation; and much as naturalism made room for objectivity in art, symbolism, equally and to an even greater degree, reinstates subjectivity. In it the idea is imposed on the entire work of art with full tyrannical force. [Symbolist art is an] art of thought, reflection, combination, therefore of willpower.[95] Nothing is left to improvisation, to the numbing literary habit that once carried the pen [thoughtlessly] through an enormous maze of subjects. Every word, every syllable is weighed, scrutinized, chosen with deliberation. And to reach the goal, the sentence must be considered as a living entity, independent, existing by virtue of its words, animated by their crucial positioning—subtle, erudite, and sensitive. And whether standing, lying down, walking, carried away, bursting, dull, nervous, flaccid, rolling, or stagnating, it is an organism, a creation, its body and soul issuing from the self and, when perfectly created, unquestionably more enduring than its creator.

Such is literary symbolism. But what about plastic symbolism? Is such a thing even possible? Can one consider symbolist painting, not in the mythological or Christian sense, but in the modern sense of the word? How can one address oneself to the idea only by expressing the visible? The difficulty is great indeed. Nevertheless, has not Gustave Moreau succeeded on some occasions? and Redon? Khnopff goes forward, as he experiments, toward similar conquests. Four works prove this through the tendencies they reveal. The first is *D'après Flaubert*.[96]

One knows the admirable story of the book. To attempt to translate it into paint was an act of beautiful daring. The queen is not as fully rendered as the model in the text, but she is nevertheless the marvelous fairy of jade and gold, childish and perverse—childish because of the bewitching curve of her lips; perverse because of the fixity and promising silence of her

gaze—and hieratic and legendary. Her tiara-bearing forehead is that of an idol! The apparition floats in a vague interplay of precious stones and metal, and a whole Orient's worth of the voluptuous and the unknown spreads around and accentuates the following words:

> "So you want the shield of Dgian-ben-Dgian, the one who built the pyramids? Here it is. . . . I have treasures locked up in galleries in which one gets lost as in a forest. I have summer palaces built of reed trellis and winter palaces of black marble. In the middle of lakes as big as seas I have round islands looking like silver coins, completely covered with mother-of-pearl, whose shores whisper music as the warm swells unfurl on the sands. . . . Oh! if you wished. . . ." Anthony straightens himself, becoming "he who remains immobile, more rigid than a stake, pale as death."[97]

The savage desert resides in his hair; the dreadful and sleepless nights, in his limbs; the victory of the spirit over the senses, in his attitude.

The drama becomes concentrated in the eyes of the two figures. Temptation strikes them as their eyes meet, and the struggle is mute. The picture, with its immense black background, is a fabulous evocation of the ambience.

Need one stress the goldsmith-like execution? the reminiscences of Moreau?—The work is typical of that of a neophyte, but it is already that of a specialist, such is the extraordinarily subtle understanding of the scene and the artist's personal rendering of its high spirituality. . . .

It has been my pleasure to see once again the *Female Sphinx* [see Fig. 12], not as it once appeared, in the oubliette of an art exhibition, when the public made fun of it, but totally remade, renovated, and conceived anew.[98]

Through a light gauze, defined at the bottom by a scintillation of precious stones, one sees the soaring body of a woman, or rather the immateriality of the body of a woman. She is hieratic, wrapped in jewels that evaporate in metallic mists around her neck, her abdomen, her hips. It is a dream made of flesh, which lures one's thought toward mystery. What do these lips promise, and what promise will they not keep? Whither do these glances, vague and infinite as the shades of the sea, draw us? What perfumes and what illusory flowers provide the scent for this nose to breathe? The apparition, filling the height of the frame—which has no architectural pretensions—stands, her arms without hands forming a cross, as if to parody the death of Him who was Hope and brought consolation to this earth. She is, before all else, delusive and attractive; she fascinates from afar, like a horizon entreating our comprehension. She is in no way brutal, and the temptation she exudes is spiritual. Delicate, exquisite, refined, subtle Female Sphinx; Female Sphinx meant for all the complicated perversities; Female

Sphinx meant for those who doubt everything, and who causes us to have doubts about doubt; Female Sphinx meant for those who have tried everything and have tired of everything, for those who are incredulous about everything; Female Sphinx meant for the Sphinx himself.

Fernand Khnopff having just entered the world of art, I leave open the door of this study, not wishing to shut it with any conclusion.

JAMES MCNEILL WHISTLER

The Ten O'Clock Lecture (1885)

Born in Lowell, Massachusetts, James McNeill Whistler (1834–1903) arrived in Paris in 1855 to perfect his artistic skills.[99] He began as an enthusiastic naturalist, soon developing friendships with Manet, Fantin-Latour, and other precursors of impressionism. All through his life he continued his careful observation of the effects of light and atmosphere on forms, retaining the spontaneous and fluid technique the naturalists developed to capture overall optical truthfulness. Even the prevalent mood of his work remained close to the dominant hedonism of the pre-impressionists and impressionists, "for Art and Joy go together, with bold openness and high head."[100]

From 1859 to 1862 he made several trips to London, settling there in 1862 but sojourning frequently on the Continent thereafter. During his early years in London he became a neighbor and close friend of Dante Gabriel Rossetti and his brother, the critic William Michael Rossetti, and of another member of their circle, Swinburne. But his allegiances sometimes changed fast.

Not surprisingly, *The White Girl* (Fig. 13), for all the attention to pre-impressionist effects of light and atmosphere on the various surfaces it reveals, evinces unmistakable Pre-Raphaelite traits: an elegant linear patterning and a somewhat introverted soulful expression.[101] Its ethereal quality was such that the naturalist critic Théophile Thoré commented ironically: "Well, yes, exactly! It is a rare image, conceived and painted like a vision that would appear in a dream, though not to anyone, to be sure, but a poet. What would be the point of art if it did not show what no one had seen?"[102] On the same occasion, another naturalist critic, Castagnary, reported having asked Whistler:

> What have you tried to do? Perform the masterly stunt of bringing out whites against whites? Let me not believe it. Let me instead see in your work something more elevated, *the morning after the wedding night,* the disquieting minute in the course of which the young woman questions herself, is astonished not to recognize any longer her recent virginity.

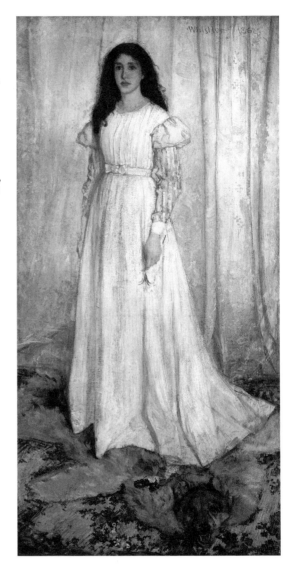

13. James McNeill Whistler, *The White Girl (Symphony in White No. 1)*, 1862. Oil on canvas, 214.7 × 108.0 cm. National Gallery of Art, Washington, D.C., Harris Whittemore Collection.

. . . as the musician gathers his notes, and forms his chords, until he bring forth from chaos glorious harmony.

WHISTLER

The critic added that "his interpretation won only his own acclaim," thus admitting that Whistler was less than amused.[103] Indeed, Whistler held in such scorn whoever "degrades Art by supposing it a method of bringing about a literary climax" that when Dante Gabriel Rossetti told him he had written a sonnet with a view to composing a picture, Whistler responded: "Why paint the picture? write the sonnet on the canvas rather than have it engraved on the frame!"[104] Henceforth Whistler articulated wittily and en-

ergetically his objections to literary inspiration in art; in so doing he laid the groundwork for those whose only criterion was "pure form" or "significant form"—at the expense of precise description, literary allusions, and any play of associations—and who saw in the romantic and romantic-symbolist traditions the roots of a major cultural decline.[105]

As Whistler himself hints in the lecture, his own work showed a marked reliance on simple, bold yet subtle, elegant patterning, and delicate and striking arrangements of colors—both partly inspired by Japanese design and both heralding synthetism.[106] Furthermore, his accentuation of expressiveness and harmony derived from the design itself—line and color—made him a dedicated exponent of musicality.

He did not by any means entirely discard the play of associations in his own work: "chimneys," under the right conditions, could become "campanili" (bell towers) and "warehouses," "palaces." Dreamlike vaporous atmospheres helped create a sense of mystery. And the strong individuality of the artist manifested itself in highly original, and necessarily subjective, evocations of the object, as in *Nocturne in Blue and Silver: Cremorne Lights* of 1872 (Fig. 14).

Whistler's search for beauty of line and color for its own sake, as well as his occasionally precious pursuit of a uniquely rare and distinguished vision transcending the contingencies of material life, placed him in the outer circle of the aesthetic movement.

"The Ten O'Clock Lecture" was first delivered in London on February 20, 1885—the time undoubtedly chosen so that the elegant crowd that came could first dine unhurriedly. Seven years earlier the artist had won one farthing damages in his flamboyant libel suit of 1878 against Ruskin, who had accused him of "flinging a pot of paint at the public's face."[107] Ruined by the expense of the trial, he was declared bankrupt the following year. He traveled, worked diligently to repair his reputation, and eventually arranged to give this lecture, which in a way was a profession of faith.

Subsequently he delivered the lecture in several capitals and published it in numerous editions. It was translated into French by Mallarmé in collaboration with the Franco-American symbolist poet Francis Vielé-Griffin. Whistler had met Mallarmé around 1886–87, attended his Tuesdays when in Paris, and became one of the poet's closest friends.[108]

The following excerpt is from James McNeill Whistler, *Mr. Whistler's Ten O'Clock* (London: Chatto and Windus, 1888), 14–29. ❧

Nature contains the elements, in color and form, of all pictures, as the keyboard contains the notes of all music.

But the artist is born to pick, and choose, and group with science, these

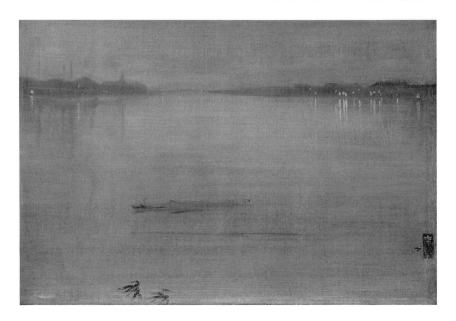

14. James McNeill Whistler, *Nocturne in Blue and Silver: Cremorne Lights*, 1872. Oil on canvas, 125.7 × 188.6 cm. Photo copyright The Tate Gallery, London.

And when the evening mist clothes the riverside with poetry, as with a veil, and the poor buildings lose themselves in the dim sky, and the tall chimneys become campanili, and the warehouses are palaces in the night, and the whole city hangs in the heavens, and fairyland is before us . . . WHISTLER

elements, that the result may be beautiful—as the musician gathers his notes, and forms his chords, until he bring forth from chaos glorious harmony.

To say to the painter, that Nature is to be taken as she is, is to say to the player, that he may sit on the piano.

That Nature is always right, is an assertion, artistically, as untrue as it is one whose truth is universally taken for granted. Nature is very rarely right, to such an extent even, that it might almost be said that Nature is usually wrong: that is to say, the condition of things that shall bring about the perfection of harmony worthy a picture is rare, and not common at all.

This would seem, to even the most intelligent, a doctrine almost blasphemous. So incorporated with our education has the supposed aphorism become, that its belief is held to be part of our moral being, and the words themselves have, in our ear, the ring of religion. Still, seldom does Nature succeed in producing a picture.

The sun blares, the wind blows from the east, the sky is bereft of cloud, and without, all is of iron. The windows of the Crystal Palace are seen from all points of London. The holiday-maker rejoices in the glorious day, and the painter turns aside to shut his eyes.

How little this is understood, and how dutifully the casual in Nature is accepted as sublime, may be gathered from the unlimited admiration daily produced by a very foolish sunset.

The dignity of the snow-capped mountain is lost in distinctness, but the joy of the tourist is to recognize the traveler on the top. The desire to see, for the sake of seeing, is, with the mass, alone the one to be gratified, hence the delight in detail.

And when the evening mist clothes the riverside with poetry, as with a veil, and the poor buildings lose themselves in the dim sky, and the tall chimneys become campanili, and the warehouses are palaces in the night, and the whole city hangs in the heavens, and fairyland is before us [see Fig. 14]—then the wayfarer hastens home; the working man and the cultured one, the wise man and the one of pleasure, cease to understand, as they have ceased to see, and Nature, who, for once, has sung in tune, sings her exquisite song to the artist alone, her son and her master—her son in that he loves her, her master in that he knows her.

To him her secrets are unfolded, to him her lessons have become gradually clear. He looks at her flower, not with the enlarging lens, that he may gather facts for the botanist, but with the light of the one who sees in her choice selection of brilliant tones and delicate tints, suggestions of future harmonies.

He does not confine himself to purposeless copying, without thought, each blade of grass, as commended by the inconsequent, but, in the long curve of the narrow leaf, corrected by the straight tall stem, he learns how grace is wedded to dignity, how strength enhances sweetness, that elegance shall be the result.

In the citron wing of the pale butterfly, with its dainty spots of orange, he sees before him the stately halls of fair gold, with their slender saffron pillars, and is taught how the delicate drawing high upon the walls shall be traced in tender tones of orpiment [a group of intense hues including light yellow, orange, and red], and repeated by the base in notes of graver hue.

In all that is dainty and lovable he finds hints for his own combinations, and *thus* is Nature ever his resource and always at his service, and to him is naught refused.

Through his brain, as through the last alembic, is distilled the refined essence of that thought which began with the gods, and which they left him to carry out.

Set apart by them to complete their works he produces that wondrous

thing called the masterpiece, which surpasses in perfection all that they have contrived in what is called Nature; and the gods stand by and marvel, and perceive how far away more beautiful is the Venus of Melos than was their own Eve.

For some time past, the unattached writer has become the middleman in this matter of Art, and his influence, while it has widened the gulf between the people and the painter, has brought about the most complete misunderstanding as to the aim of the picture.

For him a picture is more or less a hieroglyph or symbol of story. Apart from a few technical terms, for the display of which he finds an occasion, the work is considered absolutely from a literary point of view; indeed, from what other can he consider it? And in his essays he deals with it as with a novel, a history, or an anecdote. He fails entirely and most naturally to see its excellences, or demerits—artistic—and so degrades Art, by supposing it a method of bringing about a literary climax.[109]

. . . Meanwhile, the painter's poetry is quite lost to him—the amazing invention that shall have put form and color into such perfect harmony, that exquisiteness is the result, he is without understanding—the nobility of thought, that shall have given the artist's dignity to the whole, says to him absolutely nothing. . . .

We have then but to wait—until, with the mark of the gods upon him—there come among us again the chosen—who shall continue what has gone before. Satisfied that, even were he never to appear, the story of the beautiful is already complete, hewn in the marbles of the Parthenon, and broidered, with the birds, upon the fan of Hokusai at the foot of Fujiyama.[110]

Böcklin's Villas by the Sea (1895)

The Basel artist Arnold Böcklin (1827–1901) studied at the Düsseldorf Art Academy.[111] He visited Paris in 1848 and Rome two years later. After dividing his time between Switzerland, Germany, and Italy, he lengthened his stays in Italy, eventually dying near Florence. He was much admired by a whole group of younger German artists, among them Max Klinger, Hans von Marées, Franz von Stück, and Adolf Hildebrand, who constitute with him the nucleus of romantic symbolism in German-speaking lands. He had a profound influence on de Chirico and Kandinsky, among other twentieth-century artists.

Böcklin started out as a naturalist with strong romantic affiliations, often seeking otherworldly effects in his solidly painted landscapes through eerie light-and-shade patterns and the occasional introduction of mythological figures, usually going about their business with dismaying vitality. To an increasing degree, Böcklin stressed the oneiric and the supernatural; yet the deportment of his figures always gives the impression of casual ease. Jules Laforgue made this point when commenting on works by Böcklin he had seen during a stay in Germany: "One remains stunned by this sense of unity in the dream, this self-blinding in regard to the fantastic, this impeccable naturalness in the supernatural."[112]

William Ritter (1867–1955) was a novelist and a critic of music, literature, and art. His essay on Böcklin evokes the variety of powerful moods the artist could infuse into a series of related works, and in so doing Ritter implies that the series constitutes variations on a theme comparable to musical variations as well as a string of related associations.

Ritter cautions us not to compare Böcklin's series to those by Monet. But he was less than fair when he accused Monet of painting his Rouen cathedral or Saint-Lazare Station series "for the sole purpose of plastering them with paint," for Monet did convey variations of mood as he was altering atmospheric and lighting effects. Ritter had a point, however, in that Monet, still responding mostly to the gentle hedonism of full-blown impressionism,

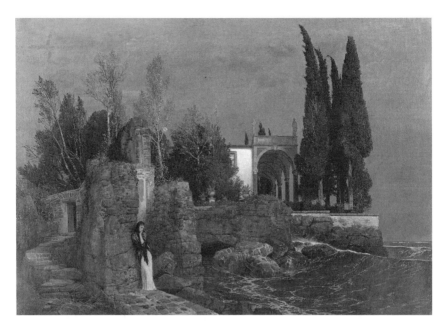

15. Arnold Böcklin, *Villa by the Sea*, 1877. Oil on canvas, 108 × 156 cm. Staatsgalerie, Stuttgart.

I can assure you that even when these scattered paintings are seen one at a time, in different places, they convey a sense of eternal waiting. RITTER

conveyed subdued moods in his series, from quiet exultation in full sunlight views to mild melancholy in dawn or dusk scenes. The variations of dramatic moods Ritter detected in Böcklin's series, which optical effects essentially corroborated, seemed to him, in contrast, on a par with those of ancient tragedy. The series executed by the younger artists Gauguin, van Gogh, and Munch are far more relevant than Monet's to Ritter's thinking, for, like Böcklin's series, they are primarily devoted to wide-ranging, and mostly dramatic, states of the soul.

There is no certainty that the lonely woman in Böcklin's *Villa by the Sea* series (Fig. 15) was intended to be Iphigenia, a figure in Greek mythology. But Ritter assumes that it was, and since the abundance of factual detail in his article implies that he had consulted Böcklin, it is likely that the artist knew, and acquiesced to, this identification. In any case, the suggestiveness of the picture seemed to encourage the play of associations, and whether the allusion to Iphigenia came from Ritter or from Böcklin, it is in keeping with the classical lines of the villa, the Mediterranean landscape, and the dramatic sea and sky.

In one version of the myth Iphigenia stood watch on the coast of Tauris,

awaiting the arrival of disoriented sailors, who would be captured and offered in sacrifice to Artemis. The figure of Iphigenia thus alludes to endless waiting, to death, and to the passage of time. The settings of Böcklin's *Villa by the Sea* series, with their varied atmospheric effects and lighting, are like successive stage sets for the unfolding drama of life.

Heralding what was to become a symbolist tradition, Ritter perceived the mythological character Iphigenia, not as the principal subject of the painting but as one that corroborates the evocative value of other elements, thus enriching the play of associations.

The excerpt that follows is from William Ritter, *L'Art en Suisse—Arnold Böcklin* (Ghent: Siffer, 1895), 85–87. ❧

It is well known that Böcklin's eventful life has taken him to many different places. Work alone has given it constancy. He has never been able to settle in a home worthy of him. Ceaselessly coming and going between Germany and Italy and Switzerland, as he is wont to do, he nevertheless might have dreamed of creating for himself a villa by the sea on some blissful part of the coast of Tuscany or Magna Graecia.[113] And, unable to have one built, he painted several times this dream villa, this utopian castle, whose wall decorations he had already allocated to his pupils. Two known views of this villa were represented in works at the Shack Gallery:[114] One of them, crepuscular, showing a stormy sea, is sometimes called *Iphigenia in Tauris* because of the figure in black watching the waves break against the sand; it also recalls Goethe's meditation on first seeing the Italian shore of Lake Garda.[115] The other, a calmer, more restful daylight view, represents Goethe's "Kennst du das Land wo die Citronen blühen?" [Do you know the land where the lemon tree blossoms?].[116]

Two new, even more striking, interpretations of this villa at the edge of the water were shown at the Secession.[117] Having rested and indulged in images of peace, Böcklin again unleashes his violent temperament and feverish imagination [see Fig. 15]. To the terrace's foundations he has added crumbling brick walls—which reappear in the picture in the Torsch House Collection in Vienna. Piles of red rubble; collapsed understructures, turned green by the oxydizing effect of the sea and salt; weeping vines; the winged flutter of yellow birch leaves, such as Sandreuter loves;[118] rocks in the sea; sticky reefs on which, here and there, dry white spots of organic crust: in this desolation, in veils of crepe, Iphigenia leans against the ruin of a cadmium red stuccoed wall. Similarly, the animated foreground of the terrace, heavy with austere meridional vegetation—tall cypresses with bent tips, beautiful intensely red flowers, masses of peach-colored laurels or azaleas—is part of the understructure of the villa, whose Florentine porphyry-

columned portico is wide open to all the sea winds. It has a simple ground floor, white walls, statues at the corners of the portico and, facing it, the agitated sea. One gets the impression that the whole villa is shaken; the waves, of a beautiful green transparency with veins of frothy white such as run in green marble, topped with even whiter crests, roar angrily as they break. Vases of aloe mark the corners of the isolated terrace. The whole exudes a magnificent classical melancholy. The rare, relatively unknown, works (none is in the Louvre) of the forgotten artist Gerard de Lairesse have once or twice revealed similar inspirations; see his *Iphigenia in Aulis,* whose setting is conceived in much the same way.[119]

Suddenly, transfigured a fourth time, this mysterious villa becomes fantastic, entirely bathed in a wild incendiary glow and adorned by the last reflection of the sun from the western sky, smoldering after the recent storm—as Léon Berthoud could have dreamed it.[120] The walls are red, but the sky is an intense blue, a cold blue like that of the sea, a blue dulled by the contrast with the long zone of clouds retaining a strip of insanely and admirably red light. The glass of the windows reflects an intense flamelike red, as if a fire burned inside the house. Behind the house the park, shady and dense with vegetation, is falling asleep; the tempest is quelled; in the sky the last red flickers are dying out; the sea is calm; the cypresses lean gently to one side; the azaleas and the laurels tame their intense pinks. Another day is gone, a day devoted by the artist to painting the same villa under four different effects, always with Iphigenia contemplating the waves that bring her nothing. Another day is over, but the contemplation of the indefatigable Iphigenia continues, hopeless yet unwearying. It is still she, always there; soon she will see nothing in the dark; her heart mourns more deeply, and she herself, seeking protection against the coolness of the night, is now entirely clothed in black.

I can assure you that even when these scattered paintings are seen one at a time, in different places, they convey a sense of eternal waiting, suggesting that much as the days, the years, the events of our lives—between two often distant viewings of the pictures—flow through spells of happiness and suffering, Iphigenia is always there, always contemplative, her feet and veils lapped by the plaintive sea. I understand that one could repeat oneself in this fashion; there is thought in this repetition; . . . it seems totally irrelevant, however, that Monet painted Rouen cathedral or the Saint-Lazare Station twenty times for the sole purpose of plastering them with different colors, and I find it painful that Luc Olivier Merson should multiply his *Rest on the Flight to Egypt* for commercial purposes. . . .[121]

Conversation with Paul Gsell (1911)

Auguste Rodin (1840–1917) looked to Michelangelo's works more than any other source for the attitudes, the modeling of musculature, and even the bone structure with which to express the great hopes and sorrows of humanity.[122] Vastly amplifying certain expressive traits of Michelangelo's work, Rodin sought a certain vagueness in the expression of even the most forceful ideas and the most intense moods and emotions, as if to make room for the doubts, indecisions, and hesitations inherent in any important moment of life. The resulting ambiguity—the imprecision in the fleshly envelopes, the lassitude even in vigorous actions, the vaporousness in the rendering of energetic features—contributes to an overall sense of mystery: "Remember," he told Gsell, "the question mark that floats over all of da Vinci's works."[123] Rodin's own figures sometimes look almost like somnambulists.

Rodin was thinking of Michelangelo's *Slaves* when he sculpted his *Age of Bronze,* also called *The Awakening of Humanity* and first exhibited under the title *The Defeated One* in Brussels in 1877, toward the end of his long stay in that city. This first masterpiece evoked the suffering and weariness following the Prussian defeat of the French in 1871 and the flexibility, energy, and determination that have characterized the cyclical rebirths of humanity—just as Michelangelo's slaves seem to fall and fade away even as their flesh swells with superhuman energy.

Rodin's other heroic works reveal a similar antithesis, generally between anxiety, suffering, and death and a robust and ardently sensual existence. These works include the monumental *Gates of Hell,* conceived in 1875 during a trip to Italy, after the artist had seen the late gothic and early Renaissance doors of the Baptistery in Florence.[124] The work had been commissioned in 1880 for a museum of decorative arts, which was never built; Rodin worked on it until the end of his life. *The Burghers of Calais* (1884–86) was accepted by the city of Calais, which had commissioned it, only in

1895. And *The Defense,* rejected by a jury charged with selecting a monument to commemorate the defense of Paris in 1870–71, was eventually erected outside Verdun in 1920 in memory of the siege of that city during World War I. Despite these setbacks—some of his other heroic works suffered similar fates—Rodin acquired worldwide fame, especially after the joint exhibition of his and Monet's works at the Georges Petit Gallery in Paris in 1889.

Rodin was an unflinching naturalist in capturing form and motion, "seizing in the raw the movements he observes," as he put it in an interview with Gsell.[125] But he was also sensitive to the expressiveness of forms—or, more precisely, of the lines one perceives as one walks around the masses. Indeed, according to Gsell, Rodin's chief concern was to arrange the forms so as to create "the lines that best express the spiritual state he was interpreting."[126] This last statement, like Rodin's frequent use of the word *harmony,* is relevant to musicality.

Rodin's comprehension of the play of associations, furthermore, was such that his imagination was quick to create permutations and combinations of themes. In the text that follows Rodin shows Gsell the sketch of a faun embracing a nymph that eventually became the sculpture *Pygmalion and His Statue* (Pygmalion was the sculptor of antiquity who fell in love with the statue of a beautiful woman he was shaping, which Venus eventually brought to life).

Although his own formal education was slight, Rodin was enthralled by poets ranging from Dante to Baudelaire, and when he alluded to literary works, he always did so spontaneously and imaginatively, through his creation of forms. Literary sources, however, were by no means indispensable to him, the objects themselves, as he explained, being capable of producing networks of associations. Ironically, he resorted to the pantheistic tradition of full-blown romanticism when he claimed that it is immaterial whether a work of art is based on a story, each individual object being part of nature, which he considered almighty and, to all intents and purposes, divine. Indeed, as he said, "a great sculptor, a Phidias, would recognize the serene harmony spread through nature by divine wisdom."

Rodin, finally, valued artistic subjectivity: "In representing the universe as he imagines it, the artist articulates his own dreams. He celebrates his own soul in the guise of nature."[127]

Paul Gsell (1870–1957) was a journalist and art critic who understood that one of the most important tasks of the critic is to bring out the artist's intimate thought. The discussion that follows was prompted partly by Rodin's handling of a motif from Dante's *Inferno* (canto 33) in his *Gates of Hell:* the ordeal of Ugolino, who, as punishment for twice betraying his city-state, was locked in a tower with his children and starved. The children died first, and the father was torn by the thought of devouring the corpses to survive.

The following excerpts are from Auguste Rodin, *L'Art: Entretiens réunis par Paul Gsell* (Paris: Grasset, 1911), 210–19. The original text uses italic type to distinguish between Rodin and Gsell. I have named each instead, putting Gsell's unspoken commentary in brackets. ❦

RODIN: In truth, when a literary subject is well known, the artist can tackle it without fear of being misunderstood.

Nevertheless, it is better, as far as I am concerned, that painters' and sculptors' works be interesting in themselves. Art, it so happens, can suscitate thought and dream without recourse to literature. Instead of representing scenes of a poem, it only has to make use of very clear symbols that do not allude to any written text.

Such has generally been my method, and it has proved beneficial.

[GSELL: What my host had just pointed out was proclaimed mutely by the sculptures surrounding us. . . . My attention was . . . caught by the *Female Centaur* (Fig. 16).

The fabulous creature with a human bust stretches desperately toward a goal she cannot reach; but her rear hooves, digging into the ground, pull her back with all the tension in her rear legs, and the heavy horse's rump, almost seated in the mud, refuses to join in any effort. This evokes a frightful tension between the two natures making up the unfortunate monster— an image of the soul, whose ethereal aspirations are held down by corporeal muck.]

RODIN: In themes of this kind, . . . the thought, I believe, can be read effortlessly. Without outside help they awaken the imagination of onlookers. And yet, far from confining it narrowly, they prompt it to roam in its fantasy. That, in my opinion, is the role of art. The forms it creates need only give the emotion a pretext for it to develop indefinitely.

[GSELL: At that point I was in front of a marble group, *Pygmalion and His Statue*. The ancient sculptor was passionately embracing his creation, which was coming to life in his arms.]

RODIN: I am going to surprise you. I must show you the first sketch for this composition.

[GSELL: Whereupon he took me toward a plaster cast.

I was indeed surprised. The work he showed me had no connection with the fable of Pygmalion. It showed a horned and hairy faun who was passionately embracing a panting nymph. The general lines were more or less the same, but the subject was very different.

Rodin seemed amused by my silent astonishment.

This revelation disconcerted me, for contrary to all I had just seen and

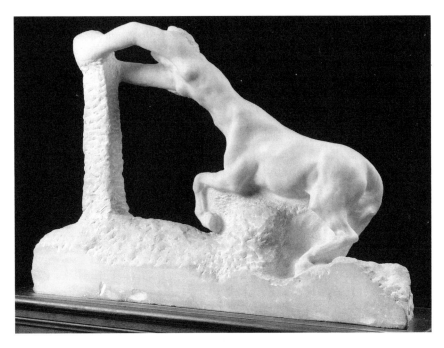

16. Auguste Rodin, *Female Centaur* (once called *Soul and Body*), pre-1889. Marble, 70.4 × 103.9 × 32 cm. Musée Rodin, Paris, S. 1031. Photo copyright Bruno Jarret, Musée Rodin, and 1992 ARS, N.Y./ADAGP, Paris.

The forms [art] creates need only give the emotion a pretext for it to develop indefinitely. RODIN

heard, it revealed the indifference he sometimes manifested toward the subject being treated. . . .

He looked at me almost mockingly.]

RODIN: In sum, . . . one must not attach too great an importance to the themes one interprets. To be sure, they have their intrinsic worth, and they contribute to the work's appeal to the public; but the chief preoccupation of the artist must be to give shape to living musculatures. The rest matters little.

[GSELL: Then, suddenly, he said, as if guessing my dismay:]

RODIN: Do not believe, my dear Gsell, that my last words contradict my earlier ones.

If I think that a sculptor can limit himself to representing swelling and quivering flesh, without concern for a particular subject, this does not mean I banish thought from his work; if I declare that he can dispense with symbols, this does not mean that I advocate an art deprived of spiritual content.

But, to tell you the truth, any idea is a symbol. Thus the forms and attitudes of a human being necessarily reveal the emotions of his soul. The body always expresses the spirit of which it is the envelope. And for him who knows how to look, nudity offers the richest signification. In the majestic rhythm of the lines, a great sculptor, a Phidias, would recognize the serene harmony spread through nature by divine wisdom; a simple torso, calm, well balanced, radiant with strength and grace, can make one think of the almighty reason that governs the world.

A beautiful landscape affects us not only through the more or less agreeable sensations it induces, but especially through the ideas it awakens in us. The lines and the colors one observes in it move us, not by themselves, but through the profound meaning we attach to them. In the silhouette of trees, in the opening of a horizon, the great landscapists, the Ruisdaels, the Cuyps, the Corots, the Théodore Rousseaus, distinguish smiling, grave, daring, or disconsolate thoughts, peaceful or anxious ones that accord with the disposition of their spirit.

This is because the artist who overflows with feeling cannot imagine anything endowed with less of it than he has himself. He suspects that there is in the whole of nature a single great conscience comparable to his own. There is not a living organism, or an inert object, or a cloud in the sky, or a green shoot in the field that does not confide in him the secret of an immense power hidden in all things.

2

DECORATIVE ARTS AND ARCHITECTURE

"The future of the arts, science, and industry lies in their cooperation," claimed Léon de Laborde, curator of the Museum of Antiquities in the Louvre, in an 1856 study based on the report he had prepared for the French government on London's Great Exhibition of 1851, for which he had served as a juror. He added:

> Can you understand how it is that art was not killed by two generations of gravediggers lugubriously succeeding one another over the past sixty years, busying themselves exclusively with digging up the graves of all past genera-tions, . . . copying them blindly, abjectly, without exercising any choice, as if animated by a fanatical fetishism? . . . Do you understand how urgently one needs to bring practical men onstage, men of healthy and vigorous stock, who would know how to draw a radical distinction between creative art and the monuments of the past, just as one distinguishes between real life and history?[1]

The revolt against a slavish devotion to tradition, the enthusiasm to ally the useful and the beautiful, and the insistence on the creative side of aesthetic composition reflect the ideas of a small group endeavoring to bring taste to industry and industrial efficiency to the production of beautiful objects in Britain. Chief among them was Sir Henry Cole, founder of Summerly's Art Manufactures, an industrial enterprise dedicated to these ideas. He was also a leading member of the commission that organized the Great Exhibi-tion and, to all intents and purposes, the founder and first director of the Victoria and Albert Museum. Moreover, he established what was to become the Royal College of Music. Owen Jones, an architect and what would now be called an interior designer, was responsible for the interior decoration of the Crystal Palace, built to house the Great Exhibition. One of his chief con-tributions was a set of rules on decoration (excerpted in this chapter), derived from the colors and flowing lines of stylized vegetation that characterized the millennial art of India and the Middle Eastern regions represented in the exhi-bition. These rules constitute an early basis for what is now called design and

had a significant impact on the development of art nouveau. Jones, further-more, was a social utopian intent on creating experimental communities that would live under ideal conditions in suitable architectural settings.

Ruskin himself played a major role in fostering good design and preparing the ground for art nouveau. Repelled by the mechanistic drudgery of fac-tory production in his own time, he associated the idiosyncrasies of Gothic sculpture and decoration with what he believed was the period's high regard for the individual artisan, who had, he claimed, "a freedom of thought, and rank in scale of being, such as no laws, no charters, no charities can secure; but which it must be the first aim of all Europe at this day to regain for her children."[2]

So intent was Ruskin on protecting the freedom and dignity of contem-porary artisans from demands for the artificial accuracy and polish of the machine age that he advised prospective buyers: "Rather choose rough work than smooth work, so only that the practical purpose be answered, and never imagine that there is reason to be proud of anything that may be accomplished by patience and sand-paper" (10:199). This advice was clearly a harbinger of the no-nonsense practicality and sophisticated crudeness—sometimes verging on naïveté—that would characterize some of the major decorative developments of succeeding decades.

Ruskin also elaborated on the principles of Gothic art that were univer-sally valid, in particular musicality: "We are to remember, in the first place, that the arrangement of colors and lines is an art analogous to the compo-sition of music, and entirely independent of the representation of facts. Good coloring does not necessarily convey the image of anything but it-self" (10:215–16).

Just as important, Ruskin saw a connection between good decoration and both a respect for age-old traditions and attempts to recapture the very life of nature in the part of the world where the artist has his roots:

> Let us not condemn, but rejoice in the expression by man of his own rest in the statutes of the lands that gave him birth. Let us watch him with reverence as he sets side by side the burning gems, and smooths with soft sculpture the jasper pillars, that are to reflect a ceaseless sunshine, and rise into a cloudless sky: but not with less reverence let us stand by him, when, with rough strength and hurried stroke, he smites an uncouth animation out of the rocks which he has torn from among the moss of the moorland and heaves into the darkened air the pile of iron buttress and rugged wall, instinct with work of an imagination as wild and wayward as the northern sea; creatures of ungainly shape and rigid limb, but full of wolfish life; fierce as the winds that beat, and changeful as the clouds that shade them (10:187–88).[3]

The statement constitutes a strong affirmation of the artist's ability to con-vey through his choice and handling of materials both the unique character

of his region and the tendencies and aspirations deriving from his own atavism. It was thus yet another endorsement of the theory of the expressive musicality of line and color; it was also a harbinger of the art nouveau artists' endeavors to incorporate the form, colors, and motions of nature in their designs.

One of the principal merits of Gothic decoration as well as structural composition, according to Ruskin, was inventiveness: the Gothic spirit "not only dared, but delighted in the infringement of every servile principle; and invented a series of forms of which the merit was, not merely that they were new, but that they were *capable of perpetual novelty*" (10:208).

Finally, the medieval artisan, according to Ruskin, considered decoration intrinsic to overall design; Ruskin praised the fitting of minute detail into the broader forms of a building or a picture (10:161–62).

Ruskin's enthusiasm for the alleged freedom of the medieval artist, for the deceptive simplicity and occasional apparent roughness of Gothic design, for the relevance of that design to national or regional characteristics, for the inventiveness of the decoration, and for its integration into an overall scheme all pointed to important future developments, starting with the British Arts and Crafts movement,[4] of which he can be considered one of the prophets, and including aspects of art nouveau and the work of the greatest symbolist artists. Like Owen Jones, Ruskin was a social utopian, dedicated to improving the lot of the working class through artistic education.

Affected as they were by Ruskin, the members of the Pre-Raphaelite group also believed that the fine and the minor arts were inseparable. On this basis Morris, Burne-Jones, Rossetti, and others in 1861 founded the house of Morris, Faulkner, Marshall and Company, "artisans in painting, sculpture, furniture, metalcrafts." The firm produced stained glass, embroideries, wallpaper and decorated furniture of every conceivable type as well as the Pre-Raphaelite figurative paintings adorning them. The decorative elements reflected the thinking of both Owen Jones and Ruskin but bore the unmistakable stamp of the individual creators. The firm changed its name to Morris and Company in 1865; after 1891 Morris concentrated on the design and hand printing of books, having founded the Kelmscott Press (in his house, Kelmscott Manor), in whose productions his artist friends also collaborated.

Other decorative artists soon took up the example of Morris and his associates—Arthur H. Mackmurdo, co-founder of the Century Guild, among them—establishing workshops devoted to the decorative arts, and frequently architecture, based on the ideas of Owen Jones, Ruskin, and the Morris circle. The various groups constituted what has become known as the Arts and Crafts movement, named after the Arts and Crafts Exhibition Society, founded in 1888 in London, whose initial promoters were Morris

and Burne-Jones but whose membership consisted mainly of the younger generation. Its ideals and practices soon reached the European Continent and the Americas and helped turn art nouveau into an international style.

Yet another artistic tradition, that of Japan, affected these developments before art nouveau emerged. Asian art had been readily visible in European capitals since the eighteenth century. Only in the early 1860s, however, did major artists begin to incorporate elements of Japanese design into their work. Whistler was among the first, stressing in his paintings as early as 1864 the uniform areas of intense color and the elegantly undulating outlines of Japanese colored woodcuts—elements that also link him to synthetism. The orthogonal decorative patterns characteristic of Japanese rice-paper and wood walls as well as tatami mats also had their impact. In 1876 Whistler covered the dining room walls of a London house with rich patterns in silver and gold against a blue background. He adopted the orthogonal pattern of an Asian-style gilded ceramics display case already in the room. The room, called the Peacock Room after Whistler's design of two fighting peacocks on one of the walls, can be regarded as one of the most fully developed harbingers of art nouveau.

Art nouveau is characterized by curves derived primarily from organic motifs "growing out one from the other"—to borrow the descriptive phrasing of Owen Jones in the excerpt that follows. These curves create undulating, sweeping interlacing patterns; round out corners; dart here and there toward edge or frame; and give rise to rhythms that are graceful or solemn, vigorous or languid. Straight lines and right angles are often used as contrasting devices. Materials are used honestly: rarely is a cheap material hidden under a costly one; rather, humbler materials needed for practicality are enlivened by painted, appliquéd, or encrusted decorations that become an integral part of the object. The quality of the work is valued more highly than the materials themselves. The designs often allude in a stylized way to plants or animals. The rhythm of the lines, the colors, and the associations called forth by specific organic forms give the designs symbolic overtones. Sometimes the lines and colors are related to, and accentuate, the functional features of the object.

The art nouveau style reached its maturity in the decorative arts in the 1880s with the designs of the London architect Arthur H. Mackmurdo. One of its most eloquent proponents was the Belgian Henry van de Velde, who, besides creating designs of great vitality and elegance, powerfully articulated the aims of the movement.

The function and cost of a building must never be lost sight of by its designer; some architects of the early nineteenth century paid such heed to these considerations that they elevated utility over beauty. According to the French architect J.-N.-L. Durand, who taught at the Ecole Polytech-

nique, the most distinguished school of civil and military engineering in France:

> Whether you question your own reason or examine actual monuments, it is evident that the purpose of architecture can never have been to please and, like-wise, that architectural decoration can never have been its object. Public and private utility, the well-being and protection of individuals and of society, such is . . . the purpose of architecture.

Durand ended nevertheless on an aesthetically positive note: "Frugality, far from being, as is usually believed, an obstacle to beauty, can be its well-spring."[5] Durand's architectural course offers a sound study of the practical aspects of architecture, leaving matters of decorative detail to the taste and purse of the patron.

The apostles of the Gothic renewal stressed the unique structural proper-ties of the Gothic system of arches, pillars, and buttresses. Ruskin noted that "in one point of view Gothic is not only the best, but the *only rational* architecture, as being that which can fit itself most easily to all services, vulgar or noble" (10:211–12). And "of all possible forms of the pointed arch . . . [the Gothic] is the strongest" (10:255–56).

The French architect Eugène Viollet-le-Duc, who had distinguished him-self in restoring the Abbey Church of La Madeleine at Vézelay as well as in reconstructive work at Chartres, Amiens, and other great cathedrals, took Durand's utilitarian approach one step further in his *Dictionnaire raisonné de l'architecture française du XIᵉ au XVIᵉ siècle*. In that work Viollet-le-Duc linked beauty with both sound economics and the expressive use of mate-rials to answer a need: "In an art [architecture] entirely predicated on con-vention and reasoning, beauty is not eternally tied to a single form: it can always exist as the expression of a need that has been satisfied, the judicious use of the chosen structural approaches and materials."[6]

Echoing Ruskin's admiration for Gothic inventiveness, Viollet-le-Duc praised the flexibility and adaptability of the Gothic edifice and its structure, which conveys the very function it fulfills—thereby meeting essential re-quirements of modern architecture:

> Whereas Gothic construction is not ruled by absolute formulas, it is subordi-nated to certain principles. All its efforts, all its improvements tend to turn these principles into laws, and it does succeed in bringing about this result: equilib-rium; forces of compression opposed to forces of tension; stability obtained through loads that convert oblique into vertical forces; as a result, horizontal cross sections of the supports are reduced in size. Such are its principles, which happen to be those of genuine modern construction. We are not referring here to construction that blindly seeks to imitate buildings raised under conditions foreign to our civilization and our needs but to the construction required by

our modern needs, our social condition. Had the Gothic builders been able to use large pieces of cast iron, they would have been eager to take up this means of obtaining supports as thin and as rigid as possible, perhaps with greater skill than our own.

The Gothic builders are subtle, eager, and indefatigable workers, reasoning things out, full of resources, never relinquishing their task, free in their procedures, always ready to adopt innovations—as many qualities or failings which place them at the fountainhead of modern civilization.[7]

A word on materials seems appropriate here. Cast iron had appeared in industrial structures in the eighteenth century; in the nineteenth, cast iron and glass were combined extensively in the construction of greenhouses, railroad stations, museum skylights, covered market halls, and the facades of commercial buildings. Among the most ingenious structures are the sky-light interior of the Bibliothèque Sainte-Geneviève, an academic library in Paris, 1843–50, designed by Henri Labrouste, and the Crystal Palace, built for the Great Exhibition of 1851 in London, designed by a gardener and botanist who had devised standardized procedures for building green-houses: Sir Joseph Paxton.

Architects, like practitioners of the decorative arts (and they were often one and the same), looked to some important principles of Gothic art to free themselves from obsolete traditions, to take advantage of scientific progress in handling forms and materials, and to express both the needs and the ideals of the contemporary world.

Art nouveau asserted itself gradually in architecture, first in the horticul-turally inspired curlicues that metalsmiths used to soften the angularity of buildings and later in sweeping, undulating motifs—like those that charac-terize the first mature architectural example of the style: Tassel House, by Victor Horta. Built in Brussels in 1892–93, it has a staircase whose ele-gantly curved metal steps branch out from a cast-iron column like the limbs of a tree, whose interweaving tendrils are painted on the ceiling vault.

The painter, sculptor, printmaker, and ceramist Paul Gauguin turned out to be one of the most penetrating critics of design and the decorative arts of his time; highly conscious of the principles of musicality, he was eager to see them applied with an understanding of the physical properties of mate-rials and their decorative potential.

Gleanings from the Great Exhibition
(1851)

Trained as an architect, Owen Jones (1800–1874) was an inveterate traveler who first attracted notice as the publisher of two splendid volumes in large folio, which appeared in 1842 and 1845, with color plates highlighted with gold leaf applied by hand, as well as woodcuts, of the Alhambra in Spain (Fig. 17).[8] Because of both the limitations of contemporary color lithography and the decorations of the Alhambra themselves, the plates, with their areas of uniform color outlined in black, constitute a harbinger of the stylized simplification later generations called synthesis.[9] Jones illustrated a number of other books in color, most of them emulating some archaic style by means of a similar technique, that had a major impact on educated taste.

Inside the Crystal Palace, he had successive transverse sections painted in gradations of color so that the interior, viewed from one end to the other, looked like the rainbow. His observation of a group of Middle Eastern and Indian textiles on display at the exhibition led him to enunciate the principles of decoration in the excerpt that follows. These same textiles prompted him to publish, in collaboration with his colleague Digby Wyatt, another richly decorated book, *Examples of Weaving and Embroidery Selected from the Royal and Other Collections* (1858), which helped spread the taste for oriental design and disseminate his principles of decoration, reprinted in Wyatt's introduction. Jones's *Grammar of Ornament* (1856), a pattern book for industrial designers presenting floral and geometric designs from different artistic traditions, had even broader repercussions.

Although strongly opposed to the eclecticism of his century, Jones advocated the study of earlier traditions, specifically those of Islam, for principles applicable to new styles more in keeping with the needs and ideals of the industrial age.

Jones believed that Islamic and the Islamic-influenced traditions he surveyed in the excerpt that follows were linked by a common rejection of the human figure;[10] thus the rules he enunciates govern nonfigurative, relatively

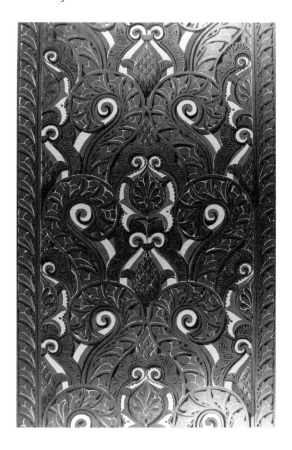

17. Jules Goury and Owen Jones, Plate XI, Soffit of an Arch, Court of the Fishpond (Hispano-Mauresque, fourteenth century or earlier), from vol. 2 of *Plans, Elevations, and Details of the Alhambra* (London, 1842–46).

Beauty of form is produced by lines growing out one from the other in gradual undulations; there are no excrescences; nothing could be removed and leave the design equally good or better. OWEN JONES

abstract design. Ultimately, these rules constitute a loose framework for achieving musicality. Indeed, he believed that ornaments must be in harmony with the object they decorate as well as with themselves, and they should be expressive, inasmuch as the best among them reflect the spirituality he recognized in the early, and to him most beautiful, manifestations of a developing culture.

In keeping with his utopian social ideals, he had attempted to create ideal communities, and he was convinced that better architecture and design were keys to social betterment. In many ways his social ideas corresponded to those of the French utopian Henri de Saint-Simon, who believed that humanity progressed in times of intense religious faith, which he referred to as "organic," and became divided and destructive in periods lacking such faith, which he called "critical." The last "organic" period for him was the Middle Ages, followed by the decline in religious faith brought about by

the humanism of the Renaissance and the resulting "critical" period that continued into his own time.[11] The cultures Jones praised were characterized by powerful religious movements; these cultures declined when their religious fervor faded, and they were relatively unaffected by the European Renaissance. He had contempt, moreover, for such Renaissance motifs as the acanthus leaf, reintroduced from antiquity, and the use of shadow-modeling. His insistence on the use of "colors," that is, hues, for achieving effects—that is, modeling—heralds similar concerns on the part of the impressionists and, eventually, Cézanne, who often tried to create the illusion of modeling by means of contrasts of hue rather than the time-honored method of gradual changes in value.[12]

The excerpts that follow are from Owen Jones, "Gleanings from the Great Exhibition of 1851, No. 1: On the Distribution of Form and Colour Developed in the Articles Exhibited in the Indian, Egyptian, Turkish, and Tunisian Departments of the Great Exhibition," *Journal of Design and Manufactures* 5 (June 1851): 89–93. ❧

In each [region] architecture has closely followed the phases which the religion has undergone, pure and simple in its origin, majestic, all-absorbing at its acme,—meaningless and decrepit in its decline.

Thus, in the early temples of Egypt, every ornament was a symbol shewing by the exquisite taste and beauty of its execution, the earnest and loving faith of the hand that carved it; in the more majestic temples of the Pharaohs, when the whole power, art, and wealth of the state, were made to accumulate upon one point, they lost in beauty what they gained in majesty. Under the Ptolemies, the religion of Egypt lost the power which it had under the Pharaohs; and although the conquerors, to ingratiate themselves with the people, undertook great works in rebuilding and restoring the temples, the hand that executed has told the tale of the want of that union of faith which before had enabled them to execute with *art* such gigantic undertakings. Under the Romans, the architecture became a mere mechanical art; the temples were larger, and the stones more nicely fitted, but their painting and sculpture excite almost disgust. . . .

The universal thirst which now exists for an architecture in harmony with our institutions and modes of thought, must ultimately be satisfied. It is evident, that had the ancients been acquainted with our present materials at command and facilities of construction, had they had our institutions and complete control over the industrial processes, their architecture would have been very different to what it was. Why, then, should we continue to consider architecture as a thing once discovered, and to recognize only the

forms in which it has hitherto appeared? Architecture is progressive, and must keep pace with the development of the wants, the faculties, and sentiments of mankind.

The great industrial movement which of late years has thrown so much of power and interest on railways, and other great national works, should have aided this; but unfortunately it arrived before the artistic world was prepared to acknowledge it. But it may have done its work in this, by showing more prominently the disordered state of artistic minds. It has awakened in the public a desire for higher results: instead of suspension-bridges alternately Egyptian or Gothic, railways covered with architectural productions of every variety of style, from Doric termini to Moorish tunnels, the new materials used, the new wants to be supplied should and might have suggested forms more in harmony with the end in view.

The religion of Mahomet, which spread meteor-like over the East with such astounding rapidity, rapidly produced an art in unison with its poetic and imaginative doctrines. Forbidden by their creed to represent the human form, the followers of Mahomet were led to adorn their temples as none others have been. A most elaborate system of ornamentation grew up recalling, perhaps the silken tissues which had adorned their tents in their wandering state, whilst their religion impressed itself on all their works: texts from the Koran, interwoven with every ornament, added beauty and expressed faith. . . . Shorn as they [the Islamic and Islamic-influenced nations] are of their power to produce great works, they are still faithful to the art as to the religion of their ancestors, and the many wonderful specimens of their industrial works in the Great Exhibition show them still equal in their power of producing refined works of art to what they ever were. . . .

[The visitor] will find [here] no carpets worked with flowers whereon the foot would fear to tread, no chairs that the hand would fear to grasp, no superfluous and useless ornament which an accident may remove. He will here be impressed with a sensation of most voluptuous repose: here there is no struggle after an effect, everything arises quietly and naturally from the want which has to be supplied. It is seen from the embroidered garment tissues to the humblest earthen vase: each follows the same law. The most brilliant colors here are harmonized as by a natural instinct; it is impossible to find a discord. Every piece of ornamentation shows that the artist thought, instead of copied whilst he worked. . . . One guiding principle of their ornamentation appears to be, that their decoration was always what may be called *surface decoration*. . . . Their flowers are not natural flowers, but conventionalized by the material in which they worked. . . . There is a total absence of shadow. The patterns of their shawls and carpets are harmonious and effective from the proper distribution of form and color, and

do not require to be heightened in effect by strong and positive oppositions; the great aim appears that colored objects, viewed at a distance, should present a neutralized bloom,[13]—each step nearer exhibits fresh beauties, a close inspection the means whereby such effects are produced. In their diapers and scroll-work, one of the means whereby this harmonizing effect is produced appears to be, that the ornament and the ground occupy equal areas. . . .

Let our artists study here: let them, on the other hand, avoid adopting or copying the conventional forms thus conveniently offered to them. Let them go to Nature's ever-bounteous works, and conventionalize for themselves. Why should the acanthus leaf keep the field against all comers? . . .[14]

Each civilization in the ascendant goes to nature or the best ages of the past for her models, each declining age substitutes its own decrepit and disordered caprices. We possess the inestimable advantage of living in an age when nothing of the past remains a secret; each stone of every monument of every clime has told its tale, which is now brought within the reach of our own firesides; yet, hitherto, how little have we shown ourselves worthy of this great privilege. . . .

The following are some few broad principles which may be discovered in nearly all the great works of the past; every student may work out for himself many others too subtle for description:—

1. The construction is decorated; decoration is never purposely constructed.

2. Beauty of form is produced by lines growing out one from the other in gradual undulations; there are no excrescences; nothing could be removed and leave the design equally good or better.

3. The general form is first cared for: this is subdivided and ornamented by general lines; the interstices are then filled in with ornament, which is again subdivided and enriched for closer inspection.

4. Color is used to assist in the development of form, and to distinguish objects or parts of objects, one from another.

5. And to assist light and shade, helping the undulation of form by the proper distribution of the several colors; no artificial shadows ever used.[15]

6. That these objects were best obtained by the use of the primaries on small surfaces, or in small quantities, supported and balanced by the secondary and tertiary colors on the larger masses.[16]

WILLIAM MORRIS

The Decorative Arts in Modern Life
(1877)

A prolific poet, whose verse gained considerable acclaim among the edu-
cated Victorian bourgeoisie and, for much of his life, a dedicated promoter
of workers' rights and a left-wing political activist, William Morris was
primarily an artist.[17] His major contribution was a set of designs reflecting
the gospel of Ruskin as well as the principles of Owen Jones that was also
characterized by a particular richness and luxuriance very much his own—
even when the overall organization looked deceptively simple. His designs
had a profound effect on the Arts and Crafts movement, first in Great Brit-
ain and then throughout the Western world. Morris, who usually wore
working clothes, considered himself the equal of the artists, artisans, and
laborers who made up his successive teams.

Morris himself excelled in pattern designs, particularly for carpets and
wallpaper, but encouraged his associates to follow their own inclinations.
He fostered the creation of sober, sturdy, practical, and—theoretically,
at least—inexpensive furniture often based on simplified and sometimes
rustic medieval prototypes—usually designed by the architect Philip Webb.
He kept his painter friends busy with commissions for stained-glass win-
dow and tapestry cartoons as well as the decoration of furniture and il-
lustration of books. Figure 18 gives an idea of the early productions of Mor-
ris's team.

Morris discovered Ruskin's writings in 1854 while a student at Oxford
and became his friend in 1856. And he joined Rossetti, Burne-Jones, and
other like-minded young artists in decorating the Oxford Union in the
summer of 1857. Even before this Pre-Raphaelite baptism, he had spent
nine months in the architectural office of George E. Street, who specialized
in Gothic revival buildings. This training, together with his ability to invest
his own money in a business, qualified him as the leader among equals at
Morris, Faulkner, Marshall and Company.

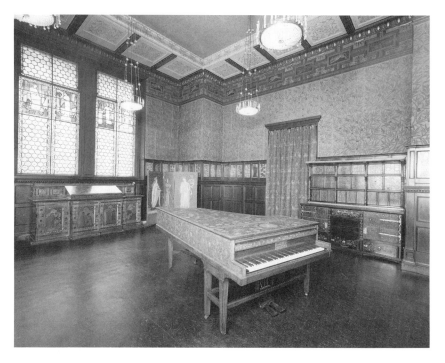

18. William Morris et al., William Morris Room, Victoria and Albert Museum, London, after 1861. Photo copyright Board of Trustees, Victoria and Albert Museum.

All the works of man that we live amongst and handle will be in harmony with nature, will be reasonable and beautiful: yet all will be simple and inspiriting.

MORRIS

Much influenced by "The Nature of Gothic," to which he referred reverentially, Morris hoped to implement Ruskin's advice to eliminate as much as possible the division of labor: "The workman often ought to be thinking, and the thinker often to be working, and both should be gentlemen, in the best sense" (10:201). The practice of art would cultivate the imagination of manual workers and would develop manual skills—albeit artfully imperfect ones—among thinkers. The resulting works of art would not only reveal the prowess of each but would suggest the social utopia to come, just as Burne-Jones's painted daydreams based on medieval subjects and his poetry based on Arthurian and other legends suggested a long-lost earthly paradise (see Figs. 4, 5).

The excerpt that follows is from William Morris, "The Lesser Arts," in

The Collected Works of William Morris, ed. May Morris, 24 vols. (London: Longman, Green, 1910–15), 22:26–27.[18] ❦

I do not want art for a few, any more than education for a few, or freedom for a few.

No, rather than art should live this poor thin life among a few exceptional men, despising those beneath them for an ignorance for which they themselves are responsible, for a brutality that they will not struggle with,— rather than this, I would that the world should indeed sweep away all art for awhile, as I said before I thought it possible she might do; rather than the wheat should rot in the miser's granary, I would that the earth had it, that it might yet have a chance to quicken in the dark.

I have a sort of faith, though, that this clearing away of all art will not happen, that men will get wiser, as well as more learned; that many of the intricacies of life, on which we now pride ourselves more than enough, partly because they are new, partly because they have come with the gain of better things, will be cast aside as having played their part, and being useful no longer. I hope that we shall have leisure from war—war commercial, as well as war of the bullet and the bayonet; leisure from the knowledge that darkens counsel; leisure above all from the greed of money, and the craving for that overwhelming distinction that money now brings: I believe that as we have even now partly achieved LIBERTY, so we shall one day achieve EQUALITY, which, and which only, means FRATERNITY, and so have leisure from poverty and all its griping, sordid cares.

Then having leisure from all these things, amidst renewed simplicity of life we shall have leisure to think about our work, that faithful daily companion, which no man any longer will venture to call the Curse of labor: for surely then we shall be happy in it, each in his place, no man grudging at another; no one bidden to be any man's *servant,* every one scorning to be any man's *master:* men will then assuredly be happy in their work, and that happiness will assuredly bring forth decorative, noble, *popular* art.

That art will make our streets as beautiful as the woods, as elevating as the mountain-sides: it will be a pleasure and a rest, and not a weight upon the spirits to come from the open country into a town; every man's house will be fair and decent, soothing to his mind and helpful to his work: all the works of man that we live amongst and handle will be in harmony with nature, will be reasonable and beautiful: yet all will be simple and inspiriting, not childish nor enervating; for as nothing of beauty and splendour that man's mind and hand may compass shall be wanting from our public build-

ings, so in no private dwelling will there be any signs of waste, pomp, or insolence, and every man will have his share of the *best*.

It is a dream, you may say, of what has never been and never will be; true, it has never been, and therefore, since the world is alive and moving yet, my hope is the greater that it one day will be: true, it is a dream; but dreams have before now come about of things so good and necessary to us, that we scarcely think of them more than of the daylight, though once people had to live without them, without even the hope of them.

Anyhow, dream as it is, I pray you to pardon my setting it before you, for it lies at the bottom of all my work in the Decorative Arts, nor will it ever be out of my thoughts: and I am here with you to-night to ask you to help me in realizing this dream, this *hope*.

ARTHUR H. MACKMURDO

The Spiritual in Art (1884)

In 1882, in collaboration with his friends and colleagues Herbert Horne and Selwyn Image, Arthur Mackmurdo (1851–1942) founded the Century Guild, one of the many associations of designers and artisans following the lead of Morris & Co.; in 1884 Mackmurdo became co-editor, with Herbert Horne, of the association's periodical, the *Hobby Horse*.[19]

Mackmurdo's background was similar to Morris's. He too received training in architecture in the workshop of a dedicated practitioner of neo-Gothic, James Brooks. He met Ruskin at Oxford, and became his friend. A short unpublished biographical manuscript even refers to a walk with the older man in the course of which Mackmurdo discovered his calling.[20] Travels with Ruskin in France and Italy opened his eyes to the wonders of "barns and cathedrals," as well as to what he referred to as the laws governing all organic forms. He fell under the spell of the Renaissance.

Mackmurdo started his own architectural practice in 1875 and devoted time and energy to the decorative arts from around 1880 to 1900, creating rich interlacing designs that reflected, sometimes all at once, Gothic, Renaissance, and Japanese elements and even traces of the baroque. His continuous sweeping lines, always derived from natural forms and movements, linked him to the mature art nouveau style (Fig. 19).

Perhaps because of Ruskin's influence, Mackmurdo devoted much of his energy during the last decades of his life to developing utopian socio-economic theories.

The manifesto that follows appeared as the lead article in the first issue of the *Hobby Horse*. Mackmurdo exhorts the members of the guild to find individual liberty in their common effort. He goes on to stress, more than any earlier Arts and Crafts pioneer, semiabstract forms developed through a process of elimination and simplification, thereby giving renewed emphasis to synthesis and to musicality. He is also outspoken on the associative power of forms and, calling Rossetti's insistence on conceiving art as a dia-

19. Arthur H. Mack-
murdo, embroidered
screen, 1884. Painted fabric
and wood. William Morris
Gallery, Walthamstow,
London.

*. . . giving our work a more
abstract, or mood-made charac-
ter than the more popular
forms of art possess.*
MACKMURDO

logue with the soul, suggests that the "idea, or spirit" of living creatures be conveyed by semiabstract designs—thus heralding Wassily Kandinsky's 1912 discourse on the spiritual in art *(Über das Geistige in der Kunst . . .).*

The excerpts that follow are from Arthur H. Mackmurdo, "The Guild's Flag Unfurling," *Hobby Horse* 1 (1884): 1–13. ✦

The common spirit that animates our work, the same fierce expectation that impels us each beyond the prose boundaries of simple craftsmanship, and keeps us undeviating in our art's progressive course, together bind the weave girdles that bind each to all.

. . . [T]his super-sensuous sentiment that pervades the whole of our work, is hardly to be seen in single parts, not to be caught in particular art, nor such as can be known by any kind of critical analysis.

. . . The first point then, at which we leave the highway tracked by the greater number of journeymen artists, is that where stands a finger-post whose extended arm directs the traveler towards a region, in which art is farthest removed from attempted portraiture of external nature. We are con-

scious of drawing largely upon the resources of previously presented conceptions, of being strongly influenced by the "treatment;" and giving our work a more abstract, or mood-made character than the more popular forms of art possess.

It is[,] compared with this more familiar form, less objective; less realistic; at all times quite consciously selective. As much the reflex of the mind from its surroundings as the naturalistic (so-called); as much the exponent of individual sentiment as the realistic (so-called); it is yet the reflex of minds more influenced by man and by man's conception, the exponent of sentiment whose immediate source lies in qualities rather than in things. . . .

This [the frontispiece of the *Hobby Horse,* captioned "That Merlin Cried to Humanity"] is, as will at once be seen, a pure creation: but creation only in the sense Shelley uses the word,—to express combination and re-presentation.[21] It does not simply combine the idea of a falling bird with the picture of a man; these are merely the flesh of the thought. For the brain that conceived this picture-poem, or poem-picture, conceived firstly the idea, or spirit of this flesh, and going into the world, sought certain things for symbols of expression, and, combining them, re-presented the idea—henceforth a new creature in the likeness of its creator. For so God made man.

The pleasure, then, which either kind of art gives to any, be he painter or possessor, depends entirely upon the imagination. If this be unmanacled of metaphysical bonds; well stored with memories of artistic conceptions; if the mind has associated stirring pleasures with particular forms of art, these previous conceptions or art treatments will enter as largely into the new productions as do the sources of associations found in external nature, enter into Birket Foster's or Vicat Cole's productions.[22] Again, strength of imagination tells in favor of what we may best call subjective art, with both painter and spectator, because strong imagination implies the power of giving what is more desired by the imagination, namely, distinct mold of moods, and that firm insistence on individual conception which always accompanies strong self-temperament. And to this class of mind, therefore, the realistic art is as impossible as it is wanting in force of interest.

In Defense of the Tower (1887)

Huysmans, echoing Viollet-le-Duc as well as the architect L. A. Boileau, a
leading specialist in the design of metal structures, announced in his review
of the 1879 Salon a new era, that of cast-iron architecture.[23] Its first monu-
ments had recently been erected in Paris: "The architects and the engineers
who built the Gare du Nord, the Halles Centrales, the Cattle Market of la
Villette, and the New Hippodrome, have created a new art, as worthy as
the old, an entirely contemporary art suited to the needs of our time, an art
deriving from a complete rethinking of traditional architecture, almost en-
tirely rejecting stone and wood—the raw materials supplied by the earth—
to adopt as their own the power and lightness of the cast-iron construction
of factories and metal mills."[24]

Huysmans praised the new cast-iron-based architecture once again in *Cer-
tains* (A few personalities) of 1889 but had only derogatory comments for
"Mr. Eiffel's tower" (Figs. 20, 21), erected as the centerpiece of the 1889
Paris Universal Exhibition, which was about to open its doors:

> His tower looks like a chimney stack under construction, a carcass waiting to
> be filled up with cut stone or brick. One cannot imagine that this funnel-shaped
> grillwork has been completed and . . . will remain the way it is, . . . [with] no
> decorative ornament, timid as it might be, no fantasy, no artistic vestige of any
> kind. When entering the tower, one is faced with a chaos of interpenetrating
> beams riveted with bolts, hammered through with nails. One can only think of
> buttresses erected to support an invisible collapsing building. . . . The tower
> could be the steeple of Our Lady Of the Used Goods Trade, a steeple deprived
> of its bells but armed with a cannon that announces the opening and closing of
> services and calls the faithful to the liturgical celebration of capital![25]

Huysmans was merely repeating and amplifying the ideas of a group of
artists and writers, including the Parnassian poets François Coppée and Le-
conte de Lisle, the novelist Guy de Maupassant, and the most fashionable

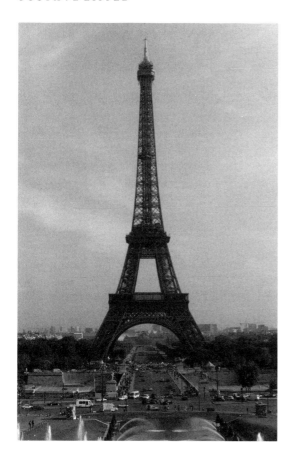

20. Gustave Eiffel, designer and engineer, and Nouguier and Koechlin, architects, Eiffel Tower, Paris, 1889. Painted riveted cast iron. Photo courtesy of Jehanne Joly.

Are not the true prerequisites of strength always compatible with the secret conditions of harmony? EIFFEL

painters of the time, Meissonier, Gérôme, and Bouguereau, among others. In a letter to the authoritative daily *Le Temps,* published February 14, 1887, just after construction had started, they requested that the tower be dismantled: "Will the city of Paris associate itself any longer with the baroque, the mercantile fantasies of a machine builder, and in so doing irremediably disfigure and disgrace itself? For the Eiffel Tower, which even mercantile America would not want on its soil, is, beyond doubt, the disgrace of Paris."

The designer of the Three-Hundred-Meter Tower, as it was then called, Gustave Eiffel (1832–1923), was trained as a civil engineer and distinguished himself early in his career through his theoretical and experimental work on the structural resistance of metal arches.[26] By 1887 he had acquired a worldwide reputation, having designed structures as bold as they were

21. Gustave Eiffel et al.,
Eiffel Tower, seen from be-
low. Photo: Jehanne Joly.

*. . . something like a Gothic
lace of iron.* GAUGUIN

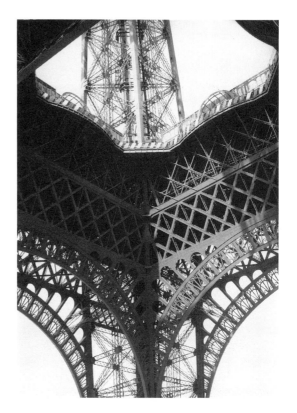

graceful, such as the viaduct of Garabit of 1882. It is he who designed the
supporting structure of F. A. Bartholdi's *Liberty Lighting the World* (1870) in
New York harbor. The tower's architects were Edouard Nouguier and
Maurice Koechlin.

The following text by Eiffel, a response to the letter of protest, accom-
panied it in *Le Temps*. Eiffel's relation of form and what he called destina-
tion, or function, was only to be expected from an engineer. It is significant,
however, that he referred openly to the pursuit of elegance in the configu-
ration of line and volume, even taking pride in the strictly mathematical
rules that determined the latter. In so doing he was echoing the seekers of
musicality, for whom harmony and expressiveness of color and line could
be independent of subject matter. The tower's sweeping, elongated curve,
moreover, was in keeping with the taste for art nouveau.

In explaining that his prime concern was that the tower withstand the
wind, Eiffel implied that he had calculated its four principal edges to com-
bine the least aerodynamic with the greatest structural resistance to the

wind. Ultimately, the form echoes one found in nature, for it approximates the tapering trunk of a large tree growing from massive roots. While subordinating the form to the laws of aerodynamics and structure theory, then, Eiffel was unwittingly abiding by Owen Jones's urging that artists "go to Nature's ever-bounteous works, and conventionalize for themselves"—albeit with greater mathematical rigor than would most.[27]

Eiffel was also aware that the effect of monumentality the tower conveyed was in itself an aesthetic factor. Indeed, size, whether at Stonehenge, Giza, or Teotihuacán, constitutes a primal human tribute to the forces of the universe.

In the following excerpt Gustave Eiffel responds to the questions of an interviewing journalist for *Le Temps*. His statement was published under the headline "Au jour le jour—les artistes contre la Tour Eiffel," February 14, 1887, 2. ❦

I shall tell you all my thoughts, and express all my hopes. I believe that my tower will be beautiful. Why should anyone think that just because we are engineers we do not concern ourselves with beauty in our constructions, and that because we endeavor to build solid and durable things we do not strive to make them elegant as well? Are not the true prerequisites of strength always compatible with the secret conditions of harmony? The first principle of architectural aesthetics is that the essential lines of a monument be determined by a perfect subordination to its destination. Which condition mattered most to me in the design of my tower? Wind resistance. Well, I maintain that the curves of the four edges of the monument, as my calculations shaped them, will convey an impression of beauty, because they will translate for the eyes the boldness of my conception.

Besides, the colossal has a unique charm and attraction to which ordinary art theories do not apply. Will anyone pretend that it is through their artistic merit that the pyramids have so profoundly marked the imagination of men? What are they, after all, but artificial little mounds? Yet what visitor remains cold in their presence? Who does not return filled with an irresistible admiration? And what is the source of this admiration, if not the immensity of the effort and the grandeur of the outcome? My tower will be the tallest edifice ever raised by man. Will it not also be grandiose in its own way? And why should what is admirable in Egypt be hideous and ridiculous in Paris? I ponder this question, and I admit that I find no answer.

PAUL GAUGUIN

At the Universal Exhibition (1889)

Paul Gauguin (1848–1903) was consecrated as the leader of pictorial symbolism two years after he wrote this article for the short-lived periodical *Le Moderniste,* whose editor, the journalist, critic, and poet G.-Albert Aurier, was his friend and was to become his staunch supporter.

By October 1888 Gauguin had cut himself off from impressionism; his synthetic work thereafter was characterized by nearly uniform areas of relatively intense hue, each delimited by a continuous outline. Gauguin had developed a considerable interest in the minor arts, having started glazing pottery made by the well-known ceramist Ernest Chaplet during the winter of 1886–87.[28] The glazing of a stoneware vase by Chaplet by Gauguin (Fig. 22) reflected a propensity toward expressive drawing and synthetist stylization. The simplification of design and the stress on harmonious linear elements in the decorative arts echoed the theories of Owen Jones and his disciples but also owed something to European medieval traditions, to Japan, and to European popular woodcuts—whose stylization referred to distant medieval precedents. More specifically, the painted gold lines separating glazed areas on the vase recall the thin strips of metal embedded in clay that separate different glazed areas on Middle Eastern and Asian vases—a technique known as cloisonné. Unlike the artists who created these works, however, Gauguin cultivated the swiftness and spontaneity in executing the design that Ruskin and some of his followers recommended.

Gauguin soon developed his own highly original stoneware technique, literally sculpting the clay. He preserved something of the plasticity characteristic of wet clay, his pots often registering the pressure of his fingers and palms. Moreover, he made good use of the variegated effects of colored glazes and evoked in the shape of his pots a wide range of figures, from little Breton bathers to Polynesian deities, to his own self-portrait (Fig. 23).

22. Paul Gauguin and Ernest Chaplet, *Vase with Breton Girls*, 1886–87. Decoration engraved on white slip and painted with various glazes, with contours picked out in gold by Gauguin on stoneware vase by Chaplet, 29 cm. high. Musées Royaux d'Art et d'Histoire, Brussels. Photo copyright A.C.L., Brussels.

Let them join forces with an artist.　　　　GAUGUIN

The articles excerpted here were Gauguin's first; many others followed. As the son of a liberal journalist who took his family into exile in Peru at the time of Napoleon III's rise to power—and died on the way—and the grandson, on his mother's side, of Flora Tristan y Moscoso, whose writings pleaded passionately, often stridently, for women's rights,[29] Gauguin was

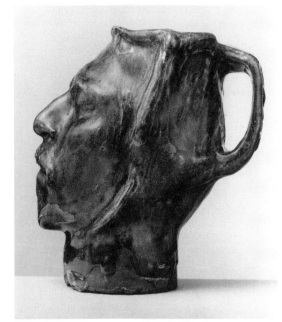

23. Paul Gauguin, *Self-Portrait in the Form of a Mug (Christ of Sorrows)*, 1889. Glazed stoneware, 19.3 cm. high. Copenhagen, Museum of Decorative Art. Photo copyright Ole Woldbye, Copenhagen.

This art was constantly honored in the remotest times, among American Indians. God made man with a little mud. GAUGUIN

himself an acerbic polemicist. After he reached Tahiti, in the 1890s, he was a frequent contributor to *Les Guêpes* (The wasps), a newspaper opposing the French colonial government, eventually becoming its manager.[30] He also published his own illustrated mimeographed sheet, *Le Sourire* [The smile],[31] which was even more hostile to the French Polynesian establishment.

His incisive humor, scathing metaphors, and bitter critique of all that is pompous, obtusely official, or academic bring to mind the barbs of Huysmans, who obviously influenced him. In fact, Gauguin's objection to the then fashionable use of terra-cotta with metal echoes Huysmans's complaint that metal remained essentially subordinated to more traditional materials, and Gauguin's comparison of the golden brown paint protecting the Eiffel Tower to butter coincides with one of Huysmans's own reproofs.[32]

Gauguin was nevertheless much bolder than Huysmans when forecasting the future of the decorative arts. Whereas Huysmans had merely deplored the lack of applied decoration on the Eiffel Tower, Gauguin proposed to take advantage of the "decorative art" available to construction engineers, "such as ornamental nuts and bolts and iron endings protruding beyond the main line," thus heralding twentieth-century constructivist developments. Gauguin applied the same concept to all the branches of art he practiced,

always intent that the decorative elements grow from the composition itself and use the same technical vocabulary.

Gauguin's wish that the craftsman be an artist and the artist a craftsman, and his insistence on the rough finish of crafted works, went back, through the Arts and Crafts movement, to Ruskin himself. Like Ruskin, Gauguin proclaimed that the final product should reflect the treatment of the material: a ceramic piece, he maintained, should reveal the high temperature to which it has been subjected. He went much beyond Ruskin, however, anticipating the doctrines of the Bauhaus, the German art and architecture school and design center of the 1920s, when he claimed that machine-made furniture, when designed by imaginative artists, could surpass furniture made by hand.

Like Mackmurdo, Gauguin stressed the "poetry in decoration," meant to bring about effects "considerably more abstract than the servile imitation of nature," and recognized the potential of musicality. He also advocated startling plays of association: "Imagine flowers as animal muscles or muscles as flowers."

The excerpts that follow are from Paul Gauguin, "Notes sur l'art—à l'Exposition universelle," *Le Moderniste* I, no. II (July 4, 1889): 84–86; and "Notes sur l'art—à l'Exposition universelle (suite)," *Le Moderniste* I, no. 12 (July 13, 1889), 90–91. ❧

CRAFT AND ART

Without doubt, this exhibition marks the triumph of iron, not only in the field of machinery, but also in that of architecture.

Yet iron architecture is in its infancy in that it does not possess a decorative tradition *homogeneous with its own medium.* Why does one find, side by side with rude and severe iron, soft materials such as barely fired terra-cotta? Why, side by side with these essentially new geometric lines, all this ancient stock of ornaments given a modern twist by naturalism? Engineers and architects have at their disposal a new decorative art, such as ornamental nuts and bolts and iron endings protruding beyond the main line, something like a Gothic lace of iron. We find a little of this in the Eiffel Tower.

❧

Statues in make-believe bronze next to iron. Imitation always! Would it not be much better to have monsters in bolt-studded iron?

❧

And why paint iron the color of butter? Why gilding as at the Opera? No, those are not marks of good taste.

Iron, iron, and still iron! Colors as severe as the medium. And you will have a construction at once imposing and suggestive of the metal in fusion. . . .

✦

. . . When we talk to an industrialist nowadays, we always hear the same refrain: "Producing something beautiful is useless, for the masses would not understand." Such reasoning seems false to us, and we answer unhesitatingly that the beautiful always finds its proper place, especially today, when the great fortunes take pride in their wealth. At Cluny [the museum of medieval art] we see objects—carved wood, faience, bibelots, and so forth— marvelous objects; for whom do you think they were made, if not for a privileged class rather than for the masses? What do you see in the homes of the great collectors of today if not valuable old things that have cost dearly? Japan takes millions of francs from us for its bronzes, its woods, its printed drawings. Don't worry! If *we were to make these,* there would be purchasers. So, industrialists, no more false reasoning; get on with the job. And above all, employ *artists,* not *workmen.* Today's furniture too, when its form is copied after older prototypes, is masquerading in that it is much *better* executed with the help of machines: as a result, no life and no individuality. Sculpture no longer consists of work by artists whose signatures are recognizable in the execution but rather of a patient workman smoothing down, skillfully sanding.

✦

Why *true* roses, *true* leaves? There is so much poetry in decoration! Yes, Gentlemen, it takes a formidable imagination to decorate any surface with taste—an art that is considerably more abstract than the servile imitation of nature.

Examine attentively at the Louvre, in the Dieulafoi Gallery, the [Assyrian] bas-reliefs of the lions; I maintain that an immense genius was required to imagine flowers as animals' muscles or muscles as flowers. All the mystical dreaming Orient can be found right here.

Decoration appropriate to the matter at hand and suitably placed is an art that seems to be vanishing, and requires long study and a special genius. Here, too, officialdom has warped public taste. [The government-owned porcelain factory at] Sèvres, not to mention the names of [specific individuals], has killed ceramics. Nobody wants any of its products, and when a Kanaka [South Sea islander] ambassador arrives, presto, he gets stuck with

a vase, much as a mother foists on you a daughter she wants to get rid of. Everyone knows this, but no one dares cast aspersions on Sèvres: it is the glory of France, and so forth. . . .

✦

The making of ceramics is not a futile endeavor. This art was constantly honored in the remotest times, among American Indians. God made man with a little mud.

With a little mud, one can make metal, precious stones—with a little mud and also a little genius!

So is it not an interesting material? But this does not prevent nine out of ten educated persons from walking past this section with extreme indifference. There is nothing one can say: for they know not what they do.[33]

CERAMICS

Take a little piece of clay. As it stands, it is not very interesting. Place it in a kiln and it will cook like a lobster and change color. A low fire will transform it slightly. Only with a very high temperature will the metal it contains reach a state of fusion. I do not pretend to offer a scientific course on this topic, but a quick exposé will help explain that in ceramics quality depends in large measure on the firing. A connoisseur will say this is poorly or well fired.

Indeed, the material coming out of the kiln is marked by the character of the fire. It becomes graver, more serious to the extent that it goes through hell. Hence all the junk on display: lightly fired ceramics is daintier and easier to produce. It follows that all decoration in ceramics must be given a character in keeping with the firing—the mainstay of beauty being harmony. Daintily mawkish lines are not in keeping with a severe medium. Hollow [creuses: low intensity?] colors next to full ones are not in harmony. And judge for yourself what an artist nature is: colors obtained in the same firing are always in harmony. As a result, a ceramist will not apply colored enamels on top of one another at different temperatures. This is what most ceramists did at the Universal Exhibition. One of them has gone overboard by applying tempera or turpentine-based paint over fired material. He had the impudence to call his little horror high-fire fresco. And the government orders such monstrosities from the works at Longwy.[34] A fresco is only a fresco inasmuch as it is painted into fresh plaster. The term fresco cannot, therefore, be used in conjunction with ceramics. And high-fire is a lie, be-

cause not a single color has gone through a firing. Yet the government authorizes these lies.

✦

Let us return to our subject. Ceramics and sculpture as well as drawing require modeling "in harmony with the raw material."[35]

✦

I beg sculptors to study carefully this question of adaptation. Plaster, wood, marble, bronze, and clay must not be modeled in the same way, since every one of these materials has different characteristics of solidity, hardness, and appearance.

One might call these subtleties excessive; but in art, they are necessities. Otherwise art is no longer complete; it is no longer art.

✦

Clay, when baking, undergoes a contraction that augments with the heat and tends to cause the surfaces to collapse. As a result, an arm, a fabric, must be extremely rigid.

✦

Among all the exhibitors we have noted only two genuine ceramists, Chaplet and Delaherche.[36] The first distinguished himself with his porcelains, the second with his stoneware. We will address the same criticism to both. Since they want to produce work that is both beautiful and modern, let them do so *completely,* and, beyond beautiful color, let them contribute FORMS of vases other than the well-known mechanical ones. Let them join forces with an artist.

We will not say the same about the GLASS, which was crafted by a factory in Nancy with all the taste of a Benvenuto Cellini [Fig. 24].[37] Each vase has a special decoration, a special shape. In [its author] we salute at last an industrialist-artist to his fingertips, as the saying goes.

Postscript: I was wrong when I wrote [in the July 4 issue] that there was no pictural art at the Universal Exhibition. Today, with the opening of the Centennial Exhibition, I speak differently.[38]

Yet it may well come back to where we started, for this exhibition marks the triumph of the artists I said were rejected or treated with contempt: Corot, Millet, Daumier, and finally Manet. The Beautiful *Olympia,* which

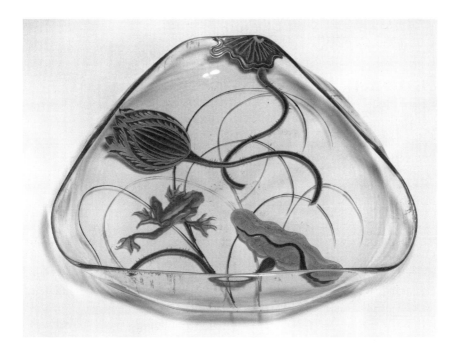

24. Emile Gallé, *Moonlight*, glass cup with frog, pre-1889. Clear glass with enamel and painted decoration with gold highlights, 24.1 × 24.1 cm. Musée d'Orsay, Paris. Photo copyright R.M.N.

In [its author] we salute at last an industrialist-artist to his fingertips, as the saying goes. GAUGUIN

has caused such an uproar over the years, stands out like a piece fit for a king and has its admirers.[39]

The conclusion: Huysmans has drawn it long ago. The example and the talent of independent artists amply demonstrate the uselessness of a budget, and the futility of a directorate for the arts. The words of Courier are still appropriate: "That which the government encourages languishes; that which it protects dies."[40]

LOUIS H. SULLIVAN

Ornament in Architecture (1892)

Louis Sullivan (1856–1924) was by no means the first architect to build a skyscraper.[41] During the 1870s in New York ten-story buildings equipped with elevators were built. But in Chicago, where Sullivan settled, the skyscraper came into its own. Perhaps William Le Baron Jenney, a graduate of the Ecole Polytechnique in Paris, where J.-N.-L. Durand once taught, was responsible for the new technique, in which a building's two external walls were supported by a metal inner structure while the other two walls, adjacent to other buildings, remained load-bearing walls, as in Jenney's Home Life Insurance Building of 1883–85 in Chicago. Whether or not he was, the use of a metal structure allowed a reduction in the size of supporting pillars and therefore made it possible to lighten the walls, provide more window area, and design much taller buildings. The prophecies of Viollet-le-Duc, based on his understanding of the structural achievements of medieval art, were being implemented: the use of metal followed the principles of "genuine modern construction. . . . the construction required by our modern needs, our social condition."[42]

Although the economic crisis of 1873 delayed reconstruction after the fire that destroyed most of central Chicago in 1871, a wave of new construction swept the city in the 1880s and 1890s. The new tall buildings fit the practical and economic needs of a dynamic industrial and commercial community where land was in short supply. The architect who contributed most imaginatively to this architectural rebirth was Louis H. Sullivan. Born in Boston, Sullivan spent a year at the Massachusetts Institute of Technology and a year at the Ecole des Beaux-Arts in Paris after successfully passing its highly competitive entrance examination. He traveled to Rome, where he was impressed by Michelangelo's decorations of the Sistine Chapel. From the Ecole des Beaux-Arts he claimed to have received "the germ of that law which later, after much observation of nature's process, I formulated in the phrase 'Form follows Function.' "[43] Ironically, that formula probably de-

rived from the already discredited pre-Darwinist theory of the French natural scientist Lamarck that living creatures develop their organs in response to their needs.

After gaining architectural experience under various practitioners, Sullivan joined the firm of Dankmar Adler, becoming a full partner in 1881. Adler and Sullivan, and then Sullivan alone (the firm was dissolved in 1895), created major buildings in Chicago and other cities over the next two decades. In the process, Sullivan, the designer in the team, established a new canon for tall office buildings. In connection with the design of the Wainwright Building of 1890–91 in Saint Louis, Missouri (Figs. 25, 26), his first steel-frame construction, he determined, as he wrote in his *Autobiography of an Idea* (1922), that "the old ideas of superposition must give way before the sense of vertical continuity."[44] In the Wainwright Building masonry strips covering fire-proofed vertical steel beams alternate with the strips constituted by the windows and ornamental panels; the strips could be compared to column shafts whose capitals form the building's elaborate cornice, as Sullivan himself suggested in his discussion of the aesthetics of tall office buildings.[45]

Sullivan believed that the principle "form ever follows function" was at the root of the inseparability of "life and the form . . . in nature," and that it opens to the architect "the high-road to a natural and satisfying art." Only when responding to it will the architect speak both for himself and his fellow citizens, for only then will he

> express in the simplest, most modest, most natural way that which it is in him to say; that he might really and would surely develop his own characteristic individuality; and that the architectural art with him would certainly become a living form of speech, a natural form of utterance, giving surcease to him and adding treasures small and great to the growing art of his land.[46]

This was tantamount to positing an organic unity encompassing both structure and decoration, a concept directly opposed to Durand's urging that ornament be considered distinct from the utilitarian aspects of the building.[47]

The organic simile was not entirely new. When he asserted that ornament should appear to have "come forth from the very substance of the material" just as "a flower appears amid the leaves of its parent plant," he was broadening Owen Jones's statement that "beauty of form is produced by lines growing out one from the other in gradual undulations."

For Sullivan, furthermore, a building should be a source of associations, "rich," "varied," "poetic," "inexhaustible." It should come as no surprise that he compared the rhythms of architecture to those of music.

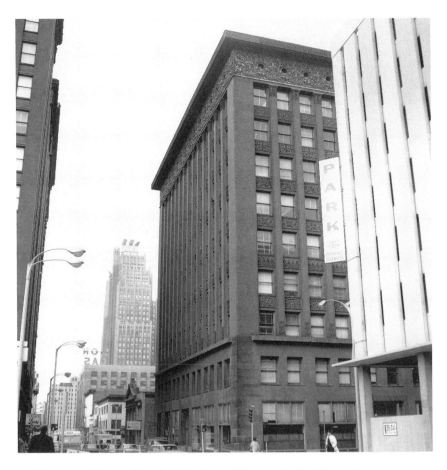

25. Dankmar Adler and Louis H. Sullivan, Wainwright Building, 1890–91. Saint Louis, Missouri. Photo: David Gebhard.

A building which is truly a work of art . . . is in its very nature, essence and physical being an emotional expression. SULLIVAN

The stress on the organic in decoration, no less than the insistence on honesty in its handling, links Sullivan to the very principles of art nouveau. The notion that the mind should "pause in its flight" when confronted with superior decoration brings to mind Pater's envisioning of the "transitory moment" conducive to ecstasy. And as for social considerations, Sullivan in another text claims that the foremost task of the architect is to interpret the material wants of democracy,[48] thus echoing William Morris and Ruskin.

Although Sullivan all his life denied having been affected by the British

26. Dankmar Adler and
Louis H. Sullivan, Wain-
wright Building, 1890–91.
Saint Louis, Missouri. De-
tail of decorative strip.
Photo: David Gebhard.

*. . . like a sonorous melody
overlaid with harmonious
voices.* SULLIVAN

Arts and Crafts movement, the architect Frank Lloyd Wright, who joined
him as an assistant in 1888 and took special charge of decoration, was an
enthusiastic admirer of Morris and became a charter member of the Chicago
Arts and Crafts Society in 1897.[49]

The excerpts that follow are from Louis H. Sullivan, "Ornament in Ar-
chitecture," *Engineering Magazine* 3, no. 5 (August 1892): 633–44. ❦

I take it as self-evident that a building, quite devoid of ornament, may con-
vey a noble and dignified sentiment by virtue of mass and proportion. It is
not evident to me that ornament can intrinsically heighten these elemental
qualities. Why, then, should we use ornament? Is not a noble and simple
dignity sufficient? Why should we ask more?

If I answer the question in entire candor, I should say that it would be
greatly for our aesthetic good if we should refrain entirely from the use of
ornament for a period of years, in order that our thought might concentrate
acutely upon the production of buildings well formed and comely in the

nude. We should thus perforce eschew many undesirable things, and learn by contrast how effective it is to think in a natural, vigorous and wholesome way. This step taken, we might safely inquire to what extent a decorative application of ornament would enhance the beauty of our structures—what new charm it would give them.

If we have then become well grounded in pure and simple forms we will revere them; we will refrain instinctively from vandalism; we will be loth to do aught that may make these forms less pure, less noble. We shall have learned moreover that ornament is mentally, a luxury, not a necessary; and that we should so use and understand it. We shall have learned by contrast wherein this luxury may become emotionally a necessary, for we shall have discerned the limitations as well as the great value of unadorned masses. We have in us romanticism, and feel a craving to express it. We feel intuitively that our strong, athletic and simple forms will carry with natural ease the raiment of which we dream, and that our buildings thus clad in a garment of poetic imagery, half hid as it were in choice products of loom and mine, will appeal with redoubled power, like a sonorous melody overlaid with harmonious voices.

I conceive that a true artist will reason substantially in this way; and that, at the culmination of his powers, he may realize this ideal.

I believe that architectural ornament brought forth in this spirit is desirable, because beautiful and inspiring; that ornament brought forth in any other spirit is lacking in the higher possibilities.

That is to say, a building which is truly a work of art (and I consider none other), is in its very nature, essence and physical being an emotional expression. This being so, and I feel deeply that it is so, it must have, almost literally, a life. It follows from this living principle that an ornamented structure should be characterized by this quality, namely, that the same emotional impulse shall flow throughout harmoniously into its varied forms of expression—of which, while the mass-composition is the more profound, the decorative ornamentation is the more intense. Yet must both spring from the same source of feeling.

I am aware that a decorated building, designed upon this principle, will require in its creator a high and sustained emotional tension, an organic singleness of idea and purpose maintained to the last. The completed work will tell of this; and if it be designed with sufficient depth of feeling and simplicity of mind, the more intense the heat in which it was conceived, the more serene and noble will it remain forever as a monument of man's eloquence. It is this quality that characterizes the great monuments of the past. It is this certainly that opens a vista towards the future.

To my thinking, however, the mass-composition and the decorative system of a structure such as I have hinted at should be separable from each

other only in theory and for purposes of analytical study. I believe, as I have said, that an excellent and beautiful building may be designed that shall bear no ornament whatever; but I believe just as firmly that a decorated structure, harmoniously conceived, well considered, cannot be stripped of its system of ornament without destroying its individuality.

It has been hitherto somewhat the fashion to speak of ornament, with perhaps too much levity of thought, as a thing to be put on or omitted, as the case might be. I hold to the contrary—that the presence or absence of ornament should, certainly in serious work, be determined at the very beginnings of the design. This is perhaps strenuous insistence, yet I justify and urge it on the ground that creative architecture is an art so fine that its power is manifest in rhythms of great subtlety, as much so indeed as those of musical art, its nearest relative.

If, therefore, our artistic rhythms—a result—are to be significant, our prior meditations—the cause—must be so. It matters then greatly what is the prior inclination of the mind, as much so indeed as it matters what is the inclination of a cannon when the shot is fired.

If we assume that our contemplated building need not be a work of living art, or at least a striving for it, that our civilization does not yet demand such, my plea is useless. I can proceed only on the supposition that our culture has progressed to the stage wherein an imitative or reminiscential art does not wholly satisfy, and that there exists an actual desire for spontaneous expression. I assume, too, that we are to begin, not by shutting our eyes and ears to the unspeakable past, but rather by opening our hearts, in enlightened sympathy and filial regard, to the voice of our times.

Nor do I consider this the place or the time to inquire if after all there is really such a thing as creative art—whether a final analysis does not reveal the great artist, not as creator, but rather as interpreter and prophet. When the time does come that the luxury of this inquiry becomes a momentous necessary, our architecture shall have neared its final development. It will suffice then to say that I conceive a work of fine art to be really this: a made thing, more or less attractive, regarding which the casual observer may see a part, but no observer all, that is in it.

It must be manifest that an ornamental design will be more beautiful if it seems a part of the surface or substance that receives it, than if it looks "stuck on," so to speak. A little observation will lead one to see that in the former case there exists a peculiar sympathy between the ornament and the structure, which is absent in the latter. Both structure and ornament obviously benefit by this sympathy—each enhancing the value of the other. And this, I take it, is the preparatory basis of what may be called an organic system of ornamentation.

The ornament, as a matter of fact, is applied in the sense of being cut in

or cut on, or otherwise done; yet it should appear, when completed, as though by the outworking of some beneficent agency it had come forth from the very substance of the material and was there by the same right that a flower appears amid the leaves of its parent plant.

Here by this method we make a species of contact, and the spirit that animates the mass is free to flow into the ornament—they are no longer two things but one thing.

If now we bring ourselves to close and reflective observation, how evident it becomes that if we wish to insure an actual, a poetic unity, the ornament should appear, not as something *receiving* the spirit of the structure, but as a thing *expressing* that spirit by virtue of differential growth. . . .

Few works can stand the test of close, business-like analysis—they are soon emptied. But no analysis, however sympathetic, persistent or profound, can exhaust a truly great work of art. For the qualities that make it thus great are not mental only, but psychic, and therefore signify the highest expression and embodiment of individuality.

Now, if this spiritual and emotional quality is a noble attribute when it resides in the mass of a building, it must, when applied to a virile and synthetic scheme of ornamentation, raise this at once from the level of triviality to the heights of dramatic expression.

The possibilities of ornamentation, so considered, are marvelous; and before us open, as a vista, conceptions so rich, so varied, so poetic, so inexhaustible, that the mind pauses in its flight and life indeed seems but a span.

Reflect now the light of this conception full and free upon joint considerations of mass-composition, and how serious, how eloquent, how inspiring is the imagery, how noble the dramatic force that shall make sublime our future architecture.

America is the only land in the whole earth wherein a dream like this may be realized; for here alone tradition is without shackles, and the soul of man free to grow, to mature, to seek its own.

But for this we must turn again to Nature, and, hearkening to her melodious voice, learn, as children learn, the accent of its rhythmic cadences. We must view the sunrise with ambition, the twilight wistfully; then, when our eyes have learned to see, we shall know how great is the simplicity of nature, that it brings forth in serenity such endless variation. We shall learn from this to consider man and his ways, to the end that we behold the unfolding of the soul in all its beauty, and know that the fragrance of a living art shall float again in the garden of our world.

HENRY VAN DE VELDE

A Clean Sweep for the Future of Art
(1894)

The Belgian artist Henry van de Velde (1863–1957) studied painting at the Antwerp Academy from 1880 until 1884, when he left for Paris.[50] At first a romantic naturalist, he was soon inspired by the sophisticated optical simplifications of Manet and adopted Seurat's neo-impressionism after seeing *Sunday Afternoon on the Island of La Grande-Jatte* (see Fig. 29). He was elected a member of Les XX in 1888 and thereafter began to design for embroidery. In 1892 he sent a tapestry cartoon to a new section of the exhibition devoted to the decorative arts organized by that group. Fully prepared to embrace symbolist principles, he was much impressed by a lecture Mallarmé gave in Brussels in 1892.[51] Even while adhering to the color principles of neo-impressionism, he turned to synthetist simplifications of design, sometimes enlivened by expressive undulations of brushstrokes in the manner of van Gogh. In 1894 he gave up painting for the decorative arts (see Fig. 28) and architecture. He had become by then one of the most vigorous practitioners of art nouveau, some principles of which he enunciates in the following text. Shortly after this essay appeared, he was called to Paris by Siegfried Bing, who was remodeling and enlarging his Asian art gallery into one for the decorative arts. Bing called the gallery L'Art nouveau, thus giving the new movement its name. Van de Velde's assignment was to design three rooms in the new manner. The gallery opened its doors to the public on December 26, 1895.[52]

The first pages of van de Velde's essay, not included here, decried with Ruskinian vehemence the decline in artistic standards since the Middle Ages. Like Ruskin, van de Velde blamed the rise of a new bourgeois and mercantile class for this state of affairs. His tone even became anarchistic: "The times have come; an idea of love will be shared by all humankind; at that time art will come to light in a new form. The earth is in labor and will bring forth a flower; but our eyes will not see it until the present is annihilated."

Van de Velde expressed admiration for William Morris and the Arts and Crafts movement in England and for Delaherche, Gallé, and others in France: "The art of the ornament suddenly became for them the unsuspected womb whose blood feeds all the works that have been variously classified under descriptive labels, only one of which is suitable, because it implies and magnifies the legend of the return of the Prodigal Son [an allusion to medieval traditions]: decorative!"

He envisioned the future of the major arts and the decorative tradition (the two were synonymous for him) in the passage that follows. His dream of "materials as malleable as sentences and as supple as thought" is in keeping with art nouveau, as is his urge to do away with frames—extending the artist's domain to whole walls—and his intention to evoke the whole of nature symbolically.

The Cultural Houses of the People (Maisons du peuple), whose prototype was built in Brussels by Victor Horta, the first significant proponent of art nouveau architecture in Belgium (Fig. 27), were centers for the promotion of socialist ideals—the one in Brussels housed the headquarters of the Belgian Socialist Workers' party. They were also intended to better the lot of workers through education, including art education, which Ruskin had so enthusiastically advocated in his effort to raise the quality of output and the living standards of manual workers. Van de Velde equated the impassioned beliefs of the organizers of these centers to a "new religion." The Brussels center counted among its leaders and professors van de Velde himself, Verhaeren, the painter Khnopff, and other members of Les XX. The idea was derived from similar efforts by Ruskin's circle that had led to the creation, under the leadership of the theologian and Christian Socialist J. F. D. Maurice, of the Working Men's College in London, where Ruskin, Rossetti, Morris, and others linked with the Pre-Raphaelite movement once taught.

The "dream" mentioned by van de Velde that "once paralyzed the tribe . . . of artists" is probably an allusion to now obsolete romantic ideals. The designer was even more emphatic in repudiating past traditions and their recent revivals when he alluded to various historical periods by their main artistic goals: the Middle Ages had "consecrated the monument to God," the Renaissance and baroque periods "to the idea of the Fatherland," the romantic era "to drama." The nineteenth century in its more eclectic aspects, furthermore, had perpetuated these attitudes, and, in idealizing material achievement, had overvalued the engineer's "daring and faultless calculation," much as it had the mechanization of the building process, which he considered to have been enslaved "by damnable numerical abstractions." Such were the trends van de Velde was intent on sweeping away.

The designer and architect was even more vehement in condemning the

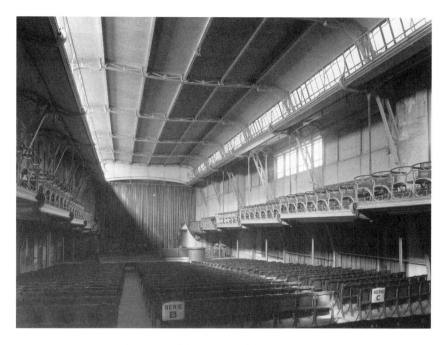

27. Victor Horta, Auditorium of the Maison du Peuple (House of the People), Brussels, 1897 (destroyed). Photo: Institut Royal du Patrimoine artistique, Brussels; copyright A.C.L., Brussels.

And the decadents became proselytizers. They joined the tumultuous crowd marching confidently toward a glorious future. VAN DE VELDE

romantic dream as having "held back the very stream of creativity." In fact, he was not so much condemning the flights of fantasy central to the play of associations of both romantics and symbolists as advocating a redirection from a concern with the past to a vision of the future—a vision focused on broad improvements of human conditions in keeping with his utopian socialism.

There is a touch of unconscious irony in van de Velde's championing of the machine as a potential ally in the production of manufactured works, for like Ruskin and Morris he fought strenuously for the manual artisan and against the standardization and mechanization necessary for machine-made work. His political stance, like theirs, was that as long as mechanization was dominated by "the greed of the industrialist," its products would be tainted; only in the utopia of his dreams would chimney stacks pour out "smoke . . . like the white wings of angels of the Annunciation." One of

van de Velde's principal opponents on the issue of mechanization was to be Walter Gropius, future leader of the Bauhaus school of the fine and industrial arts, who was committed to machine production.[53]

The text that follows was part of a lecture delivered at a meeting of La Libre Esthétique,[54] which succeeded Les XX in 1893. The lecture was published in booklet form as Henry van de Velde, *Déblaiement d'art* (1894); the excerpt is from the second edition (Brussels: Monnom, 1895). ❧

The stream [of artistic creation] had built up such pressure that it jeopardized the stability of the dams—for that is what frames are—which eventually gave in. The return of painting to a truly ornamental purpose could no longer be denied after it endeavored to create the illusion of enamel, stained glass, carpets, embroidery.[55] [As it got closer to the decorative arts] painting simultaneously regained hold of and negated itself. And it was our privilege to recognize that the [framed] picture was but the manifestation of the extreme old age of painting in any civilization, of the shrinkage of the body that immediately precedes death.

Despite this miserable appearance and all men's sacrilegious manipulations, the picture could not rid itself of the sign that links it to its source. The *frame* is the umbilical cord that attaches it to the monument, of which it is the imaginary reduced version. The imprint is evident and indelibly links the picture of a bygone age, of the present day, of all times, to the fresco, the stained-glass window, the mosaic.

The evolution of the frame follows that of architecture. If the Gothic picture is pressed between small, frail columns and is surmounted by an ogee and, above it, a steeple-like tracery, the Renaissance frame is characterized by the pedantry of ornamental principles that are poorly visualized and misunderstood. Indeed, if all the buildings erected by the successive kings of France were to be destroyed, one might still get an idea of what they were like from studying the frames of each era. The same can be said of the Regency and Empire periods.

Do not those pompous monstrosities in false gold that frame modern works link them to our "grand cafés," our "concert halls," our "entertainment emporia?"

Not surprisingly, the recent apparition of the white frame had caused a commotion among aesthetes.[56] It occurred to them that the white frame was the equivalent of a manifesto. It was the affirmation that painting was about to reconquer the wall, which the frame itself had simulated. And when the frame became polychromatic,[57] the transformation coincided with the birth of a new unselfconscious architecture employing new materials.

Indeed, this dream will come true—a dream of materials as malleable as sentences and as supple as thought.[58] A new era of large buildings, distinguished from those of the past in that they make another step toward the full materialization of thought, is about to dawn on us.

Already one detects a longing for a decor corresponding to the state of the soul we bring, in normal living, to one or another part of our abodes. For indeed we are wasting our strength if we try to laugh, in spite of everything, in a decor that overwhelms us with boredom; if we immerse our thoughts in what is deep and eternal in rooms that only accentuate the frivolous. In the long run, the decor gets the better of us. Despite our efforts we give in to its enduring suggestiveness.

And it will come to pass that the one unchangeable thought we shall have inscribed on the walls of our rooms, in the structure of our furniture, will safeguard us against any intrusion of a contrary feeling and will endow our life with serenity.

This is the secret that causes the brutes, just like sensitive souls, to rush toward the countryside, where, under the high vault of the sky, instinct leads them to a decor suited to their souls. The intellectual character of the rural setting is at the root of its charm and its excellence. Landscapes are rooms that can be chosen at will, and we choose the most expansive and most colorful: in meadows streaked with rivers, strewn with flowers we give way to our joy [Fig. 28]; dense forests call forth our vague daydreams, our undefined longings; endless tree-lined roads evoke bitterness; and we confide our sufferings to the sheltering limbs of large trees, which rock them to sleep.

Accordingly, it will be appropriate in the future to borrow the patterns of landscapes, to employ for the design of our apartments the significant lines they themselves display,[59] which generate such compelling sensations.

The idea of borrowing from the most beautiful sources of [nature's] construction and ornament, of seeking inspiration from the most beautiful monument conceivable—the ground, the trees, the flowers, and, up above, the sky—is but the manifestation of a return to the genuine architectural tradition.

❦

The past consecrated the monument to God, to the idea of the Fatherland, to that of justice, to drama, and without believing in it too strongly ourselves, we had perpetuated this traditional practice; but today's creation, with no goal in mind other than the financial exploitation of monuments whose beauty is limited to daring and faultless calculation, is the trademark of a vile mind.

28. Henry van de Velde, *Angels' Watch*, 1893. Wall hanging in wool and silk-embroidered appliqué, 140 × 233 cm. Museum Bellerive, Zurich. Photo: Marlen Perez.

Landscapes are rooms that can be chosen at will, and we choose the most expansive and most colorful: in meadows streaked with rivers, strewn with flowers we give way to our joy. VAN DE VELDE

For a long time now, dishonorable purposes have roused in us little sense of revulsion, and today an avenue of monuments rises that will consecrate the ignominious despoilment of the human spirit and its enslavement by damnable numerical abstractions.

It happens that a class of men whose hearts have remained as unspoiled as their hands by any share of the gold that has soiled us all—I mean the people—are gathering the remains of art [that are still unsoiled]. Their purity of heart and their naive spirit are preserving art in its [rightful] abode. And when those who had increasingly become confined to the tallest [ivory] towers by an infinite disgust with material things and an overwhelming uneasiness in the face of ordinary human dealings recognized this new potential, they joyfully sacrificed their isolation and went to the Maisons du peuple [see Fig. 27].

And the decadents became proselytizers. They joined the tumultuous crowd marching confidently toward a glorious future.

The books that once elicited our affection are set aside like daydreams now that all the aesthetes are engrossed in edifying and systematic readings on the new religion.

And so great was the aesthetes' impatience for the advent of an art of the future that they [mistakenly] believed they recognized it in works they called social art—works that did not yet bear all the markings of the art yet to come. These were paintings and sculptures—admittedly beautiful ones— whose subjects were drawn from more or less pitiful occurrences in the lives of the underprivileged. The error of their creators is to believe that the art of the future will borrow motifs from the people, when, in fact, art will give itself to the people. And to that end it must abandon all form that might be intended for only one among us.

An unforgivable aberration makes us devote our lives and our faculties to churning out works born of no unique and compelling ornamental concept, works that can only increase the decorative discord in our homes.

Having money in one's pockets is no more satisfying than creating a work of art beautiful in itself whose beauty is offset by the monstrosities around it.

What benefits only a single individual is close to being useless, and in the society of the future only what benefits all will merit consideration. And the day when artists want to create useful work—a desire that will not lessen the esteem in which they are held—will also be the day when painting and sculpture as such will perish, exhausted and morally bankrupt as means of expression. They will be ignored because their spirit and their essence are egotistical, whereas artists' hearts today are generous and altruistic; for, indeed, they are thinking now of how to increase their products and struggle to conquer the machines that will come to their assistance. Indeed, it is obvious that machines will one day make up for all the miseries they have caused, that they will compensate mankind for the abominations they have spread. Yet their culpability is disputable. What they drop indifferently from their entrails is both the monstrous and the beautiful. Their iron wombs will spawn beautiful products as soon as Beauty agrees to make them fertile. But a monster is crouching near them: the greed of the industrialist. He bears down on them with uninterrupted frenzy, spitting the fire of his craving for profits into their sides, as well as the seed of his maddening anxiety. And the issue of this interplay is tainted.

I have seen art donning armor as in a legend and defying the monster, and when the corrupt black blood flows, the hosanna will rise toward heaven, and the smoke of tall factories will spread out like the white wings of angels of the Annunciation.

Our faith in Beauty has returned, and the miracle within us has come to pass, giving us a new conception of life and of art.

One can wait for the work of the future with as much confidence as one can affirm that it will be born. And that time is not far off, for when equality reigns among men, their first common determination will be to

erect large buildings to glorify the idea that fills them with so much happiness!

Confident now, we have stopped procrastinating and have thrown off the indolence that seemed forever to have fettered our bodies and our minds.

For the [romantic] dream has held back the very stream of creativity. It once paralyzed the tribe, the great tribe of artists chosen to carry art within them from the distant era whence we come, to display it to succeeding generations, but sometimes only after intervals of centuries.

[The tribe] has resumed its march, following the sun because the sun symbolically feeds it its bread—the only one that suits it—kneaded with purity, light, and all the excellent virtues.

The assembly is gathering at the edge of the Old World, in the West. We must journey toward the Americas, for there the soil of the Occident has not yet flowered.

The road we shall follow is the shining one of gold that the sun traces in the vast sea; it leads to the immense purifying hearth [the sunset] that it lights up every evening. It is the curtain of fire that art will cross to purify itself.

And when the royal child appears, over there, in its fascinating virginal nudity, the imposture of all that had usurped his name will reveal itself. The people will confess their error and will become exultant.

And the artists will get down to work.

3

LITERARY SYMBOLISM

The relationship between literary and artistic symbolist groups was a close one. It had become increasingly apparent since the days of Gautier and Baudelaire that appreciative words from a celebrated writer were the strongest and most lasting recognition an avant-garde artist could aspire to in his lifetime. Writing for large dailies in the 1880s, the novelist Huysmans became the single most important promoter of romantic symbolists such as Moreau and Redon.

In the 1870s and 1880s a younger generation of poets and critics writing in little magazines, many of which were raising or about to raise the symbolist flag—some called it the flag of decadence—eagerly took up the cause of like-minded artistic pioneers. These writers and artists met at a number of informal clubs, such as Les Hydropathes, founded in 1878, and the literary cabaret Le Chat Noir, founded in 1881, where they greeted the raucous verve of naturalist-oriented popular songsters as enthusiastically as they had the subtle mythological allusions of recent Parnassian poetry. The younger generation appreciated sweeping flights of the imagination, both convoluted and daring; a new and sometimes excessively opulent vocabulary; and verse that combined rhythm and rhyme with a rich, sometimes startling, sequence of poetic imagery. They felt contempt for all things material and engaged in occasional bouts of morbidity and defeatism. This generation included the poets Jules Laforgue, Gustave Kahn, and Jean Moréas; the multilingual Polish critic Teodor de Wyzewa, who kept his friends abreast of artistic and literary developments abroad; and the poet and critic Edouard Dujardin, who, like Wyzewa, extolled Wagner and acclaimed the new French poetry.

Commenting on the poems of Gustave Kahn in an article of 1890, the critic Félix Fénéon pointed to the freedom and complexity the new school achieved in prosody and the play of associations:

These poems are a living arabesque in which the metaphor, before even being completed, diverges as the mood changes, bringing forth another that itself metamorphoses. The extreme motility of the idea is borne out by the grammatical context: garlands of genitives, impersonal and neutral verbs becoming active, every word getting full play, and, in vocabulary, quantities of words evoking a Near East in which Kahn, a Semite, takes delight.[1]

Three poets, one dead and two living, dominated the gatherings of the writers and artists: Baudelaire, Verlaine, and Mallarmé. Although Baudelaire had died in 1867, his *Flowers of Evil* (1857) was reissued in 1868 with an important preface by Gautier. In it Gautier praised "the language [*langue* also means "tongue" in French] already laced with the green of decay" that characterized Baudelaire's "style of decadence," a style intended to intensify poetic perception to the extreme. In his own words, it was "the last word of the Word of life summoned to express everything and pressured to the utmost."[2] Paul Verlaine was somewhat older than the other members of the new school. The daring music of his prosody, no less than his sardonic delight in decadence and his notorious not-so-private life, had already set him apart from the Parnassians and had drawn the admiration of the new generation. Stéphane Mallarmé became the hub of the group as early as 1879, because of both his personal affability and the younger poets' and artists' appreciation of his poetry, with its hermetism, its richly complex fragmented imagery, and its tonal and rhythmic suggestiveness.

The theoretical contributions of these three poets affected the fine arts as much as literature. The considerably younger poet Arthur Rimbaud was also important. He appeared only briefly, sometimes scandalously, in Paris in the early 1870s, but when his poems were published in avant-garde periodicals, their intense multifaceted vision and the astonishing theoretical intuitions they revealed had considerable impact.

New literary groups were formed and dissolved, each meeting in a different nightclub or café, or in the offices of the periodicals defending their particular cause. The elite of these groups gathered at the home of Mallarmé, who in 1880 initiated small weekly literary and artistic receptions, his Tuesdays, which by 1887 had acquired a high repute in literary circles.[3] Two Belgians who attended regularly, the critic Emile Verhaeren and the playwright Maurice Maeterlinck, spread the new doctrines abroad; others, such as Wyzewa, propagated them in France as well as abroad.

In 1885 a witty parody of the new movement's poetic manner lampooned its "decadence," which was also attacked in a closely reasoned insensitive article of August 6, 1885, in the widely circulating daily *Le Temps*.[4] Moréas defended the poets in *Le Dix-neuvième siècle* of August 11, 1885, in a piece where he also stated his preference for the term *symbolist* over *decadent*.[5] He

then issued his manifesto on symbolism, included in this chapter, outlining his version of the movement's aims in poetry, a gesture that won him a position of leadership among the uninitiated.

Emile Hennequin ranked among the faithful at Mallarmé's Tuesdays,[6] as did Félix Fénéon, the critic who did most to promote Seurat's neo-impressionist theories, and the poet and critic G.-Albert Aurier, a friend of Gauguin's, who proclaimed the artist the leader of pictorial symbolism. Gauguin himself was an occasional guest.

Many of the symbolist critics and poets launched and directed avant-garde literary periodicals. Edouard Dujardin founded both *La Revue wagnérienne* and *La Revue indépendante*—Fénéon helped manage the latter. Gustave Kahn founded *La Vogue*—also with Fénéon's help. The most influential and enduring symbolist periodical was *Mercure de France*. Its art critic, Aurier, wrote important articles on van Gogh and Gauguin; its literary critic, Remy de Gourmont, became a major theoretician of symbolism and influenced the literary avant-garde of the early twentieth century.[7]

Baudelaire and the Decadent Movement
(1881)

At the time he published this essay, Paul Bourget (1852–1935) already had a reputation as a novelist.[8] States of the soul take precedence over material considerations in his writings; in this respect he was closer to the symbolist than the naturalist tradition.

Bourget's text on Baudelaire was one of a series of critical studies intended to highlight the psychological component of artistic creativity. In analyzing the pessimism and morbidity of much of Baudelaire's poetry—which Bourget, like Gautier in his preface to *Les Fleurs du mal*,[9] associated with the aesthetics of earlier eras of decadence—Bourget wrote what amounts to the first manifesto of decadence. Those who soon thereafter developed similar ideas included the mercurial Verlaine, who simultaneously upheld what he wittily called *décadisme* and conveyed his ironic enthusiasm for the trend in his charming poem "Langueur" (Listless indolence) by evoking a bored and degenerate Roman at the end of the Empire;[10] Huysmans, whose half-ironic, half-serious novel *Against the Grain* at once mocked and praised late-nineteenth-century decadence; and Henri Beauclair and Gabriel Vicaire, two witty journalists who, under the pseudonym Marius Tapora, published a parody of symbolist/decadent poetry in *Les Déliquescences d'Adoré Floupette* [The melting ways of Adoré Littleflop], which, ironically, helped diffuse the ideals of *décadisme*.[11] It appeared a year before the periodicals *Le Décadent* and *La Décadence* made their ephemeral appearance.[12]

For Bourget, social decadence was by no means incompatible with artistic achievement; it could indeed lead to the creation of masterpieces. This view of the relationship between art and society reflects the notion that however great temporal corruption and decay may be, artistic ideals will transcend them.

It was appropriate that Bourget should call Baudelaire "one of the seminal educators of the emerging generation," especially because Bourget had

come to associate decadence with the primacy of the aesthetic experience, thus echoing the view of Walter Pater and the aesthetes. In evoking Baudelaire's imagery Bourget approximates the spirit of romantic symbolists like Moreau, particularly in the passage that refers to a sky "as colorful as the background of a picture by da Vinci, with its nuances of a dying pink and a nearly fading green" and to "the beauty of woman [that] appeals to him [Baudelaire] only when it is precocious and almost macabre in its thinness, with the elegance of a skeleton under adolescent flesh."

The excerpts that follow are from Paul Bourget, "Essai de psychologie contemporaine: Charles Baudelaire," *La Nouvelle Revue* 13 (1881): 398– 417. ✦

If a special nuance in the meaning of love and a new way of interpreting pessimism make Baudelaire's mind a psychological curiosity of a higher order, what gives him his place in the literature of our time is that he has marvelously understood and almost heroically exaggerated this special character and this quality of newness.

He has realized that he arrived late in an aging civilization. And instead of deploring this tardy arrival, like La Bruyère and Musset, he would have been delighted—I almost said honored—by it.[13] He was a man for times of decadence, and he turned himself into a theoretician of decadence. This may well be the most disquieting trait of this disquieting figure, and the one most disturbingly seductive to a contemporary soul.

The word *decadence* frequently refers to the state of a society that produces too many individuals ill-suited to the work of the community. A society must be thought of as an organism.

. . . If citizens in a time of decadence are inferior as toilers for the grandeur of the country, are they not also superior as artists delving into the depth of their own souls? If they are ineffectual in private or public endeavors, is it not because they are too skillful in their solitary thinking? If they cannot produce the generations of the future, is it not because the abundance of their refined sensations and exquisite feelings has turned them into sterile yet refined virtuosi of voluptuousness and suffering? If they are incapable of the abnegation of deep faith, is it not because their overcultivated intelligence has rid them of prejudice and because, having circumnavigated the world of ideas, they have reached this supreme state of equanimity that validates all doctrines while excluding any form of fanaticism? To be sure, a Germanic chieftain of the fourth century A.D. was better able to invade the Roman Empire than a Roman patrician was to defend it; but the erudite,

refined, inquisitive, and jaded Roman emperor Hadrian, the art-loving Caesar of Tivoli, represents a much richer treasure of human acquisitions.[14]

The great argument against decadence is that it knows no tomorrow and in the end is always destroyed by barbarity. But is it not the fate of the exquisite and the rare always to be in the wrong in the face of brutality? One is entitled to acknowledge this wrong and to prefer the defeat of decadent Athens to the triumph of violent Macedonia.

The same is true of the literatures of decadent periods. They too have no tomorrow. They lead to alterations of vocabulary, subtleties of meaning that make them unintelligible to the generations to come. Fifty years from now the style of the Goncourt brothers—I name men who have deliberately chosen the path of decadence—will be understood only by specialists.[15] The theoreticians of decadence would retort: what does it matter? Is the writer's purpose to set himself up as a perpetual candidate before the universal suffrage of centuries to come? We delight in our so-called corruptions of style as well as in the refined beings of our race and our time. It remains to determine whether the exceptional group we constitute is not, in fact, an aristocracy and whether in the realm of aesthetics the plurality of votes does not, in fact, add up to a plurality of dunces. It is as childish to believe in the writer's immortality—soon the memory of men will be so overloaded by the prodigious quantity of books that any notion of glory will necessarily be bankrupt—as it is deceitful to lack the courage to sustain one's intellectual pleasure. Let us take pleasure, therefore, in the peculiarities of our ideals and forms, even if they imprison us in a solitude unbroken by visitors. Those who will still come to us will really be our brothers, and why sacrifice to others what is most intimate, most special, and most personal in us?

Both alternatives [producing generations of the future and becoming virtuosi of voluptuousness and suffering] are legitimate, but rarely does an artist have the courage deliberately to choose the second. Baudelaire had it and pushed it to the point of foolhardiness. He proclaimed himself a decadent, and sought—one knows with what deliberate recklessness—all that in literature and art seems morbid and artificial to simpler souls. The sensations he prefers are those elicited by perfumes because they stimulate more than others this I-know-not-what of sensual sadness that we carry within us. His beloved season is the end of autumn, when a melancholic charm seems magically to fill a lowering sky and a heavy heart. His hours of delight are the evening hours, when the sky is as colorful as the background of a picture by da Vinci, with its nuances of a dying pink and a nearly fading green. The beauty of woman appeals to him only when it is precocious and almost macabre in its thinness, with the elegance of a skeleton under adolescent flesh, or else late in life, in the state of decline that comes with ravaged maturity:

... And your heart, bruised like a peach,
Is as ripe as your body for sophisticated love.[16]

Caressing and languid music, rare antiques for his furniture, and singular paintings are the necessary accompaniments to his dreary or happy thoughts, "morbid" or "petulant," as he himself puts it with greater appropriateness. His bedside reading is the work of exceptional authors . . . who, like Edgar [Allan] Poe, stretched their nervous mechanism to the point of hallucination, rhetoricians of a troubled life whose "language" is "laced with the green of decay."[17] He feels drawn by an invincible magnetism to the glow of what he has called, with justified outlandishness, "the phosphorescence of decay." At the same time, his intense disdain for the vulgar erupts in outrageous paradoxes, laborious mystifications. Those who have known him tell extraordinary anecdotes in regard to this last point. Legend aside, the evidence unquestionably points to this superior man's evincing something disquieting and enigmatic, even for intimate friends. He treated with similarly painful ironic contempt both the foolishness, naïveté, and nonsense of innocent acts and the stupidity of sins. A little of this irony still colors the most beautiful poems of *Flowers of Evil*, and the fear of many readers, even the most subtle among them, of becoming the victims of his overwhelming disdain prevents their fully admiring him.

Being what he is, notwithstanding the subtleties that put his works out of reach of the masses, Baudelaire remains one of the fertile educators of the rising generation. His influence is not as easily recognized as that of a Balzac or a Musset because it makes itself felt on a small group. But in this group are distinguished minds: poets of tomorrow, novelists already dreaming of glory, chroniclers still to come. Indirectly and through them, some of the psychological peculiarities I have tried to bring out in this text reach a broader public; and is not what we call the atmosphere of a period made out of such penetration?

The Art of Poetry (1874)

A onetime Parnassian and an early champion of decadence, Paul Verlaine (1844–1896) proudly accepted the leadership of the young "decadent" poets, having set up his Wednesday literary receptions around 1885–86.[18]

In 1883, a series of articles in the periodical *Lutèce,* he grouped under the title "poètes maudits" (accursed poets) critical biographies of avant-garde poets, followed by short anthologies of their works. The poets included Mallarmé, Rimbaud, and eventually Verlaine himself, and Verlaine traced their major innovations to Baudelaire. The series was a first attempt to classify the future symbolists.[19] Never repudiating the Parnassians, "among whom I am honored to have counted for something," as he put it in 1890, Verlaine had abandoned "momentarily . . . certain subjects, the historic and heroic ones, for instance," seeking primarily "sincerity, and, for this purpose, the impression of the moment rendered precisely."[20]

Verlaine's attitude resembles that of the post-impressionist artists, for they too, broadly speaking, repudiated the historical, mythological, and religious themes of the Parnassians for external reality. The post-impressionists nevertheless went far beyond what the poet calls "the impression of the moment"—the hallmark of impressionism—in expressing states of the soul; but then, so did Verlaine, even in what seem his most frivolous and sensuous poems![21]

The poem that follows, written in 1874, alludes to the principal points of Baudelairean aesthetics. Musicality is emphasized; indeed, "music come[s] first." But the poet must not merely be an abstract arranger of sounds, and if Verlaine wants to affiance "the flute to the horn," he also wants to link "dream to dream" and in so doing stress the importance of a play of associations. As for mystery, it is suggested by "the gray song," which probably alludes to twilight, although—and this is typical of Verlaine's raucous humor—*grise,* besides meaning "gray," is also the feminine of a colloquial word for "drunk." An element of mystery is also suggested by the stress on

nuance rather than color, and a deliberate vagueness in the use of words, "that joins the uncertain to the precise." The poet's idealism is conveyed by his rejection of cruelty, sarcasm, and raw vulgarity ("the murderous thrust/ Cruel wit and impure laughter") as well as by his disavowal of naturalism: "all this garlic of lowly cooking!" His stress on the life of the soul connotes subjectivity: the verse must "take wing / Like a departed soul that flees, one feels, / Toward other skies, other loves"—the ever-longing soul being Verlaine's own, in keeping with the dictates of subjectivity.

Finally, unlike the Parnassians and Baudelaire himself, all of whom attached great importance to precise versification, Verlaine advocated a certain freedom or, more specifically, a subordination of rhythm and rhyme to the requirements of musicality, heralding in this the post-impressionists' deliberate subordination of line and color to the requirements of harmonies and discords, on the one hand, and expressiveness, on the other—musicality, in other words. Even more important, the whole process of creation must have an element of randomness, as if to give free rein to the unconscious: "May your verse be a prophecy / Cast into the taut morning wind." Verlaine thus heralded the notion, held by Gourmont and twentieth-century theorists, poets, and artists, that an element of haphazardness could enrich poetic and artistic creativity.

The poem that follows is Paul Verlaine, "Art poétique," from *Jadis et naguère* (Paris: Messein, 1923), 23–24. It was originally published in *Paris-Moderne,* November 10, 1882. For an up-to-date annotated version, see *Verlaine: Œuvres poétique complètes,* ed. Yves-Gérard Le Dantec and Jacques Borel (Paris: Gallimard, 1992), 326; see also 1148. ✦

THE ART OF POETRY

Let music come first,
And for this I choose an odd meter,
Vaguer and more evanescent,
Weightless and unaffected.

And you must not
Select your words without some vagueness:
Nothing is more precious than the gray song
That joins the uncertain to the precise.

Such are beautiful eyes behind veils,
Such is the full trembling daylight at noon,
Such, in a warm fall sky, is
The blue confusion of bright stars!

For we still want nuance,
Not color, nothing but nuance!
Only nuance affiances
Dream to dream and the flute to the horn!

Flee far from the murderous thrust,
Cruel wit and impure laughter
That make the azure cry,
And all this garlic of lowly cooking!

Seize eloquence and wring its neck!
You will do well, while you are at it,
To make rhyme a little more orderly,
For if one does not watch, how far will it go?

Oh, who will tell what is wrong with rhyme?
What deaf child or mad Negro
Has molded this cheap jewel
That sounds hollow and false under a file?

Music, again and always!
May your verse take wing
Like a departed soul that flees, one feels,
Toward other skies, other loves.

May your verse be a prophecy
Cast into the taut morning wind
Scented with mint and thyme . . .
And all the rest is literature.

ART POÉTIQUE

De la musique avant toute chose,
Et pour cela préfére l'Impair
Plus vague et plus soluble dans l'air,
Sans rien en lui qui pèse ou qui pose.

Il faut aussi qu tu n'ailles point
Choisir tes mots sans quelque méprise:
Rien de plus cher que la chanson grise
Où l'Indécis au Précis se joint.

C'est des beaux yeux derrière des voiles,
C'est le grand jour tremblant de midi,
C'est, par un ciel d'automne attiédi,
Le bleu fouilli des claires étoiles!

Car nous voulons la Nuance encor,
Pas la couleur, rien que la nuance!
Oh! la nuance seule fiance
Le rêve au rêve et la flûte au cor!

Fuis du plus loin la Pointe assassine,
L'Esprit cruel et le Rire impur,
Qui font pleurer les yeux de l'Azur,
Et tout cet ail de basse cuisine!

Prends l'éloquence et tords-lui son cou!
Tu feras bien, en train d'énergie,
De rendre un peu la Rime assagie,
Si l'on n'y veille, elle ira jusqu'où?

O qui dira les torts de la Rime?
Quel enfant sourd, ou quel nègre fou
Nous a forgé ce bijou d'un sou
Qui sonne creux et faux sous la lime?

De la musique encore et toujours!
Que ton vers soit la chose envolée
Qu'on sent qui fuit d'une âme en allée
Vers d'autres cieux à d'autres amours.

Que ton vers soit la bonne aventure
Eparse au vent crispé du matin
Qui va fleurant la menthe et le thym . . .
Et tout le reste est littérature.

The Unsettling of All the Senses (1871)

In two letters to his former high school teacher Georges Izambard when he was seventeen years old, Rimbaud expressed, succinctly and directly, his newly evolved literary goals.[22] The letter that follows reveals striking similarities between Rimband's thought and that of Baudelaire—even some of the older poet's ideas that had not yet been published. The difference between the two poets' views is mostly one of emphasis: Baudelaire's acceptance of the irrational was but a point of departure for Rimbaud.

Indeed, for Arthur Rimbaud (1854–1891) the act of creation was not, as it was for Baudelaire, one of cultivating "[his] hysteria with delight and terror."[23] Hysteria was no longer sufficient in itself: Rimbaud wanted to "reach the unknown through the unsettling of *all the senses,*" to become a "seer," as he explains later in the text. In other words, not content to rely on a pathological state to stimulate his imagination, Rimbaud wanted to alter his overall perception of the universe so that he could become a visionary.

If a parallel exists between Rimbaud and the post-impressionists, it lies, first, in Rimbaud's striking abridgments and simplifications, which find their equivalents in the stylization of Seurat, Gauguin, van Gogh, and Cézanne, who, each in his own way, aggressively challenged the concepts of perceptual reality that had prevailed since the early Renaissance, and, second, in his rapidly changing imagery, which shocks and delights as it evolves from one sentence or clause to the next and, like the imagery of the post-impressionists, sparks the play of associations at the core of the whole symbolist movement.

Just as Baudelaire had praised Poe for discovering "the supernatural sensual delight man can experience at the sight of his own blood,"[24] Rimbaud asserted the need to experience *dédoublement,* to be at once participant and observer, as Poe had been for Baudelaire, and, ultimately, to have a "double nature."[25] Rimbaud thus exclaimed, "I is another [Je est un autre]."

The young poet's repudiation of Izambard's subjective poetry, which "will always be horribly mawkish," further confirms his acceptance of the principle of *dédoublement,* calling, no doubt, for an impassive Baudelairean probing of one's own depths.

Rimbaud's letter to his former high school teacher is quite arrogant, reflecting a new willingness to scoff at traditional norms and even to repudiate uncomprehending friends; it contrasts with one sent a few months earlier that expresses respect and affection for that same Izambard.[26] The tone both echoes an inner crisis and reflects the Baudelairean notion of the poet as a social outcast (Rimbaud had just read Baudelaire's works with passionate enthusiasm).[27]

The statement was written a few months before Rimbaud was called to Paris by Verlaine, to whom he had sent samples of his poetry; on Rimbaud's arrival there the two poets began a dramatic and often scandalous relationship. By 1875 Rimbaud had started the wanderings that took him through much of Europe and eventually to Java, Egypt, Cyprus, Aden, and Abyssinia, where he was involved in supplying arms to warring factions. He was hopelessly ill when he returned to France in 1891 and died shortly thereafter.

The letter that follows is from the version published in Georges Izambard, "Arthur Rimbaud pendant la Commune, une lettre inédite de lui-le voyant," *La Revue européenne,* October 10, 1928: 988–89. ❧

Charleville, May [13,] 1871.

Dear Sir!

So you are a teacher once again. One owes oneself to society, you once told me; you are a member of the teaching profession: you are rolling in the right rut. I too am behaving according to principle. I am cynically turning myself into a kept young man; I ferret out old fools from my high school years: all I can think of that is stupid, dirty, and wicked, in action as well as in speech, I dish out to them. I get paid in pints of beer and bottles of wine.[28] *Stat [sic] mater dolorosa, dum pendet filius* [The grieving Mother stood by the cross on which hung her Son].[29]

I do indeed owe myself to society—and I am right.

You too are right, for today.

When all is said and done, all your principle stands for is subjective poetry; the obstinacy with which you are returning to the academic feeding trough (sorry!) proves it. But you will always end up pleased with yourself for having done nothing, for never having wanted to do anything. Not to mention that your subjective poetry will always be horribly mawkish. One

day, I hope—many others do too—I shall make your principle stand for objective poetry; I shall handle it with greater sincerity than you would! I shall be a committed worker: it is the idea that holds me back when wild anger pushes me toward the battle of Paris—where so many committed workers are dying even as I write![30] Work now? Never, never; I am on strike.

At the present time, I steep myself in debauchery as thoroughly as I can. Why? I want to be a poet, and I am working toward becoming a seer; you will not understand me at all, and I am not sure I could quite explain. The point is to reach the unknown through the unsettling of *all the senses*. The suffering is terrible, but one must be strong; one must be born a poet, and I have recognized myself as being a poet. It is not at all my fault. It is wrong to say, I think: one should say, someone else conceives me in his thoughts. Forgive the pun.[31]

I is another. Too bad for the wood that happens to have become a violin,[32] and I scorn those unconscious ones who quibble over things they know nothing about!

For me, you are not a *member of academia*. I give you this [the text ends with the poem "Le coeur supplicié" (The tortured heart)[33]]: Is it satire, as you might call it? Is it poetry? It is fantasy, always. But I beg you not to underline with your pencil or, to an excessive degree, in your thought.

JULES HURET

Interview with Stéphane Mallarmé (1891)

The poet Mallarmé (1842–1898) had close contacts with the artistic world. He sustained a friendship with Manet from 1873 to the time of the artist's death, in 1883; during the last eleven years of his life, he counted Whistler among his closest friends. Two articles he wrote on Manet constitute incisive symbolist analyses of impressionism.[34]

Like Verlaine and Baudelaire, Mallarmé had been a Parnassian early in his literary career. During the 1860s he increasingly adopted a Baudelairean approach to poetry, eventually cultivating an even more variegated play of associations and, through his frequent use of ellipses and of ambiguous sentence structure, a more pervasive sense of the mystery of even everyday subjects.

Mallarmé almost banned the traditional use of myth—so highly valued by the Parnassians. "What!" he exclaimed on the subject of Wagner's achievements, "Has the century, or our country that exalts it, dissolved the myths in its philosophy only to make them anew?" He himself advocated preserving only myth that is not "fixed, or age-old and notorious, but unique, devoid of personality, for it makes up our multiple aspects." This was tantamount to saying that whatever myth the poet resorted to had to be treated abstractly to convey multiple states of the soul, rather than as a story in its own right. Indeed, distinguishing between a humdrum theatrical performance and one that magically set the spectator's imagination free, he likened the traditional handling of myth to the first, fettered by "a static set and a real actor." The effective playwright, he added in the same article on Wagner, should have spectators focus on what they imagine takes place before their eyes, rather than on physical objects and real events: "What does the spiritual fact [the essence of a poetic message]—the symbol that buds and blooms—require but an imaginary focus for the crowd's eye?"[35] Mallarmé did, in fact, allude to ancient myths in his poetry, but cryptically and always to enrich rather than to constitute central themes.

The journalist Jules Huret (1864–1915) interviewed Mallarmé in 1891. The interview was one of a series intended to gauge the significance of symbolism as perceived by men of letters and artists affiliated with a variety of schools. The text was corrected in proofs by the poet himself.[36]

The principal elements of Baudelairean aesthetics emerge in Mallarmé's answers. The praise of obscurity can be linked with Baudelaire's own advocacy of obscurity as well as mystery.

The "precious stones" that must be "created," rather than merely described, by drawing "from the soul of man states, glowing lights, of such absolute purity that, well sung and well lighted, they become the jewels of man" constitute "the symbol," recalling Baudelaire's search for expressiveness and harmony through musicality of line and color—the simile of the gems adding the notions of luminosity and of a multiplicity of effects.

The interplay of gems could also refer to the play of associations, a notion taken up more explicitly in Mallarmé's concept of individual objects. Indeed, linked as they are to "the images soaring from the reveries they have induced in one [which] constitute the song," such objects bring to mind Baudelaire's idea that "for Delacroix, nature is a vast dictionary," whose individual entries stimulate the artist's "memory, [which] speaks to one's own memory."[37]

Seen in this light, the "infinity of shattered melodies" stresses the new multiplicity of associations as well as the breakdown of traditional form one also finds in the works of the major post-impressionists.

Mallarmé went beyond Baudelaire in stressing the magic or sacredness of poetry. He refers to the "incantation" of unusual juxtapositions of sounds in the verse, as if to imply that the musical effects themselves can induce sublimation.[38] The idea seems to resemble the pursuit of ecstasy advocated by theoreticians of the aesthetic movement.

The excerpts that follow are from Jules Huret: *Enquête sur l'évolution littéraire* (Paris: Fasquelle, 1913), 55–65. The interviews first appeared in *L'Echo de Paris,* March 3–July 5, 1891. ✧

MALLARMÉ: We are currently witnessing . . . an extraordinary performance, unique in the history of poetry: each poet going into his own corner to play, on a flute very much his own, whatever tunes he wishes; for the first time poets do not sing by their music stands. Until now, of course, one needed the great organ of consecrated meter as an accompaniment. Well, one has played too much of it and gotten tired of it. I am quite certain that the great Hugo, when he died, was persuaded that he had buried poetry for a whole century; yet Verlaine had already written *Sagesse;*[39] one can forgive such

an illusion on the part of a man who had performed so many miracles, but he failed to take into account the eternal instinct, the perpetual and ineluctable lyrical thrust. Above all, [Hugo was] unaware of this incontrovertible notion: that in an unstable society, lacking unity, no stable and definitive art can be created. From this incomplete social organization, which explains in itself the disquiet of the human mind, an unexplained need for individuality arises, of which the present literary manifestations are a direct reflection. . . .

As I just told you, one reason present-day verse has developed is that we have all gotten tired of consecrated verse; even its proponents have experienced this lassitude. Is there not something abnormal in the certainty of discovering, when opening any book of poetry, uniform and agreed-upon rhythms from beginning to end, even though the avowed goal is to arouse our interest in the essential variety of human feelings! Where is inspiration? where the unforeseen? and how tiresome! Consecrated verse must be put to use only during moments of crisis of the soul. Present-day poets have properly understood this; with delicate restraint they have wandered around it, have approached it with a singular timidity—one might say with some apprehension—and, instead of seeing it as a principle and a point of departure, they have made it burst out suddenly as the climax of the poem or the sentence.

In music, the same transformation has occurred: the firmly delineated melodies of yesteryear have made way for an infinity of shattered melodies that enrich the fabric without making us feel the cadence as strongly. . . .

HURET: So much for form. What about content?

MALLARMÉ: I believe . . . that, as far as content is concerned, the younger generation is closer to poetic ideals than the Parnassians, who still, in the manner of the old philosophers and rhetoricians, treat their subjects directly. I believe, to the contrary, that there must only be allusion. The contemplation of objects, the images that soar from the reveries they have induced, constitute the song. The Parnassians, who take the object in its entirety and show it, lack mystery; they take away from readers the delicious joy that arises when they believe that their own minds are creating. *To name* an object is to suppress three-quarters of the enjoyment of the poem, which derives from the pleasure of step-by-step discovery; to *suggest,* that is the dream. It is the perfect use of this mystery that constitutes the symbol: to evoke an object little by little, so as to bring to light a state of the soul or, inversely, to choose an object and bring out of it a state of the soul through a series of unravelings.

HURET: We are approaching . . . an area that brings up a serious objection I intended to raise . . . Obscurity! [ellipsis after *raise* in original].

MALLARMÉ: That aspect, indeed, is equally dangerous . . . , whether the obscurity derives from the deficiencies of the reader or those of the poet. . . . But eluding this task [of deciphering the poem] is tantamount to cheating. Indeed, if a being of average intelligence and an insufficient literary preparation should by chance open a book written along these lines and pretend to enjoy it, there would have to be a misunderstanding. One must set things straight. There must always be enigma in poetry, and the goal of literature—there is no other—is *to evoke* objects. . . .

HURET: What do you think of the tail end of naturalism?

MALLARMÉ: The childishness of literature, up to now, has been to believe, for instance, that choosing a certain number of precious stones and writing down their names on a piece of paper, even very precisely, was *to make* precious stones. Well, no! Poetry being an act of *creation,* one must draw from the soul of man states, glowing lights, of such absolute purity that, well sung and well lighted, they become the jewels of man: that is what is meant by symbol; that is what is meant by creation, and the word *poetry* here finds its meaning: it is, in sum, the only possible human creation. And if, in truth, the precious stones with which one adorns oneself do not convey a state of the soul, one has no right to wear them. . . .

MAURICE MAETERLINCK

Small Talk—the Theater (1890)

Impressed by the Parnassian doctrine as early as 1887, then attracted by symbolist ideas, the Belgian poet Maurice Maeterlinck (1862–1949) wrote his first symbolist play, *La Princesse Maleine,* in 1889. It is reported that Mallarmé, who received a copy that year, made sure the work was reviewed by the novelist and influential critic Octave Mirbeau.[40] In a splendid eulogy in *Le Figaro,* August 24, 1890, Mirbeau called the young dramatist "a Belgian Shakespeare."[41] It is also reported that at Mallarmé's request Maeterlinck, during a stay in Paris in 1891, attended one of the Tuesdays, thereby starting a relationship that lasted until Mallarmé's death in 1898.[42]

The article from which the excerpts that follow are taken was published shortly after the first production of the play *L'Intruse* (The intruder) of 1890. Maeterlinck's dramas, whether they develop a mythical or legendary theme or have the trappings of meticulous realism, are invariably dedicated to the life of the soul. The action takes on the aspect of a mysterious rite, the characters seem impersonal, and the effect is gripping.

When the poet claimed that "we all know something we have not learned," and "we must pay attention only to what we cannot properly assess," he was referring to the workings of the unconscious, which, for the creative symbolist artist and poet, at any rate, was "whatever is best in us." What is more, much like the founding fathers of surrealism, Maeterlinck sensed an equivalence between the irrational aspects of the unconscious and the vagaries of the external world, referring to the first as "the secret gates of our instinct—one might say the gates of destiny."

Mallarmé's thoughts on Wagner's art—that "a static set and a real actor" can be impediments to evoking spiritual facts[43]—recurs, somewhat altered, in Maeterlinck's article where the actor's soul prevents full communion between the poet's soul and the hero's unless actors have learned to make themselves "creatures without destiny, whose identity would no longer erase that of the hero." The characters in his plays, one must add, are meant

to move and speak with such stylized simplicity and restraint as to become guides, leading us through the unfolding spiritual drama.

Maeterlinck's characters bring to mind Pater's description of the heroes of Provençal poetry: "Here, under this strange complex of conditions, as in some medicated air, exotic flowers of sentiment expand, among people of a remote and unaccustomed beauty, somnambulistic, frail, androgynous, the light almost shining through them, as the flame of a little taper shows through the Host."[44] In the realm of the plastic arts, such stylization parallels the archaizing simplifications of synthetism. Beyond that, Maeterlinck's wish to depersonalize the physical beings onstage so as to preserve the full mystery and complexity of the play of emotions is echoed in the strangely immobile, impersonal, and expressionless figures in so many post-impressionist works, from the strollers in Seurat's *Grande-Jatte* (see Fig. 29) to Gauguin's *Portrait of Marie Derrien* to Cézanne's *Portrait of Madame Cézanne*.[45]

Maeterlinck's friend Verhaeren notices a similar apparent dehumanization in the work of the Belgian painter Ensor; Verhaeren refers to figures in some of Ensor's works as "an eddy of thought in the tumultuous rush of cosmic powers."[46]

The excerpts that follow are from Maurice Maeterlinck, "Menus propos— le théâtre," *Jeune Belgique* (September 1890): 331–36. ❧

To Jules Destrée[47]

When we sit down in a theater before a performance, we feel anxious. This preliminary illusion can be compared to a warning coming from beyond us. We all know something we have not learned, and it may well be the only thing we know accurately, for all the rest is doubtful. We must pay attention only to what we cannot properly assess, for our ignorance here is stamped with the almost impalpable image of whatever is best in us. It is as if a hand that does not belong to us strikes, now and then, the secret gates of our instinct—one might say the gates of destiny, so close is the one to the other. One cannot open them, but one must listen cautiously. At the source of this disquiet may lie a very old misunderstanding, as a consequence of which the theater is never exactly what the crowd instinctively feels it is, namely, *the temple of dreams*. Admittedly the theater, at least in its tendencies, is an art; but I find there none of the characteristic traits of other arts; or rather, I find two traits, each of which seems to cancel out the other. Art always seems evasive and never speaks face-to-face. One might say it is the hypocrisy of the infinite. It is the temporary mask under which the faceless unknown intrigues us. It is the substance of eternity within us, introduced by

the distillation of the infinite. It is the honey of eternity extracted from a flower we do not see.

The poem is a work of art characterized by these oblique and admirable traits. But theatrical representation constitutes a contradiction. It causes the swans to fly from the pond; it throws the pearls back into the abyss. It puts things back exactly where they were before the poet arrived. The mystical density of the work of art has disappeared. The theater, unlike the poem, produces just about what would happen if you were to give substance to the subject matter of a painting and in doing so turn it into everyday life: If you transported its profound, silent, secret-laden characters into the midst of the glaciers, mountains, gardens, and archipelagoes where they appear to be, and if you yourself entered after them, an inexplicable light would suddenly be extinguished, and without the mystical delight you had previously experienced, you would suddenly find yourself in the situation of a blind man at sea.

And so one is compelled to recognize that most of the great poems of humanity are not fit for the stage. Lear, Hamlet, Othello, Macbeth, Anthony and Cleopatra cannot be represented, and it is dangerous to see them on the stage. Something of Hamlet died for us the day we saw him die onstage. . . .

The stage is where masterpieces die, because the presentation of a masterpiece by *accidental* and *human* means is a contradiction. All masterpieces are symbols, and the symbol never withstands the active presence of man. The forces of the symbol continuously diverge from those of the man who struggles with them. The symbol of the poem is a shining center, whose emanating rays spread out toward infinity, and these rays, if they start from absolute masterpieces like those we are discussing, have a range limited only by the power of the eye to follow them. But imagine the actor advancing to the very core of the symbol. Immediately an extraordinary polarization manifests itself in relation to the passivity of the poem. For the actor the rays no longer diverge but converge; the accident has destroyed the symbol, and the masterpiece has essentially died during this manifestation and its aftermath. . . .

One should perhaps eliminate the living being from the stage. It is not inconceivable that one would thus return to the art of distant centuries, whose last imprint may well be borne by the masks of Greek tragedians. Will the day come when sculpture—about which a number of strange questions are being raised—will be used onstage? Will the human being be replaced by a shadow? a reflection? a projection of symbolic forms, or a being who would appear to live without being alive? I do not know; but the absence of man seems essential to me. Whenever man penetrates a poem, the immense poem of his own presence snuffs out everything around him. Man

can speak only on his own behalf and has no right to speak on behalf of a multitude of dead people. A poem that I *see* being recited is always a lie; in ordinary life I must see the man who is talking to me, because most of his words have no meaning whatsoever independent of his presence; but a poem is an ensemble of words so extraordinary that the presence of the poet is forever chained to it; and it is simply not permissible that a soul, precious among all souls, should free itself from voluntary captivity only to assimilate to itself the trappings of another soul, which are almost always meaningless because they are unassimilable.

It is difficult to foresee how one might replace humans onstage with lifeless beings, but it seems that the strange impressions experienced in galleries of wax figures, for instance, could long since have led us to the traces of a dead art or a new art. We would then have onstage beings without a destiny, whose identity would no longer erase that of the hero. It also seems that any being apparently alive but deprived of life elicits extraordinary powers, and these powers may be exactly the same as those the poem calls for. Does the fear inspired by these beings, like us but visibly endowed with a dead soul, derive from their absolute lack of mystery? Does it derive from the absence of eternity about them? Is it the fear born precisely from the lack of fear that always surrounds a living being—a fear so inevitable, so usual, that its elimination frightens us, much as we would be frightened by a man without a shadow or an army without weapons?[48] Is it the look of our ordinary clothes on these bodies without a destiny? Are we terrified by the gestures and words of a being similar to us, but for one monstrous exception, because we know that these gestures and words reverberate nowhere and reveal nothing of eternity? Is it because they cannot die? I do not know; but the atmosphere of terror in which they move is the very atmosphere of the poem; in consequence, they are dead people who seem to talk to us, with august voices. It is possible, finally, that the soul of the poet, no longer finding the place destined to him occupied by a soul as powerful as his own—all souls having exactly the same strength—no longer objects to descending for a moment into a hero whose jealous soul no longer forbids it to enter.

TEODOR DE WYZEWA

Notes on Wagnerian Painting (1886)

Of Polish origin, the multilingual literary, artistic, and musical critic Teodor de Wyzewa (1862–1917) was a champion of comparative literature and criticism among the Parisian avant-garde. He was one of the principal collaborators in *La Revue wagnérienne* founded in 1885 by his friend Edouard Dujardin. Both men became regular visitors at Mallarmé's Tuesdays.

Wagner had based his aesthetics on the union of dance, music, and poetry, for, as he wrote in 1849, by their nature these cannot be separated

> without disbanding the stately minuet of Art; for in this dance, which is the very cadence of Art itself, they are so wondrously closely interlaced with one another, in fairest love and inclination, so mutually bound up in each other's life, in body and spirit: that each of the three partners, unlinked from the united chain and bereft thus of her own life and motion, can only carry on an artificially inbreathed and borrowed life; not giving forth her sacred ordinances, as in their trinity, but now receiving despotic rules from mechanical movement.[49]

The affinities between Wagner's approach to artistic activity and the Baudelairean notion of sensory correspondences must have struck the theoreticians of symbolism.

The text by Wyzewa that follows loosely elaborates on a passage by Wagner postulating a subjectivity shaped by the Schopenhauerian concept of will.[50] In it Wagner claims that fully embodying the aim in a work of art is tantamount to "emotionalizing the intellect."[51] For Wagner, the emotions were equally susceptible to sounds and sights. As for Wyzewa, he took an essentially Neoplatonist stand: "trees, animals, men" are "shadows," coming to life only when perceived by a "privileged soul." In keeping with the subjective approach typical of symbolism, he wrote that "the mind cannot get outside itself, and the things it imagines external to it are merely its own ideas." He did fully echo Wagner on the goal of art as "an aesthetic reconstitution" of "sensation, thought, and emotion."

It is ironic that Wyzewa advocated themes from everyday life when Wagner based his themes exclusively on myth. But then for the idealist Wyzewa, everyday life, like myth, becomes meaningful only when it embodies a "superior reality."

The excerpts that follow are from Teodor de Wyzewa, "Notes sur la peinture wagnérienne et le Salon de 1886," *La Revue wagnérienne* 2 (May 8, 1886): 100–113. ✦

Painting, as a form of art, must subordinate itself to the overall purpose of art.

Art, Wagner tells us, must create life. Why? Because it must voluntarily pursue the natural function of any activity of the mind. For it so happens that the world in which we live, and which we call real, is but a pure creation of our soul. The mind cannot get outside itself, and the things it imagines external to it are merely its own ideas. To see, to hear, is to create appearances within oneself, and this is tantamount to creating Life. But our deadly practice of repeating the same creations has led us to lose the joyful awareness of our creative power; we believed the dreams we brought into the world were real, like ourselves, limited by and captive to the things we had conceived. Henceforth we became the slaves of the world, and the sight of this world, in which we have staked our interests, has ceased to be a source of pleasure for us. And the life we had created so that it provide us with the joy of creation has lost its original character. We must therefore recreate this life: above this world of habitual, desecrated appearances we must build the holy world of a better life—better because we can create it out of our own free will, and be conscious of creating it. Such is the very task of art.

But where will the artist seek the elements of this superior life? He cannot take them from anywhere other than our lowliest life, what we call reality. This is because the artist, and those to whom he wants to communicate all the life he creates, cannot, because of their mental habits, erect a living work in their souls unless it presents itself to them under the very conditions that have determined their perception of all forms of life.

Thus the necessity for realism in art—not so much a realism transcribing, with no other goal, the vain appearances we believe real as an artistic realism extracting these very appearances from the false, materially oriented reality in which we perceive them and turning them into a superior reality that is not materially oriented. We see around us trees, animals, men, and we assume them to be alive; but when so perceived, these are but vain shadows in the ever-changing scene; they will come to life only when the artist, in

whose privileged soul they have a more intense reality, instills in them this superior life, re-creates them before us.

Therefore art must consciously re-create, by means of *signs,* the total life of the universe, that is to say the soul, in which the varied drama we call universe is played. But the life of our soul is composed of elements whose differing complexity produces special modes of life that, by the arbitrary limits of classification, can be reduced to the three distinct and successive modes of sensation, thought, and emotion. All three are really made up of a simple element common to them all: sensation.

In the beginning, our soul experiences sensations—phenomena causing pleasure or pain. These consist of the diverse colors, resistances, smells, or sonorities, all of which we believe are external qualities though all are inner states of the mind. At a later stage, our sensations become linked, and their number, through repetition, lessens. Groups form, abstracted from the initial set; words now give them permanence. The sensations become thoughts; the soul thinks after having felt. Finally, beneath the level of thoughts an even more refined mode comes into being: the sensations become enmeshed in dense breath; and there arises in the soul something akin to an immense flow, whose waves lose themselves in confusion. The sensations and thoughts thin out, multiply themselves so that they become imprecise in the overall flow. This is the stage of emotions, passionate anxiety, and feverish joy—supreme and rare states of the spirit; they are still a confused vortex of colors, sonorities, and ideas: and one is dazzled by this vertigo.

These three modes, sensation, thought, and emotion, constitute the whole life of our soul. As a result, art, the deliberate and disinterested re-creation of life, has always attempted—indeed, must attempt—an aesthetic reconstitution of these three vital modes.

[A brief history of the plastic arts follows.]

. . . Today these colors and lines, which belong to the technique of painting, can be applied to two very different modes, one sensory and descriptive that re-creates the exact appearance of objects, the other emotional and musical, which neglects the object these colors and these lines represent, utilizing them only as emotional signs, marrying them to one another with the sole purpose of producing within us, through their free play, an impression like that of a symphony.

JEAN MORÉAS
[IOANNES PAPADIAMANTOPOULOS]

A Literary Manifesto—Symbolism (1886)

Born in the Peloponnisos, Greece's southern peninsula, whose pre-independence name, Morea, he adopted, Jean Moréas (1856–1910) spent some time in Germany as a young man after a first visit to Paris. Upon returning to the French capital, he met Verlaine, in 1882, and Mallarmé, in 1883. His poems *Les Syrtes* (Quicksand), published in 1884, established his reputation among the avant-garde literary clubs. An article mocking new poetic trends by Paul Bourde led him to counterattack; he formulated a first, rather abstract, definition of these trends. After recognizing the impact of Baudelaire, he asserted: "The so-called decadents seek, first and foremost, the pure concept and the eternal symbol in their art."[52]

Moréas formulated "the fundamental principles of the new school" when asked to do so by the editor of the literary supplement of the conservative daily *Le Figaro*.

Some essentials of Baudelairean doctrine are readily recognizable.[53] In its allusion to a link between the spiritual and material, Moréas's notion of clothing "the Idea in a form perceptible to the senses," is but a consequence of the theory of correspondences. The play of associations has its equivalent in "the sumptuous trappings of external analogies," "bold and multiform trope," and other variants of the metaphor. The poet's insistence on a "rhyme of mysterious fluidity" and on rhythmic arrangements that vary from the classical to boldly new numerical divisions of verse can be associated with musicality. The endorsement of obscurity and ambiguity, furthermore, bears witness to the pursuit of mystery. Subjectivity is indirectly specified inasmuch as the idea is all-important, and "objective description" is henceforth banned.

In some ways, Moréas looked backward. When advocating "rhyme, glowing and hammered as a gold and bronze shield," he was harking back to the resonances of the Parnassians, and his advocacy of "primordial ideas" recalls that school's dedication to myth. His infatuation with classical rheto-

ric, from "suspended anacolutha" to the "bold and multiform trope," moreover, reveals a preference for the play of imagery in traditional poetry over the bolder, livelier, more fluid associative imagery in symbolist poetry, derived from Baudelaire and further developed by his more innovative contemporaries and successors.

From the standpoint of the plastic arts, Moréas's antiquarian enthusiasm for the style of such Renaissance writers as Villon and Rabelais and for that of the medieval Rutebeuf bears comparison with the contemporary interest in the art of the Middle Ages, the ancient Near East, and Japan that led to the development of synthetism.

Moréas parted company with the symbolist group to lead the poets dedicated to the classical traditions of L'Ecole Romane in the spring of 1891.[54]

Moréas's manifesto gave rise to heated polemics in the press.[55] The most penetrating criticism came from Remy de Gourmont, a writer who only rarely, and reluctantly, acknowledged being a symbolist and by far preferred to call the new trends idealism.[56] Gourmont nonetheless was to make important observations on the contribution of symbolism and to have a profound impact on future generations. He rightly implied that metaphor in itself was a venerable poetic tool and could not be regarded as an innovation. It is the formation of new metaphors and, generally speaking, associations, as well as the dissolution of associations that have become commonplaces that for him marked true poetic creativity.[57] Of Moréas, Gourmont said: "Symbolist theory, which is abstruse as far as I am concerned, is clear according to some. It has no mystery for Moréas; he knows that symbol means metaphor, and contents himself with that definition. He is a charming poet, but how strange to proclaim him head of a school!"[58]

The excerpts that follow are from Jean Moréas: "Le symbolisme," Supplément littéraire du *Figaro*, September 18, 1886, 150. ✦

An enemy of didactic pursuits, of "declamation, of false sensitivity, of objective description,"[59] symbolist poetry endeavors to clothe the Idea in a form perceptible to the senses that nevertheless does not constitute an ultimate goal in itself, but, while helping to convey the Idea, remains subordinate.

The Idea, in turn, must not allow itself to be deprived of the sumptuous trappings of external analogies; for the essential character of symbolic art is never to reach the Idea itself. Accordingly, in this art, the depictions of nature, the actions of human beings, all the concrete phenomena would not manifest themselves; these are but appearances perceptible to the senses destined to represent their esoteric affinities with primordial ideas.

The accusation of obscurity thrown at such an aesthetic by hurried readers cannot surprise us. But what can one do about it? Were not Pindar's *Odes of Victory,* Shakespeare's *Hamlet,* Dante's *Vita Nuova,* Goethe's *Faust,* part 2, and Flaubert's *Temptation of Saint Anthony* also attacked for their ambiguity?

To achieve an exact implementation of its synthesis, symbolism requires an archetypal and complex style: pure sounds, densely convoluted sentences alternating with gentler rhythms, significant redundancies, mysterious el-lipses, suspended anacolutha, any bold and multiform trope, and finally good language, restored and modernized—the good, luxuriant, and lively French from the days preceding Vaugelas and Boileau-Despréaux, the lan-guage of François Rabelais, of Villon, of Rutebeuf,[60] and of so many other writers who were free and took aim with the sharpest words, like the ar-chers of ancient Thrace with their waving arrows.

Rhythm: the ancient meter revived, a knowingly organized disorder; rhyme, glowing and hammered as a gold and bronze shield next to rhyme of mysterious fluidity; alexandrine verse with multiple and mobile caesuras; the use of certain prime numbers—seven, nine, eleven, thirteen—broken up into the various rhythmic combinations of which they are the sum.

4

THE POST-IMPRESSIONISTS

The works of most of the members of the group called post-impressionist were broadly and profoundly affected by the principles of symbolism.[1]

These artists accentuated musicality, subordinating the naturalist ideals of proportion and lighting to expressive effects of line and color, as well as to a concern for harmony, and sometimes discord. The artists most instrumental in this change, who labeled themselves synthetists or cloisonists, sought inspiration in Japanese art and medieval art, and Middle Eastern as well as Asian pottery, all of which stress intense uniform hues delimited by continuous lines. Others, most particularly Ensor in some of his pictures of the late 1880s and early 1890s, handled the multicolored brushstrokes of impressionism with a new arbitrariness and emotional intensity, creating artificial, dreamlike, deliberately discordant, and vibrantly expressive atmospheres from which struggling figures hauntingly emerge. Cézanne remained essentially faithful to both the technique and the themes of the impressionists, nevertheless stressing rhythmic effects in his brushwork and distortions of forms along semi-geometric patterns that infused his works with drama and spirituality.

Every one of these artists evokes complex, sometimes conflicting, often jarring associations—like those in the imagery of the boldest symbolist poets. Most post-impressionists rejected the mythical, religious, and legendary subjects of the romantic symbolists and returned to the scenes of everyday life of the naturalists, in many cases those favored by the impressionists.[2] When themes were developed in a series of related works, they revolved around similar or gradually changing situations—generally with diverse emotional and spiritual connotations.[3] Mythical or religious themes usually reappeared as distant allusions corroborating some of the essentially subjective message. All subjects acquired an aura of spirituality through stylization; often they seem intended to suggest a visionary or trancelike attitude, or at least a very intense daydream, on the part of the creator. It is

not out of place, finally, to recall, in connection with those subjects—the majority—drawn from everyday life, Baudelaire's awareness of the magic the inspired poet could infuse into them: "In certain supernatural states of the soul the profundity of life reveals itself in the sight before one's eyes, however ordinary it might be. The second becomes the symbol of the first."[4]

In the work of Seurat, stylized impressions of daily life, elegant and mildly caricatural, are the conduit for expressing subtle and complex states of the soul. In the words of his lifelong friend and fellow neo-impressionist Paul Signac, Seurat's impressions of Parisian lowlife are "the aesthetic representation of the pleasures of decadence."[5] According to the poet and critic Gustave Kahn, Seurat believed "that the most suggestive—most pictorial and artistic—way of seeking the symbol (without paying undue attention to that word) lay in the interpretation of a subject, not in the subject itself." Kahn pointed out the different and conflicting moods Seurat achieved by the evocative power of his figures and settings.[6] For Gauguin in his maturity the simplified, almost rustic, evocations of Breton peasants, Tahitian aborigines, and the objects of their daily lives carried religious, mythological, or sociological meaning—the artist becoming an "algebraist of ideas," as G.-Albert Aurier was to put it[7]—turning them into points of departure for complex, often quite dramatic, and always subjective meditations on his own fate and human destiny. For van Gogh, a simple café scene could suggest purpose and aimlessness, good and evil, hope and despair and could give rise to sweeping mental wanderings and, ultimately, the expression of innermost longings and fears.[8] Cézanne grappled with what he called "his strong sensation of nature," a struggle that had deeply personal connotations, for he linked it, as he put it, with "the means of expressing our emotions,"[9] which, to judge from the explicitly expressive content of his early work, are rich, powerful, and complex. He distrusted "the literary spirit," which "so often causes the painter to stray from his true path."[10] As a result, the emotions in his mature work are implicit, conveyed through the often dramatic handling of light, color, and line. Furthermore, he reaffirmed Baudelairean correspondences and musicality in his own terms when he wrote: "Art is a harmony parallel to that of nature."[11] Ensor, Munch, and Hodler, among others, began with a fugitive vision—sometimes more or less obviously allegorical—giving it permanence through their vigorous handling of line and color and developing around it plays of associations that are often complex and always express potent states of the soul.

The element of mystery persists. Figures seem to perform mute rites that are not immediately explicable. Gauguin intended that enigma stir the interest of the onlooker. The artist wrote to his wife from Tahiti about a canvas to be exhibited in Denmark: "Naturally, many of my pictures cannot be readily interpreted, and you will have the occasion for a little fun." He

went on to explain the work, adding: "This is a little text that will make you appear very learned to the critics when they bombard you with their malicious questions."[12] Van Gogh considered that "the painter [unlike the poet] never says anything; he holds his tongue, and I like that too"[13]—which in no way prevented him from making many, frequently veiled, sometimes explicit allusions to the contents of his pictures in his letters. Furthermore, he often added to the sense of mystery through incongruous juxtapositions of imagery: in a golden sunlit field an impressionist might have conceived, the artist associates "a reaper fighting like a devil to get to the end of his task" with "a figure of death."[14] The examples are numerous.

As in poetry, subjectivity is ever present. For Gauguin, artistic inspiration demanded a deeply personal empathy with the external world. He thus wrote to his wife as he was preparing to leave for Tahiti that he would hear there "the sweet murmuring music of my own heart moving in amorous harmony with the mysterious beings of my entourage."[15] Munch sought to determine all that his burdensome heredity, his alcoholism, and his misogyny contributed to the drama of his life and translated his findings into disquieting images that recur in his works and form the basis of five incomplete manuscripts of an autobiographical novel.[16]

Inevitably, the process of *dédoublement* is prevalent, manifesting itself in the dispassionate irony with which Seurat probed his experiences; the calm detachment with which Gauguin evoked the struggles of his own soul in peaceful Breton and South Seas motifs; the closely argued rhetoric by which van Gogh justified and explained in his letters the pictorial evocation of his passionate, sometimes supranatural, visions; and the outwardly benign and serene appearance Cézanne in his mature work gave the dramatic forces of nature and the human soul.

The artist scrutinized even the process of his own unique visual creation. Van Gogh thus went so far as to point to his own pathological visions as sources of visual metaphors. It is no surprise that the clouds in *Starry Night* form a yin-yang sign, age-old Chinese symbol of eternity.[17] "In a state of overexcitement," he once wrote his brother, "my own feelings lean . . . toward a preoccupation with eternity and eternal life."[18] Cézanne noted how his mode of observation became adapted to his analyses and syntheses of visual reality: "The eye becomes concentric through working and observing." He explained: "I meant that in an orange, an apple, a ball, a head there is a culminating point; and this point is always, despite the terrible effect—light, shadow, color sensations—the closest to our eye; the edges of the objects recede toward a center on our horizon line." By "terrible effect" he meant the awesome impact of the wealth of his own visual sensations in the presence of the motif: "Planes tumble on top of one another," he wrote over a year later, and presumably had to be put into some order.[19]

Cézanne's observation that only one point of a convex object is nearest

our eye is in keeping with Leonardo's in that, optically speaking, the eye is a point, and the rays of light joining it to an object have a pyramidal shape. Leonardo even mentioned that peripheral parts of an object appear smaller than central ones because they are further from the central axis of the pyramid and thus, one can infer, appear to recede.[20] The main difference between Cézanne and Leonardo is that Cézanne had evolved from an acceptance of traditional perspective, which assumes a fixed viewpoint, to the practice of changing his viewpoint as he worked on a motif. This flouted traditional perspective but enabled him to distort the volumes and corresponding surfaces of objects to create tense and vibrant arrangements of forms in space. To him, then, "concentric" seems to refer to the relationship between the mobile center of vision—the eye—and the "center," or closest point, of a convex object.

Neo-Impressionism (1887)

At the eighth and last group exhibition of the impressionists, in May 1886, a robust and original offshoot of that movement, neo-impressionism, first manifested itself to the public. Aside from Camille Pissarro, an early adherent of impressionism, and his son Lucien, the artists composing the new group were Georges Seurat, Paul Signac, and Albert Dubois-Pillet. Others sharing their views would join them in later exhibitions.

Félix Fénéon (1861–1944), an employee of the War Ministry and a journalist, was associated with Edouard Dujardin in managing *La Revue indépendante* and was a regular contributor to *La Vogue*. After 1897 he was the senior editor of yet another avant-garde periodical, *La Revue blanche*. He had shown much appreciation for the symbolist writers and had been a regular visitor at Mallarmé's since 1885.[21]

In his artistic and literary criticism Fénéon analyzed as objectively as possible the technical character of the work under discussion and outlined the aesthetic principles of its author. Often he asked the artists or writers whose work he discussed to correct factual inaccuracies in his critical studies, thus turning what he wrote into a significant historical source.

In 1884, at the first Salon de la Société des Artistes Indépendants, he had noticed Seurat's *Bathers at Asnières,* which announced the new school through its stylization, its regular crisscross strokes alternating with traditionally glazed areas,[22] and a methodical approach to the division of color (an area of a given color was broken into smaller patches of purer hues intended to recombine on the viewer's retina into a version of the original color but with heightened luminosity). These elements contrasted with the impressionists' sweeping, curved brushstrokes and their more intuitive division of color.

Fénéon's friendship with Seurat and Signac dates from the final impressionist exhibition,[23] where he saw Seurat's *Sunday Afternoon on the Island of La Grande-Jatte* (Fig. 29). On that occasion he wrote "Les Impression-

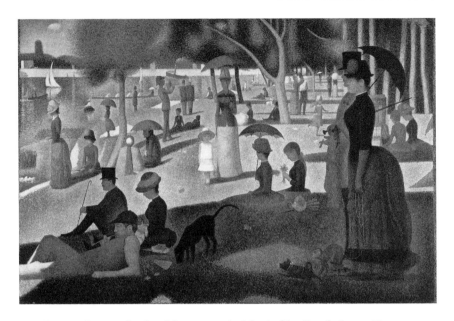

29. Georges Seurat, *Sunday Afternoon on the Island of La Grande-Jatte*, 1884–86. Oil on canvas. 207.6 × 308 cm. The Art Institute of Chicago, Helen Birch Bartlett Memorial Collection, 1926.224. Photo copyright 1992, The Art Institute of Chicago. All rights reserved.

To synthetize the landscape into a definitive aspect that perpetuates one's sensation of it, that is the task the neo-impressionists have set for themselves.

FÉNÉON

nistes en 1886," giving a detailed analysis of Seurat's division of color. Seurat, familiar with recent work on experimental optics, employed what Fénéon called a system of small spots.[24] Not Seurat but Pissarro, however, seems to have been the first to execute a picture completely in the new technique.[25] In the *Grande-Jatte* Seurat used mostly crisscross strokes for the grass, and multicolored near-parallel lines for the garments, animal figures, and the water, as well as some glazing (Signac, for his part, was using similar techniques); only in completing the work did he employ the dot technique, and further dots were added years after the original completion.[26]

Fénéon also stressed in the article of 1886 the archaizing stylization of the composition—he referred to it as "hieratic and summary"[27]—which he considered fundamental to the process of synthesis. In so doing he unwittingly acknowledged the stylistic simplifications derived from pre-Renaissance traditions, including Eastern ones, heralded by Owen Jones as early as 1851, as well as the "inevitable, synthetic, childlike barbarity" adumbrated by

Baudelaire in 1863, which was given a new impetus by the growing enthusiasm for the bold simplifications of line and color of Japanese art.[28] Puvis de Chavanne's linear simplifications, which Gautier called synthetic, must also be acknowledged, although they derived from Renaissance styles, because Seurat in his student days was a friend of Edmond Aman-Jean, who had assisted Puvis.[29] Fénéon himself referred to Seurat as "a modernizing Puvis."[30] He stresses a similar point in the text that follows when he observes in connection with the *Grande-Jatte:* "To synthesize the landscape into a definitive aspect that perpetuates one's sensation of it, that is the task the neo-impressionists have set for themselves." Fénéon's parallel, moreover, implies a link between the self-absorption of Seurat's figures and the somnambulism of Puvis's.

Beyond stylistic synthesis, Fénéon perceived in neo-impressionist work an idealist vision of the universe—"a superior sublimated reality in which their [the artists'] personality transfuses itself"—in keeping with the Neoplatonist bent already noticed in connection with romantic symbolism and the theories of literary symbolism. This vision significantly affected other symbolist art critics.

Fénéon referred to the new movement for the first time as neo-impressionism in 1886, thereby unofficially baptizing it.[31] In an article later that year for the Brussels journal *L'Art moderne* on the annual juryless Salon de la Société des Artistes Indépendants, in which artists of the new group participated, Fénéon associated the neo-impressionists' combined simplification of surface and systematic application of color with a stress on harmony—thus a concern for musicality: "From each colored surface emerge colorations, energized in various degrees, that diminish in intensity as they spread, and the picture acquires unity, synthetizing into a harmonic general sensation."[32]

Fénéon barely touched on two important elements of neo-impressionist composition, and then only later. The first is the geometric system that for several artists loosely determined composition. Fénéon referred to it when he noted, again in *L'Art moderne,* in 1888, that the colors of three different-colored objects in Seurat's *Models* of that year show the same relation as the corresponding hues on the color circle of Charles Henry.[33] The second element is the elegant undulations of Japanese design that affected the linear patterns of the principal neo-impressionists.[34]

On the occasion of the third Salon de la Société des Artistes Indépendants in 1887, in which the neo-impressionists were well represented, Fénéon contributed the article that follows to *L'Art moderne.* The Vingtistes to whom he refers are the participants in the annual Brussels avant-garde exhibitions Les XX. Ensor, Khnopff, and van de Velde were regular participants. Whistler, Rodin, Monet, and eventually Gauguin, van Gogh, Cé-

zanne, Pissarro, Seurat, and Signac, among others, were all at some time or other invited as foreign guests.

In addition to stressing the significance of the synthetist approach to design, Fénéon enumerates in his article the principles determining the division of color developed intuitively by the impressionists and systematized by Seurat and the neo-impressionists. As Signac later confirmed in his *De Delacroix au néo-impressionisme,* serialized in *La Revue blanche* in 1898 and published in book form in 1899, these principles derived largely from the technique of Delacroix. In the preference for pure hues juxtaposed on the canvas and the knowledge that any hue appears to be surrounded by a halo of its complementary Fénéon and the neo-impressionists were indebted to the work of the chemist Michel-Eugène Chevreul.

The excerpts that follow are from Félix Fénéon, "Le Néo-impressionnisme," *L'Art moderne* (Brussels), May 1, 1887, 138–39. ❧

A gallery of the third exhibition of the Société des Artistes Indépendants (in the Pavilion of the City of Paris) is dedicated to some fifty impressionist paintings. Among those whose signatures appear on the canvases are Georges Seurat, Paul Signac, Albert Dubois-Pillet, Lucien Pissarro, and Charles Angrand.[35] I will try to define, more fully than I did in 1886, the significance of the reform they and their older colleague Camille Pissarro attempted. The Brussels reader will kindly remember the canvases by Camille Pissarro and Georges Seurat at the last Salon of the Vingtistes.

I

Already incipient in Turner and Delacroix (Chapel of the Angels at Saint-Sulpice, etc.), impressionism began to evolve into a system with Edouard Manet, Camille Pissarro, Auguste Renoir, Claude Monet, Alfred Sisley, Paul Cézanne, and Ludovic Piette. These painters distinguished themselves by their extraordinary sensitivity to the reactions of colors, a tendency to the decomposition of hues, and an effort to suffuse their compositions with intense luminosities. As far as subjects went, they eliminated history, the anecdote, and the dream; as regards technique, they advocated a rapid and direct execution in the presence of nature.

If the word *impressionism* is to retain a reasonably definite meaning, one must use it only to label the work of the luminists. Mary Cassatt, Degas, Forain, and Raffaelli, whom a misguided public placed in the same category as Claude Monet and Camille Pissarro, must therefore be eliminated, even though they all sought a sincere expression of modern life, despised academic practices, and exhibited jointly [with the luminists].

One remembers the first impressionist exhibitions. Surrounded by the definitive canvases, as well as the fierce medleys of color, the public gave free rein to its inveterate stupidity. That a color could call forth its complementary—for ultramarine, yellow; for red, blue-green—seemed insane. And even if physicists had issued authoritative assurances that darkening all the hues of the spectrum is ultimately equivalent to adding increasingly large amounts of violet light, the public would nevertheless have bucked at the purplish shadows of a painted landscape. Accustomed as it is to the bituminous sauces concocted by the kitchen chefs of the art schools and academies, the public responds to high-value colors as it would to a punch in the stomach.[36] Let us admit, however, that it was sometimes aroused by a touch of revolutionary prurience, as when it visited those kindly prostitutes de Nittis, Roll, Carrier-Belleuse, Dagnan-Bouveret, Goeneutte, Gilbert, Béraud, Duez, Gervex, and Bastien-Lepage—and great orgies of modernity ensued.[37]

As for technique, nothing very specific yet: the works of the impressionists had the look of improvisation: their overall effect was summary, brutal, and approximate.

II

Since 1885, instigated by Georges Seurat, impressionism has disposed of a rigorous technique. Already implicit in the work of Camille Pissarro, Seurat's innovation is based on the division of hue.[38] Here is what this means: instead of mixing pastes on the palette to produce more or less accurately the color of the surface to be rendered, the painter applies on the canvas brushstrokes denoting the local color, that is, the color the surface would have in white light—in effect the color of the objects seen from very close range. This color, which has not been chromatically attuned on the palette, he attunes on the canvas according to the law of simultaneous contrast by another series of strokes.[39] These correspond to

1. The portion of colored light reflected without being altered by the surface (this is usually sunlight orange);
2. A weak portion of the colored light that penetrates the surface and is reflected after being modified through partial absorption;[40]
3. The reflections projected by neighboring bodies;
4. The complementaries of ambient colors.[41]

The individual brushstrokes are the outcome, not of swift dashes of the brush, but of the application of minute dots.

The following are some of the attributes of this manner of proceeding:

1. These individual brushstrokes combine on the retina in an optical mixture. It so happens that the luminous intensity of the optical mixture is much higher than that obtainable through the [physical] mixture of pigments. That is what modern physicists maintain when they say that any mixture on the palette is but one step toward the creation of black.

2. The numerical proportion of colored spots on a given area can be varied indefinitely. As a result, the most delicate modeling transitions, the most subtle gradations of hues can be accurately rendered.

3. This play of spots on the canvas requires no manual dexterity, but only—oh! only—a trained artistic vision.

III

The look of sky, water, greenery varies from moment to moment, as pointed out by the first impressionists. The primary goal is to capture some of these fugitive appearances on the canvas. Hence the necessity of completing a landscape in a single sitting and of causing nature to make faces so as to establish beyond doubt that it was caught in a unique moment never to be recaptured.

To synthetize the landscape into a definitive aspect that perpetuates one's sensation of it, that is the task the neo-impressionists have set for themselves. (Aside from that their execution does not tolerate haste and requires that work be done in the studio.)

In their scenes with figures, the same distancing from the accidental and the transitory is evident. As a result, critics enamored of anecdote whine: we are shown mannequins, not men. These critics are not tired of the Bulgar who seems to ask: Guess what I am thinking! They are not distressed when seeing on their walls the gentleman whose sarcasm has achieved eternal status in a wily wink, or some long-aborning flash.

The same critics, always perspicacious, compare neo-impressionist paintings to tapestry and mosaic and issue their edicts of condemnation. Even if their argument were valid, it would have little merit. But it is illusory: two steps backward are enough for the variously colored spots to melt into one another, creating undulating luminous masses. All traces of the execution process, one might say, disappear, and the eye is attracted by nothing other than what is essentially the painting.

Is there any need to point out that this uniform, almost abstract, execution does not encroach on the artist's originality and even heightens it? Indeed, to confuse Camille Pissarro, Dubois-Pillet, Signac, Seurat . . . would be silly [Fénéon's ellipsis]. Each of them imperiously stresses his disparity, if only through his own interpretation of the emotional meaning of colors and the degree of sensitivity of his optical nerves to this or that stimulus, but never through a monopoly of deft studio tricks.

Amid the swarms of mechanical copyists of externals, these four or five artists impose [on the public] the very sensation of life: that is because objective reality, for them, is but a theme serving as a base for creating a superior sublimated reality into which their personality transfuses itself.

Frame-making: the beginning of the abandonment of the strictly white frame [advocated by the impressionists] becomes noticeable. This summer, neo-impressionism will wear broad oak frames with a white inner border a few centimeters wide. Those of Albert Dubois-Pillet are adorned with astragals [narrow moldings]. Those of Charles Angrand are dull gold. All remain rectangular, even though it would seem more equitable to circumscribe a landscape in an oval or a circle.

GEORGES SEURAT

Aesthetic and Technical Note (1890)

An article of 1890 by Jules Christophe gives a somewhat edited version of a short theoretical text by Seurat (1859–1891).[42] Irritated by the changes, and intent on correcting them, Seurat drafted the passage that follows in a letter to another journalist, Maurice Beaubourg, but he may never have sent it.[43]

Seurat does not mention the theory of the division of color, presumably because it had been fully divulged earlier. He insists instead on the rules underlying his pursuit of harmony and expression through line and color—musicality, in other words. These rules, applied with great subtlety, were the basis for his most important compositions, starting with *Les Poseuses,* or *The Models,* of 1886–88. The text was written on the occasion of the first exhibition of *Le Chahut* (see Fig. 30) at the Salon de la Société des Artistes Indépendants of 1890, which Christophe called a triumph.

Seurat makes no mention of the arithmetic involved in applying the rules in his own compositions. Indeed, the system explained in this letter is only a simplified, somewhat modified version of the formulations of his friend Charles Henry (summarized in the next section of this chapter), as well as those of other theoreticians. William Homer has pointed out that Seurat had combined Humbert de Superville's notion of the expressiveness of directions with a modified version of Charles Henry's theory of the expressiveness of hues.[44]

Seurat's basic distinction between harmonies based on analogy (i.e., the repetition of similar elements and gradations) and those based on opposition, while compatible with Henry's theories, was, as Homer has pointed out, based on a formulation made some fifty years earlier by Chevreul.[45]

Seurat's last paragraph is particularly terse. In some of his pictures, the frame (or a strip of paint around the picture serving as one) is curved along one side so as to oppose the directions of the dominant lines, as shown in his diagram. In the earliest painted strips he also attempted to apply hues and values that were mostly complementary to neighboring ones on the

canvas. In later ones, as well as on whole frames, a dominant low-value blue was intended to contrast with the orangy yellow of the lighting in the picture. Most earlier strips were eventually covered over with the later type.

The text that follows (along with Seurat's diagrams) is from the facsimile of the draft in Robert Rey, *La Renaissance du sentiment classique dans la peinture française à la fin du XIX^e siècle* (Paris: Beaux-Arts, 1931), opposite p. 132. Punctuation has been added. ✦

Aesthetics

Art is Harmony. Harmony is the analogy of opposites and the analogy of similar entities, of value, hue, and line.[46]

The opposites are

for *value*, one more $\begin{bmatrix} \text{luminous} \\ \text{light} \end{bmatrix}$ as against a darker one;

for *hue*, the complementaries

$\begin{bmatrix} \text{red–green}^{47} \\ \text{orange–blue} \\ \text{yellow–violet} \end{bmatrix}$

for *line*, those at right angles to each other.

Gaiety is the luminous dominant for *value;* the warm dominant for *hue;* those lines above the horizontal for *line.*

Calmness is [determined by] the equality of dark and light for *value;* of warm and cool for *hue;* and [by] the horizontal for *line.*

Sadness is [determined by] the dark dominant for *value;* the cool dominant for *hue;* [and by] downward directions for *line.*

Technique

The retina's retention of a luminous impression over a certain length of time results in a synthesis [of color stimuli]. The means of expression is the optical mixture of the values and the hues (local ones and those of the light,

sun, oil lamp, gas, etc.)—that is, of the lights and their reactions (shadows), according to the laws of contrast, gradation, and irradiation.[48]

The harmony of the frame opposes that of the values, hues, and lines of the painting.[49]

CHARLES HENRY

Introduction to a Scientific Aesthetics
(1885)

The mathematician-physiologist-psychologist Charles Henry (1859–1926) drew from a variety of sources the elements he synthetized in a number-based aesthetics applicable to line and color as well as sound, perfume, and, more tentatively, metaphor—the last indicating the importance symbolist circles attached to the play of associations.

Henry's point of departure is a letter of January 3, 1850, from the mathematician Hoene-Wroński—who was also a mystic preaching universal harmony, based on a numerical series—to Count Camille Durutte, who was investigating the application of a similar mathematical theory to musical harmony.[50]

Wroński's numerical series was that established by the astronomer and physicist Carl Friedrich Gauss to determine which polygons, or divisions of a circle, could be established geometrically, that is, by dividers and a set square, rather than arithmetically—the latter task being beyond the capacity of many craftsmen of the day.

Henry postulated that the divisions of the circle according to the Gauss and Wroński series determine directions that are harmonious with one another, while similarly divided dimensions constitute harmonious proportions. Likewise, hues picked along divisions of the color circle according to the Gauss and Wroński series are also harmonious.[51]

In addition, Henry considered the golden section ratio (the irrational, or unending, decimal .618 . . .), first used by the ancient Egyptians and Greeks, particularly harmonious (the ratio is such that when it divides a length into two segments, the smaller segment divided by the larger is equal to the larger divided by the whole, or, algebraically, if a is the small segment, and b the large, $a/b = b/a + b$, as indicated in Henry's text). There is incontrovertible evidence that Seurat took these rules into account in the design of grids underlying his compositions in *Parade de cirque* (Circus parade) of 1887–88 and later pictures.[52]

Seurat modified Henry's postulate concerning the expressive value of directions. For Henry, directions from bottom to top and left to right (the upper right quadrant of a circle) are uplifting, and those from top to bottom and right to left (the lower left quadrant of a circle) are depressing. Seurat, relying on D. P. G. Humbert de Superville's book of 1827–32,[53] asserted in the letter to Beaubourg summing up his own theories that rising lines (forming a V) are gay, and descending ones (inverted V), sad. Seurat's statement that warm hues are gay, and cool hues sad corresponds roughly with Henry's thought about the expressive value of directions: if the color circle is placed so that red is at the top, the upper right quadrant is, in fact, filled with warm hues, and the lower left with cool. But cool hues penetrate into the other two quadrants, thus introducing another discrepancy between the views of theoretician and artist.[54]

Henry's theories were referred to in the press as early as 1879,[55] and the work excerpted here was announced in 1884 in *La Revue indépendante,* in whose management Fénéon was actively involved.[56]

"Introduction to a Scientific Aesthetics" contains, in the form of hypotheses, most of the aesthetic theories Henry was to develop, with increasing assertiveness, in a series of volumes. Seurat must have become familiar with Henry's views, and in all likelihood met him, in 1885 or 1886, because Fénéon linked Seurat's arrangement of lines and colors to Henry's theories in discussing *Les Poseuses* (The models), which Seurat began in 1886.[57]

Henry's aesthetico-physiological experiments on patients (who happened to be insane), who were made to pull weighted ropes in various directions under diversely colored lights,[58] do not necessarily contribute to the plausibility of his postulations. Nevertheless, however questionable the validity of Henry's scientific aesthetics, it did contribute to Seurat's and, for a time, Signac's reliance on geometric and numerical systems for their compositions. This reliance, in turn, led these artists to attach a new importance to formal surface composition. Moreover, Henry's formulations constitute a major attempt to systematize the two components of musicality: the harmony (or discord) and the expressiveness achieved through line and color in painting, which are assumed to correspond to rhythm and notes in music.

The excerpts that follow are from Charles Henry, "Introduction à une esthétique scientifique," *La Revue contemporaine* 2 (August 1885): 441–69. An explanatory text precedes each passage. Ellipses are in the original text except where noted. ❧

[Henry postulates that any problem pertaining to the aesthetics of forms can be reduced to the study of directions and therefore translated into quantitative terms.]

It is evident that the problem of the aesthetics of forms comes down to this question: Which are the most pleasing lines? But a little reflection soon proves to us that line is an abstraction: it is the synthesis of the two opposing directions that describe it: reality lies in the [element] of direction. I see no circles; I only see circles described in one direction or another—what is called *cycles*. The problem can therefore be reduced to the following statement: which are the pleasing directions? which the disagreeable? In other words, which directions do we associate with pleasure and which with pain?

[Our very emotions can be associated with specific directions; pleasure and pain can be associated with specific directions.]

It is hardly necessary to mention the *downcast, prostrate, concentrated* attitudes linked to pain and the *active, exultant, radiant* attitudes linked to pleasure.

In sum, the direction from bottom to top corresponds to the experience of pleasure; it happens to be the direction that characterizes the energy available to us, the energy the theory of heat mechanics calls *energy of position.* The direction from top to bottom corresponds to pain; this direction also characterizes energy that has lost any usefulness, called *degraded energy.*

Two additional directions must be significant: that from left to right and that from right to left: their expressiveness is less general than the previous ones, but the first is mostly pleasant: this is why we tend to place to our right those whom we want to honor and to see.

[Henry attempts to quantify the concept of harmony in line with Wroński's adoption of Gauss's series for the postulation of rules of universal harmony.]

Up to now we have considered directions. Let us now study changes in directions. Any change in direction is an angle: it so happens that any angle can be measured in terms of the arc of a circle intercepted by its sides, the center of the circle being the apex of the angle. The question therefore comes down to determining the divisions of the circumference that are pleasing and taking advantage of such divisions for the construction of regular polygons. It so happens (and I solicit the full attention of the non-mathematician among the readers) that we can construct *geometrically*[59] the regular polygons of 4, 8, 16, 32, . . . or of 2^n sides; of 3, 6, 12, 24, or 3.2^n sides; of 5, 10, 20, 40, . . . or 5.2^n sides; of 15, 30, 60, 120, . . . or $3.5.2^n$ sides; of 17, 34, 51, 68, 85, . . . or $3.5.17.2^n$ sides; etc.—in general the regular polygons the number of whose sides is 2, or a power of 2, or a prime number in the form of $2^n + 1$, or a product of a power of 2 by one or more prime numbers of that form. But we cannot construct any other *geometrically:* all changes in direction that would determine on the circumference a number of sections that are not of this form would therefore be absurd, as would any identification of different quantities. I shall prove that Gauss,

when he established this magnificent theory, simultaneously founded the science of rhythm and, indirectly, of measure.[60]

[He defines the golden section as being a particularly pleasing proportion.]

A proportion that is even more pleasing than a ratio is the equality of ratios, two, three, and so forth—that is, a simple or continuous proportion. Four terms are required for a simple proportion, $(a/b = c/d)$; but when the eye, which always proceeds by additions and subtractions, can reduce these four terms to three, or to two, much more pleasing proportions are obtained: in the first case it encounters the proportion so aptly named by the Greeks *harmonic:* $(a/c = a-b/b-c)$. . . [ellipsis added]; in the second, Paccioli's divine proportion: $(a/b = b/a+b)$.[61] The Germans call the latter *golden section,* which is nothing less than the philosophical definition of harmony.

[Henry then associates hues and emotions.]

That hues should have precise expressive values, no one has ever contested: they have even been linked to the most complicated ideas: hope to green, faith to blue, and so forth. Our task is obviously to establish their simplest expression. Red, orange, yellow are gay hues; green, blue, violet, sad ones. With the first we associate light, with the second, darkness. That many people prefer the second is but a proof of these people's melancholy. The order in which we enumerated the hues is the order in which their wavelengths decrease: hues being correlated to space, it is understandable that one should prefer, up to a point, the longest wavelengths. Sounds, in contrast, being correlated to time, we prefer, up to a point, the smallest vibrations (high notes) because they occur in greater number within a unit of time.[62]

[And he associates hues and directions.]

[In a color circle] red and the direction from bottom to top being very pleasant, we place on the vertical radius perpendicular to the horizontal diameter a red that grows in intensity from the center up. Yellow and the direction from left to right being pleasant, we place yellow on the radius forming a right angle [clockwise] with the first. The directions from top to bottom and from right to left being sad, we place blue on the following radii, 90 degrees away. We naturally place orange between red and yellow; green, between yellow and blue; violet, between blue and red. Between these reference points are the various gradations from one to the other. We thus obtain, rationally placed on the circumference, all the hues, on the radii all the values (containing a proportion of white). The lower values

will be provided by other circles on which quantities of black have been mixed. . . .[63]

As a general rule, all other conditions being satisfied, contrasts between colors separated on the rational color circle by a section of the circumference expressed by a number in the form 2^n, or a prime number $2^n + 1$, or their product, are pleasing.

[The above postulates could be applied to metaphor and, one gathers, to the symbolist play of associations in general; but even the daring Henry stops short of providing a mathematical formula.]

In the written or spoken language, a metaphor is nothing other than the awareness of the relationship between two more or less similar changes in direction: the more subtle and profound the changes are, the more complex the formula, the more beautiful the metaphor. Metaphors such as "the thirsty hounds of wandering desire," or "the profoundly deserted plains of boredom," "you are a beautiful clear pink autumnal sky," "my desires depart in a caravan" ([Baudelaire's] *Flowers of Evil*) will doubtless be eternally beautiful, and science, by studying the changes of direction associated with them will characterize their rhythm, confirming anew the genius of the poet.[64]

GUSTAVE KAHN

Seurat (1891)

When still studying Asian languages in Paris and while enrolled at the prestigious Ecole des Chartes, an institution of higher learning that trains archivists and paleographers, Gustave Kahn (1859–1936) contributed to avant-garde periodicals of the presymbolist period such as *Les Hydropathes,* sponsored by the literary club of that name. He founded *La Vogue* in 1886, and later managed *Le Symboliste* and *La Revue indépendante*—all three in the forefront of the symbolist movement. He also made a mark as an innovator in the development of free verse with his sensitive and lyrical *Palais nomades* (Nomadic palaces), of 1887. A regular at Mallarmé's Tuesdays, he was also among the first serious historians of literary symbolism, having written his *Symbolistes et décadents* in 1902.

Fénéon, a close friend and collaborator of Kahn's, undoubtedly drew him to the neo-impressionist artists. Kahn wrote perceptively about their endeavors, his most important and informative article being the one excerpted here—an obituary of Seurat, who had died on March 29, 1891.

In it Kahn covers several aspects of Seurat's technique and insists on the importance scientific theory had had for him, even quoting the following statement of Seurat's (not reproduced below) that he had written down or remembered: "Since I did discover scientifically, thanks to my artistic experience, the laws of pictorial coloration [des couleurs picturales], can I not discover an equally logical, scientific, and pictorial system that would enable me to make the concurrence of lines tend toward harmony, as I have succeeded in having the colors concur?"

The text that follows implies Seurat's awareness of both the associative value of the objects he depicted and the potential of such associations to be complex to the point of creating strong oppositions. His contention that the symbol should be sought "in the interpretation of a subject, not in the subject itself" is in no way surprising; did not Moréas maintain that while symbolist poetry clothes "the Idea in a form perceptible to the senses," its essential characteristic was "never to reach the Idea itself?"[65]

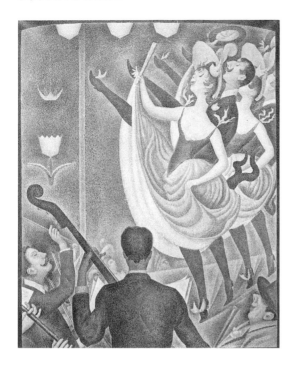

30. Georges Seurat, *Le Chahut*, 1889–90. Oil on canvas, 169 × 139 cm. Photo copyright Rijksmuseum Kröller-Müller, Otterlo, Netherlands.

And for the synthesis of the public, one has only to look at that remarkable pighead of a spectator. KAHN

The excerpts that follow are from Gustave Kahn, "Seurat," *L'Art moderne* (Brussels) 11, no. 14 (April 5, 1891): 107–10. ❦

If one should look at *Le Chahut* [Fig. 30] and see it less as a painted picture than as a diagram of ideas, one would read the following:

Female dancers constitute a principal rhythm, both mobile, through the direction of the movement, and still, because theirs is the principal movement, the leitmotiv of the only action that interests us in these dancers—their dance. The head of the female dancer—admirable for its beauty—because of the contrast between the official, almost priestess-like,[66] smile and the tired delicacy imprinted on her fine, desire-laden, diminutive features, suggests that this beauty attains its full significance only in carrying out this principal action of this feminine brain, which is to dance just that way. And for the dancer, this action acquires solemnity because it is habitual.

The male dancer is ugly and typical. His features are a crudely banal exaggeration of the physiognomy of the woman at his side, without, however, her smiling sparkle, for his activity is not one for which his gender

has best endowed him. He is simply practicing an ignoble trade. His tails are twisted like those of a devil in a painting by one of the old visionary artists. The conductor, no doubt randomly appointed to direct the solemn ritual, is similar in many ways to the male dancer; they are of the same ilk, and both are there to practice a trade. And for the synthesis of the public, one has only to look at that remarkable pighead of a spectator, the archetype of the fat reveler, placed very near and below the female dancer, wickedly expecting the moment of delight planned for him, experiencing nothing but a dumbhead's hilarity and low desire. If you are looking for a symbol, you will find one in the opposition of the female dancer's beauty—extravagance in a modest fairyland dream—and the admirer's ugliness; you will also find one in the hieratic execution of the canvas and its subject, an ignominy of our time.

Seurat's opinion was that the most suggestive—most pictorial and artistic—way of seeking the symbol (without paying undue attention to that word) lay in the interpretation of a subject, not in the subject itself; and he was not the only one to hold that view.

Anarchist Sympathies (1894)

Seurat's closest friend and fellow neo-impressionist, Paul Signac (1863–1935), became the unofficial leader of the group after Seurat's death. Signac, along with others among the neo-impressionists, more isolated from the mainstream of society than the artists and writers of earlier generations, had links with anarchist circles. Pissarro, Seurat, and Fénéon are also known to have had such ties.

At the height of civil unrest, in 1894, Fénéon was tried for having stored in his desk at the Ministry of War six detonators and a vial of mercury (used in making explosives); he was acquitted.[67] The artistic and literary contingent sympathetic to the anarchist movement was convinced that their work in the arts and literature manifested their struggle for a new social order: "Justice in sociology, harmony in art: the same thing," wrote Signac.[68] He and several other artists were nevertheless convinced, as he indicated in a document of around 1900, that "the anarchist painter is not he who executes anarchist paintings, but he . . . who struggles against bourgeois and official conventions, basing his work on eternal principles of beauty that are the same as those of morality."[69]

The passage that follows is from "Extraits du journal inédit de Paul Signac, I (1894–95)," ed. John Rewald, *Gazette des Beaux-Arts* (July–September 1949): 113. Courtesy of the Archives Paul Signac and the *Gazette des Beaux-Arts*. ✦

December 21, 1894

. . . First public representation of Ibsen's *Enemy of the People*.[70] Sustained applause for the passages with anarchist overtones, for all the sallies against authority, politicians, journalists. . . .

Clemenceau is there, in a box; he applauds vigorously.[71] Felix [Fénéon]

points out to Thévenot that the anarchists' acts of terror have been better propaganda than twenty years of pamphlets by Reclus or Kropotkin.[72] He points out the logic of the various assaults: against the stock market by Gallo; against the judiciary and the army (Lobeau Barracks) by Ravachol; against the Chamber of Deputies by Vaillant; against the voters by [Emile] Henry; against the head of state by Caserio.[73] Henry's action, directed toward the voters—who may be more guilty than the elected, since they compel elected officials to perform their contemptible tasks as deputies—that seems to me the most typically anarchist.

EDOUARD DUJARDIN

Cloisonism (1888)

In the winter of 1887–88 Louis Anquetin exhibited the first canvases in the manner he called cloisonist—first in a restaurant on Paris's avenue de Clichy, in the company of Vincent van Gogh, Henri de Toulouse-Lautrec, and Emile Bernard, then in the offices of *La Revue indépendante,* managed by Dujardin (1861–1949) with the assistance of Fénéon. He exhibited similar paintings at Les XX in Brussels in February 1888 and then at the Exposition des Artistes Indépendants in Paris the following month.[74]

Anquetin had attended the relatively unstructured art school managed by the academically trained Fernand Cormon. There he met Emile Bernard as well as Cormon's former student Toulouse-Lautrec, developing his new style in collaboration with Bernard. Both artists had gone through a neo-impressionist period, preserving from that phase only a "hieratic and summary" drawing, as Fénéon would have put it, and then had rejected the optical mixture for intense, more or less uniformly applied hues, filling areas delimited by continuous low-value outlines.[75]

The new manner had distinct affinities with the naive prints of Epinal, France; medieval woodcuts and stained glass; and various Middle Eastern and Asian traditions—including that of Japan—as well as the decorative arts of the day, which themselves reflected such traditions, in keeping with the earlier preachings of Owen Jones. Cloisonism owes its name to Japanese as well as Persian ceramics whose surface is divided by continuous metal strips forming compartments, or *cloisons* in French, that prevent the uniformly applied glazes from mixing before and during firing.

Vincent van Gogh had encouraged Bernard and Anquetin to study Japanese art at Bing's gallery in Paris in 1887.[76] Unquestionably, however, the linear archaizing style of the neo-impressionists that contributed to their simplifications constituted an early and decisive harbinger of cloisonism, and, since the two are synonymous, synthetism.

Dujardin was yet another journalist-poet who had close ties with Mallarmé. In 1884 he founded the most important symbolist periodical of the next few years, *La Revue indépendante,* and in 1885 established *La Revue wagnérienne;* these journals for a time gave him influence among the various symbolist coteries. An early practitioner of free verse, he wrote plays and novels as well as scholarly books on early Christianity. His article on cloisonism is significant primarily for articulating Anquetin's point of view at the time, and very likely also Bernard's. His arguments are unimpeachable from a historical standpoint, since art of the major archaic traditions stressed both the symbolic value of the objects represented and a deliberate stylization and simplification of their outlines. Dujardin was on weaker ground when he claimed that "line expresses what is permanent, color what is momentary"; he is likely simply to have embroidered on Fénéon's perceptive observation that the aim of the neo-impressionists was "to synthetize the landscape into a definitive aspect that perpetuates one's sensation of it,"[77] implying that lines as they were used by, say, the ancient Egyptians created an effect of stillness, whereas colors as used by the impressionists capture a fleeting sensation. One could claim, on the contrary, that the colors of medieval stained glass create a sense of permanence and the lines of Degas, a sense of transience! The formulation nevertheless applied specifically to Anquetin's rejection of the color effects of impressionism and neo-impressionism.

The goals of the new movement, as Dujardin describes them—to bring out "the *feeling* of things," their "*character,*" their "intimate reality," and "the essence of the object"—are closer to the impressionist Degas's naturalist approach to subject matter than to the symbolists' subjective approach to objects as starting points for their own play of associations. Had not neo-impressionism cut its ties to "the *feeling* of things," conjuring, instead, a "superior sublimated reality," as Fénéon had put it?[78] The same holds true for romantic symbolism and all manifestations of symbolism.

In stressing Anquetin's rejection of antithetical elements, including complementaries, in the execution, and his adoption of "a violent color in distinct patches," Dujardin disregarded the romantics' use of antitheses as a dramatic tool and repudiated the neo-impressionists' concern for balanced contrasts and controlled harmonies. He also heralded the powerful expressive musicality to be achieved by van Gogh and Gauguin through the daring juxtaposition of hues. Indeed, the description of the execution of the *Mower* under intense sunlight, no less than the picture itself, must have had an impact on van Gogh's own later paintings of similar subjects.

The excerpts that follow are from Edouard Dujardin, "Aux XX et aux Indépendants. Le Cloisonisme," *La Revue indépendante* 6, ser. 3 (March 1888): 487–92. ❧

To exhibitions of the classical impressionism of Guillaumin, the neo-impressionism of Signac, the arabesques of Jacques Blanche, and the modernism of Helleu, must be added a new development at the Salon des XX in Brussels to which the *Revue indépendante* calls its readers' attention.[79]

It is of Louis Anquetin that I want to talk. He is twenty-seven and has painted for about six years. He started out in the atelier Bonnat,[80] continued in that of Cormon, and then took up impressionism—all the impressionisms, including that of the dot. (He now paints uniform color areas.) I have known him for a long time; as an obstinate researcher, a man endowed with a reasoning and conscientious mind, he experimented with the current formulas before finding a personal one; and the outcome of this vigorous apprenticeship has been, to say the least, a power of execution, skill, and steadiness of hand that no one who has seen his canvases contests.[81]

Anquetin had never exhibited until last month. His first acknowledged works were hung at the exhibition of Les XX in Brussels. They will be shown at the Indépendants exhibition in Paris at the end of March. His selection includes a series of paintings and a group of drawings. The paintings are *Mower, Noon; Street, Five O'Clock in the Evening,* a sketch [Fig. 31]; *Boat, Sunset; Fan.* The drawings are charcoal and pastel figure studies for a large painting of the Café-Restaurant Bruant.[82] Add [to these] a fantasy, *Background for the Puppet Theater* (oil), and *Horses* (pastel). Paintings and drawings measure, on the average, 80 × 60 cm.

At first sight, these works look like decorative paintings: solid outlines and violent color in distinct patches that inevitably remind one of folk imagery and japanism.[83] Then, under the generally hieratic character of drawing and color, one perceives a truth of sensation emerging from the romanticism of frenzied execution; and, above all, something deliberate, reasoned out, intellectually and systematically constructed, that requires analysis.

The point of departure is a symbolic conception of art. In painting, as in literature, nature is a chimera; the ideal representation of nature (whether or not seen through a temperament) is the trompe l'oeil.[84] And why is it that in a trompe l'oeil painting the figures do not move? . . . Why do we not hear them? . . . The concern with the representation of nature logically turns theater into the supreme art. The purpose of painting, of literature, in contrast, is to provide, by means specific to each, the *feeling* of things. Not the image but the *character* should be expressed. Once this principle is accepted, what is the point of reproducing the thousand details the eye perceives? One must seize the essential trait, reproduce it, or, even better, produce it; a silhouette suffices to express a physiognomy; the painter, ignoring all that is photographic, with or without retouching, only seeks to put down, in a few lines and in characteristic colors, the intimate reality, the essence of the object he sets out to paint.

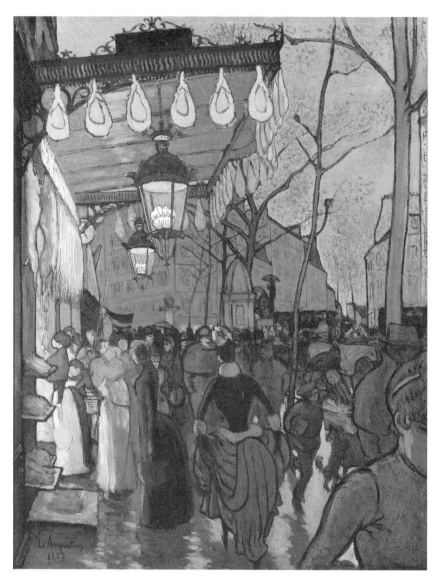

31. Louis Anquetin, *Avenue de Clichy, Five O'Clock in the Evening*, 1887. Oil on paper mounted to canvas, 69.2 × 53.5 cm. Wadsworth Atheneum, Hartford, Connecticut. Ella Gallup Sumner and Mary Catlin Sumner Collection. Photo: Joseph Szaszfai; copyright Wadsworth Atheneum.

The painter draws continuous lines forming closed loops, applying inside them the various hues whose juxtaposition must give the sensation of the desired overall coloration. DUJARDIN

Primitive art and naive art—which is the continuation of popular art in the contemporary era—are symbolic in this way. The imagery of Epinal relies on the drawing of outlines. At the height of their craft, ancient painters had adopted this technique. Such also is Japanese art . . . [Dujardin's ellipsis].

What practical application can we draw from these observations?

In the first place, one must stress a definite distinction between drawing and coloration. To confuse line and color—one must not bring up the futile claim that lines do not exist in nature[85]—is to misunderstand the special means of expression of each: line expresses what is permanent, color what is momentary; line, an almost abstract sign, gives the character of the object; the unity of color determines the atmosphere, fixes the sensation. Whence the circumscription of color by line as conceived in popular imagery and Japanese art;[86] the Epinal and Japanese artists first draw lines and within them, with the help of templates, add color; in the same way the painter draws continuous lines forming closed loops, applying inside them the various hues whose juxtaposition must give the sensation of the desired overall coloration, the drawing strengthening the color and the color the drawing. The work of the painter resembles painting *by compartments,* analogous to the cloisonné manner, and such a technique consists in a sort of cloisonism.

That Louis Anquetin should have reached the stage of perfectly implementing this theory, I am still far from claiming; but it is evident that, thanks to remarkable gifts as an artist and a painter, a true knowledge of his craft, and an assiduously rigorous logic in pursuing his idea, he has been able, in the few canvases he has produced, to give a notable example of what he wants to accomplish. His *Mower,* a mower in a wheatfield, a path in the foreground, houses in the rear: the path, edged with grass; the grass, a few shorn clumps; the wheatfield; some ears of wheat that suggest a general movement. Above, bushes with flamelike tips. The houses, silhouettes that strengthen the character of the setting.

As for color, the light is that of an August noon seen head-on (the landscape being between the sun and the spectator); incandescent light, orangy sensation; the hues of the different areas of the picture are coordinated within the general gamut; there are no complementaries, which would destroy unity. The need for antitheses to heighten the effect is denied here, as in some literature.

It is evident that a different coloration would yield a different sensation. It is as if he saw the landscape through a colored glass.

EMILE VERHAEREN

Ensor's Vision (1908)

In the mid-eighties and early nineties, the Belgian artist James Ensor (1860–1949) played a leading role in the breakdown of traditional natural-ism.[87] He himself had cultivated a masterly naturalism, sometimes employ-ing an exaggerated Manet-like painterliness along with his own imaginative use of color to achieve effects highly expressive of inner moods. A skilled print-maker, he may have extrapolated from his etchings the bold hatchings with which he created atmospheric and expressive effects, using clusters of dashing, variously colored lines in his paintings to achieve similar ends. *Jesus Quelling the Tempest* of 1891 (Fig. 32) is a case in point: Christ and the aura of light radiating from him constitute a limited area of peace and light in the maelstrom of natural forces evoked by clustered strokes. These strokes convey the turbulence of nature as well as suggesting the turmoil of the artist's psychic world. Although Ensor continued to use clusters of strokes in his later paintings, he frequently relied more heavily on typical synthetist patterning in later years.

Emile Verhaeren (1855–1916), a steady defender of the withdrawn and somewhat paranoiac Ensor, wrote his short but penetrating book on the artist, excerpted below, at the height of his own literary career. He was the first to stress the full implications of Ensor's trancelike imagery, com-paring the artist to a seer, and referring to his "tumultuous lines," and "the frenzy of the brushstrokes," which he considered powerful expressive devices.

The frenzy Verhaeren perceived in Ensor's brushstrokes, no less than the diminution in the size and importance of representational elements in the overall turmoil, brought the concept of expressive musicality to a climax; it also heralded the graphic automatism of the surrealists.

The following excerpt is from Emile Verhaeren, *Ensor* (Brussels: Van Oest, 1908), 39–40. ❧

32. James Ensor, *Jesus Quelling the Tempest*, 1891. Oil on canvas,
80 × 100 cm. Museum voor Shone Kunsten, Ostend, Belgium.

A human being is but an eddy of thought in the tumultuous rush of cosmic powers.
VERHAEREN

Ensor's *Oyster Eater* can be compared to a triumphal landing at the summit
of artistic production. In the eyes of the painter, however, this canvas is less
a point of arrival than one of departure. Here, as in *Cabbage* of 1880, he
began to paint in pure or nearly pure hues. But Ensor is a seeker; one might
say that he follows several paths at once. He gives up neither sea, nor land-
scape, nor still life. One finds him completing, in 1883 and 1884, his *Roofs
of Ostend; Grand View, Ostend; The White Cloud; Holly; The Dune;* and *View
of Brussels.* And in *The Hoboes, The Scandalized Masks,* and *The Haunted
Cabinet* he also explores the realm of fantasy and hallucination.

In *Christ Walking on the Sea* yet another path seems to open up before
him. In it a new concern for composition manifests itself. Taking biblical
subjects for themes, the painter suddenly raises himself to the status of vi-
sionary. The figures in many of his astonishing works occupy only a mini-
mal area. At first sight one does not distinguish them. One must look for
them. They seem to be part of the elements: wind, clouds, waves, suns.
The ancient masters in their works invariably gave pride of place to human
actions. In the myths unfurled in the history of art, only gods and men

exist. But as the idea of force has displaced and modified myth, humanity comprehends that a human being is but an eddy of thought in the tumultuous rush of cosmic powers; the importance of his gestures has diminished.

Christ Walking on the Sea is conceived in the same vein. It is the sea and sky that with their immensity fill the entire canvas. Barely an aura, barely a glow, emerges from a vague shape to reveal the extraordinary event.

Adam and Eve Driven from Paradise corroborates even more readily the previous observations. It is a marvel. The skies, turbulent with thunder and lightning, occupy just about the whole surface. Cyclones pass, a formidable glow appears, the whirling atmosphere is caught by the artist. Truly, this is a celestial wrath that swells, moves about, bursts. The Angel of Death seems to extend across the whole swarm of clouds. To the right, moving in terrified flight, as if burned by the avenging sword, Adam and Eve appear. They are almost indistinguishable in the corner of the canvas, swirled around like flotsam while the storm occasioned by their miserable frailty occupies the four corners of space.

The supernatural effect is produced without recourse to the melodramatic opposition of blacks and high values in the color scheme. The general tonality remains luminous—magnificently so—and almost delicate. But the tumultuous lines are most appropriate to the subject, and the frenzy of the brushstrokes fills one with wonder.

In 1891 *Jesus Quelling the Tempest* [see Fig. 32] continues the series of legend-inspired works. The sky and the sea in this work meet at the horizon like the two halves of an enormous oyster that seems to have contained both rain clouds and the sea. The figures, invariably at the right of the picture, as in *Christ Walking on the Sea* and *Adam and Eve Driven from Paradise,* reveal the painter's search for an almost standard composition. A traditional knowledge of composition, of equilibrium, of the successful continuity of arabesques—all that contributes to a studied and successful arrangement of forms—is of little concern to him. He sees in one fell swoop, as if a curtain had suddenly been ripped open, and he renders what he sees and no more. Seers proceed in this way.[88]

PAUL GAUGUIN

Letters to Emile Schuffenecker
(1885, 1888)

THOUGHTS ON AESTHETICS (1885)

Paul Gauguin (1848–1903), after losing his position in a Paris stockbroker-age in 1883 and taking up painting full-time, decided in 1884 to follow his Danish wife and children, who had just gone to live with his mother-in-law in Copenhagen. He spent several months there.[89]

Gauguin's letter to Emile Schuffenecker, excerpts from which follow, was written when the artist was still fully committed to impressionism; in it Gauguin announces some of his most radical innovations to come (some of these ideas were adumbrated at the same time or a little earlier in "Notes Synthétiques").[90]

Some of Gauguin's ideas may have come from the thought of Charles Henry; other notions—on straight lines and curves and on the expressive impact of the weeping willow—come from Charles Blanc's *Grammaire des Arts du dessin* of 1867. Gauguin had probably also read recent works on experimental psychology. More than any other theories, however, musicality and the associative value of form seem to have drawn his attention.

Gauguin discusses the effect that stimulation of the senses can have on emotional life. On the one hand, he claims, such an effect can be produced through reflex reactions to intuitively recognized forms (a large spider, a weeping willow, and so forth); on the other, the effect may derive from intrinsic aesthetic properties of forms and colors, in keeping with the theory of musicality. The "large spider," and "the large trunk of a tree in a forest" that "produce a terrible sensation without your being able to determine why" are allusions, incidentally, to well-known prints and drawings of those subjects by Redon.

Gauguin's evaluation of Cézanne's art is particularly noteworthy, for he is among the first to have sensed an element of mysticism in that artist's per-ception of nature. His awareness of the "literature" in Cézanne's paint-

ings—the expression of emotions that goes beyond the here and now of naturalism—and of the use of sometimes ambiguous parable-like imagery to convey such emotions further indicates his understanding of the aesthetics of the play of associations and their effect on Cézanne.

Even after Gauguin returned to Paris from Copenhagen, in 1885, he persevered along the impressionist path. Indeed the works he sent to the last impressionist exhibition in 1886 were in the mainstream of that movement. That same year, however, he was adopting linear simplifications, rooted in the manner of Degas, that point toward synthetism; his pottery then and subsequently reveals a remarkable imaginative boldness in form and execution, and, in one early example (see Fig. 22), an appreciation of cloisonist effects.[91] He fully adopted the synthetist manner and the fundamental precepts of symbolism in his paintings late in the summer of 1888, while staying at Pont-Aven in Brittany, and showed consummate mastery in handling both.

Emile Schuffenecker (1851–1934) had been Gauguin's colleague in one of the Parisian financial houses. He too painted, adopting a loose and rather pale impressionist manner to depict scenes sometimes tinged with mysticism.

The excerpt that follows is from Paul Gauguin to Emile Schuffenecker, January 14, 1885, no. 65, *Correspondance de Paul Gauguin,* ed. Victor Merlhès, 3 vols. announced (Paris: Fondation Singer-Polignac, 1984), 1:87–89. Courtesy of Monsieur Merlhès and the Fondation Singer-Polignac. ❧

As for me, at times I am under the impression that I am mad. And yet, the more I think, at night in bed, the more I believe I am right. For a long time philosophers have been arguing about phenomena that seem supernatural but of which we nevertheless have the *sensation*. Everything is there, in that word. The Raphaels and others were the sort of people in whom sensation was formulated long before thought, enabling them, as they studied, to preserve that sensation and to remain artists. For me the great artist is the one endowed with the greatest intelligence. He is the one reached by feelings as well as by the most delicate—and consequently the least obvious—translations of the mind.

Observe the immense creation of nature, and you will see whether there are not laws by which to create all human feelings, under different aspects that are yet similar in their effect.

Visualize a large spider or the large trunk of a tree in a forest; both produce a terrible sensation without your being able to determine why. Why does it disgust you to touch a rat and other, similar, creatures? No reasoning

stands up to such feelings. All our sensations, affected by an infinity of things, reach *the brain directly,* and no amount of education can suppress them.[92] I conclude from this that there are lines that are noble, deceitful, and so forth . . . [Gauguin's ellipsis]. The straight line suggests infinity; the curve limits creation.[93] Then there is the fatality of numbers. Have not the figures 3 and 7 been sufficiently discussed? The colors are even more revealing, though less susceptible of multiple effects than lines, because of their power over the eye. There are hues that are noble, others common; tranquil and consoling harmonies, others that stimulate through their boldness. In sum, you find in graphology the features of men who are frank and those of others who are liars. Why should not lines and colors reveal to the art lover the more or less grandiose character of the artist? Look at Cézanne, the misunderstood, and see the essentially mystical nature of the Middle East (his face looks like that of an elder of the Levant). Like a man lying down to dream, he cherishes mystery and heavy tranquillity in form. His color is as severe as the character of Middle Easterners; a man of the South, he spends whole days on mountain tops, reading Virgil and looking at the sky. As a result, his horizons are high, his blues are intense, and in his work red is astonishingly vibrant. Like the writings of Virgil, which are open to diverse interpretations, the literary side of his pictures is like a parable; his backgrounds are as imaginary as they are real.[94] To sum up, on seeing one of his paintings, one exclaims: Strange, but this is madness. Mystical h a n d w r i t i n g with detached letters, *drawing* likewise.[95]

The further I go, the more I am inclined to translate thought into something quite different from literature.[96] We shall see who is right. If I am wrong, why does your Academy, which knows all there is to know about the methods of the old masters, not produce masterpieces?

One does not create outright one's own nature, intelligence, or heart. When he was young, Raphael intuited his,[97] in his paintings there are harmonies of line that are not obvious because they reveal the most intimate, entirely veiled, part of the soul. Look at the details, even the [background] landscape, in a painting by Raphael, and you will find the same feeling as in the rendering of a head. One is pure in everything. But a landscape by Carolus-Duran is as much a brothel as it is a portrait.[98] (I cannot express it, but I have this feeling.)

Here, I am more than ever tormented by questions pertaining to art, and neither my money torments nor my pursuit of business endeavors can keep me from them.

You tell me that I would do well to join your Society of Independents;[99] do you want me to tell you what will happen? You are now around one hundred; tomorrow you will be two hundred. The merchant-artists will constitute the two-thirds of intrigue mongers among them. In a short while

you will see the likes of Gervex and others become important.[100] What shall we, the dreamers and the misunderstood, do then? This year you have had a *favorable* response in the *press;* next year the opportunists (there are Raffaellis everywhere)[101] will have raked up mud to cover you with so that they themselves might appear clean.

Work *freely, madly;* you will improve, and sooner or later your true worth, if you have any, will be appreciated. Above all, do not sweat over a painting. A great feeling can be translated immediately; dream over it and seek its simplest form.

The equilateral triangle is the most solid and perfect form of a triangle. An elongated triangle is more elegant. In pure truth there is no side; in our feeling there is one. Lines going to the right go forward; those going to the left, backward. The right hand hits, the left is in a defensive position. A long neck is graceful, but heads settling between shoulders are more pensive. A duck with its eyes directed upward listens, . . . but what do I know? I am telling you a lot of silly things. Your friend Courtois is more reasonable, but his painting is so stupid. Why are willows with drooping limbs called weeping willows? Is it because drooping lines are sad?[102] And is the sycamore sad because it is made to grow in cemeteries? No, it is the color that is sad.

As far as business goes,[103] my situation here is just what it was in the beginning. I shall see results, if any, only in six months' time; in the meanwhile I am penniless, up to my neck in dung. This is why I seek consolation in my dreams. Little by little we will pull through, my wife and I, through giving French lessons. You will laugh; me, giving French lessons!

I wish you better luck than ours.

SELF-PORTRAIT (LES MISÉRABLES) (1888)

Gauguin sent this letter to his friend Schuffenecker from Pont-Aven, a fishing village and artists' summering resort in Brittany, in October 1888. He had become friends there with the much younger Emile Bernard, who had probably urged him to take up the synthetist manner more boldly and consistently than he had done in the past; Gauguin now mentions synthesis.[104] Incidentally, the two artists and like-minded colleagues would show their works in an exhibition titled Impressionist and Synthetist Group at the Grand Café des Beaux-Arts (or Café Volpini), located near the official Fine Arts Pavilion of the Paris Universal Exhibition of 1889.

Whereas Anquetin and Bernard had generally limited themselves to an archaizing simplified linear style and uniform color areas in their synthetist works, without the allusions that are the basis of a play of associations, Gauguin not only practiced a similar vigorous stylistic synthesis but also

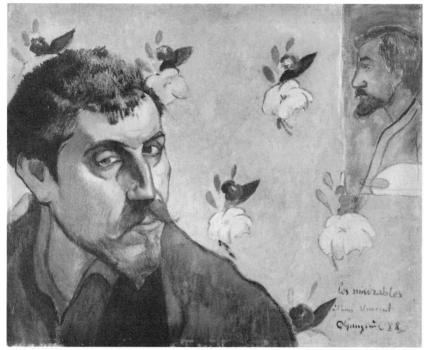

33. Paul Gauguin, *Self-Portrait (Les Misérables)*, 1888. Oil on canvas, 45 × 55 cm. Vincent van Gogh Foundation / Vincent van Gogh Museum, Amsterdam.

The drawing is altogether special (total abstraction). The eyes, the mouth, the nose are like the flowers of Persian carpets, also embodying symbolism.

GAUGUIN

introduced into his works numerous allusions, some with powerful emotional messages, as the letter that follows reveals.

The painting he describes was destined for Vincent van Gogh, who had been in Arles, in the South of France, since late February 1888 and had asked his friends Bernard and Gauguin for portraits of themselves in exchange for his own.[105] The allusion to Jean Valjean, the principal character of Victor Hugo's *Les Misérables* (1862), in the title of Gauguin's *Self-Portrait (Les Misérables)* (Fig. 33) must have been inspired by van Gogh, for whom the messianic ex-convict was a favorite literary hero.[106]

Gauguin had met van Gogh by November 1887.[107] If Gauguin gave the "impressionist" painter he still considered himself to be the name of Jean Valjean, it was probably to create a surprising, unprecedented, evocative association that van Gogh himself would have been likely to appreciate.[108]

Van Gogh, after all, had painted a *Self-Portrait* in the spring of 1887 with fire-colored strokes radiating from the center of his face as if to suggest a consuming inner turmoil—in keeping with the "emotion of an ardent temperament," as he put it on another occasion—as peripheral ripples in the surrounding blue atmosphere evoke the dissipation of energy in a cold, dark yonder.[109]

Gauguin, in describing the self-portrait, echoed Victor Hugo's juxtaposition of the apparently conflicting images of ex-convict and Messiah. He compared the colors of his face in the portrait with "pottery twisted in high fire,"[110] suggesting inner torment, contrasting them with the "childlike posies—the room of a pure maiden" in the background that evoked for him the ultimate dream of transcendent purity, all the while simplifying the material rendering in keeping with synthetism, to the point of recalling in some areas the abstract quality of "the flowers of Persian carpets."

Such new and startling links are precisely those Remy de Gourmont would advocate in his "Funérailles du style" of 1902.[111]

Like Owen Jones and Dujardin before him, Gauguin associated the simplified patterns of his design with the stylized motifs of ancient Middle Eastern civilizations, fully aware of the potential for musicality in good abstract design.

The excerpt that follows is from Paul Gauguin to Emile Schuffenecker, October 8, 1888, no. 168, in *Correspondance de Paul Gauguin,* ed. Victor Merlhès (Paris: Fondation Singer-Polignac, 1984), 1:248–49. Courtesy of the Fondation Singer-Polignac and Monsieur Victor Merlhès. ❧

This year I have sacrificed everything—execution, color, style—in my endeavor to achieve something other than what I know how to do. I believe it is a transformation that has not yet borne fruit but will do so.

I did a portrait of myself for Vincent, who had asked for it [see Fig. 33]. It is, I believe, one of the best things I have done: it is absolutely incomprehensible (don't you believe it) because it is so abstract. At first sight it is the head of a bandit, a Jean Valjean (*Les Misérables*), personifying also an impressionist painter, unrecognized and always chained like a convict in the eyes of the world. The drawing is altogether special (total abstraction). The eyes, the mouth, the nose are like the flowers of Persian carpets, also embodying symbolism.[112]

The color is rather distant from that of nature; a vague memory of my pottery twisted in high fire—all the reds, the violets, with fiery streaks radiating from the eyes where the thought of the painter struggles—the

whole thing against a background of pure chrome yellow strewn with child-like posies—the room of a pure maiden.

The impressionist is a pure being, not soiled by the putrid kiss of the Beaux-Arts (School of).[113]

[Theo] Van Gogh has just sold 300 francs worth of [my] pottery.[114] So I am leaving at the end of the month for Arles, where I shall stay a long time, considering that I undertake this sojourn so that I can work without having to care about money until he is able *to get me launched*. From now on he will provide every month for my modest subsistence. Don't you forget me during my absence. I shall write you and think of you.

Symbolism in Painting: Paul Gauguin (1891)

In October 1888, when Gauguin was painting his *Self-Portrait (Les Misérables),* he was completing a large canvas that can be regarded as the pictorial manifesto of the symbolist aesthetics he elaborated at Point-Aven: *The Vision after the Sermon, or the Struggle of Jacob and the Angel* (Fig. 34). The archaizing linear style and the application of color in more or less uniform outlined areas make the picture a synthetist work; the expressiveness and harmony of lines and color, the aura of mystery, the bold play of association, the somnambulistic demeanor of the figures—the image suggests a visionary or trancelike attitude or an intense daydream on the artist's part—and Gauguin's own role figuratively (and literally) as both observer and participant, all make it a symbolist work.

To paraphrase Gauguin himself, the red background is as imaginary as it is real,[115] for if it recalls the reddish hue of *varech,* the seaweed villagers spread on the fields to dry before they stored it as fodder, it also recalls the red lacquer background of Japanese decorative objects. The intensity of the red ground and the blue clothes of the wrestlers, with their Byzantine or Romanesque folds, and the subtle striations in each, along with the delimiting outlines, suggest medieval stained glass and give the whole scene a particularly non-naturalistic, indeed visionary, character.

As for the fighting figures, it was the practice for young Breton villagers to participate in wrestling matches after Sunday mass,[116] but Gauguin transformed the scene into an archaizing vision of Japanese wrestlers in Western medieval garb, one of whom, in keeping with the just-heard sermon, has sprouted wings, so that the two represent the biblical struggle of Jacob and the Angel. The biblical theme itself, moreover, brings to mind Delacroix's *Struggle of Jacob and the Angel,* completed in 1861 for Saint Sulpice in Paris (see Fig. 1), and yet another set of associations. Indeed, well-informed admirers of Delacroix—and Gauguin was definitely an admirer—would have recognized Delacroix's figures as "an emblem of the ordeals to which God

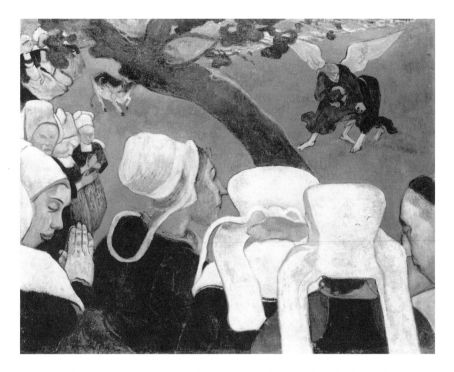

34. Paul Gauguin, *The Vision after the Sermon, or the Struggle of Jacob and the Angel*, 1888. Oil on canvas, 73 × 92 cm. National Gallery of Art, Edinburgh.

Is he not, in some way, an algebraist of ideas? AURIER

sometimes subjects the chosen ones" and, as such, of the struggle of the creative artist with his ideal.[117] Not surprisingly, the priest on the right has Gauguin's characteristic angular nose, as if to stand for the artist conjuring up the vision of his struggle with his ideal before the congregation and introducing to it the new artistic tradition, symbolism.[118]

The women are rendered in the synthetist manner; the crude, angular modeling of their faces and coifs, however, recalls the primitive Breton sculptural tradition going back to the Middle Ages.

The women on the left are shown on their knees, their eyes shut in prayer before the vision within the overall vision—the wrestlers. Thus they unwittingly pay tribute to the style and content of the new art; and their attitude implies that the most recent post-impressionist developments, based in part on such supposedly backward traditions as those of Japan and the Western Middle Ages, have the same effect on the world's uncultured masses as

their own primitive artistic traditions; the women's attitude also suggests their awe before the titanic struggle of Gauguin—the Gauguin-Messiah of *Self-Portrait (Les Misérables)*—to implement his ideal.

G.-Albert Aurier (1865–1892), the first critic to produce an important article on Gauguin, placed the artist at the head of pictorial symbolism. Aurier had developed a system of aesthetics that he enunciated in the preface of a work interrupted by his early death.[119] He took a stand against the so-called scientific aesthetics of Hippolyte Taine, insisting that the artist's message was primarily subjective.[120] The main point of the work of art, for Aurier—echoing Moréas[121]—was the expression of what he calls "the Idea" by means of a "formal envelope," shaped by the artist's temperament, as he had explained in his article on van Gogh of 1890. The formal envelope itself, he implies in the excerpt that follows, consists of a number of "signs," here compared to Egyptian hieroglyphs and therefore likened to the "confused words" issuing from Baudelaire's forest of symbols. The signs had to go through a "necessary *simplification*"; the artist had to select "from the multiple elements of objective reality, to use in his work only the lines, forms, and general and distinctive colors that enable him to describe precisely the ideic significance of the object."

The element of deliberate simplification was in keeping with Dujardin's concept of cloisonism, and, generally speaking, synthesis. Aurier nevertheless introduced the notion of "ideic," meaning pertaining to the world of ideas—a far cry from Dujardin's "*feeling* of things," their "*character*," their "intimate reality." What is more, when Aurier conceived an interplay of signs, or hieroglyphs, handled by an "algebraist of ideas"—reminiscent of Baudelaire's description of nature as a dictionary out of which Delacroix selected words for his own expressive ends—he was alluding to a play of associations in symbolist art far more complex than Dujardin's notions.[122]

But hieroglyphs, or signs, in themselves, are not works of art. To make them aesthetically meaningful the artist must reach a state of spiritual exaltation Aurier called ecstasy. Aurier explained elsewhere that only in such a state of exaltation, which he compared to love, can the artist instill his soul into the work of art, a process to be replicated by the onlooker wishing to absorb the artist's full emotional message.[123] No wonder Aurier referred to Plato when stressing the spirituality of the artistic message, nor is it surprising that, attributing the origin of the concept to the Neoplatonic School of Alexandria, he should use the word *ecstasy* to refer to the high moments of the aesthetic experience—the same word Pater, himself much influenced by Plato and the Neoplatonists, had used for a similar purpose.[124]

Aurier's stress on the ultimate importance of ideas over perception appears to derive from Kant, whereas the importance of subjective response in aesthetic matters seems to reflect the idealism of Fichte.

A regular participant in Mallarmé's Tuesdays, Aurier sent the older poet manuscript versions of his own verse before publication.[125] *L'Œuvre maudit* (The accursed work) appeared in 1889; its title paid a discreet tribute to Verlaine's articles on symbolist and near-symbolist poets, "Poètes maudits" (The accursed poets), of 1883. Aurier was the editor of *Le Moderniste,* for which Gauguin had written a text on the arts and crafts at the 1889 Paris Universal Exhibition; a contributor to *Le Décadent,* as well as many other symbolist periodicals; and a founder of the principal symbolist periodical, *Mercure de France,* first published in 1890. He was the art critic for this same journal, in which his article on Gauguin appeared.

The article was intended to promote Gauguin at the time the artist was preparing a public sale of his work in anticipation of his departure for Tahiti, on April 4, 1891.

The excerpts that follow are from G.-Albert Aurier, "Le Symbolisme en peinture: Paul Gauguin," *Mercure de France* 2 (March 1891): 155–64. ❧

What do you think he would answer, if one were to tell him that, until then, he had only seen ghosts, that he now has before his eyes objects that are more real and closer to the truth? Would he not think that what he had seen earlier was more real than what he is shown now?

Plato[126]

Far away on a fabulous hill, its ground a scintillating vermilion, the biblical struggle of Jacob and the Angel unfolds.[127] While these two legendary giants, who from a distance look like pygmies, engage in their formidable struggle, women watch them, curious, interested, and naive, doubtless not fully understanding what is going on over there, on this fabulous purprescent hill. They are peasant women, Breton, to judge from the width of their white coifs spreading out like the wings of seagulls, the typical multicolored patterns of their shawls, and the shapes of their dresses and jackets. They are in the respectful attitudes and have the stunned expressions of simple creatures listening to extraordinary and somewhat fantastic tales retold by some revered, unchallengeable fabulist. One might think of them as being in a church, such is their silent attentiveness, so thoughtful and devout their demeanor; thinking of them in church, one might imagine a vague smell of incense and prayer fluttering around the white wings of their coifs as the respected voice of the old priest glides over their heads . . . [Aurier's ellipsis]. Yes, of course, in a church, in some poor church in some little Breton village . . . [Aurier's ellipsis]. But then, where are the moldy green pillars? where are the milky walls and their diminutive chromolithographic stations

of the cross? and the pine pulpit? and the old preacher, whose mumbling voice, to be sure, can be heard? Where is it all? And why, over there, far away, is there the soaring flank of the hill whose soil appears to be a scintillating vermilion? . . . [Aurier's ellipsis].

Ah! Because it happens that the moldy green pillars, the milky walls, the diminutive chromolithographic stations of the cross, the pine pulpit, and the old priest who preaches vanished a few minutes earlier, stopped existing for the good Breton peasant women! . . . [Aurier's ellipsis]. What a marvelously touching accent, what a luminous evocation, strangely adapted to the ears of the unsophisticated audience, this hemming and hawing village Bossuet has conjured up.[128] All the ambient material realities have gone up in smoke, have disappeared. The evocator himself has faded away,[129] and it is now his voice, his poor old pitiful spluttering voice, that has become visible, imposingly visible; and it is his voice that the peasant women in their white coifs hear in naive and devout admiration; and it is his voice that has been transformed into that rustically fantastic vision—the vision that has arisen over there, far away; and it is his voice, that fabulous vermilion hillside in that land of childish dreams where two biblical giants, transformed into pygmies because of the distance, engage in their harsh, fearful combat! . . .

◆

Before this marvelous canvas by Paul Gauguin, which truly highlights the enigma of the biblical poem of the paradisaical hours of primitive humanity; which reveals the inexpressible charms of the dream and of mystery and lifts the symbolic veils that the hands of simple souls only manage to half-raise; which resolves, for him who knows how to read, the eternal psychological problem posed by the potential human impact of religions, of politics and of sociology; which exposes, finally, the wild primordial beast overcome by the magical philters of the Chimera. Before this prodigious canvas—and I am not referring to some fat petit bourgeois banker taking pride in his important collection of Detaille (secure value) and Loustauneau (growth oriented),[130] but to some art lover, reputedly intelligent, and so sympathetic to acts of youthful daring as to favor the harlequin vision of the pointillists [neo-impressionists]—such a visitor would exclaim:

> — Oh no! by Jove! this is too much! Coifs and shawls from Ploërmel,[131] and turn-of-the-century Breton women in a picture called *The Struggle of Jacob and the Angel!* Well, I dare say, I am not a reactionary; I accept the excesses of impressionism; in fact, I accept only impressionism, but . . . [Aurier's ellipsis].

> — And who told you, my dear Sir, that this work has anything to do with impressionism?

Indeed, it might be time to dissipate an unfortunate ambiguity created by this word *impressionism*—a word too widely abused.

[Aurier then explains that for him, impressionism's goal "is still the imitation of matter, not so much in its own form, its own color as in its perceived form, its perceived color. It is the translation of sensation with all the unforeseen elements of spontaneous notation, with all the distortions of a rapid subjective synthesis." And he concludes that the public associates impressionism with "a faithful translation, *devoid of any sense of the beyond, of the purely sensory impression* of a sensation."]

Be that as it may, now that we are witnessing the agony of naturalism in literature and, simultaneously, the preparation of an idealist, even mystical, reaction, we should wonder whether the plastic arts are revealing a similar evolution. *The Struggle of Jacob and the Angel,* which I have attempted to describe by way of an introduction, is sufficient proof that this tendency exists, and one must understand why painters treading this new path reject this absurd label of impressionist, which implies a program diametrically opposed to theirs. This little discussion about words—which might appear ridiculous at first—is nevertheless, I believe, necessary, for everyone knows that the public, supreme judge in artistic matters, has the incurable habit of judging things according to their names. One must, therefore, invent a new term ending in *ist* (there are already so many of them that this will make no noticeable difference!) for the newcomers whose leader is Gauguin: synthetists, ideists, symbolists, as one likes best. . . .

Oh, how rare, in truth, among those who flatter themselves that they have "artistic dispositions," how rare are the blessed, the eyelids of their souls unsealed, who can exclaim with Swedenborg, the inspired seer: "This very night, the eyes of my inner man were opened: they became capable of peering into the heavens, into the world of ideas and into hell! . . . [Aurier's ellipsis].[132] And yet, is that not the preliminary and necessary initiation that the true artist, the absolute artist, must undergo? . . . [Aurier ellipsis].

Paul Gauguin seems to me one of those sublime travelers. He seems to me the initiator of an art, not so much new in the whole of history as in our own time. Let us analyze this art from a general aesthetic standpoint. This involves a study of the artist himself that will probably achieve more than the usual monograph composed of the description of some twenty canvases accompanied by ten flattering plates, such as today's school of criticism considers satisfactory.

It is obvious—and to state it is almost banal—that two major contradictory tendencies exist in the history of art, one depending on the blindness,

the other on the clairvoyance of that "inner eye of man" to which Sweden-borg refers: the realist and the ideist (I do not say idealist for reasons that will become apparent).

Without question, realist art, the art whose only purpose is to represent the outer aspects of matter, appearances perceptible to the senses, consti-tutes an interesting aesthetic manifestation. It reveals to us, almost by way of a reaction, the soul of the artist, since it exposes the distortions the object has undergone in its travel across that soul. Besides, no one contests that realism, if it has been a pretext for many monstrosities, as impersonal and banal as photographs, has also sometimes produced unchallengeable mas-terpieces that shine in the museum of all memories. And yet it is no less beyond question that ideist art appears purer and more elevated to whoever considers the matter fairly—purer and more elevated, just as all ideas are purer and more elevated than matter. One might even contend that the supreme art could only be ideist, art by definition (intuition tells us) being but the material representation of what is most elevated and divine in the world, which, in the last analysis, is all that exists—the idea. As a result, do not those who neither see the idea nor believe in it deserve our compassion, like the unfortunate, stupid prisoners of Plato's allegorical cave?[133]

Yet with the exception of most of the primitives and some of the great masters of the Renaissance,[134] the general tendency of painting has been al-most exclusively realist.[135] Many individuals even admit that they cannot understand how painting, a *representational* art above all else, able to imitate to the point of illusionism all the visible attributes of matter, might be any-thing other than a faithful and exact reproduction of objective reality, an ingenious *facsimile* of the so-called real world. The idealists themselves (again I stress that one must not confuse them with the artists I call ideists) were most often, whatever they may say, nothing but realists. The goal of their art was the direct representation of material forms; they were satisfied to *arrange* objective reality according to conventional notions of quality. They prided themselves on representing *beautiful* objects, but those objects are *beautiful only inasmuch as they are objects,* the interest of their work resid-ing always in the form—that is, in reality. Indeed, what they called ideal was only crafty makeup applied over ugly tangible things. In a word, they have painted a conventional objective reality, but objective reality nonethe-less. If I may paraphrase one of them, Gustave Boulanger, ultimately the only difference between idealists and realists is the difference "that separates the helmet [*casque*] from the hunting cap [*casquette*]!"[136]

The idealists too are the poor stupid prisoners of Plato's allegorical cave. Let them stultify themselves in contemplating shadows they mistake for reality and let us return to men who, having broken their chains, find ec-stasy in contemplating the radiant sky of ideas, far from the cruel jail in which they were born.

The goal of painting, as of all the arts, as already pointed out, cannot be the direct representation of objects. Its end purpose is to express ideas as it translates them into a special language.

Indeed, in the eyes of the artist, of the one who must *express absolute entities,* objects, that is, relative entities that translate ideas (absolute and essential entities) in a way suited to our apprehension, have a significance only insofar as they are objects. The artist sees them only as *signs,* letters of an immense alphabet that only the genius knows how to read.

To write one's thought, one's poem, with those signs, all the while remembering that the sign, however indispensable, is nothing in itself and the idea alone is everything—such appears to be the task of the artist whose eye can determine the evocative potential of tangible objects. The first consequence of this principle is too obvious for us to have to ponder: it is, as one might have guessed, a necessary *simplification in the writing of the sign.* Indeed, were this not so, would the painter not resemble the naive literary figure who imagines that attention to his handwriting and the addition of futile calligraphic flourishes would contribute something to his work? [137]

But even if the only real entities in this world are ideas, if objects only reveal the external appearance of these ideas and are thus important only as signs of ideas, it is no less true that to our myopic human eyes—that is, the eyes of the proud *shadows of pure entities* [that we are], shadows unconscious of the illusory condition in which they live and the beloved false tangible entities they encounter—objects mostly appear as objects, nothing but objects, independent of their symbolic significance—to such an extent that, despite our efforts, we sometimes cannot imagine them as signs.

This nefarious propensity in practical life to consider the object as nothing but an object is obvious and, one may say, almost general. Only the superior man, enlightened by the virtue the Alexandrians so aptly named ecstasy, [138] knows how to convince himself that he is but a sign, cast by some mysterious preordination into the midst of an innumerable crowd of signs; he alone, tamer of the monster illusion, knows how to stroll as a master in this fantastic temple

> in which living pillars
> Sometimes emit confused words

whereas the stupid human, fooled by the appearances that will make him repudiate essential ideas, remains blind as he travels through

> forests of symbols
> That observe him with familiar glances. [139]

The work of art must not lend itself to such ambiguities, even in the eye of the popular herd. It so happens that the dilettante (who is not necessarily an artist and who, as a result, has no sense of symbolic correspondences) would find himself, before that work, in a situation like that of the crowd before the objects of nature. He would perceive the represented objects as nothing but objects—something it is important to avoid. It is therefore essential that this confusion be prevented from occurring in an ideist work. It is also necessary that we believe that the objects in the picture have no value as objects and are but signs, words, with no importance in themselves whatsoever.

As a result, certain laws must govern pictorial imitation. The artist, in every form of art, must carefully avoid the following [inherent] antinomies: concrete truth, illusionism, trompe-l'oeil. Indeed, he must not convey in his picture a false impression of nature that would act on the spectator like nature itself, without any suggestiveness, that is (forgive my barbaric neologism), ideicidally.[140]

It is logical to imagine the artist fleeing the analysis of the object to protect himself from the perils of concrete truth. Indeed, in reality every detail is a partial symbol, irrelevant most of the time to the total signification of the object. In consequence, the strict duty of the ideist painter is to make a reasoned selection from the multiple elements of objective reality, to use in his work only the lines, forms, general and distinctive colors that enable him to describe precisely the ideic significance of the object, in addition to a few partial symbols corroborating the general symbol.

Indeed, it is easy to deduce that the artist will always have the right to exaggerate, attenuate, and distort these directly signifying elements (forms, lines, colors, and so forth), not only according to his individual vision, his subjectivity (as happens even in realist art), but also according to the requirements of the idea to be expressed.

❧

To sum up and conclude, the work of art as I have evoked it logically, is

1. *Ideist,* since its unique ideal is the expression of the idea;
2. *Symbolist,* since it expresses the idea by means of forms;
3. *Synthetic,* since it writes out those forms, these signs, according to a mode susceptible to general comprehension;
4. *Subjective,* since the object depicted is not considered as an object, but as a sign of an idea perceived by the subject;
5. And (as a consequence) *decorative*—inasmuch as decorative painting, as the Egyptians understood it and very probably the Greeks and the

primitives, is only a manifestation of an art that is at once subjective, synthetic, symbolist, and ideist.

And decorative painting is, properly speaking, true painting. Painting can have been created only to *decorate* the bare walls of human edifices with thoughts, dreams, and ideas. Easel painting is an illogical refinement invented to satisfy the fantasy or the commercial spirit of decadent civilizations. In primitive societies the first attempts at picture making could only have been decorative.

This art that I have tried to legitimize and characterize, this art that may appear complicated and that some chroniclers would gladly call deliquescent,[141] can therefore, in the last analysis, be reduced to the formula of simple, spontaneous, and primordial art.[142] Such is the criterion of appropriateness in the aesthetic reasoning I present here. Ideist art, which had to be justified by abstract and complex arguments because it seems so paradoxical to our civilization, which happens to be both decadent and forgetful of any initial revelation, is therefore, irrefutably, the true and absolute art. Not only is it legitimate from the standpoint of theory, but it is also, in the last analysis, identical to primitive art, to art as it was intuited by the instinctive geniuses of the dawn of humanity.

But is this all? Is not some element missing that would transform an art so understood into what would truly be Art?

This man [Gauguin], who, thanks to his native genius and to all his acquired gifts, finds himself able, in the presence of nature, to read in each object an abstract signification of a dominating primordial idea[143]—this man, who, through his intelligence and skill, knows how to use objects as a sublime alphabet to express the ideas revealed to him—is he truly, in this very respect, a complete artist? The Artist?

Is he not rather a scientific genius, a supreme articulator who can write ideas like a mathematician? Is he not, in some way, an algebraist of ideas, and is not his work a marvelous equation, or rather a page of ideographic writing reminiscent of the hieroglyphic texts of the obelisks of ancient Egypt?

Yes, undoubtedly, the artist, if he has no other psychic gift, if he would be nothing but a *comprehensive articulator* is only that. Although comprehension complemented by the *power of expression* is sufficient for a man of learning, it is not for the artist.

To be worthy of this beautiful title of nobility (so polluted in our age of industrialization), the artist has to add to this power of comprehension an even more sublime gift, the *capacity for emotion*—not the capacity everyone experiences before illusory combinations of beings and things, not the ca-

pacity familiar to music-hall songsters and manufacturers of chromolithographs, but a transcendental capacity for emotion so great and so precious that it causes the soul to quiver in the presence of the undulating drama of abstractions.[144] Oh, how few are they whose bodies and hearts are moved by the sublime vision of pure being and pure ideas! But this gift also happens to be the *sine qua non,* the spark that Pygmalion desired for his Galatea, the spiritual illumination, the golden key, the daimon,[145] the Muse. . . [Aurier's ellipsis].

Thanks to this gift, symbols—that is, ideas—rise out of the darkness, become animated, start living a life that is no longer our contingent and relative life but a life of dazzling light that is the essential life, the life of art, the life of the being.

Thanks to this gift, the art that is complete, perfect, absolute finally exists.

One finds consolation in dreaming about such art, the art I like to imagine in the course of the compulsory strolls among the pitiful and depraved artsy-crafteries of our industrialist art exhibitions.[146] Such is the art, I also believe—unless I have misinterpreted the thought underlying his output—that this great genius Paul Gauguin, endowed with the soul of a primitive being and to some extent that of a savage, has endeavored to introduce in our lamentable and putrefied nation.

His output, already marvelous, I can neither describe nor analyze here. I shall content myself with characterizing and justifying the praiseworthy aesthetic conception that appears to guide him. How, indeed, can one suggest in words all that is inexpressible, the ocean of ideas that the clairvoyant eye can perceive in these magisterial works, the *Calvary, The Struggle of Jacob and the Angel,* the *Yellow Christ;* in these wonderful landscapes of Martinique and Brittany, in which all line, all form, all color is the word of an idea; in this sublime *Garden of Olives,* in which a red-haired Christ seated in a desolate site seems to convey through his tears the inexpressible sorrows of the dream, the agony of the Chimera, the betrayal of contingencies, the vanity of the real and of life, and, perhaps, of the beyond. . . .[147] How can one put into words the philosophy of the carving ironically titled *Be in Love and You Will Be Happy,* in which lechery in full power, the struggle of flesh and thought, and all the suffering of sexual voluptuousness twist about and, so to speak, grind their teeth? How does one evoke that other wood carving, *Be Mysterious,* which glorifies the pure joys of esoterica, the troubling caresses of the enigma, the fantastic shadows of the forests of the problem? How can one explain, finally, the strange, barbaric, and savage ceramics in

which, sublime potter that he is, he has kneaded the soul even more pow-
erfully than the clay? . . .

✦

Yet one must consider that however troubling, masterly, and marvelous his
output, it amounts to little in comparison with what he could have pro-
duced in another civilization. Gauguin, like all ideist painters, is, above all,
a decorator. His compositions are constrained by the restricted field of his
canvases. One might sometimes be tempted to take them for fragments of
enormous murals, and they almost always seem ready to burst the frames
that unduly contain them . . . [Aurier's ellipsis].

Now then! In the course of our century we have produced only one great
decorator, two, perhaps, when counting Puvis de Chavannes. And our im-
becile society of bankers and *polytechniciens* refuses to provide for this rare
artist the least palace, the most diminutive national shack, in which to dis-
play the sumptuous cloak of his dreams![148]

The walls of our Boeotian Pantheon are soiled by the ejaculations of the
Lenepveus and the thingamajigs of the institute! . . . [Aurier's ellipsis].
Come on, have a little sense; you have among you a decorator of genius:
walls! walls! give him walls! . . . [Aurier's ellipsis].[149]

Letter to André Fontainas (1899)

Gauguin wrote the letter from which the text that follows is excerpted during his second stay in Tahiti. He had returned to the island in 1895 after a stay in Paris and in Brittany in 1893–94. It was addressed to André Fontainas, a Belgian-born symbolist poet who had become a somewhat overliteral disciple of Mallarmé. He held Aurier's former post as art critic for the *Mercure de France* at the time Gauguin wrote to him.

In that periodical Fontainas wrote a lukewarm review of Tahitian works by Gauguin exhibited at the dealer Ambroise Vollard's gallery late in 1898. He compared them with Puvis's more easily decipherable pictures, commenting specifically on *Whence Do We Come? What Are We? Where Do We Go?* of 1897 (Fig. 35): "I do not very much like the art of Paul Gauguin." Although the critic recognized the strength of the artist's drawing and acknowledged his ability to create in the viewer's mind "a reverie analogous to his own," Fontainas complained that "nothing—neither the two supple and pensive figures who drift through it, tranquil and so beautiful, nor the clever evocation of a mysterious idol—would reveal the meaning of the allegory if [Gauguin] had not taken the precaution of writing in a corner, at the top of the canvas 'Whence do we come? What are we? Where do we go?' [D'où venons-nous, que sommes nous, où allons-nous?]."[150]

Gauguin's rebuttal consisted of an ironic lesson on the aesthetics of symbolism. The artist felt he had been at the very core of the symbolist movement, having been anointed by Aurier in the *Mercure de France* some eight years earlier. Moreover, Mallarmé and his circle had welcomed him after the young symbolist poet Charles Morice introduced him in late 1890 or early 1891.[151] Gauguin attended Mallarmé's Tuesdays, and the poet and artist gave further tangible evidence of their esteem for each other: Gauguin made a pencil portrait of Mallarmé that he subsequently used for a magnificent etching; he presented a copy of it, warmly inscribed, in January 1891.

In 1895 he gave the poet a dedicated print of a woodcut, *Oviri* (The savage) based on a ceramic statue he later wished to have placed on his own grave. At around the same time, he carved a log evoking a Tahitian faun-god and nymphs, *L'Aprés-midi d'un faune* [The afternoon of a faun], named after Mallarmé's celebrated poem. In January 1891 the poet askèd Octave Mirbeau to write an article in a major daily before Gauguin's public sale of his works to raise funds for his first departure for Tahiti scheduled for April 4.[152] Mallarmé also proposed the first toast to Gauguin at a farewell banquet in his honor at the Café Voltaire on March 23.

Not surprisingly, Gauguin drew on Mallarmean aesthetics in his letter to Fontainas.[153] Reaffirming the role of musicality, he explained that the inscription under the painting is "in a written language," whereas the subject (here he quoted what must have been a comment by Mallarmé) is "a musical poem" that "needs no libretto."

In one respect, however, Gauguin returns to an earlier notion of the emotional impact of line and color. Although he stresses "the musical role color will henceforth assume in modern painting," he later asserts that "the essence of a work of art . . . consists precisely of what is not expressed, from which lines arise implicitly, without colors or words," thus recalling Dujardin's statement in his article on cloisonism of 1888: "line expresses what is permanent, color what is momentary."

Gauguin's dismissal of "literature" in painting, incidentally, has a rhetorical flavor. The expressive content, he claims, is conveyed "without any recourse to literary means"; the idol is not meant as a "literary explanation"; even the inscription is "not so much a title as a signature." These are among the pointers to the importance Gauguin attached to musicality. Nevertheless the inscription, whether it is a title or a signature; the idol; and the references to both ancient myths and the artist's views on creation and the cycle of life—all pertain to the play of associations.

The myths themselves, dating from times "immemorial," were drawn from *Voyage aux îles du Grand Océan* of 1837, written by the traveler Jacques-Antoine Moerenhout at a time when some of the older inhabitants still remembered the native religion, the practice of which had been almost totally eradicated by Christian missionaries. The statue in *Whence Do We Come* is that of Hina, goddess of the moon. She had attempted to secure life after death for man, while her lover, the god of the earth, Tefatou, was determined that material life, including man's, should eventually end. A quarrel between the two ended in victory for the god.[154] In Gauguin's several pictorial interpretations, however, Hina scored a moral victory in that the cycle of reproduction ensured the survival of humanity.

Gauguin's references to the old Polynesian religious tradition constitute in

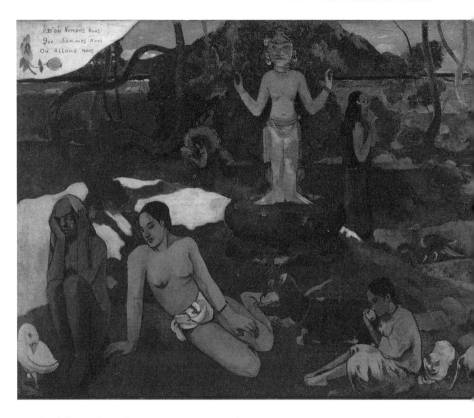

35. Paul Gauguin, *Whence Do We Come? What Are We? Where Do We Go?*
1897. Oil on canvas, 139.1 × 374.6 cm. Tompkins Collection, courtesy
Museum of Fine Arts, Boston. Photo copyright 1991 Museum of Fine Arts,
Boston. All rights reserved.

Here, near my hut, in total silence, I dream of violent harmonies amid the natural
perfumes that intoxicate me. GAUGUIN

some respects a return to the Parnassians' love of ancient myths. Gauguin
nevertheless assumed the role of an imaginative anthropologist, re-creating
Polynesian mythology in a visual language inspired by the natives them-
selves and the archaeological artifacts he found and resuscitating, so to
speak, their primordial dreams.

 In the picture, the goddess impassively watches the figures before her as
both an impotent observer of the rise and fall of the individual and a witness
to the lasting cycle of life. Birth,[155] maturity, death, and decay are sug-
gested, from right to left, by the figures on the canvas—the standing male
in the center picking the biblical apple that set the whole cycle in motion.
Goddess and villagers, however, are only part of the principal drama, which

also expresses an agonized state of the soul. In a letter from Tahiti, Gauguin described the conditions under which the picture was painted:

> The mail having arrived, not having received anything from [the dealer] Chaudet, and having almost recovered my health, that is, having no longer a chance of dying naturally, I decided to kill myself. I went to hide in the mountains, where my corpse would have been devoured by the ants. I had no revolver, but I had arsenic I had hoarded when I was ill with eczema; was the dose too strong, or did my vomiting the poison annul the effect? I do not know. After a terrible night of suffering I returned home. . . . I wanted to paint, before dying, a large canvas I had composed in my head. I worked night and day all month in an unheard of fever. . . . I shall never make a better or a similar one.[156]

In other words, the meditation on life, death, and humanity's survival evoked by the picture was Gauguin's artistic testament.

The excerpts that follow are from a copy of the original letter, kindly shared with me by Victor Merlhès. It will appear in a forthcoming volume, *Correspondance de Paul Gauguin,* ed. Victor Merlhès (Paris: Fondation

Singer-Polignac). The translation omits words Gauguin crossed out and adds punctuation. Gauguin's epigraph is from Verlaine's *Sagesse* (Paris: Société générale de librairie catholique, 1881), 84.[157] ❧

Tahiti, March 1899

A vast black sleep
Falls over my life
Sleep, all hope
Sleep, all desire

 Verlaine

Monsieur Fontainas,

Mercure de France, January issue, two interesting articles: Rembrandt—Galerie Vollard. I am mentioned in the latter; despite your repugnance, you have shown that you intend to study the art, or rather the work, of an artist who does not affect you emotionally, and write about him with integrity. This is a rarity in criticism today.

I have always thought the painter had a duty not to respond to reviews, neither those that are insulting—especially not those—nor those that are complimentary, which are often elicited by friendship.

Without abandoning my habitual reserve, this time I am impelled to write to you—by a caprice, if you will—and like any man guided by passion, I cannot resist. This is not an answer, since it is a personal note, but a simple discussion of art: your article invites it, calls for it.

We, painters—those condemned to misery—accept all the vicissitudes of material life without complaining, but we suffer in that these constitute a hindrance to our work. How much time is wasted just getting our daily bread! Lowly manual tasks, defective studios, and a thousand other impediments—hence much discouragement and, as a result, impotence, anger, violence.

You could not care less about all these considerations; I bring them up only to convince the two of us that you are quite justified in mentioning my faults.

Violence, monotony of hues, arbitrary coloring, and so forth. Yes, all this must be true, is true. Sometimes, though they are deliberate, do not these repetitions of monotonous harmonies—in terms of the musical significance of color—invite analogies with oriental melopoeias, sung in a sharp voice accompanied by close, vibrant tones that enrich them through opposition? Beethoven makes frequent use of them (so I thought, at least)—in the *Pathé-*

tique sonata, for instance—as does Delacroix, with his repeated harmony of brown and muted violets—somber cloak suggesting the drama.

You often go to the Louvre. Think of what I am saying and take a careful look at Cimabue. Think also of the musical role color will henceforth assume in modern painting. Color, which, like music, is vibration, can reach what is most general and consequently most vague in nature: its inner power.

Here, near my hut, in total silence, I dream of violent harmonies amid the natural perfumes that intoxicate me. My delight is enhanced by I know not what sacred and horrible ritual I sense in times immemorial. I breathe in the present the aroma of joy from earlier times. Animal figures rigid like statues: something ancient, august, religious in the rhythm of their gestures, in their exceptional immobility. Eyes that dream have the quivering surface of an unfathomable enigma.

And now comes night—everything rests. My eyes are closed so that they might *see without understanding* the dream that flees before me into infinite space; and I feel the sweet, sad progress of my hopes.

Praising certain pictures I consider insignificant, you exclaimed: "If only Gauguin would always be like that!" But I do not always want to be like that! And "in the large picture Gauguin exhibits, nothing would reveal to us the sense of the allegory, if . . ."—but my dream cannot be grasped [Gauguin's ellipsis]. It embodies no allegory: a musical poem, it needs no libretto (as Mallarmé has said). As a result, the essence of a work of art, immaterial and superior, consists precisely of what is not expressed, from which lines arise implicitly, without colors or words. The work is not materially constituted by these.

Mallarmé was also heard to say in front of my Tahiti paintings: "It is extraordinary that one should be able to put so much mystery into so much splendor."

To return to the panel,[158] the idol is not meant as a literary explanation; it is there as a statue. Perhaps it is less a statue than the animal figures, and less animal-like, being an integral part of what I dreamed in front of my hut, along with the whole of nature that reigns over *our primitive soul,* the imaginary consolation for our sufferings insofar as these are vague and misunderstood in relation to the mystery of our origin and our future.

And all this sings painfully in my soul as well as in the setting in which I simultaneously paint and dream, with no graspable allegory in reach—perhaps because of my lack of literary education.

When reawakening, once my work is completed, *I say to myself:* Whence do we come, what are we, where do we go? The reflection is no longer part of the picture and is therefore set out separately in language, on the surface around it—not so much a title as a signature.

You see, much as I understand the value of words—abstract or concrete—in the dictionary, I no longer grasp them in painting. I have tried to translate my dream into a decorative setting without any recourse to literary means, with the greatest possible simplicity in the practice of my craft—a difficult task. Blame me for failure but not for trying, and do not advise me to alter my goal in order to dither, like Puvis de Chavannes, with ideas that have already been accepted, consecrated.

To be sure, Puvis overwhelms me with his talent, as well as experience, which I lack; I admire him as much as you do, even more, but for different reasons (do not let this make you angry)—and with greater knowledge of the matter. Each to his own time.

The government is right not to commission me to decorate a public building. Such a decoration would upset the ideas of the majority, and I would be wrong to accept it, for I would have no alternative but to cheat the public or the government or to lie to myself.

At my Durand-Ruel exhibition, a young man asked Degas to explain pictures he did not understand.[159] Smiling, Degas recited a fable by La Fontaine. "You see," he said, "Gauguin is the thin wolf, without a collar."[160]

My fifteen-year struggle has liberated me from the Ecole [des Beaux-Arts], and all that sorry bundle of recipes without which there was no salvation, no honor, no money. Drawing, color, composition, sincerity in the presence of nature, what more can I say? Only yesterday some mathematician was trying to impose on us immutable lights and colors (Charles Henry's system).

The danger is over. Yes, we are free, and yet I see the gleam of danger on the horizon: *and* I want to talk to you about it. This long and boring letter is only written with this in mind.

Today's school of criticism, serious, full of good intentions, and educated, is inclined to impose on us a way of thinking, of dreaming that would bring about another enslavement. Preoccupied with what concerns it, with literature its special domain, it might lose sight of what concerns us: painting. If this were indeed to happen, I would haughtily repeat to you Mallarmé's definition: "A critic! A gentleman who minds someone else's business!"

In memory of him, allow me to offer you these few lines sketched in a minute, vague memory of a beautiful, beloved face, with a limpid glance in the darkness. It is not a gift but an appeal to your indulgence, of which I shall have need because of my madness and my savagery.

Very cordially,
Paul Gauguin

VINCENT VAN GOGH

Letters on *The Night Café* (1888)

Dutch-born Vincent van Gogh (1853–1890) served as an apprentice salesman in various branches of the prosperous international art dealer Goupil & Cie and then studied painting, first at the Academy School in The Hague, then on his own in the Dutch countryside, and finally at the Antwerp Academy School.[161] In pursuing these activities, he familiarized himself with the principles and techniques of the romantic-naturalist Barbizon School and its vigorous offspring in the Netherlands, the School of The Hague. Both were essentially naturalist but had symbolist propensities. Expressiveness of form, color, and subject turned the works produced by artists of these schools into moving odes to village life and the faith and fortitude of the peasants.

Van Gogh wrote to his brother, Theo, in 1885 of the expressive distortions of his predecessors: "My great longing is to learn to make those very mistakes, deviations, remodelings, changes in reality, so that they may become, yes, lies if you like—but truer than literal truth."[162] Men, animals, inanimate objects were endowed with a moving symbolism:

> The return of the sheep at dusk was the final movement of the symphony I heard yesterday.
> The day went by like a dream. All day I was so immersed in that heartrending music that I literally forgot food and drink. . . . The day was over, and from dawn till dusk, or rather from one night till the other, I had totally abandoned myself to that symphony.[163]

Vincent moved to Paris in 1886, living there with his brother, who managed the branch of Goupil & Cie—by that time Boussod & Valadon— specializing in avant-garde art. Soon after his arrival in Paris his palette lightened, and he gradually became an adept of impressionism. He then experimented with neo-impressionist technique and its small dot, retaining

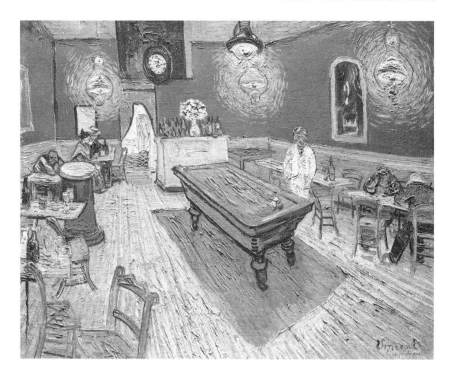

36. Vincent van Gogh, *The Night Café*, 1888. Oil on canvas,
72.4 × 92.1 cm. Yale University Art Gallery, New Haven, Connecticut,
bequest of Stephen Carlton Clark. Photo Josef Szaszfai.

*I have sought to convey that the café is a place where one can ruin oneself, go mad,
commit a crime.* VAN GOGH

by 1887 only the multicolored striations used by Seurat and Signac before
they painted whole pictures in the small-dot technique. Eventually he
adopted a loosely cloisonist or synthetist approach, often using large, bold,
and expressive brushstrokes that created their own patterns in relief on the
surface. By 1888 Vincent's strokes were turbulent monochromes within the
distinct areas that were prerequisites of synthetism. They looked like swirl-
ing streams, the hue often varying from one stroke to the next while still
respecting an overall synthetist color configuration. The resulting surface
effects were dazzling and fully justified the potent metaphors Aurier devised
to convey their decorative and expressive power.

The extracts that follow all refer to *The Night Café* (Fig. 36), executed
early in September 1889, when van Gogh was waiting for Gauguin to join
him at Arles. He had been in this quiet and picturesque city in southern

France since late February, trying to soothe his perennial inner turmoil far from the tense atmosphere of Paris, enjoying the climate, and discovering Japanese traits in the landscape, or convincing himself that he did: "I am always telling myself *that here I am in Japan,*" he wrote his sister from Arles.[164]

The letters excerpted here span just over a month's time. They reveal van Gogh's perspicacity and honesty in analyzing the conflicts of his own soul. The same conflicts, raised to the level of universal dramas, invest the humble café. The play of associations is evident. Judging from the attitudes of the waiter and the clients, the café was a quiet enough place; yet in painting it, van Gogh wanted to hint at the passions that tormented him. He described the café as "a place where one can ruin oneself, go mad, commit a crime." To stress the point, he declared that he wanted to evoke dramas like those of Tolstoy in *The Power of Darkness* and Zola in *L'Assommoir,* both of them somber and heartrending works about the blight of alcoholism. Indeed, in keeping with what we have called musicality, he meant "to express with red and green the terrible passions of humanity." He added: "The color is not locally true from the realist trompe l'oeil standpoint but suggests some emotion of an ardent temperament." When he contrasted the "tender Louis XV green of the counter, on which there is a pink nosegay," to "this fiery furnace" as well as "an infernal furnace of yellow sulfur," he was metaphorically opposing the sensualism and moral dissolution of Louis XV and his rococo age with the severe puritanical tradition of the Protestant faith in which he himself had been raised.

Under the pretext that the café gave refuge to wanderers with nowhere to go, van Gogh set out on a metaphysical disquisition. He thought of himself as "a traveler going somewhere, to some destination," though he implied that "the somewhere and the destination do not exist." This in turn led him to accept human beings as "nothing at all" but having "the illimited possibility of a future existence." Human beings were accordingly "*unsubstantial*"; thus he stressed in another letter: "I want to paint men and women with the I-know-not-what of the eternal that the halo used to symbolize, which we seek to convey by the actual radiance, the vibration of our coloring."[165] However tangible they may appear, figures and objects are thus part of an intangible, spiritual world and must be looked on as apparitions or visions. What is more, van Gogh, intent on arguing that there will be an afterlife, weighed the merits of worldly fame against the assurance of heaven. Ultimately, his spirituality was as compatible with old-fashioned religious values as with a new religion of humanity.

In the actual Night Café, van Gogh quarreled with Gauguin in December 1888, on the night he cut off part of one ear.

The excerpts that follow are from letters of Vincent van Gogh to his

brother, Theo. The first set is from a letter of August 6, 1888, no. 518, 2/4–4/4; the second, from one of September 8, 1888, no. 533, 1/4–2/4, 3/4, 4/4; the third, from one of September 9, 1888, no. 534, 1/8, 6/8 (dated by Pickvance, *Van Gogh in Arles* [New York: Metropolitan Museum of Art and Harry N. Abrams, 1984], 263). They are reproduced by kind permission of the Vincent van Gogh Foundation, Amsterdam. All can be found in *Letters of Vincent van Gogh (1886–1890): A Facsimile Edition,* Vincent van Gogh Foundation, Amsterdam, 2 vols. (London: Scolar Press, 1977). ❦

August 6, 1888

My dear Theo,

. . . Today, I shall probably begin the interior of the café where I am boarding, in the evening by gaslight. It is what is called here a "night café" (they are fairly numerous), which stays open all night. Night wanderers can find shelter in them when they do not have enough money for a lodging or are too drunk to be admitted to one.

All those things—family, country,—are perhaps more appealing in the imagination of those like us who can fairly readily do without a country or a family than in reality. I always feel I am a traveler going somewhere, to some destination. But if I should tell myself that the somewhere and the destination do not exist, that statement would seem to me well argued and truthful. A brothel pimp bouncing someone abides by a similar logic, reasons well, and is always right. I know it.[166] So at the end of the road I shall be wrong. So be it. At that time I shall find out that the fine arts and everything else as well were but dreams, we ourselves nothing at all. If we are as *unsubstantial as that,* so much the better for us, for then nothing would interfere with the illimited possibility of a future existence. How is it that in the present case of our uncle's death the dead man's face was calm, serene, and grave, whereas when he was alive, whether young or old, he was not like that? I have often observed a similar effect when looking at a dead person as if to question him. And this for me is a proof—not the weightiest one—of a life beyond the grave.

Likewise, a child in his cradle, when one watches it at one's leisure, has the infinite in its eyes. In sum, although I know nothing about it, it is precisely this feeling of *not knowing* that renders the real life we are currently living comparable to a simple railroad trip. One travels fast, but one does not distinguish objects from a very close range, and above all, one does not see the locomotive.

It is rather strange that our uncle, like our father, believed in an afterlife. Quite aside from our father, I have heard our uncle argue several times on

this point. Ah, to be sure, they were far more convinced than we are and showed anger when affirming their beliefs if one dared to delve into the matter in depth.

I do not see much in the notion of artists living after death *through their works*. Yes, artists do establish a continuity by passing along their torch, Delacroix to the impressionists and so forth. But is that all?

If a good old mother of a family, whose ideas have probably been limited and paralyzed by the Christian system, should be immortal, as she firmly believes she is—and I for one will not contradict her—why would a consumptive and neurotic hackney-cab horse like Delacroix or Goncourt, whose ideas, nevertheless, are broad, be any less worthy of immortality?[167] All the more so since the shallowest people feel a budding awareness of this indefinable hope.

Enough, though. What is the point of worrying about it? But why should not we, living at the heart of civilization, the heart of Paris, the heart of the fine arts, retain this old woman's *me?* If the women themselves lost their instinctive belief in "that is that," they would not find the necessary force to create and to act.[168]

At that point the physicians will tell us that not only Moses, Mahomet, Christ, Luther, Bunyan, and others were mad, but also Frans Hals, Rembrandt, Delacroix, and the little old women with as narrow a range of ideas as our mother.[169]

Ah, this is serious. One might ask these physicians: what, then, of the reasonable people? Are they the brothel pimps who are always right? It is likely.

So what to choose? Luckily, we do not have to choose.

A good handshake.

Ever Yours,
Vincent

September 8, 1888

My Dear Theo,

A thousand thanks for your good letter and the three hundred francs you enclosed. After a few weeks marred by worries, I have just had a much better one. And just as worries do not come singly, neither do joys. Indeed, always under financial pressure from the landlord [the café's owner], I made the best of it in a cheerful way. I had bawled out my landlord, who is not a bad man after all and told him that to avenge myself for having paid so much money unnecessarily, I would paint his whole wretched dump so as to repay myself. As a result, to the great joy of the landlord, the postman I

had already painted, and the night-wandering visitors—and to my own great joy—I spent the whole of three nights painting, going to bed in the daytime. It often seems to me that the night is much more lively and richly colored than daytime. Now as far as recouping the money I paid the landlord is concerned, I am not insisting, for the painting is one of my ugliest ever. It is equivalent to, although different from, the *Potato Eaters*.[170] I have tried to express with red and green the terrible passions of humanity.

The room is blood red and dull yellow; a green billiard table in the middle; four lemon yellow lamps whose rays are orangy yellow and green.[171] Everywhere the most diverse antithesis of reds and greens struggles. In the figures of the little sleeping tramps in the sad and empty hall, violet and blue. The blood red and the yellow-green of the billiard table, for instance, contrast with the discreet,[172] tender Louis XV green of the counter, on which there is a pink nosegay.

The white clothes of the proprietor watching in a corner in this fiery furnace become a pale and luminous green–lemon yellow.

I am making a drawing of the picture heightened in watercolor to send you tomorrow, to give you an idea of what it is like. . . .

The color is not locally true from the realist trompe l'oeil standpoint but suggests some emotion of an ardent temperament.

When Paul Mantz saw at the Champs Elysées exhibition we went to the violent and exalted sketch by Delacroix, *The Boat of Christ,* he exclaimed afterward in his article, "I did not know one could achieve such a terrifying effect by means of blue and green."[173]

Hokusai causes you to exclaim in the same way, but, in his case it is the lines, the drawing, that prompts you to write in your letter: "These waves are claws, the embarkation is caught between them; one feels it."[174]

Well, if one were to apply the color just right, or draw just right, one would not convey those emotions. . . .

September 9, 1888

My Dear Theo,

I have just sent in the mail the sketch of the new picture, *The Night Café,* as well as another I did earlier. I might end up doing some Japanese prints and drawings. . . .[175]

In my painting *The Night Café* I have sought to convey that the café is a place where one can ruin oneself, go mad, commit a crime. Well, I have tried, by contrasts of tender pink and blood red and burgundy, and gentle Louis XV green and Veronese green contrasting with yellow-greens and hard blue-greens—all this in the atmosphere of an infernal furnace of yellow

sulfur—to express something like the power of darkness or an *assommoir*.[176] And all this under the appearance of Japanese gaiety and the good nature of Tartarin.[177]

And yet what would Mr. Tersteeg say of this picture?[178] He who in the presence of a Sisley—Sisley, the most discreet and tender of the impressionists—said: "I cannot help thinking that the artist who painted this was a little inebriated." My own picture, he would undoubtedly say, then, is a full-blown case of delirium tremens.[179]

G.-ALBERT AURIER

The Lonely Ones—Vincent van Gogh
(1890)

The text that follows is one of a series Aurier devoted to unrecognized art-
ists whom he considered superior. It appeared in the first issue of *Mercure
de France,* January 1890, by far the longest and most thoughtful article on
van Gogh during his lifetime.

It is characteristic of Aurier's rejection of Taine's principles of art history
that although he conceded that van Gogh "was not remote from his racial
heritage" and shared in particular the "realism" of the great Dutch seven-
teenth-century masters, he made it clear that the creative temperament tran-
scended geographic, racial, and even historical influences and asserted in-
stead the importance of the artist's psychological makeup, in keeping with
the symbolist concern for subjectivity.

Indeed, taking advantage of the leeway Emile Zola had unwittingly al-
lowed for symbolist developments in his celebrated definition of naturalism,
"a corner of nature seen through a temperament," already noted, the critic
stressed the role van Gogh's temperament played in his process of creation.
He compared the artist's execution to handwriting, endowed with intense
expressive power: "Even in the most minute characteristics of his technique,
he shows himself a powerful, daring male, often brutal but sometimes in-
genuously delicate." And the drawing is "frenzied, powerful, often clumsy,
and somewhat heavy." Aurier, moreover, was fully aware of the musical
parallel important to symbolists: "The brilliant and dazzling symphonies of
color and line . . . are but simple expressive *means* . . . of symbolization."
And he remarked on the associative value of pictorial elements: the shape of
the mountains brings to mind the backs of "mammoths or rhinoceroses";
the sunflower suggests the sun. And Aurier creates a Mallarméan metaphor
to evoke the total impression: the physical effect of the work, like "the
richest jewelry," [180] corresponds to states of the soul so intense that the form
becomes "nightmare," and the color "flame, lava, and precious stones."

Subjectivity, finally, transcends objective reality: through the artist's "great love . . . of the truth—his own truth—his temperament manifests itself."

One of Aurier's most remarkable contributions derives from a strong empathy with van Gogh's act of creation—an empathy that enabled him, among other things, to perceive and understand even the morbid aspects of the artist's genius. He refers to the repetition of certain themes as "monomaniac" and calls van Gogh "a terrible maddened genius . . . always verging on the pathological." But Aurier attributes to van Gogh's abnormalities the artist's ability to seize "the subtle, secret character of lines and forms and, even more, of colors, lights, nuances invisible to healthy eyes." The artist, we are led to surmise, takes advantage of his psychological makeup to create haunting visions.

Even before the article on Gauguin, Aurier perceived here a new art in which material reality was but a language with which to express the Neoplatonic Idea.[181] Although the attachment to matter that characterized Dutch art throughout its history persists, van Gogh "takes into account this magical matter only as a marvelous language ultimately intended to translate the Idea."

Aurier stressed other points of similarity between van Gogh and Gauguin. Van Gogh's drawing mostly "exaggerates character, simplifies, and vaults masterfully and victoriously beyond detail to achieve a magisterial synthesis and a grand style." Moreover, he noted van Gogh's enthusiasm for "an art of the tropics" and its eventual appeal to "the people . . . demanding works related to the newly inhabited regions." This statement was echoed by van Gogh in a letter written just after Gauguin had joined him in Arles: "What Gauguin tells about the tropics strikes me as marvelous. Without question that is where a great renaissance of painting will take place." And, a few days later: "I venture to hope that within six months Gauguin and I will realize that we have founded a little workshop that will last and will remain an outpost, or a way station, necessary, or at least useful, to all those wishing to visit the South."[182]

In the letter thanking Aurier for the article, van Gogh wrote that he appreciated it "as a work of art in itself. I find that you create color with your words; in sum, I recognize my canvases in your article, but better than they are in reality, richer, more meaningful."[183] Always modest, he promptly diverted some of the credit to others: Monticelli, "to whom I owe so much!" for "no colorist comes so straight and directly from Delacroix." And "I owe much to Gauguin."[184]

Fully aware of the complex symbolic overtones of Gauguin's work, van Gogh, moreover, rightly perceived that artist's moral concerns; in the same letter he called Gauguin "this friend [who] likes one to feel that a good

painting must be the equivalent of a good deed, even though he does not say so but, withal, with whom it is difficult to have sustained contacts without being aware of a certain moral responsibility."

Van Gogh did not share all of Aurier's dislikes in artistic matters and came to the defense of the successful academician Meissonier.[185] He also felt the need to correct the critic: he referred to a book of emblems he possessed, according to which "the sunflower follows the heavenly body that gives it life," when he wrote that "sunflowers . . . express an idea symbolizing gratitude."[186]

The excerpts that follow are from G.-Albert Aurier, "Les Isolés—Vincent van Gogh," *Mercure de France* 1 (January 1890): 24–29. ❧

Suddenly, now that I had returned to the ignoble, muddy, razzle-dazzle of the dirty street and ugly real life, these disparate bits and pieces of verse emerged in my memory, as if in spite of myself:

> The intoxicating sameness
> Of metal, marble, and water. . . .
> Everything, even the color black,
> Seemed polished, clear, iridescent;
> The liquid concentrated its glory
> In the crystalline ray. . . .
> And heavy waterfalls
> Like curtains of crystal
> Hung, blindingly bright,
> From metal ramparts. . . .[187]
> [Aurier's ellipses]

Under skies carved in glaring sapphire or turquoise, kneaded with I-know-not-what infernal sulfur, hot, pernicious, blinding; under skies like flows of molten metal and crystal, in which, now and then, suns emit scorching rays; under a steady, fearful multiplicity of trickling lights; in the heavy burning atmosphere of fantastic furnaces that would vaporize gold, diamonds, and singular gems—a strange, disquieting nature is displayed, at once real and almost supernatural. It is a nature given to excess, in which everything—beings, objects, shadows and lights, forms and colors—rears up, rises with raging determination to screech its own song in the most intense overpitched tone. Here trees twisted like the arms of battling giants proclaim, with menacing gestures of their knotted limbs and a tragic flight of their green manes, their untamable might, their muscular pride, their sap

warm as blood, their eternal defiance of hurricane, lightning, and cruel nature itself. Cypresses point toward the sky, their nightmarish flaming silhouettes pretending to be black; mountains arch their backs like mammoths or rhinoceroses; white, pink, and gold orchards recall the ideal dreams of virgins; squatting houses contort themselves like beings in a passion of physical delight or suffering, or like beings who simply think; stones, parcels of land, brush, lawns, gardens, rivers seem sculpted in unknown minerals, polished, reflective, iridescent, fantastic. The flamboyant landscapes look like multicolored enamels boiling in a diabolical alchemist's crucible; the foliage seems cast in antique bronze, or new-made copper, or spun glass; flowerbeds consist not so much of flowers as of the richest jewelry set with rubies, agate, onyx, emeralds, corundum, chrysoberyl, amethysts, and chalcedony. Here is the universal, mad, blinding glitter of things; matter, nature in its entirety, frenetically twisted, brought to paroxysm, carried beyond rage so that form becomes nightmare; color becomes flame, lava, and precious stones; light becomes a consuming fire; life, a high fever.

✦

Such, and without exaggeration, whatever one might think, is the impression the retina retains after a first glance at the strange, intense, and feverish works of Vincent van Gogh, this compatriot and worthy descendant of the old masters of Holland.

Oh! how far we are (are we not?) from the great, beautiful, robust, restrained older art of the Low Countries! How far from the Gerard Dous, Aelbert Cuyps, Terborchs, Metsus, Pieter de Hoochs, van der Meers, van der Heydens and their seductive canvases—canvases that are somewhat bourgeois because they have been so patiently elaborated, so dispassionately refined, their details rendered so scrupulously. How far from the beautiful landscapes—sober, moderate, often enveloped in gentle, gray, and imprecise vapors—of the van der Heydens, Berchems, van Ostades, Potters, van Goyens, Ruisdaels, Hobbemas! How far from the somewhat cold elegance of the Wouwermans, of the eternal candlelight of Schalcken, of the shy myopia, the fine brushes, and the magnifying glass of Pierre Slingeland![188] How far from the delicate color, always a little cloudy and hazy, of northern climes and from the indefatigable attention to detail of these even-tempered artists, products of a particular place and time, who painted, so to speak, by their fireside, calm in spirit, their feet warm, and their bellies full of beer. And how far from the competent, conscientious, scrupulous, Protestant, democratic, brilliantly commonplace art of these incomparable old masters

whose only fault—if indeed they thought it one—was to have been heads of families and mayors of towns! . . .

And yet, let no one be mistaken, Vincent van Gogh is not so remote from his racial heritage. He is subject to the ineluctable laws of atavism. He is Dutch to the core, of the sublime lineage of Frans Hals.

First, like all his illustrious compatriots, he is a realist in the fullest sense of the term. *Ars es homo, additus naturae* [Art is man added to nature], Chancellor Bacon once said. Emile Zola has defined naturalism as "nature seen through a temperament." Bacon's "homo additus" is the equivalent of Zola's "seen through a temperament." In essence the objective, which is always one, is shaped by the subjectives, which are always diverse, thus complicating the issue and making it impossible to judge irrefutably the sincerity of the artist. As a result, the critic is forced to make inferences that are hypothetical and always questionable. I believe, nevertheless, that in the case of Vincent van Gogh, despite the often dismaying strangeness of his works, those who wish to be impartial and know how to look cannot deny or contest the naive truthfulness of his art or the ingenuity of his vision. Indeed, besides the indefinable good faith and truth emanating from all his pictures, the choice of subjects, the constant relationship of the most excessive accents, the conscientious study of the characters, the continual search for the essence of every item, a thousand significant details all confirm beyond question his profound and almost childlike sincerity, his great love of nature and of the truth—his own truth.

Having established the above, we can characterize his human, or rather his artistic, temperament by a legitimate process of induction—a process that could be corroborated by biographical facts. What distinguishes all his work is excess—of strength, of nervousness, of violent expression. In categorically affirming the character of things, in often audaciously simplifying forms, in staring insolently into the sun, in the vehement ardor of his color and drawing, even in the most minute characteristics of his technique, he shows himself a powerful, daring male, often brutal, but sometimes ingenuously delicate. Beyond that, as one may gather from the quasi-orgiastic excesses of everything he has painted, his exalted temperament is the enemy of bourgeois sobrieties and of minutiae. He is a sort of drunken giant, more likely to move mountains than to handle bibelots on shelves, his feverish brain spewing lava into all the hollows of art. He is a terrible maddened genius, often sublime, sometimes grotesque, always verging on the pathological. Finally, and above all, he is affected by an extraordinary sensitivity, perceiving as he does with abnormal, perhaps even painful, intensity the subtle, secret character of lines and forms and, even more, of colors, lights, nuances invisible to healthy eyes, the magical iridescences of shadows. And this is why his own realism, the realism of a neuropath, his sincerity, and

his truth are so different from the realism, sincerity, and truth of the great petit bourgeois of Holland, whose bodies were healthy, whose souls were balanced—his ancestors and his masters.

✦

This respect and love for the reality of things cannot in themselves, finally, explain and characterize the profound, complex, exceptional art of Vincent van Gogh. Without doubt, like all the painters of his race he is conscious of the importance and beauty of matter, but more often than not he takes into account this magical matter only as a marvelous language ultimately intended to translate the Idea. He is almost always a symbolist, like the Italian primitives, mystics who scarcely felt the need to dematerialize their dreams, for he is continually pressed by the need to give his ideas precise, palpable, tangible forms; dense, fleshy, physical envelopes. In almost all his canvases, under this form, this fleshy flesh, this material matter, there lies, for whoever knows how to see it, a thought, an Idea, and this Idea, the essential substratum of the work, is at once its determining and final cause. As for the brilliant and dazzling symphonies of color and line, whatever their importance in the eyes of the painter, they are but simple expressive *means,* simple *processes* of symbolization. Indeed, if one did not recognize the existence of these idealist tendencies under this naturalist art, a large part of the work we are studying would remain incomprehensible. How would one explain, for instance, *The Sower* (Fig. 37), this august and moving sower, this rustic character with the forehead of a brutish genius, reminiscent of the artist himself, whose silhouette, gesture, and work have always obsessed van Gogh, whom he painted and repainted so often, sometimes under the incandescent red skies of dusk, sometimes in a glowing golden noon—how would one explain him apart from this idée fixe that haunts his brain: the need for a man to arrive now, a messiah, a sower of truth, to regenerate our decrepit art and perhaps also our imbecile industrialist society? Likewise this obsessive passion both for the sun, which he makes shimmer in the fiery glow of his skies, and for that other sun, that vegetal heavenly body, the sumptuous sunflower, which he repeats tirelessly, like a monomaniac—how can one explain it without admitting his preoccupation with a vague and glorious heliomythical allegory?

✦

Indeed, Vincent van Gogh is not just a great painter, enthusiastic about his art, his palette, and nature; he is also a dreamer, an exalted believer, a devourer of beautiful utopias living on ideas and on dreams.

For a long time he took pleasure in imagining a renewal of art sparked by

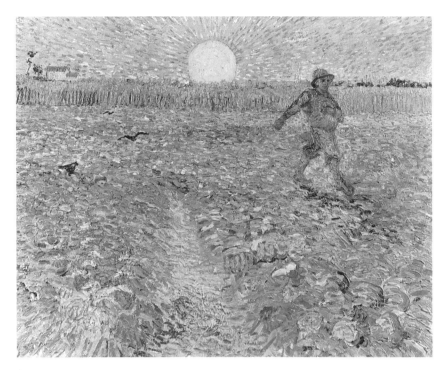

37. Vincent van Gogh, *The Sower*, 1888. Oil on canvas, 64.0 × 80.5 cm.
Rijksmuseum Kröller-Müller, Otterlo, Netherlands. Photo: Tom Haartsen.

*. . . a sower of truth, to regenerate our decrepit art and perhaps also our imbecile
industrialist society?* AURIER

a change of cultural setting: an art of the tropics.[189] People were demanding
works related to the newly inhabited regions; painters, facing a hitherto
unknown nature, wonderfully luminous, would finally admit the inade-
quacy of the old school tricks and set out, naively, to translate all these new
sensations! . . . [Aurier's ellipsis]. Indeed, would he himself not be the in-
tense and fantastic colorist who appears to grind gold and precious stones—
rather than like Guillaumet, the mawkish Fromentin, and the muddy Gé-
rôme[190]—the worthy painter of these resplendent countries, of flashing suns
and blinding colors? . . .

 And then, because of his conviction that everything had to start anew in
art, he had long cherished the idea of inventing a very simple painting,
popular in spirit, almost childish, that could move the humble, who do not
seek refinement, and be understood by the most naive among the intellec-
tually deprived. *Woman Rocking a Cradle,* this gigantic and inspired *image*

d'Epinal [popular woodcut], which he has repeated with interesting varia-
tions a number of times; the portrait of the phlegmatic and indescribably
jubilant *Postman; The Drawbridge,* so crudely luminous and so exquisitely
banal; the naive *Young Girl Holding a Rose, The Zouave,* and the *Provençal
Woman* indicate with the greatest clarity this tendency toward simplification
in art, one that, more or less emphasized, is found in all his work and ap-
pears to me neither absurd nor worthless in these extraordinarily compli-
cated times of myopia and clumsy analysis.

◆

Can all these theories, all these hopes of van Gogh's, be implemented?
Are they not vain and beautiful pipe dreams? Who knows? In any case, I do
not have to resolve the matter here. To complete my analysis of this unusual
spirit, so removed from the common path, I have only to say a few words
about his technique.

The external and material component of his painting is correlated abso-
lutely with his artist's temperament. In all his works the execution is vig-
orous, exalted, brutal, intense. His frenzied, powerful, often clumsy, and
somewhat heavy drawing exaggerates character, simplifies, and vaults mas-
terfully and victoriously beyond detail to achieve a magisterial synthesis and
a grand style—sometimes, but not always.

His color we already know: it is dazzling beyond any expectation. As far
as I know, he is the only painter who perceives the chromatic properties of
objects with such intensity, with such a metallic, gemlike quality. His in-
vestigations regarding the color of shadows, the influence of hues on other
hues, and of full exposure to the sun are most intriguing. Yet he does not
always know how to avoid disagreeable roughness, disharmony, disso-
nance . . . [Aurier's ellipsis]. As for his execution proper, his devices for the
actual coloring of the canvas are, like everything else about him, impetuous,
powerful, and nervous. His brush makes enormous impastoes of pure hues,
curved streaks interrupted by rectilinear strokes . . . [Aurier's ellipsis], often
clumsy buildups comparable to shimmering masonry, and all this gives his
canvases the solidity of dazzling ramparts of crystal and sunlight.

◆

This robust and genuine artist, very much a thoroughbred, whose brutal
hands are those of a giant, whose nervousness is that of a hysterical woman,
whose soul is that of a visionary, so original, and so detached from our
pitiful art of today, will he know someday—everything is possible—the
joys of reputation? the flattery—compounded by the public's remorse—of
success? Maybe. But whatever the outcome, even in the unlikely event that

it becomes fashionable to pay for his canvases the price of the disgraceful little pictures by Meissonier, I do not think the belated admiration of the public at large will ever be very sincere. Vincent van Gogh is at once too simple and too subtle for the contemporary bourgeois spirit. He will be fully understood only by his brothers—by the most artistic of artists . . . [Aurier's ellipsis] and by the blessed among the lowliest class, who will be fortunate enough to be spared the beneficent teachings of our public education system! . . . [Aurier's ellipsis].[191]

Cézanne (1888)

Paul Cézanne (1839–1906) exhibited in the impressionist group's first and third exhibitions, in 1874 and 1877.[192] He was so hurt by the exceptional abuse heaped on him by the press, however, that he stopped exhibiting with them. In the 1880s he began to spend much of the year in his native Aix-en-Provence, where he lived in relative isolation. He had gradually adopted impressionism's division of color in the early 1870s but always subordinated his handling of both form and color to a certain passion in the execution and willful distortions reflecting the emotions of a powerful temperament. These emotions are at the root of a revolutionary vision of his physical environment (Fig. 38) whose originality Huysmans perceived.

Indeed, however ironic Huysmans's tone, the critic was fully aware of both Cézanne's innovative vision and his "exasperated perception." It is likely, furthermore, that when Huysmans wrote about the "burdened canvas that bends," he alluded to Cézanne's lively modulations of colored planes. Huysmans was mistaken, however, in giving Cézanne's vigorous and expressive manner a role in the founding of impressionism. Cézanne's highly individualistic, often violent, expressive distortions led, not to the gentle hedonism of impressionism, but to the much more intense subjectivity and dramatic musicality of post-impressionism. That Cézanne was no novice in the play of associations is evident in some of his work: his two oils and watercolor *The Struggle of Love*,[193] depicting brutal and voluptuous bacchanalians, acquire an element of spirituality through the airy crystalline handling of forms and atmosphere and thus evoke emotional conflicts. Similar intentions are revealed by most of Cézanne's works, whether still lifes, views of mountains, or bathing scenes. Indeed, what Gauguin said of his backgrounds—that they "are as imaginary as they are real"[194]—applies to the eloquent transformations of visual reality characteristic of his whole mature output. Clearly there is a place for Cézanne, even if a marginal one, under the broad mantle of symbolism.

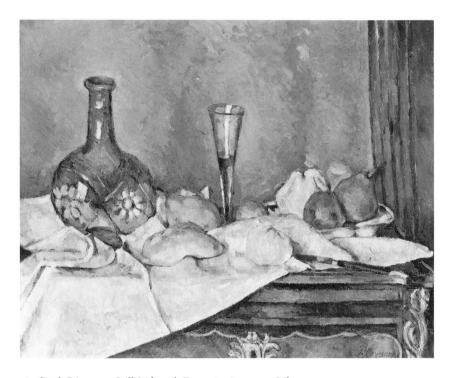

38. Paul Cézanne, *Still Life with Dessert*, 1877–79. Oil on canvas,
59 × 73 cm. Philadelphia Museum of Art, '63-116-5, Mr. and Mrs. Carroll S.
Tyson Collection.

Strange and real hues, singularly authentic spots, nuances [of glazes lightly applied
over] the linen, areas occasioned by the shadows of the curving fruit that spread into
plausible and charming bluish areas make these canvases all the more innovative to
the extent that one recalls the usual still lifes dashed off to become muddy repous-
soirs *detaching themselves from unintelligible backgrounds.*

<div align="right">HUYSMANS</div>

Huysmans did not conceal his ambivalence about Cézanne when Pissarro
questioned him a few years later: "Yes, his is an artist's temperament, but if
one sets aside a few still lifes that hold up well, the rest (in my opinion) is
not viable. It is interesting, unusual, suggestive, but he certainly suffers
from a visual defect, of which he himself is aware, I am told."[195]

The excerpt that follows is from Joris-Karl Huysmans, "Trois peintres—I
Cézanne," *La Cravache parisienne,* August 4, 1888. ❧

Fully lighted, in porcelain fruit dishes or on white tablecloths, are pears and
apples, rough, misshapen, formed with a trowel, corrected with the thrust

of the thumb. At close range: a furious plastering on of vermilion and yellow, green and blue; to the side, in dabs of paint, full, flavorful, inviting fruit destined for the showcases of Chevet.[196]

And hitherto unacknowledged truths become apparent; strange and real hues, singularly authentic spots, nuances [of glazes lightly applied over] the linen, areas occasioned by the shadows of the curving fruit that spread into plausible and charming bluish areas make these canvases all the more innovative to the extent that one recalls the usual still lifes dashed off to become muddy *repoussoirs* detaching themselves from unintelligible backgrounds.[197]

Then, there are sketches of plein air landscapes, attempts left in limbo, pictorial essays whose freshness is spoiled by retouching, childish and barbaric daubs, and finally an unsettling lack of equilibrium: houses leaning to one side like drunkards, lopsided fruit in lurching pots, nude bathers surrounded by insane lines, . . . [all] for the greater glory of the eyes endowed with the passionate ardor of a Delacroix without visual refinement or a discriminating touch, whipped by a frenzy of spoiled colors, screaming, in bold relief, on a burdened canvas that bends!

In sum, a revelatory colorist who contributed more than the late Manet to the impressionist movement, an artist with sickly retinas whose oversensitive vision discovered the first stages of a new art—in such words can we assess this forgotten painter Cézanne.

He has not exhibited since 1877, when his work was seen rue Le Peletier,[198] sixteen canvases whose perfect artistic probity was for a long time a source of laughter for the crowd.

PAUL CÉZANNE

Excerpts from His Letters (1904, 1906)

Cézanne, in various letters to colleagues, friends, and relatives, made several attempts to explain his physio-psychological response to nature as well as the intellectual effort required to translate it into pictorial language. He claimed only partial success in expressing verbally what were unquestionably intense and complex phenomena.

He once complained of being unable to do justice to the fullness of his impressions, specifically, to emulate "the magnificent richness of coloration that animates nature." He gave an idea of what he meant when he stressed his need to evoke the "links that attach [him] to this old native soil, vibrant, harsh, able to make light reverberate from it, causing the eyelids to blink and casting a spell over the physiology of sensations."[199] Incapable of rendering such effects on the canvas, he could at least, he explained, "animate this impression through another, corresponding, one, even in bitumen."[200] This was tantamount to the claim that the artist could proceed through sensory equivalents of his perception of nature, an echo of Baudelaire's concept of "correspondences." And Cézanne referred specifically to musicality when he wrote: "Art is a harmony parallel to nature."[201] Cézanne's work, moreover, has an element of Mallarméan sublimation, inasmuch as poignant emotions manifest themselves not so much through the object itself as through subtle iridescence and modulations of color and form. Cézanne developed a complex technique "to evoke the portion of nature that, falling under our eyes, gives us the painting."[202] With this technique in mind, starting in 1904 he exchanged letters with Emile Bernard, who had come to visit him at Aix in 1904 and 1905, after long sojourns in Egypt, Spain, and Italy. Bernard had abandoned cloisonism and was emulating the great Venetian masters of the late Renaissance, among others.

COMPOSING WITH COLORED PLANES (1904)

Cézanne was determined to have Bernard shed his infatuation with the art of the past. His principal argument was that, in keeping with the division of hues intuited by the impressionists and later systematized by Seurat, the artist breaks down light into its component hues and that in a good composition individual planes should be related to those individual hues, which he referred to as "half-tone, quarter-tone." The whole process comes down to a systematic response to one's sensations of color—a principle that happens to be at the root of the color modulations so characteristic of Cézanne's work. Were Bernard to follow it, Cézanne adds, he would have no need to "go from black to white," that is, no need for traditional value- (or shadow-) modeling, to which he clung "like a swimmer" to "a board."

Whereas Seurat and Signac referred to value as *ton* and hue as *teinte*, Cézanne here clearly intended *ton* to mean "hue," since, immediately after explaining his construction method in terms of tone, he stated that he was responding to the impact of color (*sensation colorante*), and it was generally accepted that black and white are not, in themselves, colors. This use of *ton* is not surprising; to this day, both *ton* and *teinte* can mean "hue," or "value," or both.

The excerpt that follows is from a letter of Paul Cézanne to Emile Bernard, December 23, 1904, in *Paul Cézanne. Correspondance,* ed. John Rewald (Paris: Grasset, 1978), 308–9. The italics follow those in P. M. Doran, *Conversations avec Cézanne* (Paris: Macula, 1978), 44–45. Courtesy of Editions Bernard Grasset and John Rewald. ❧

I received your good letter dated at Naples. I shall not engage in drawn-out aesthetic considerations. Yes, I approve of your admiration for the most valiant Venetians; we hold Tintoretto in high esteem. Your need to find moral, intellectual support in works that will surely never be surpassed makes you alert to subtleties that will undoubtedly lead you to derive your means of expression from your feeling for nature. Rest assured that when you have done this, you will again find effortlessly in nature the *means* employed by the four or five greats of Venice. Unquestionably—I affirm it—an optical sensation causes us to classify *according to light,* halftone or quarter tone, the planes evoked by color sensations. Light, therefore, does not exist for the painter. If we go from black to white, the first of these abstractions being comparable to a point of support, for the eye as much as for the brain, we flounder, we fail to establish our mastery *over ourselves.* At

this stage (I necessarily repeat myself) we are drawn toward the admirable works that past ages have transmitted to us, in which we find comfort and support, like a swimmer with a board. All that you say in your letter is quite true. I am happy to learn that Madame Bernard, you, and the children are in good health. My wife and my son are in Paris at the present time. We will get together, soon, I trust.

I am trying to respond as best I can to the principal points of your good letter. . . .

MULTIPLE VIEWPOINTS (1906)

Cézanne explains in a letter to his son one of the most original aspects of his handling of forms in space: the objects, in theory at least, are observed from various points of view. Herein lies the intellectual justification for the multiplication, superposition, and distortion of volumes and corresponding surfaces characteristic of Cézanne's mature works: "to capture the strong sensation of nature."[203] The cubist artist Jean Metzinger relied on this same conception of the movable point of view in his article "Cubism and Tradition" of 1911,[204] his attempt at a logical justification for cubism's complex breakup of objects into semitranslucent polygonal facets interpenetrating in space.

Cézanne stresses the importance of the relation between sensation and intellectual effort in any human undertaking: praising his son's handling of family business, he relates sensations and reason just as he had related sensations and colored planes in the letter to Emile Bernard.

The last paragraph reveals Cézanne's sardonic attitude toward the conventional seekers of material success as well as his own belief that only a combination of hard work and lucky breakthroughs leads to genuine achievement.

The excerpt that follows is from a letter of Cézanne to his son, Paul, September 8, 1906, in *Cézanne. Correspondance,* ed. John Rewald (Paris: Grasset, 1978), 324–25. Courtesy of Editions Bernard Grasset. ✦

My dear Paul,

Today (it is nearly eleven o'clock) the heat has returned with a vengeance. The air is superheated, without a whiff of a breeze. This temperature only promotes the expansion of metals, the welfare of liquor stores, the joy of beer merchants—whose industry seems to be assuming very respectable proportions in Aix—and the pretensions of our local intellectuals, a bunch of ignoramuses, cretins, and scoundrels.

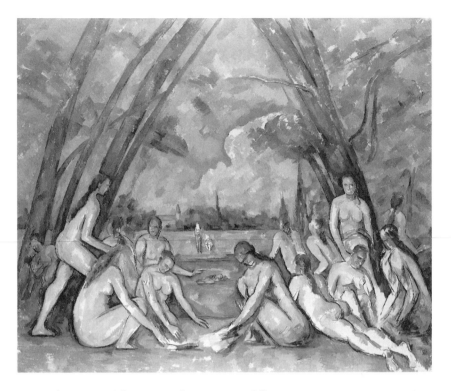

39. Paul Cézanne, *The Large Bathers*, 1902–6. Oil on canvas,
208.3 × 251.5 cm. Philadelphia Museum of Art, W '37-1-1, W. P. Wilstach
Collection.

Here on the bank of the river the motifs multiply; the same thing from a different
angle offers a subject of study of great interest, and so varied that I could keep busy for
months without changing places simply by leaning sometimes to the right and some-
times to the left.

CÉZANNE

There may be exceptions, but they are hard to find—modesty always
ignores itself. Well, I must tell you that I am becoming, as a painter, more
lucid in the presence of nature,[205] but with me, to realize my sensations is
always painful. I cannot achieve the intensity that manifests itself to my
senses; I do not have the magnificent richness of coloration that animates
nature. Here on the bank of the river the motifs multiply [Fig. 39]; the same
thing from a different angle offers a subject of study of great interest, and
so varied that I could keep busy for months without changing places simply
by leaning sometimes to the right and sometimes to the left.

My dear Paul, to conclude, I must tell you that I have full confidence in

your sensations, which lead you to manage our interests advantageously. This will give you an idea of what assurance I have in the direction you are taking with our affairs.

I have learned with a sense of patriotic pride that the venerable statesman who presides over the political destinies of France is expected soon to honor our region with a visit.[206] From Aix, he will cause much excitement among our southern population. Where will you be, Jo?[207] In this world and in life, are artifice and convention the surest preconditions of success? or is it a series of happy coincidences that makes our efforts succeed?

PAUL SÉRUSIER

Nabi Principles (1889)

The painter Maurice Denis, when he was nineteen, began an article, "Definition of Neo-Traditionism," with an axiom: "One must remember that before it is a war-horse, a nude woman, or whatever anecdote, a painting is essentially a flat surface covered with colors assembled in a certain order."[208] Denis went on to stress the importance of musicality, claiming that the impact of a work of art derived from form and color. He attacked any excessive reliance on studio recipes, rejected the "naturalist lie," and cautioned against both the literary spirit and literal illustration. Ultimately the feeling of the work of art must be rooted, "unconsciously, or almost so," in the soul of the artist—an eminently subjective point of view. His artistic credo and the religious fervor that characterized much of his own output were boldly exemplified by the childlike synthetism and emotional intensity of such early works as *Climbing Mount Calvary* of 1889 (Fig. 40).

Denis's article can be regarded as the manifesto of the Nabis, a group of art students of the Académie Julian that coalesced in the fall of 1888. The group included Paul Sérusier (1864–1927), who had just been in Pont-Aven in Brittany, where he executed a small panel painting under the virtual dictation of Gauguin by way of an initiation to the theories and practices of that artist. Aside from Denis, the group also included Pierre Bonnard, Henri Ibels, Georges Lacombe, Paul Ranson, Ker-Xavier Roussel, Edouard Vuillard, Auguste Cazalis. It was eventually to include the Hungarian József Rippl-Rónai and the Swiss Félix Vallotton. Most of the French artists had been pupils at the Lycée Condorcet, then called Lycée Fontanes, where Mallarmé taught English until 1884.

Nabi is the Hebrew word for prophet, and the new artistic creed the young men wished to disseminate was that of Gauguin. Around 1890 Cézanne was admitted to their pantheon, and a little later it was Redon's turn. On April 22, 1890, Denis made his first appearance at Mallarmé's Tuesdays, a visit that constituted an initial link between the Nabi group and the poet's entourage.[209]

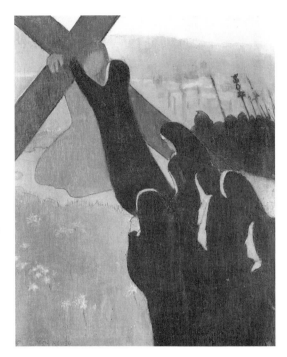

40. Maurice Denis, *Climbing Mount Calvary*, 1889. Oil on canvas, 41 × 32.5 cm. Musée d'Orsay, Paris, gift of Dominique Denis. Photo copyright R.M.N.- SPADEM.

One must remember that before it is a war-horse, a nude woman, or whatever anecdote, a painting is essentially a flat surface covered with colors assembled in a certain order.

DENIS

Sérusier wrote the letter that follows during his second stay in Brittany, in 1889, when he became even more closely associated with Gauguin, sharing a room with him in the little fishing village of Le Pouldu, a few hours' travel from Pont-Aven. Gauguin's ideas seem to have had a considerable impact on what Sérusier calls "our philosophy," which in turn affected Denis's article of 1890. Sérusier treats the "literary side" less harshly than Denis; in fact, like Gauguin, the Nabis did not avoid literary allusions, and they excelled at illustrating symbolist texts and designing sets and costumes for symbolist plays. Their acceptance of such allusions as only "a pretext" suggests their belief in an associative relationship between the ideas and moods of the text and the content and form of the picture.

Other theories of Gauguin's can be recognized in the letter, not least the rejection of manual skill stressed in articles he published in *Le Moderniste* in the summer of 1889.[210] Whether or not the Nabis relied on a science of art, they believed in its "immutable principles," and harmony was one of them—testifying to their allegiance to musicality. The stress on personality can be equated to subjectivity.

The excerpt that follows is from a letter of Paul Sérusier to Maurice Denis, between June 7 and July 27, 1889, in Paul Sérusier, *ABC de la peinture* (Paris: Floury, 1950), 42–45. ❦

PAUL SÉRUSIER

Brother Nabi,

To a philosophical letter, a philosophical response. I know some who would not like it, but you are not one of them.

First of all forgive the incoherence of my last letter, begun in a moment of bitterness and disgust and completed in a period of irrational elation. I am feeling remorse over what I told you about Gauguin.[211] There is no humbug about him, not, at any rate, with respect to those he knows are capable of understanding him. I have lived with him for the past fifteen days in the closest association. We share a room. I have told him what I dislike about his work: what I said can be regarded as a sally against the ingrained habits of contemporary painting.

But let's get back to our philosophy.

I am not attempting to establish an artistic formula; let us subdivide and analyze:

PAINTING

Art	Workmanship
(a) Immutable Principles	(a') Science
(b) Personality	(b') Manual skill

(a) Immutable principles exist in art. There is a science, namely aesthetics, that teaches them. Today this science is dead. It was alive in the days of the beatific primitives,[212] if not in written form, at least through tradition (the same is true of Japan). All one has to do to be convinced of it is to observe the impeccable harmony of line and color one finds in their works. These principles, forgotten over time, were rediscovered by a few geniuses such as Rembrandt, Velázquez, Delacroix, Corot, and Manet. These principles can be deduced from innate principles within us, ideas of harmony common to all unspoiled men. One may discover them inductively by observing, in the work of different masters of all times and all countries, common points; these are the laws of harmony of line and color.

(b) I respect personality; it is an abstract entitity. A certain number of lines and colors constituting a harmony can be arranged infinite ways. The literary side in painting is a secondary element of personality; it may exist—it must exist—but only as a pretext; if it dominates, one falls into the realm of illustration. You see that I do not wish to legislate personality. It is the variety we bring to unity that constitutes harmony. Short of individual personality, one can create beautiful things from the personality of a people or a country: Gothic cathedrals, Egyptian art.

(a') The science [of painting], although it is not absolutely necessary, never hurts. It obviates much experimentation by trial and error, but one must, above all, not confuse it with b', skill. The first can be taught; the second must not be, and must even be combatted. To give birth to a work

of art requires a system of signs, a handwriting; but calligraphy is of no use to the man of letters. What will necessarily happen to manual skill is what happened to handwriting: if one neglects it, it becomes all the more clumsy and personal.

In sum, a and a′ must be learned: one must determine formulas suited to them; b remains totally free; and as for b′, one must not bother with it. The more accurately a and a′ are established, the more freedom of action b has.

I do not know whether I am very clear: a large tome might be required to express my thought, as well as corroborating examples; we will talk again about all this.

MAURICE DENIS

The Nabis in 1890

Written a few months after the preceding letter by Sérusier, this letter bears witness to the spirit of camaraderie uniting the Nabis. These young men met once a month for lunch, performing, half in jest, semireligious rituals emphasizing their devotion to purity in art. They also gathered at other times to discuss their latest pictures and their views on art.[213]

The letter also testifies to the independence of each young man's experiments within the context of the basic principles acquired largely from Gauguin, whose impact Maurice Denis (1870–1943) emphatically acknowledges here (ironically, he mentions Gauguin only in passing in his "Definition of Neo-Traditionism,"[214] to which he makes reference). This letter reveals that Denis and the editor of the periodical *Art et critique* exchanged views on Gauguin when they met that eventually led to the acceptance of the article.

The Nabis, determined to succeed financially as soon as possible, were keen to show their work and to find support among influential people, a concern reflected in this letter as well as others. The Nabis slowly gained recognition through the Expositions des peintres impressionnistes et symbolistes, held at the gallery of the dealer Le Barc de Boutteville beginning in December 1891. They also received considerable support from *La Revue blanche,* founded in 1892.

The excerpt that follows is from a letter of Maurice Denis to Paul Sérusier, 1890, in *ABC de la peinture* (Paris: Floury, 1950), 49–52.[215] ❧

I respond to your letter immediately. I am delighted to perceive in it so much enthusiasm and such a sustained striving for improvement. We do not need to worry; there is no question that we are going forward. Bonnard, just back from his barracks, discovers new rhythms and subtle harmonies;

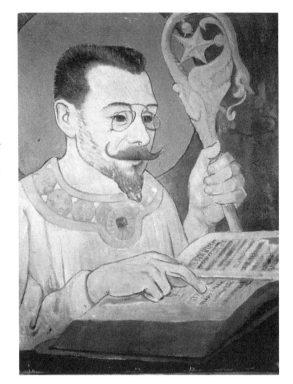

41. Paul Sérusier, *Paul Ranson, Nabi*, 1890. Oil on canvas, 60 × 45 cm. Private collection.

A certain number of lines and colors constituting a harmony can be arranged infinite ways. The literary side in painting is a secondary element of personality. SÉRUSIER

Vuillard (whose calm and joy come to him as a pleasant surprise after his three years of fever and uncertainty) produces, with such ease, the most delicate things one could dream of, always with unexpected elements in his exquisite forms. Ranson drags his feet; he is sad and unwell, suffering as he does from fatigue—Cazalis and I are concerned about it.[216]

Since the time of the Nabi honored only by the two of us, I have had the opportunity of becoming better acquainted with the Nabi Ranson [Fig. 41] and Madame Ranson, for whom a feminine form of the word *Nabi* is definitely needed. They have come to Saint-Germain twice and have encouraged me with effusive praise.[217]

Were it not for the competitions at the Ecole and the portraits one has to paint for reasons you will readily understand, I would work a lot: some of my works have given me much confidence in myself, and I do not find the finicky painting of little bourgeois canvases too demanding: it is such a different endeavor and has so little to do with painting![218]

While on this topic, I must tell you that three of us worry about the impossibility of making a living from painting. I recently saw the friend

who introduced me to the symbolists.[219] Do you remember the visit that was of so little use to us? He is set on trying once again to take aggressive steps. In the meantime, one of the young men I brought to see you, Stuart Merrill,[220] is becoming famous in New York, and one is becoming aware of that fame in Paris. My friend is obtaining high ratings in the Conservatoire competitions and widens his circle of acquaintance in the social world we have turned away from but still depend on.

No word on my Verlaine [illustrations],[221] but the periodical *Art et critique,* published by Jean Jullien, who admitted he understood nothing about the works of Gauguin at the time of the exhibition,[222] may well publish my frank notes on art. And then, my friend has spoken about us with his theatrical emphasis all along the boulevard: the people who know only Anquetin and Signac are enquiring: "Where are [the Nabis]?"

I shall put him in touch shortly with Vuillard and Bonnard,[223] and why not? Since we have to, we shall do what we can to have our works shown.

He insists that there be an organized movement: he wants us to assemble our studies under one roof (perhaps at your studio, which is near the boulevard?) to show them, not to the public, but to a very special audience. His practical common sense being what it is, he finds our scruples and our fear of putting forth incomplete works astonishing.

. . . [Ellipsis in printed source]. In the meantime, we might perhaps get opportunities to sell bourgeois portraits or inept illustrations.

I would be happy to receive an answer from you on these matters, as well as the opinion of P. Gauguin, if that is possible. Why are we waiting to proclaim what the public does not want to admit, that the author of the *[Breton] Calvary, The Struggle of Jacob and the Angel* [Fig. 34], and the carving *Be in Love* is simply a master?[224] Because—one must spell it out—Gauguin would be proposed as the dominant personality of neo-traditionism.

Finally, let us envy the supreme calm and independence you are enjoying over there as you contemplate the sea while we struggle, so painfully and clumsily, in the swells of ambition and cupidity. . . .[225]

[P.S.] Since you were able to give me valuable information on your current technical studies, do not fail to send me your notes on art, which I would submit alongside mine.[226]

And please give me the name and the address of the young priest who is a teacher of philosophy, of whom Ranson and Vuillard have spoken so highly.[227]

EDVARD MUNCH

The "Saint-Cloud" Manifesto (1889–90?)

The early articles of faith of Edvard Munch (1863–1944) that have been called a manifesto reappear several times, in slightly modified form, among the Norwegian artist's mostly unpublished, mostly autobiographical writings.[228] They originate in a set of notes written around the time of Munch's stay in Saint-Cloud, near Paris, in 1889.

During his first trip to Paris in 1885 Munch had adopted a somewhat more impressionist touch, updating a naturalist style derived from the Barbizon artists and already simplified and made colorful by Manet's impact in the 1860s on the avant-garde of Kristiania, present-day Oslo. He soon put the impressionist touch to the service of expression, accentuating the character of facial features and creating an overall blur to stress a visionary spirituality, rather than the physical interplay of light, atmosphere, and surfaces emphasized by the impressionists.

During a second stay in Paris, in 1889, Munch adapted from neo-impressionism a stress on linear edges and an interest in delicate lighting. He ignored the movement's small-dot technique, however, as he achieved effects that are both highly personal and haunting. A loosely synthetist technique that emerged in his work in the summer of 1891 owes much to Gauguin (well known to the Norwegian avant-garde at the time of the 1889 Universal Exhibition), whose works could be seen at the exhibition of the Grand Café des Beaux-Arts (Volpini) and at Boussod & Valadon, headed by Theo van Gogh, as well as at the residence of Gauguin's wife in Copenhagen, where Munch stopped in 1891.[229]

Munch was affected by the new awareness of symbolist developments in Nordic literature, as Ibsen transcended his apparent naturalism in evoking the eternal, often inexplicable, conflicts of human passions and younger writers, such as the novelist Knut Hamsun, stressed the unfathomable in man's psyche. In Paris Munch saw Mallarmé, whose portrait he executed in lithography in 1896.

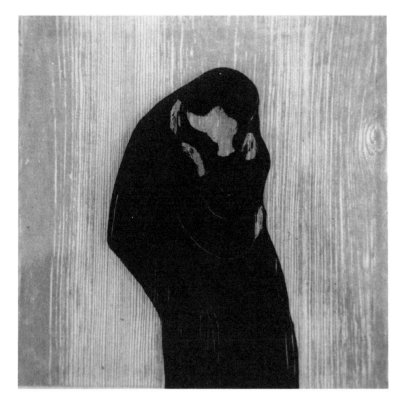

42. Edvard Munch, *The Kiss* IV, 1902. Gray and black woodcut, 44.7 × 44.7 cm. Munch-Museet, Oslo, Schiefler 102D.

The people who see this scene would understand its sacred character and take off their hats, as if in church. MUNCH

In his statement Munch articulates his intention to extract, like van Gogh, the most intense and universally relevant emotional messages from his observations of humanity (Fig. 42), thus announcing the advent of the expressionist movement, which flourished in the early twentieth century. His adoption of a synthetist manner enabled him to stress expressive musicality through bold simplifications of color and line and to implement his intentions with singular power.

Munch refers frequently to the subject of a work of art as but a link in the historical chain of human emotions. This idea is in keeping with his own effort to anchor his art in the realm of universals. For example, he often repeated a motif in his work, sometimes with ingenious variations, as if to stress that it continued to have significance for him as he evolved in time.

He was essentially creating both a linkage of current and variously distant events, similar in their fundamental significance but different in mood and expression, and a play of associative memories.

Munch was also aware of the aesthetic potential of showing together pictures with different subjects that are somehow linked through the personality of the artist who created them, as revealed in his comment on the major exhibition of his work in Berlin in 1892: "Various paintings had connections through their contents. When they were placed together, suddenly, a single musical tone passed through them, and they became totally different from what they had been before—a symphony resulted. It is in this way that I began to paint friezes." [230] Here the simultaneous viewing of different scenes—all highly subjective—seems to endow them with associative significance; Munch himself, moreover, establishes a musical parallel, related to content as well as to line and color.

The practice of variations on a motif had an antecedent in the work of Arnold Böcklin, with which Munch must have become familiar in the course of his travels. Both Gauguin and van Gogh, furthermore, consciously repeated motifs, introducing new variations each time to alter the emotional impact. [231]

The text that follows is reproduced from the "Saint-Cloud" manuscript at the Munch Museum, Oslo. Courtesy of the Munch Museum. ✦

A robust naked arm, a powerful tanned neck. A young woman resting her head on the muscular chest of the man. She has closed her eyes, she listens, her mouth half-open, to the words he whispers through her long, undulating hair.

I should like to give this scene, as I conceive it now, a material form, but in a bluish atmosphere. The man and woman, at that instant, were not themselves; they constituted a link in the interminable chain linking one generation to the next. The people who see this scene would understand its sacred character and take off their hats, as if in church.

I shall paint a certain number of pictures of this type.

One will no longer paint interiors in which one reads or knits. In the future it will be people who breathe, who suffer, and who love.

I felt it was my duty to paint such scenes—it seemed so natural to me. Their corporeal substance would take shape, and the color would come to life.

FERDINAND HODLER

The Mission of the Artist (1897)

Born in Bern, Switzerland, of poor parents, Ferdinand Hodler (1853–1918) had a mediocre schooling and became a painter of signs and tourist-trade landscapes as a youth. A chance encounter with the Geneva artist Barthé-lemy Menn, pupil of Ingres and erstwhile friend of Corot and a professor at Geneva's School of Fine Arts, led him to the serious study of art.

His first endeavors were in the naturalist vein, but before long, in rhyth-mic composition and expressive figures and evocative details, he introduced associations that were metaphysical in scope. At the sight of a still mostly naturalist painting of an old craftsman lost in his dreams, *A Look on the Eternal* (1885), his friend the avant-garde writer Louis Montchal was struck by a daring association: "Out of the contrast between this rough-hewn car-penter and this unfathomable word *Eternity* the mystical spark suddenly ignites."[232] The picture, somewhat abstract, also embodied an element of mystery in relation to an earlier (1879) work with the same title, now de-stroyed, that represented a man meditating near the corpse of his dead child.[233] A higher degree of abstraction is apparent in *Intimate Dialogue* of 1884, in which the synthetist rhythm of outline, remotely based on the male figure in ancient Egyptian friezes, and the self-absorption of the subject suggest that the nude youth depicted in the work is communing with a spiritual entity. About the time he painted this work, Hodler, through his close friendship with the editor of the avant-garde *Revue de Genève,* Louis Duchosal, was introduced to the aesthetics and music of Wagner, the poetry of Baudelaire, and, generally speaking, the principles of symbolist thought.

In subsequent years Hodler evoked states of the soul in large-scale pictures partially inspired by Puvis de Chavannes. He was much bolder than Puvis, however, in subordinating his forms to an essentially synthetist line that was forcefully simplified, hieratic, expressive, and rhythmically sweeping. The first great masterpiece in this manner, *Night* (1889/90), was acclaimed in 1891 at the second Salon of the Société Nationale des Beaux-Arts in Paris,

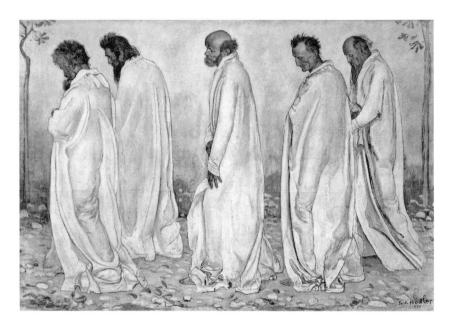

43. Ferdinand Hodler, *Eurythmy*, 1895. Oil on canvas, 167 × 245 cm. Kunst-museum, Bern.

It is easy to perceive the common principle and to understand that the parallelism of these subjects from life is also a decorative parallelism. HODLER

a group that had splintered from the Salon in 1890 under the leadership of Meissonier, a pillar of the Academy of the Fine Arts, as well as Rodin and Puvis; the group elected Puvis its president after Meissonier's death in 1890. It offered entrants more freedom than the official Salon and ensured a greater selectivity than the Salon des Indépendants. Hodler's *Eurythmy* of 1895 (Fig. 43) was also shown at the Salon de la Société Nationale des Beaux-Arts; it evokes what Hodler referred to as "the march of humanity toward death."[234]

The excerpts that follow are from a lecture Hodler delivered to define and explain his principal theories. Much of what he says about line falls under the general heading of synthetism. His discussion of color distantly echoes the theories established by Seurat and his friends and as such harks back to impressionism and, ultimately, to Delacroix. His technique differed from theirs, however, in that he tended to apply color in large areas rather than in small units and was therefore more fully synthetist.

Hodler clearly states his awareness of musicality as a source of expression. The importance he attaches to what he calls parallelism—the rhythmic ef-

fect of symmetrical, repetitive patterns of line and color intended to unify the whole composition—reflects an understanding of musicality as a pursuit of harmony.

The concept of parallelism, it should be noted from his examples, refers to the harmonies themselves—physical, intellectual, and spiritual—as well as to the relationship between the first and the other two, implying correspondences in the full Baudelairean sense. Indeed, Hodler's choice of examples implies relationships both between diverse physical entities, such as the repetitive pattern of trees in a forest or the rhythms of a figure's drapery, and between the physical and the intellectual or the spiritual, the forest also alluding to the romantics' pantheism and the folds in the drapery, ultimately, to states of the mind and soul of each individual. Likewise, the crowd listening to an orator suggests both links among the listeners and the impact of the intellect of the speaker, and the faithful attending a religious service evoke both the unity of the congregation and spiritual communion.

Finally, Hodler, in stating that the choice among impressions that "determines all the aspects of the work" reflects a painter's own "character," recalls Baudelaire's notion, adopted from Delacroix, that nature is a dictionary offering a choice of associations suited to the artist's personal expression. His intent to choose the impressions that best express his own artistic individuality, moreover, reflects an exaltation of subjectivity similar to that of Baudelaire and Delacroix.

The excerpts that follow are from "La Mission de l'artiste," *La Liberté* (Fribourg), March 18–20, 1897. Courtesy of *La Liberté*.[235] ✤

The mission of the artist—if one may be allowed to say it—is to express the eternal element of nature, beauty, to bring out nature's essential beauty. The artist exalts nature by displaying objects; he displays the human form under its best light. He shows us an aggrandized nature, a nature that has been simplified, freed from all insignificant detail. He shows us a work of art in keeping with the depth of his experience, of his heart and of his mind.

Art is the gesture of beauty. Plato's definition of "beauty as the resplendence of truth" means that we must open our eyes and look at nature.[236]

If man starts with nothing, he can do nothing. In executing a work of art, the artist borrows elements from the existing world in which he lives. The most imaginative is guided by nature, the great source of information that stimulates our imagination. The more one penetrates the spirit of nature, the more completely one can convey it. The more one possesses the means of expression, the better one can trace its image.

One reproduces what one loves: this figure rather than that; one reproduces the delicious landscape one happens to enjoy.

Emotion is one of the first causes leading a painter to create a work. He wants to recount the charm of this landscape, this human being, this nature that has so powerfully moved him.

Nature leaves on us a more or less profound and lasting imprint, and the choice among the impressions we receive determines all the aspects of the work and very character of the painter.

Through the intermediary of our eye and our intelligence the splendors surrounding us more or less profoundly affect us, according to our faculties of perception and our ability to be impressed.

The Eye

. . . What does the trained eye see? It sees in a single glance not just the object, but its outline, the totality; it seizes in one fell swoop the character of the proportions, the way the figures are separated from one another in space, and the effect of light.

Often, thanks to the configuration of his eye, the painter, through his perception of color, can experience a particular effect, even a charming one; but if this were the only merit of his work, it would be but a secondary work of art. The only real work of art is one that germinates in the thought and the heart. Superior vision consists precisely in this.

The gifted individual has a premonition of harmony that he cannot yet *define*. He has *opened* his eyes to see the things he likes. All he needs now is an *opportunity* for this harmony to manifest itself in a way others can perceive.

When the artist has a goal, when he does not limit himself to reproducing an anecdote any which way, when he has a decorative purpose, he can take aim at form, or color, or effects of light and shade. . . .

Concerning Form

[Hodler goes on to distinguish between form and color, postulating the expressive value of simple geometric forms, claiming that "form is the outer expression of a body, the expression of its surfaces," and that the artist has at his disposal "line and the flat surface."]

The form of each object, as it presents itself to us, consists of an external outline and internal shapes. That is a result of our mode of vision, for in reality all the surfaces of a body are external. The outline not only conveys the width, the elevation, and the depth of a figure but also has an ornamental and architectural character, in that it clearly stands out from the surrounding bodies; but it does so essentially as the outcome of a deliberate

endeavor on the part of the artist, and therein emerges the power of certain masters.

The outline of man changes according to the *movements of the body* and is, in itself, an element of beauty.

The artist almost always goes through a long inner struggle in his double pursuit of the logic of movement, on the one hand, and the beauty, the character, of the outline, on the other.

Line, therefore, conveys all these things.

Today one gives a preponderant role to the outline, one stresses it, and as a result it becomes ornamental. One might say that decorative art is becoming increasingly ornamental.[237]

But the common characteristic of the old masters is to have distinctly *detached* the figure as a whole and to have *sought* the beauty of lines in the outline. They opposed long [sweeping?] lines to short ones and took advantage of the movements and divisions of the human body, conveying its rhythmic aspect.

How do we see things? By means of what differentiates high and low value, lighting and shadow, and hue. Again, bodies detach themselves distinctly from one another essentially through the outline [and background]—whether this male figure seems light over a dark ground or dark over a light ground. All bodies, having a mostly smooth surface, have distinct outlines. When to achieve an effect of softness one makes the outline mawkish, attenuating it or erasing it at the expense of the rounded internal modeling, so that it becomes softened and more gradual when lighting conditions demand distinctness, then one creates a bogus work. . . . But if the emphasized outline has its beauty, the gradations have their own too. . . . I know nothing more beautiful than certain [quattrocento] women's portraits, whose outlines are admirably sharp.

Color

Color characterizes and differentiates objects; it accentuates them and sets them off; it contributes enormously to the decorative effect. Color has a swaying musical charm independent of form. It has moral impact; it is an element that causes joy, gaiety! High-value colors, above all, which are associated with light, cause this sensation, whereas low-value colors give rise to melancholia, sadness, and even terror.

The meaning one assigns to white is purity, whereas black stands for evil, suffering. Vivid red expresses violence; light blue, sweetness; violet, sadness. The charm of colors is heightened according to the associations they bring forth; they harmonize or accompany one another like parallel ornaments,[238] or else clash and produce oppositions.

The brilliance and impact of color are a function of its intensity, of the

surface area it covers, and of its location relative to other colors that set it off or weaken it according to the proximity of white or black.[239] When perceived in relation to form, color stands out even more forcefully and heightens the rhythms arising from variety and repetition; in any case, it is never totally independent of form, but form can set it off.

The coloration of objects is affected by that of the ambient light; the nuances differ according to the color of the sky. When the sky is blue, we are more cheerful, because of the illumination of the atmosphere, the opposition between the surfaces exposed to the light and those in the shade, and *especially* the uplifting interplay of the colors of everything in the shade, which, instead of being gray, is soaked in blue and violet, with scintillating orangy hues on the surfaces that reflect the rays of the sun.[240]

Under a beautiful blue sky the color of the shade is blue and violet, that of the trees, ultramarine; and all the illuminated leaves shine as if they were a single mass. What a pleasant sensation we derive from this harmony of green and blue! . . .

The charm of colors derives primarily from their harmonies, from the repetition of nuances of a same hue. Gentle harmonies affect us more intimately; they seem to be the heart's favorites. I am thinking of certain fragments of the friezes of the Parthenon. Opposition, contrasts, however, excite us, surprise us, seem to jolt our nervous system. The passage from a gentle to a strong harmony occurs frequently in life.

But all this lavishness of color, these dark and light spots, these contrasts, these varied harmonies of vibrant hues are a consequence of light, from which all the universal charm of colors and shadows results.

Concerning the Work of Art

If I now compare the objects that have left a strong and durable impression on me—those that in their unified totality have most forcefully seized hold of me—I recognize in each case a similar beauty of parallelism. I now want to try to outline it.

Whether parallelism itself plays a dominant role or brings out diversity, it is at the root of a great unity.

If I should enter a forest of pines moderately high, whose trunks are elongated, I would have *before* me, to my *right* and to my *left,* these innumerable columns created by the tree trunks. I would always have around me these vertical lines, repeated infinitely. Whether they stand out in high value against a background of lower values or against the deep blue of the sky, the dominant element, the impression results from the parallelism of these pine trunks. . . .

In the clothes that cover our physical frames have we not, at the shoulders, the same folds; in the two elbows the same folds; in the two knees the same

imprints—all reflecting our [unique] movements? If we compare these decorative phenomena to those of our lives, we are surprised to find once again the principle of parallelism. We all know from experience that what unites us is greater than what differentiates us.

If there is a feast, somewhere, you see men trooping in the same direction. At other times, they surround an orator who expounds an idea. Enter a church during the service, and the prevailing unity will affect you. When we are gathered for a happy occasion, we do not like to be jarred by a discordant voice. In all these cases, it is easy to perceive the common principle and to understand that the parallelism of these subjects from life is also a decorative parallelism.

To aim for unity, a strong and powerful unity, is to exalt something above everything else, to express this something strongly, be it a subject characterized by grace or by strength. But there is nothing else. Our epoch proves it. The mad race toward diversity is general, except for a few who, like Puvis de Chavannes, introduce this note of harmony.

Diversity is an element of the beautiful, as is parallelism, but it must not be excessive. Our very point of view introduces diversity in a subject characterized by absolute unity. The artist is well aware of it; no sooner does he want to maintain a sense of unity in his subject than he is hindered by this rule of perspective, according to which the apparent size of a man, for instance, diminishes the further he is from us. Look at three or four men walking with a similar motion. Their physiognomical differences, in themselves, constitute a great diversity.

It is not always as easy as it might seem to achieve simplicity.

I have said that although the trained eye is more apt than another to perceive the phenomena of light and form, it must have at its disposal other instruments to assess the beauty of the body. The greatest of these instruments is the human brain, which, through its ability to compare harmonies to one another, discovers their true relationships; from this action of the brain, united to that of the heart, new magnificence derives.

The work of art will reveal the perception of a new order in things and will be beautiful by virtue of the overall idea emanating from it.

5

THE ARTISTS OF THE SOUL

A diffuse new symbolist wave issuing primarily from romantic symbolism made itself felt in the 1890s, only to recede toward the end of the decade. It was the last manifestation of symbolism as a movement, although important symbolist principles radically affected twentieth-century art.

In February 1896 representatives of this last phase of symbolism participated in an exhibition in the lobby of the Théâtre de la Bodinière in Paris. They called themselves *les artistes de l'âme* (the artists of the soul). A series of lectures on the exhibition were delivered at the theater and published in *L'Art et la vie* the same year.[1]

Several articles had already appeared in that same publication under the general heading "Les Artistes de l'âme," devoted to some of the artists who were to participate in the 1896 exhibition. The nucleus of the group includes Carloz Schwabe, Edmond Aman-Jean, Alexandre Séon, Alphonse Osbert, and Armand Point. To these should be added Lucien Lévy-Dhurmer, who presented his first retrospective in 1896; Edgard Maxence more marginally; and Henri Martin and several others. Stylistically, most favored a Botticellian elegance and decorated their backgrounds, draperies, and accessories with quattrocento tendrils. Some, like Maxence, Point, and Séon, adhered to the linear clarity of the early Renaissance; others, like Lévy-Dhurmer, simulated a vaporous veil around figures and objects that recalled the vaporousness of some of the later Pre-Raphaelites or their friends, such as George Frederic Watts. Henri Martin emulated the fluid multicolored surfaces of late impressionism (the critic Roger Marx alludes to the comma strokes of impressionism when discussing Martin's work in an article excerpted in this chapter) and even the small dots of neo-impressionism in striving for a fairy-tale atmosphere. As with the romantic symbolists the figures have a somnambulant air of detachment and are self-absorbed, wrapped up in their own dreams, more intent on some inner voice than on any action, if indeed one is alluded to. The artists' ultimate aim is to sug-

gest states of the soul—an exceedingly delicate and subtle soul in many ways comparable to that exalted by the British aesthetes, whom the artists of the soul also resemble in the touch of androgynous eroticism they give their work.

The movement seems to have resulted from the convergence of two currents. The preponderant influence was undoubtedly that of the French romantic symbolists and derived in particular from the example of Puvis de Chavannes and Moreau, both of whom had won full recognition and acclaim. Indeed, Puvis was overwhelmed with official commissions and had assumed the presidency of the Société Nationale des Beaux-Arts; Moreau, living a more retired life, was nevertheless elected a member of the Academy of the Fine Arts in 1888 and became a professor at the Ecole des Beaux-Arts in 1892. Some artists of the soul had been the pupils of one or the other; all were their fervent admirers.

Concurrently, a new understanding of the Pre-Raphaelite movement developed in France. An important group of second-wave Pre-Raphaelite works was displayed at the Paris Universal Exhibition of 1878, including two major works by Burne-Jones that were highly appreciated for the Botticellian charm of the artist's figures and the dreamy suggestiveness of his Mantegnesque backgrounds. Charles Blanc, twice director of the fine arts for the French government, a member of the French Academy, and probably the most revered French critic of the time, found in the Pre-Raphaelite works in the exhibition "a quintessence of the ideal and a sublime poetry that grip my heart."[2]

Watts's vaporous rendering and dreaming figures, also characteristic of some later Pre-Raphaelite works, were evoked in Huysmans's *Against the Grain* of 1884 and were as influential on artists of this second wave as the Italianate delicacy and otherworldly detachment of Burne-Jones's figures.[3] In 1887 Joséphin Péladan, a young novelist and critic, wrote the preface to the first translation into French of Dante Gabriel Rossetti's volume of poems *House of Life,* justly praising the poet-painter for continuing the Neoplatonic tradition.[4] Burne-Jones received a special tribute when almost the entire Parisian press praised his only entry at the 1889 Paris Universal Exhibition, *King Cophetua* (see Fig. 4).

This last phase of symbolism developed at the time when Péladan was elaborating his own views on aesthetics and religion. The artists of the soul found support in the circle of the Rose + Croix esthétique, which Péladan had founded with a view to reviving the mystical tradition of the Middle Ages;[5] these artists also participated in the series of exhibitions that body organized under Péladan's leadership in Paris from 1892 (see Fig. 46) through 1897.

Péladan's aesthetic message was not particularly original. In articles that

appeared in 1881 in *Le Foyer,*[6] a conservative periodical intended for the Catholic middle classes, and then in his series of Salon reviews, he condemned naturalism in all its manifestations—attacking Emile Zola's writings with particular vehemence—and sought to foster a new spirituality through works of art modeled on those of the Middle Ages and early Renaissance and to promote Neoplatonic ideals while upholding a strict Catholicism.

Péladan had a major advantage over most young critics of his time: he had acquired a considerable readership through the success of his erotico-androgyno-spiritualist novels. His exotic appearance and dress (see Fig. 47), his gifts of persuasion, and his intellectual and spiritual pretensions (he had bestowed on himself the title Sâr, allegedly of Assyrian origin, and referred to himself as a magus) gave added impact to his pronouncements and contributed, at least in the beginning, to the success of the Rose + Croix exhibitions.[7]

There was a jury of admission, but artists judged to comply with the ideals of the movement were invited to send work to the exhibition without going through the jury process. Moreau, Puvis de Chavannes, Burne-Jones, and Khnopff were all invited to participate in the 1892 exhibition (all but Khnopff turned down the offer). Hodler was also represented and caused a sensation. A number of artists who had belonged to the neo-impressionist, Pont-Aven, and Nabi groups also took part in this and successive exhibitions. But the artists of the soul gradually stood out among the faithful; the final exhibition in 1897 seems to have marked the end of their cohesiveness.

ROGER MARX

The Salons of 1895

The passages that follow are from a series of articles published in 1895 in the *Gazette des Beaux-Arts* devoted to the three major annual exhibitions in Paris. The old Salon, founded in the seventeenth century and at one time the special preserve of the Academy of the Fine Arts, was now the Salon des Artistes Français, frequently called the Salon des Champs-Elysées to distinguish it from its two major competitors: the Salon de la Société des Artistes Indépendants, founded in 1884, which was open to all comers and awarded no prizes, and the Salon de la Société Nationale des Beaux-Arts, also known as Salon du Champ-de-Mars, founded in 1890 and pur-porting to be both freer from traditional constraints and more selective than the Artistes Français.

Roger Marx (1859–1913) had pursued a double career, distinguishing himself as an art and literary critic of advanced views in major news-papers—he had praised Seurat in a review of the 1884 Indépendants exhi-bition—and holding a post in the government's administration of the fine arts, eventually becoming inspector. He served as assistant to the then ailing Jules-Antoine Castagnary—who had been a staunch supporter of Courbet and had written one of the few sympathetic reviews of the first exhibi-tion of the impressionists in 1874—when Castagnary became directeur des beaux-arts, in 1887, until his death, in 1888. Marx became deputy inspector general of the provincial museums in 1889 and took an active part in re-forming them. He also organized exhibitions such as the Centenary Exhi-bition of French Art at the 1889 Universal Exposition that showed works by Manet, Monet, Pissarro, and Cézanne.

Inevitably the official point of view affected even such a forward-looking critic, and some of the young artists he mentioned in his review of the 1895 Salons became the academicians of a later age.

Marx starts his series with a survey of the artistic situation in 1895 as it presented itself in the three Salons. Understandably, he gives short shrift

to impressionism, the great representatives of that movement having long ago forsaken such group exhibitions. Among the post-impressionists only Denis, who called himself a symbolist, attracts his notice. Accepting the reemergence of the symbol as an established fact, he traces its dominance to the achievements of the romantic symbolists, acclaiming the total victory over realism of those who have sought "to express this need of the infinite, anchored in the most profound depths of our soul, that will only sink with it."[8] The artists he praises include the British Pre-Raphaelites, Arnold Böcklin in Switzerland, Max Klinger in Germany, and, in France, Gustave Moreau and Auguste Rodin, with Rodin at the head of his artistic hierarchy. After paying tribute to Eugène Carrière and Henri Fantin-Latour among the initiators, he tackles the newcomers, who consist principally of the artists of the soul, pointing out admiringly all the psychology of character and mood their work conveys, unafraid, furthermore, to draw parallels with presymbolist and symbolist literature.[9]

His comments on three artists are excerpted. Carloz Schwabe, who was born in Germany, became a citizen of Geneva, where he studied industrial art. He moved to Paris and attracted critical attention at the Salons of both the Société Nationale des Beaux-Arts and the Rose + Croix. His painting is characterized by a stress on elegant linearism and smooth surfaces reminiscent of the early Renaissance and by lacy decorative elements that create nebulous settings for his usually languid figures. Besides painting easel pictures, he designed wallpaper in the art nouveau style and was a prolific book illustrator.

Edmond Aman-Jean was a product of the Ecole des Beaux-Arts, where he had become friends with Seurat and occasionally assisted Puvis de Chavannes in squaring up sketches into mural-sized designs, sometimes inviting Seurat to help. A great admirer of the Pre-Raphaelites, he interpreted their motifs in a subtly multicolored brushwork distantly affected by impressionism. He was close to the symbolist as well as the Rose + Croix groups and occasionally attended Mallarmé's Tuesdays.

Henri Martin attended first the Ecole des Beaux-Arts of Toulouse, where he obtained the Grand Prix, and then the Ecole des Beaux-Arts in Paris. Attracted by neo-impressionism in 1889, he endeavored to adapt its color principles to Puvis-like stylizations evoking dreamlands. Although he was associated with symbolist and Rose + Croix circles in his early days, he eventually asserted himself as an academic artist in the manner of Puvis and became successful.

The excerpts from Roger Marx's series on the three artists are from "Les Salons de 1895," *Gazette des Beaux-Arts* (July 1, 1895): 23–24 (Schwabe); (May 1, 1895): 446 (Aman-Jean); (June 1, 1895): 453–55 (Martin). ❧

Carloz Schwabe

It used to be that one made fun of "celestial superstition," that one said of the divinities of Christianity that they had been "forever annihilated under the glare of modern analysis." Yet here they are, being reborn, as long-maligned religious symbolism is making a triumphant return. What we can expect from it is readily foreseen from studying the past: it "tempered the austere dogmas of scholasticism, participated in the education of the meek and the humble, and turned itself into a book for those unable to read."[10] Under the creative breath of art, idea becomes form, fleshes out into visible entities, becomes accessible to all. Human effort, destiny, death have given liturgical writers subjects for sublime meditations that are unquestionably beneficial to the soul. Yet who knows them? Should we not be grateful to Carloz Schwabe for having given us their plastic equivalent? for having induced the spirit—on first apprehension of his works and solely by virtue of his allegories—to seek edification in the gravity of such problems? There is something of the ecstatic in this aesthete who calls on the whole of nature, and the sky and the earth and the waters, to concur by their magic in expressing these symbols whose troubling greatness and precise linearity Albrecht Dürer would have appreciated . . . [Fig. 44; see Fig. 46].

Edmond Aman-Jean

Whereas man willingly bares his inner self, there is something of the sphinx in the eternally feminine; the subtle and acute analysis of Aman-Jean sets out to resolve these enigmas and triumphs over them. He unravels the secrets of the soul, reveals intimate feeling, and in a variety of figures investigates what is human; the attitudes, at once serious and simple, are those of every day, of yesterday, and of tomorrow; a neutral background makes the imprecise atmosphere around these delicate creatures one of calm and silence conducive to meditation: one figure holds a flower [Fig. 45], another goes quietly her way, a third takes pleasure in her inner thought. To convey the figures' supple and delicate grace the artist gives their gestures a partial lassitude; the hands, with their elongated fingers, indicate indolent abandon; and the unfathomable mystery of the eyes and the vague smile—of irony, interrogation, or regret—suggest the flight of troubled thought. There is an abundance of exquisite notations; Aman-Jean renders a restful glance, a unique reflection of undulating hair with the comprehensive intuitive tenderness of a poet—a Baudelaire or a Maeterlinck. One can uninhibitedly draw on such memories in connection with portraits, for which the artist has relied on all that the most refined and penetrating psychology can add to art. . . .

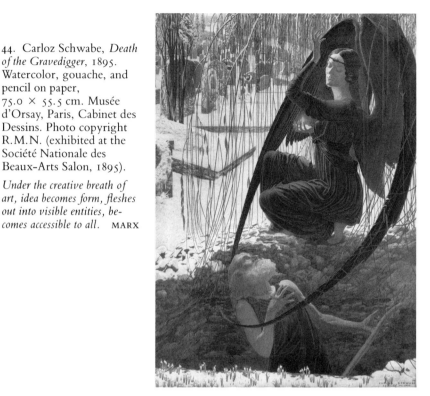

44. Carloz Schwabe, *Death of the Gravedigger*, 1895. Watercolor, gouache, and pencil on paper, 75.0 × 55.5 cm. Musée d'Orsay, Paris, Cabinet des Dessins. Photo copyright R.M.N. (exhibited at the Société Nationale des Beaux-Arts Salon, 1895).

Under the creative breath of art, idea becomes form, fleshes out into visible entities, becomes accessible to all. MARX

Henri Martin

Everyone knows [Henri Martin's] manner: how, to render the play of light in all its subtleties, he proceeds by juxtaposing small dots or comma strokes that meld together when seen from a distance. [In his frieze for Paris's city hall, 1892–94] the very uniformity of the execution—always evenhanded, always similar—contributes to the overall decorative effect, so that the painting is like a tapestry from which the inopportune illusion of relief and of abrupt foreshortening is banned. To technique and a respect for decorative traditions one must add the contributions of a young and emotionally responsive imagination overflowing with tenderness and freshness. One might see in him an Alfred de Musset eager to seize the dialogue between poet and muses [in the picture *Inspiration*], not so much in the depth of tenebrous nights as at dusk, when the last ray lets its reddish glow signal farewell as it caresses the tips of the tall firs. He evokes the hour when nature and human thought are most mysterious: shadows have invaded the undergrowth, in which the tree trunks become as smooth as pillars. Look into

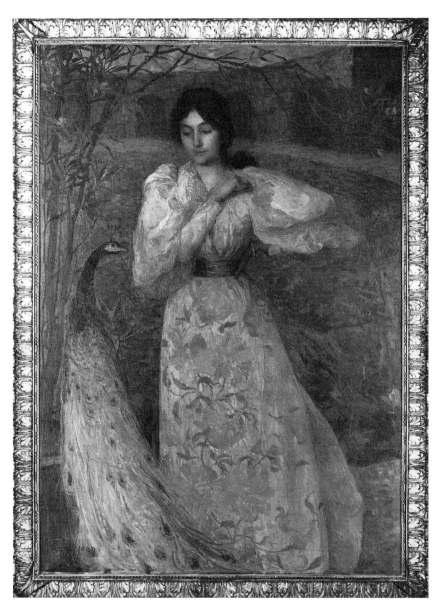

45. Edmond Aman-Jean, *Young Woman with Peacock*, 1895. Oil on canvas, 150 × 104 cm. Musée des Arts Décoratifs, Paris. Photo: Laurent Sully Jaulmes. All rights reserved (exhibited at the Société Nationale des Beaux-Arts Salon, 1895).

The unfathomable mystery of the eyes and the vague smile—of irony, interrogation, or regret—suggest the flight of troubled thought. MARX

the atmosphere as it becomes heavy with fog; look at those figures floating in it above the solitary dreaming minstrel, their inner voice pouring forth divine inspiration for him as he wanders into the haunted forest.

The irresistible attraction that draws Henri Martin toward intellectual labor also suggested to him the allegory of his frieze; it initiated in him the struggle of the inventor in search of a concept; it brought to bear on him the holy agonies that are the wages of him who gives birth to the work of art—itself doomed to indifference, hatred, or neglect. The theme alone should earn him the sympathy of all whom destiny has condemned to intellectual labor. When did anyone pay attention to their torment and endeavor to express so persuasively all its wrenching sweetness? The cost of success here is increased to the extent that Martin had to overcome great difficulties and that the composition had to encompass a particularly irregular and unrewarding wall surface. . . .

JOSÉPHIN PÉLADAN

Materialism in Art (1881)
In Search of the Holy Grail (1888)

Even before he initiated the Salons of the Rose + Croix (Fig. 46), held from 1892 through 1897, the self-styled magus Joséphin Péladan (1858–1918) had influenced a section of the public and a growing group of artists through his Salon reviews and other writings on art (Fig. 47).

The first of the two texts that follow, written in 1881 but used as a preface to Péladan's Salon review of 1882, sets the historical bases of his aesthetics. The second, written in conclusion to the 1882 review, establishes the premises of an idealist spiritual revival in art. In later years Péladan repeatedly used similar historical surveys to back up his rhetoric—usually with considerable pedantry.

That he owed much to Ruskin is not surprising since both men were affected by some of the same influences. Indeed, Péladan's esteem for Ruskin was so great that he once called him "the Saint Augustine of art."[11]

Like Ruskin after his aesthetic conversion, Péladan preferred the quattrocento artists to their successors, with the exception of a few Renaissance masters, particularly Leonardo, whose androgynous sensuality and lofty spirituality Péladan echoed in his novels.

Furthermore, Péladan shared Ruskin's bitter contempt for the materialism he claimed had pervaded all artistic forms since the High Renaissance. The "vermilion of the School of Antwerp," for instance, is a mocking reference to Rubens, Jordaens, and Van Dyck. Unlike Ruskin, however, who gradually detached himself from his religious upbringing, Péladan persistently advocated the rebirth of a mystic Catholic art.

Ruskin came to admire the art of the quattrocento and its mystical manifestations after exposure to the theories of the Nazarenes. Péladan also owed much to these artists and their leaders. Indeed, in the excerpts that follow he praises two of them, Overbeck and Cornelius, as well as their French disciples. Among these, Ingres had admired the Nazarenes' style and even briefly emulated it, and Orsel and Périn considered themselves representa-

46. Carloz Schwabe, poster for the First Salon de la Rose + Croix, 1892. Lithographic process, 185.4 × 81.3 cm. Photo courtesy of The Piccadilly Gallery, London.

The work of art is a fugue: nature supplies its motif; the soul of the artist creates the rest.　　　PÉLADAN

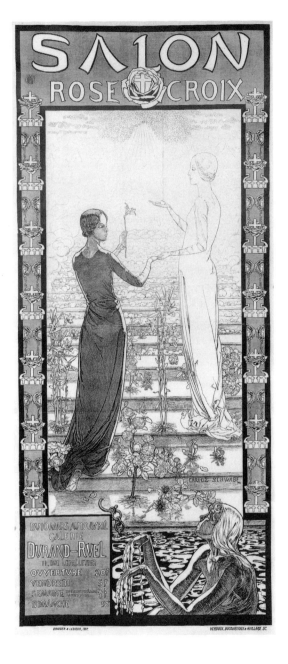

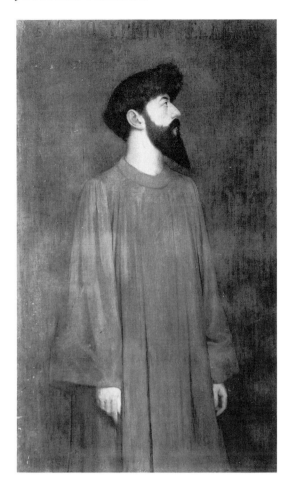

47. Alexandre Séon, *Portrait of the Sâr Joséphin Péladan*, 1891. Oil on canvas. 132 × 80 cm. Musée des Beaux-Arts, Lyons, 1936-50, gift of Mme Joséphin Péladan.

Art, this initiatory rite to which only the predestined should be admitted, is being turned into a commonplace to suit the crowd. PÉLADAN

tives of the Nazarenes in France.[12] Chenavard declared the conception for his large decoration for the Paris Pantheon, only temporarily affixed to its walls (1848–52), the outcome of an exchange of views with Overbeck and Cornelius in Rome.[13] Chenavard himself was impassioned about aesthetics and theory and had a profound influence on Péladan, who referred to him as "the first aesthetician in France."[14]

The critic's attacks on Taine were to be expected, since Taine believed in a rationally accountable link between the work of art and the cultural, ethnic, and geographic milieu of the artist, whereas Péladan saw in artistic creation the outcome of a divinely inspired spiritual experience.

Péladan's invectives against the materialism of his time end by attacking

the bourgeoisie. In this he echoes a common theme of the romantics—Delacroix himself, borrowing biblical imagery, considered himself, as an artist, among the Lord's chosen. He nevertheless consciously displays the snobbery that infused much of his other writing and was intended to appeal to the vanity of his followers—themselves mostly bourgeois. Moreover, the discrepancies revealed by comparing Péladan's quotations of writings by various authorities with the originals point to a less than scrupulous approach to history. Ingres's alleged reference to "faith in God," for instance, is a fabrication.

The first text was published in *Le Foyer,* August 21, 1881, 177–79. It was reprinted with minor changes as "Le Salon de 1882—Considérations esthétiques. I. Le matérialisme dans l'art," in *L'Art ochlocratique* (Paris: Dalou, 1888), 13–16, where it served as a prologue. The second text is the conclusion of *L'Art ochlocratique,* 211–13. The volume is principally devoted to a review of the Salon of 1883. ✦

MATERIALISM IN ART

A synchronic parallelism exists over time between the ideas and the achievements of a century, its thoughts, its actions, its art, its philosophy, its poetry, and its religion. The book, the monument, the fresco express through different modes—the words, the lines, the colors—the same thing: the state of the soul of an epoch. As a consequence, art elevates itself or falls into decline as it nears or draws further from God.[15]

Let us open the book of history.

Plato's idea was plastic, as was Phidias's form, as was the plan of Ictinus.[16] The characteristics of the Roman people—vanity, cruelty, utilitarianism—are inscribed on the buildings that are suited to their needs: the arch of triumph, the amphitheater, the aqueduct.

The art of the catacombs, born on the grave of the martyrs, is as distant from Apelles or Zeuxis as the Gospels are superior to Epictetus's *Discourses* and Marcus Aurelius's *Meditations*.[17] Even in the symbols the first Christians borrowed from expiring paganism, the ideal has changed. It leaves the body for the soul, the earth for the sky, man for God. The promise of the sky fully opens the wings of the soul, and the artists, who are saints, infuse their God-laden heart into works that are clumsily sublime.

During Byzantine times, art was intensely hieratic, for dogma had to stiffen itself against the schisms and oppositions it encountered. In the tenth century, Christianity settled down and acquired an aura of solidity: Romanesque art was born. In the thirteenth, triumphant religion joined its hands in the pointed arch; every bay is a giant orant,[18] and the soul of the people

bursts out toward God, as does the spire of the cathedrals. Thomas à Kempis writes the *Imitation,* Giacomo da Varaggio *The Golden Legend,* and Vincent of Beauvais the *Speculum Universale.*[19] The holy sword of the crusaders writes the greatest heroic song of modern times. It is the time of the Gothic.

In Italy, Saint Francis of Assisi sings of divine Love. Here are the Christs of Margaritone,[20] the Virgins of Cimabue. Giotto is there; the blessed Fra Angelico follows. Primitive art, the greatest of all, blossoms within the Godhead. But suddenly a mirage leads all astray: the Renaissance. Man believed he had rediscovered antiquity; he had only come upon Rome, that caricature of Athens.[21] Leonardo, Michelangelo, and Raphael write the great odes of the Cenacolo, of the Sistine Chapel, of the Stanze, but great art has come to an end.[22] Gone is the time when Dante descended into hell; Savonarola instead climbs the scaffold while the duke of Valentinois gambols through Italy like a tiger in the jungle.[23]

After hiding behind Ovid and the marbles of Paros, the great Pan reappears and unleashes the beast within man.[24] The dry, short breath of the Reformation could not sustain German art; it followed Albrecht Dürer to his grave. The van Eycks and the Memlings disappear under the sensual vermilion of the School of Antwerp. The Carpaccios and the Bellinis become shrouded in silence, while Tintoretto and Veronese sound their voluptuous fanfares. Spain, which maintains her faith, has her Murillo, Zurbarán, Ribalta, Joanes.[25] France has Le Sueur and Philippe de Champaigne, the Jansenist; but its glory remains in the stained glass of its old cathedrals.[26]

In the eighteenth century, all that is left is wit. The man of the century, Arouet,[27] develops it to such a degree as to make it look like genius. Then the rabble invades the stage of history under the leadership of lawyers.[28]

This glimpse at the past affirms the truth of Ingres's thought: "To create a work of art one must have a certain elevation of the soul and faith in God."[29] Well, today it is as fashionable to ban the soul from the arts as it is to repudiate man's soul. Genius has been reduced to a mathematical function, and the ideal to a swing going back and forth. Corresponding to the scientific materialism of Darwin is the literary materialism of Zola. The platitudes of Sarcey, Vacquerie, and Rochefort, find echoes in the daubs of Ortego, Casanova, and Frappa. Renan is more widely read than Ohnet, and Huysmans than Balzac.[30]

Taine, whose *Origines de la France contemporaine* has performed a great service for literary criticism, has been so foolhardy as to formulate a new aesthetics. He is a pupil of Stendhal, who, one knows, hesitated between Canova's *Paris* and Michelangelo's *Moses.* The two volumes on his trip to Italy by the positivist historian are distressing.[31]

In Milan, in front of [Leonardo's *Last Supper*] at Santa Maria delle Grazie, Taine finds that Leonardo had no other purpose than "to represent vigorous

Italians around a table."[32] At the Pitti Palace, [in Florence, Raphael's] *Virgin of the Chair* appears to him "a sultana deprived of thought with the gesture of a wild animal." At the Campo Santo [in Pisa] he does not find "the rich vitality of firm human flesh."[33] In the Sistine Chapel he is surprised that the frescoes by Signorelli, Botticelli, and Ghirlandaio were not destroyed when Michelangelo is there, who teaches us "the worth of limbs, the human structure, and the supporting points of its beams." For him, Raphael "had the same feeling for the animal body as the men of antiquity, particularly all that constitutes in man the runner and the athlete." Finally, Taine summarizes his thoughts as follows: "Only external form exists," and "one must follow nature to the letter; one must only seek the healthy body."[34]

Write history, Monsieur Taine, and leave aesthetics alone; or else tell me if only exterior form exists in Fiesole? Admit that the statues of the Medici Chapel are taller by two heads than nature followed to the letter would dictate, and note that the Belvedere Apollo is tubercular according to Dr. Fort.[35]

This clutter of ideas boils down to the old formula found in all the books: art is the imitation of nature. In any case, nothing is superior to plaster casts and color photography. True drama is contained in the stenographic pad of a criminal court.

No, nature is not the purpose of art, it is only its means; it constitutes the sum total of expressive forms. That is all!

The work of art is a fugue: nature supplies its motif; the soul of the artist creates the rest. But the rest cannot be learned at the rue Bonaparte, in the course of Cabanel;[36] and the rest is what is lacking in Taine.

If the whole of the painter is in the brush, the whole of the sculptor in the scraper, the whole of the architect in the dividers, how is it that Puvis de Chavannes is the only artist we regard as a master? Because, as far as skill is concerned, the artists of our time are well endowed with it; everything that can be taught they already know.

An [imaginary] etching by Meissonier will convey the difference between craft and art.[37] The subject is not complicated: a half-opened door and a broom leaning against a wall. Make it truthful, well executed; that is a matter of craftsmanship. But fill the opening of the door with black, roughen in a certain way the bristles of the broom, cast a few streaks of shadow, and you will have a drama: the murder of Fualdès or one of Poe's nightmares. This is art.[38]

Let us examine the facts; they speak louder than theories. When after three centuries German art was resuscitated, it was resuscitated Catholic, with Overbeck, Cornelius, Kaulbach, and the school of Düsseldorf.[39] Belgium has had as its only true contemporary master Henri Leys, a believer who worked in the manner of Dürer.[40] In France, Ingres, Flandrin, Orsel, Chena-

vard, Périn, Tymbal, Ziegler, Chassériau, Mottez, and Scheffer are all Catholic painters; Delacroix, Decamps, and Guignet are not materialists—that I know.[41]

There are two incontrovertible propositions:

1. The masterpieces of art are all religious, even among unbelievers.

2. For nineteen centuries the masterpieces of art have all been Catholic, even among Protestants, for instance, the *Virgin with a Donor* by Holbein and *Lazarus* by Rembrandt. The masterwork of the voluptuous Titian is the *Assumption,* that of Rubens the *Descent from the Cross,* and so forth. What is left of materialism? The fooling of the eye by De[s]goffe; the fish by Monginot.[42]

Talk to the daubers and they say that Giotto is messy and that [Raphael] Sanzio and [Michelangelo] Buonarotti are writers rather than painters. Yes they are poets, and that is what gives them such a high standing. For them line and color are but the envelope of their thought. But thought was a good thing in the old . . . school; they have changed all that.[43] A new era is about to start, that of *secularized . . . and compulsorily thoughtless* art![44]

IN SEARCH OF THE HOLY GRAIL

French art is still the first in the world, thanks to some twenty artists who possess this supreme quality: style. Suppress these twenty masters, and what one calls the French school will reveal itself for what it is: a hard-pressed, scrambling group that is soon to be equaled by Americans and Belgians.

To discuss political democracy is beyond me; but I now want to jeer at artistic democracy. In art, a people is not worth a man, and one million worthy works do not weigh as much as a masterpiece. Art is more than an aristocracy; it is a feudal entity, and around a few barons, to whom I pay the homage of a liege, there are too many truants, mercenary riders, vagabonds—in other words, scum! Ten thousand painters, one thousand sculptors, an indefinite number of engineers who have the effrontery to call themselves architects! This is no longer a school, it is a horde—and, worse than being barbarian, it is bourgeois. The vocation of the artist, comparable to that of the priest, becomes a career, just like that of the recorder of deeds, and a fashion too. One sees nothing but color boxes and rolls of sheet music in the streets. Prudhomme joyously twiddles his thumbs.[45] His daughter practices watercolor; his son produces *bodegones,* and never has art been so flourishing in his eyes.[46] *Art in France has risen to the level of an industry; it is one of the branches of national trade that shows the greatest promise.* This is, word for word, what I have heard at the Salon itself, and he was not wrong, this bourgeois! In what period and where has one ever seen an annual exhibition

of five thousand works of art chosen from ten thousand entries? This production is monstrous. The flood of mediocrities that has already submerged everything else will also submerge art unless one slays with contempt and invective the hydra of the bourgeoisie—most dreadful, for the incorrigible stupidity of its millions of heads.

Vulgarization—that is the great crime of the modern mind. It is Prospero lowering himself to serve Caliban; Ariel, his wings torn and himself dragged in the gutter.[47] The French school, instead of forcing the public to elevate itself, crawls before it! Vulgarization is the senility of a civilization coming to an end. Art, this summit that must be made inaccessible, has been lowered to a ridiculous level; art, this initiatory rite to which only the predestined should be admitted, is being turned into a commonplace to suit the crowd. Such is the singular aberration of an epoch rendered stupid by Renan and his gang of Germans![48] Attempts are being made to induce the people to participate in the feasts of the ideal, and all the talk one hears is about secularizing the church's social functions, specifically education! I declare, on the basis of historic fact, that only Catholicism could have been, and can be, popular without ceasing to be sublime and accessible to all without demeaning itself; and that is one of the supernatural proofs of its truth. Outside the church, art is no more than a hermetic tradition. The *Allegories* of Puvis de Chavannes, the symbolical lyricisms of Moreau, the *Sataniques* by Rops, can be understood only by the initiated.[49]

As for the artists who stoop low so that Monsieur Prudhomme can understand their works, they are nothing other than *Prudhomme* painters. Let this be known: the public's applause is but a frog-like noise; authority, where aesthetics is concerned, belongs to metaphysicians; for great art is but figurative metaphysics.

If in my [career as a critic] I have asked for medals, out of concern for the artists' material well-being, I nevertheless condemn juries, academies, examinations, professors, crosses, medals, and other ludicrous baubles of this time. As for my reputed austerity, it derives from my high notion of the artist's duty and my effort to convey it to others. Art is the only prestigious entity to remain intact in present-day France, which still rules the world in the name of aesthetics. Those who defeated us in 1871 are unworthy to clean Puvis de Chavannes's and Moreau's palettes, to wet Chapu's plaster, to wipe Rops's copper plates—that is obvious.[50] But patriotism that blinds itself is not true patriotism; fourteen centuries are a lot for a civilization, and if the present pace [of decline] is maintained, if the blasphemy is allowed to continue, we are at the end of art, the end of a race.[51]

The Latin world is endangered. It is facing a metaphysical threat, thanks to Renan and his gang. Of all the Frances, aesthetic France is the only one standing. But, alas, it is threatened!

When Polonius asks Hamlet what he is reading, the prince of Denmark answers: "Words! words!" Well, at the end of this study on the Salon, if one should ask me what I have seen, carefully stating a few exceptions, I would answer: lines! forms! colors!

What determines the worth of a feeling also determines the strength of a doctrine. It so happens that tradition is steadfast, and its teachings can be summarized thus: *the work of art is the feeling of an idea sublimated to its highest level of harmony, or of intensity, or of subtlety.* As for hierarchy, I do not even dare utter its name; it is strangely seditious at this point in our history; I shall nevertheless say that if France is glorious, it is through the heroism of its knights and not the probity of its recorders of deeds. The artist must be an ever-struggling medieval knight in symbolic pursuit of the Holy Grail, a furious crusader against the bourgeoisie!

Florence, Botticelli, *La Primavera* (1896)

Armand Point (1861–1932) participated in five out of six of Péladan's Rose + Croix exhibitions. Furthermore, one of the articles on the artists of the soul was devoted to him and to his work.[52] A fervent admirer of Ruskin, and much influenced by the British Pre-Raphaelites, he also came to sympathize fully with Péladan's ideas. Indeed, according to his friend the novelist Elémir Bourges, Point, under the influence of Péladan and his circle, "oriented his art toward a symbolism tinged with mysticism." He believed in the "transmigration of souls, was impassioned about Swedenborg, took delight in reading occultists and Neoplatonists . . . and did not take fright at the practices of spiritism, tarot—which he repeatedly interpreted very well—graphology, and chiromancy." He even talked about "supernatural experiences."[53]

After a sojourn in Florence in 1894 he abandoned the academicism enlivened by an impressionist touch that he was then cultivating for a deliberate return to the art of the quattrocento.[54] From then on his figures, like those of Burne-Jones, are firmly and elegantly delineated by continuous flowing outlines. The sfumato in the shaded areas,[55] no less than the ghost of a sad smile, suggests subtle and somewhat mysterious psychological overtones that have their origin in Leonardo. The decorative backgrounds themselves are gently stylized in the mode of the quattrocento whereas the floral patterning and, above all, the elongated limbs showing through light draperies are Botticellian touches (Figs. 48, 49). And the gentle, soulful nostalgia prevalent among the British aesthetes becomes a hallmark of his work.

The text that follows, written in Florence in 1894, dates from the time of Point's "conversion" to the ideals and the manner of the quattrocento. His exalted description of Botticelli's *Primavera* (*Spring*) of 1477–78 at Florence's Uffizi Gallery testifies to his new near-religious attitude toward that period. Besides stressing the importance of the subject, in opposition to naturalism's pursuit of externals, Point addresses the associative power of imagery and

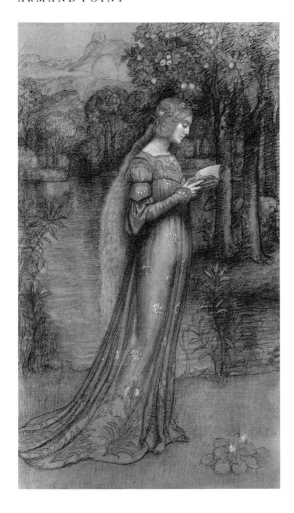

48. Armand Point, *The Eternal Chimera*, c. 1895. Pastel on paper, 44 × 29 cm. Private collection. Photo courtesy of The Piccadilly Gallery, London.

I knew that ancient objects look at you and judge you before they reveal the secrets of the past. For those they disdain, they remain useless, indifferent, or sad: their mysterious words of beauty come only in response to those who interrogate them. POINT

the importance of mystery and musicality. When he claims that "nothing exists outside the more or less refined objectivity of the individual," he calls on the subjectivity of the artist. The occasional reference to the perverse aspects of amorous desire is in keeping with the spirit of decadence of the aesthetic movement. The erotico-androgyno spirituality itself, as well as such allusions to occultism as the tetragram, derive from Péladan.

From the early 1890s on, Point lived within a short distance of Mallarmé's country house in Valvins and was in touch with the poet. He established a crafts workshop in nearby Marlotte in 1896, producing, with the help of assistants, enamels, ceramics, bronzes, embroideries, and other decorative objects in the spirit of William Morris's work. In Marlotte, Point was host

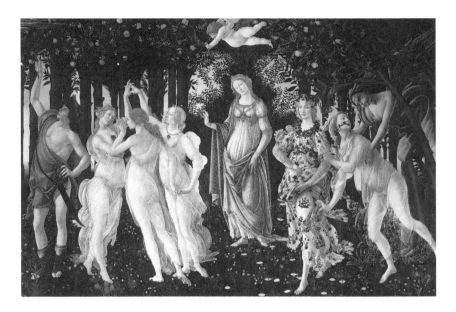

49. Sandro Botticelli, *La Primavera*, 1477–78. Oil on canvas, 203 × 314 cm. Galleria degli Uffizi, Florence. Photo courtesy of Gabinetto fotografico, Soprintendenza beni artistici e storici di Firenze.

[La Primavera] . . . *haunted my work, seducing me toward the sickly grace of delicate souls, [those] captivating sisters of the frail irises that die from a kiss.* POINT

to the most flamboyant member of the British aesthetic movement, Oscar Wilde, released from Reading Gaol, which he made famous in the ballad of that name, a few months before his death.[56]

The text that follows is from Armand Point, "Florence. Botticelli. La Primavera," *Mercure de France,* 17 (January 1896): 12–16. The ellipses at the beginning of the excerpt are Point's. ❧

And, to be sure, if one carefully and with sound judgment examines these two arts one sees in them such an overwhelming union and correlation of affinity that one calls, as a result: "Painting, Poetics that is silent."

"Poetics, Painting that talks."

<div style="text-align:right">

Giovanni Battista Armenini, 1530–1590
Of the True Precepts of Painting, Bk. 1, chap. 3[57]

</div>

. . . Florence . . . night . . . stars . . . diamonds and pearls in the scintillating wake of a great Archangel, clothed in light, whose flaming gold

sword writes in the black azure: *Beauty—Nobility—Intelligence—Willpower.* Sacred tetragram, emblem of the temple of art, diadem of the capital of Tuscany.

At the gate of the city, I had adorned my spirit and my heart with the rarest jewels: I knew that ancient objects look at you and judge you before they reveal the secrets of the past. For those they disdain, they remain useless, indifferent, or sad: their mysterious words of beauty come only in response to those who interrogate them.

My eyes, disquieted and trembling because of the revelation of my own self in the presence of the unknown, first opened up for Botticelli's *La Primavera* [see Fig. 48], a painting I already loved through having seen it in an engraving, which haunted my work, seducing me toward the sickly grace of delicate souls, [those] captivating sisters of the frail irises that die from a kiss.

My anxious hesitation in this sanctuary of silence, shadow, and inner concentration for a moment darkened my thoughts. Unwilling to believe that this was disillusionment, I was frightened by my lack of understanding.

The artist being androgynous, the perception of color, wholly feminine, first reveals to us the soul of a work of art. My [mental] habits, the visual predictions awakened in me by this delicious word "Primavera" were upset by the somber monochrome aspect of Botticelli's masterpiece. Two powerful identical notes resonate, two reds, one at the center, on the body of the princess, the other at the extreme left, on the body of the adolescent; the remainder has the color of wilted white roses or of ancient marbles, which seem to have been gilded as they ripened under the sun, like beautiful fruit. The trees and the field are bathed in the silent color of night, whereas these creatures of a dream emerge under a light from Mount Olympus, like visions.

I was affected, despite my inexperience, and my mind was guided by the spiritual radiation emanating from the work of Botticelli, for none of the thoughts that accompany the creation of a work of art are ever lost: the molecules of matter shelter them, and when a soul delicately touches them, they return to talk to the visiting friend.

"I shall sing of *La Primavera,*" the painter-poet once said. "In the garden of Hesperides, I shall ravish the trees that produce the golden fruit: I shall set them like the columns of a temple, one next to the other, so that shadow and mystery favor the dream creatures I shall evoke. The perfume of love of their starlike flowers must accompany the charm of the fruit one might pick. Grass will be a carpet, embroidered with plants, spreading out the rhythm of their leaves in tune with the balancing of the corollas on the curve of graceful stems under the blue sky, as limpid as the eyes of a young virgin. In that chapel of flowers and greenery, I shall evoke the *Dream Princess. She* will be noble, beautiful, and chaste; secret desires will escape from under

the drapery of her royal purple mantle and will assume corporeal forms around her, revealing her intimate dream of love. . . .

"Under the arrows of Cupid, who will fly over her head, the most ardent desires are awakened. I shall symbolize them by means of the *Sower of Roses,* whose hands will drown in the sweetness of the flesh of the roses; the disquieting smile on her lips will make her seem about to swoon, like an open-hearted rose, and her eyes will be perverse and cold, for caresses are cruel to the heart of the poet who crowns himself with roses. . . .

"With my knowledge of the harmony of lines, I will sing the whole poem of *La Primavera* as she arrives on the earth in her chariot made of a sweet-briar rose, carried off by butterflies amid the lilacs and roses."

How far I was from the frivolous, thoughtless, and formless sparkle of short-lived, *so-called modern art!* I was now being taught all the power of the *subject* in the work of art, as the emotion, the intelligence, and the sublimity of the artist become engraved in it with the precision of a steel burin: this is no longer the facile achievement of a little sensation, noted in a chance encounter with the greater or lesser manual skill of the worker; it is the manifestation of a choice between the three great domains of creation, whereby our mind conceives the law of supreme harmony, the domain of raw matter that feeling vivifies, and the realm that thought illuminates to perceive God. . . .

I know how much pleasure there is in the stroke of a brush heavy with paint, in crushing [on the canvas] two harmonious tones that melt together like the flavorful juices of two fruits.[58] But how much nobler is the thorough search to express a feeling, a thought, with the severe obedient modesty of the painter's craft!

One takes shelter behind a false shield out of intellectual poverty, pettiness of character, softness and lack of energy, cupidity for instant gratification: *Belief is gone; Christian mysticism is dead, and with it the source of inspiration for great thoughts has dried up. Our time belongs to science: the [surgeon's] scalpel has killed the soul; only in the [medical school] amphitheater are miracles performed. Everything is positive.*[59] *"Illusion," henceforth, is a word deprived of meaning: the reality of nature is evident [to the senses and to reason].*

Lie! hypocrisy! Nothing exists outside the more or less refined objectivity of the individual. All is mystery, for nothing is, or will ever be, proved. Even if the old dogmas that once nourished dreams are worn out, decrepit with age, the spirit is always young and alive.

Let us spread our wings wide; the azure over our heads is limitless. Let us raise ourselves to the most perfect notion of divinity; let us love, desire, understand, and possess harmony. Let us build a temple to beauty, eternal, unchangeable beauty, which gives life to, and deifies, the whole of nature; to beauty, which manifests itself in the plant lifting its leaves toward the sky

as if in prayer and in the most perfect human creature, for something greater than the external exists in nature; it is animated by the breath of the Spirit.

On the threshold of the temple, humble and faithful, I address this prayer, with all the power of my being, to the goddess Beauty:

"Beauty, scintillating Lighthouse, whose light humanity seeks on the road to betterment.

"Star of the Desert, which leads to the sanctuary, to our grave, where God will reveal himself.

"Banner of Desire, which revives our strength during our struggles, and preserves the proud ones from the dangers of unproductive rest.

"Princess of the most caressing smile, who brings consolation to the present, to you, who exhale a balm over the Future.

"Guardian of Truth, who lights a star on the forehead of the chosen ones, rendering their course more luminous, like that of the celestial bodies on the blue carpet of the unfathomable.

"To your cult I have dedicated my heart and my spirit.

"Cast a ray of light over my road.

"In you alone I have faith.

"Thanks to you I shall stay away from the vulgar and the ephemeral: I know the upward stride of beings, the evolution of Cycles;[60] at the top of Jacob's ladder I have had a glimpse of the angels who fade away in a dazzling light.[61]

"Give me Perseverance and Willpower, these two companions who guide us with assurance in our work.

"Pride, which renders contemptible and powerless all vile things coming from below.

"The Understanding of the secret laws by means of which you govern the whole Universe.

"And may the tree, the rock, the flower, the cloud, the shadow and the light, the mountain and the sea, and man in the whole of nature always reveal you to my adoring sight."

Florence, January 1894

Armand Point

OCTAVE MIRBEAU

The Artists of the Soul (1896)

The excesses of refinement, the erotic allusions, and the often facile mysticism of the artists of the soul were easy prey for the stinging irony of the Parisian press. The journalist and novelist Octave Mirbeau (1850–1917), then a naturalist, had attacked British and French manifestations of the aesthetic movement with ferocious humor. In the satirical periodical *Gil Blas* of July 27, 1886, he lampooned the British Pre-Raphaelites and their French admirers. The fictitious Loïs Jambois, an aesthete in the manner of Huysmans's des Esseintes, had admired in England, in the studio of a great artist, a woman "very tall, very thin, supernatural, with her white dress, her statue-like glance, her golden hair, which covered her like the mantle of an empress, and the lily stalk she held in her hand, oh, so hieratically!"

Referring to Rossetti, Burne-Jones, Moreau, and others, Jambois exclaimed: "Nature! what barbarity! First, there is the lily, I believe, and this is contested by no one; then there is the umbrella. And then there is nothing. The whole of Pre-Raphaelitism is nothing but the hagiographic interpretation of the umbrella."[62]

The artists of the soul exhibitions aroused Mirbeau to even more violent outbursts: "sexless" and "aesthetes," he calls the artists. "I could care less about Burne-Jones."[63] To him, the Pre-Raphaelite feminine type is decidedly morbid. Undoubtedly referring to Burne-Jones's *Golden Stairs* (Fig. 5), but extending the insult to all the artists of the soul in his article "Lilies! Lilies!" of 1894, he exclaimed: "Oh, their princesses with bodies like vine stakes and their faces like venomous flowers, who pass one by on cloudlike stairs, on the terraces of sickly moons, in dresses made of galvanized sheet metal! In an article of August 7, 1895, his outrage led him to his most vehement outburst: "Lilies, lilies, dung!"[64]

The excerpt that follows is devoted to the 1896 exhibition of the artistes de l'âme in the Théâtre de la Bodinière, which the author proudly admits to not having visited. Here Mirbeau attributes the most outrageous remarks to an imaginary artist, Kariste, while he assumes the role of an ironically

moderating interviewer. Kariste, the author explains, had distinguished himself in a series of portraits of the "types of the great [Napoleonic] Epic for the matchboxes of the Régie des Tabacs [French state tobacco monopoly]." He is likely to have been recognized as Meissonier, who had died six years earlier. Indeed, Mirbeau refers to "our discussions of yesteryear."[65] Always sarcastic, Mirbeau attacked even Meissonier himself, accusing him of lacking the spark of creativity.

Mirbeau was an ardent apostle of impressionism as well as Monet's and Rodin's intimate friend. He was also a courageous defender of Gauguin and van Gogh and other great avant-garde artists. It is he who first introduced Maeterlinck to the Paris public. In 1899 he published a novel with strong symbolist overtones, a brutal parody of Dante's *Inferno* transported to contemporary China: *Le Jardin des supplices* (The garden of torments).

Assaults like this one did much to distance critics and public alike not only from the artists of the soul (Mirbeau's novel also makes fun of Maurice Denis) but also from the aesthetic movement as a whole. The spirit of decadence more or less apparent in their works provided as easy a target for Mirbeau as it had for Robert Buchanan's arrows in 1871; but Mirbeau went beyond the British critic in that the artist in this dialogue postulated a positivist-materialist point of view that challenged the avowed pursuit of spirituality and any form of idealist content. Together with Whistler's campaign against "literature" in art and the new tenets of formalism yet to be developed in Britain by Roger Fry and Clive Bell, Mirbeau's assaults would help discredit the whole concept of symbolism for several decades.

Some major figures of the symbolist movement were fully aware both of the excesses of Péladan's aesthetic preachings and of the relative weakness of the artists who gathered under the Rose + Croix banner as well as those who exhibited as artists of the soul. Gauguin's friend and occasional literary mouthpiece Julien Leclercq, a young poet who was himself on the periphery of the Mallarmé circle, referred in 1894 to a group that must have encompassed the artists of the soul: "The hypocrisy of false mysticism and facile symbols . . . has emigrated toward the rue de la Paix, where the Rose + Croix has set up shop."[66]

The excerpt that follows is from Octave Mirbeau, "Les Artistes de l'âme," *Le Journal,* February 23, 1896. It is presented in the form of a dialogue, whose participants are the author and Kariste, a painter (probably a caricature of Meissonier). Ellipses throughout are Mirbeau's. ❦

KARISTE: Did you see this? What a joke!

AUTHOR: What is it?

KARISTE: There is an exhibition of the artists of the soul today at la Bodinière.

AUTHOR: Come on!

KARISTE: Yes, my friend, . . . artists of the soul, that is what is printed on the invitations, the posters. The walls themselves are bursting with laughter. Artists of the soul!

AUTHOR: And who are they? . . . Tell me their names.

KARISTE: But they are always the same. Schwab, Séon, Osbert, period [*point* in French];[67] that's all. . . .

AUTHOR: Period? You must mean Armand Point, the one who paints modern female sphinxes? . . .

KARISTE: Exactly. She-sphinxes from the Batignolles quarter,[68] or souls, it's all the same.

AUTHOR: And Maurice Denis, is he one of them?

KARISTE: No, my friend, not this time. He has become more exclusive ever since he started producing bedrooms fit to make you want to sleep . . . under the stars.[69]

AUTHOR: How cruel you are! . . .

KARISTE: Let's go to la Bodinière, . . .

But I pointed to the fine weather as a pretext, the charming street, the sky with its partly clouded sun, all the excitement of this precocious spring.

KARISTE: After all, you are right. We would be silly to stay indoors when it is such a pleasure to walk. And above all, why lose our patience? And about what? . . . About souls—when we have before us the sight of life itself. . . . What is more, I know them, these artists of the soul! These fellows draw women who are too big and trees that are too small [see Fig. 49]. As soon as you notice somewhere a picture representing a woman without breasts, without hips, without a bottom, without thighs, who is bigger by twenty arm's lengths than the most immense oaks and the most gigantic firs, you can say with certainty that it is by an artist of the soul. For these good people, a soul is only a stake, with, here and there, a lily, an iris, and a poppy. . . . Sometimes she holds a lyre in her hand, or a frond . . . and her eyes are drawn and blackened as if she had spent the night with a steve-dore.[70] When people would explain Burn[e-]Jones to me long ago, they would say: "Please notice the quality of the hematoma around the eyes; it is

unique in art. One cannot tell whether it is occasioned by self-abuse or lesbian practices, by natural love or by tuberculosis. . . . That is the key to everything." What fools! . . . And they would not even be capable of fore-shortening the hat of Murat or of drawing a full-face view of a dragoon's helmet, as I do on my matchboxes.[71]

AUTHOR: But why get so excited? Let them draw women who are too tall; after all, it is not a crime. They do what they can, and despite it all, they are a decent bunch. . . . What should it matter to you?

Kariste looked at me with a sinister gleam in his eyes. Hatred flared in them as would a torch in the night under a strong wind.

KARISTE: (*stuttering and with a strangled voice*) What it does to me? . . . what it . . . for heaven's sake! But don't you know that. . . .

Kariste grabbed my arm and pushed me toward the terrace of a café.

KARISTE: Let's go and have a beer. Aesthetics makes me choke, and I have all their god-awful souls in my throat.

AUTHOR: So ended our discussions of yesteryear. Poor Kariste had not changed. Under his bourgeois clothing he had preserved the fiery soul of a bohemian, in which the little flower of creation would never blossom.

EPILOGUE:
FORMALIST CRITICISM AND
HARBINGERS OF SURREALISM

Mirbeau's contempt for the spiritual complexities of the artists of the soul, just like Whistler's vilification of anything that smacked of literature in art, was to culminate in widespread attempts to repudiate any reliance on metaphors or the play of associations in art. Symbolist principles did survive, however, and were to play an important role in twentieth-century aesthetic developments. Suffice it to say that Matisse, Picasso, and others among their contemporaries produced works with strong symbolist affinities and that the symbolist play of associations is at the root of the clash of moods and ideas that characterizes the expressive content of surrealist works.[1]

Early in the twentieth century, the critic Roger Fry and his colleague and friend Clive Bell led the attack against anything that interfered with the aesthetics of pure form (what I have called musicality), including the requirements imposed by objective description and even allusions to unrelated imagery that might be introduced by the associative mechanisms of the brain—not excluding literary allusions. Fry claimed in 1912:

> All art depends on cutting off the practical responses to sensations of ordinary life, thereby setting free a pure and as it were disembodied functioning of the spirit; but in so far as the artist relies on the associated ideas of the objects which he represents, his work is not completely free and pure, since romantic associations imply at least an imagined practical activity. The disadvantage of such an art of associated ideas is that its effect really depends on what we bring with us.[2]

Fry spread the message through art periodicals, avant-garde exhibition catalogue prefaces, and erudite lectures, while Bell broadcast it in his simple and forceful manifesto *Art* (1914), which was widely distributed. The two men became veritable pillars of what has since been called formalist criticism, that is, criticism that analyzes the arrangement of form and of color and the emotions it gives rise to.[3] Fry, however, came to question Bell's

dismissal of visual associations and, shortly before his death, even acknowledged the merits of literary associations.

A number of French avant-garde critics and poets remained faithful to the fundamental principles of symbolism.[4] Some poets, indeed, became bolder, more ingenious, and more disturbing in their often dazzling play of associations. The more innovative among these gravitated to the critic and poet Remy de Gourmont, whose role as literary critic of the *Mercure de France,* along with his intelligence and talent, made him a leader among a new intellectual avant-garde.

In the issue of *Mercure de France* dated February 1891 Gourmont praised the extraordinary visions of Lautréamont—pen name of Isidore Ducasse, eventually regarded by the surrealists as one of their principal prophets—in his *Chants de Maldoror* of 1868 and 1869 and his *Poésies* of 1870.[5] No doubt Gourmont was thinking of Lautréamont as well as of the more audacious symbolists, when he wrote in 1892:

> One is always complicated and always obscure in matters related to one's self, and the simplifications and clarifications brought about by one's conscience are works of genius; personal art—and it is the only art—is always more or less incomprehensible. Once it is understood, it ceases to be pure art and becomes a motive for new artistic expressions.
>
> But however personal symbolist art may be, it must touch the nonpersonal at least in one place—be it only to justify its name; and it must always be logical. It must ask the permanent meaning of transitory facts and endeavor to give it permanence without interfering with what its own vision requires—like a solid tree emerging from the ever-fluid underbrush;[6] it must look for the eternal in the momentary diversity of forms, find solid truth in fleeting falsity, see perennial logic in the momentarily illogical—and nevertheless plant a tree so special, so unique in its pattern of branches and its bark, its flowers and its roots, that it might be recognized from among all trees as one whose essence is unique. . . .
>
> . . . [I]t is important that one should tolerate, alongside known forms, forms that are unknown and, in the hothouse of literature, that one not exclude plants that take root by chance, ignored by botanists and gardeners.

While Gourmont repeated notions, such as subjectivity and the need for obscurity, already well established in symbolist doctrine, he attached a new importance to the chance encounter of ideas and all that it might imply in illogical, surprising, and even incongruous plays of associations. Perhaps even more important, he advocated links with "transitory facts" as well as "the momentarily illogical"—susceptible to interpretation as the vagaries of the external world, the irrational aspects of the unconscious, or both.[7]

Gourmont, furthermore, went beyond his predecessors in specifying the role of the unconscious—he called it the subconscious, in keeping with the

latest psychological concepts—in any creative effort, even one destined to lead to purely rational results. He thus wrote in 1890:

> The subconscious state is one of free automatic cerebration, whereas intellectual activity pursues its course at the limit of consciousness, a little below it and beyond its reach. . . . Imaginative intellectual creation is inseparable from the subconscious state; in this category of creations must be included the discovery of the scientist and the ideological construction of the philosopher. All who have invented or discovered something new, in any field whatsoever, are imaginative beings as much as observers. The most evenhanded, thoughtful, and painstaking writer is constantly, and in spite of himself, enriched by the subconscious. No work is so completely a product of the will that it does not owe the subconscious some beauty or innovation.[8]

Indeed, writing of men who were to him "if not the leaders of humanity," at least "the judges," he explained: "These men, raised above the rest, attain their fullest potential only at those moments when the subconscious, becoming conscious, opens the locks of the mind and releases to the world the flood of sensations it owes, in the first place, to the world. They [these men] are the magnificent instruments on which the subconscious alone plays with genius; and genius too is subconscious."[9]

The play of associations, important for Gourmont in the relation between conscious and unconscious processes, was consequently for him a major component of poetic creation. But symbolism as a movement had nearly spent itself, and in the beginning of the twentieth century, Gourmont articulated a corollary: the poetic role of the play of dissociations—the outcome, that is, of separating two ideas whose union had become a commonplace or a cliché or of removing an object from its usual context, thus causing us to discard a stale aesthetic experience.

Gourmont's awareness of the role of the unconscious in the handling of subject matter, his belief that a parallel can exist between the irrationalities of life and the incongruities of the unconscious, his acceptance of the absurd and the equivocal in the outpourings of the unconscious, and his insistence that new associations of ideas as well as new dissociations are essential to poetic creation—as well as to sound judgment in practical matters—made him an important forerunner of surrealism.

The poets Alfred Jarry and Guillaume Apollinaire, who were friends, belonged to Gourmont's circle. Each wanted in his own way to make powerfully evocative metaphors drawn increasingly, if not exclusively, from the universe of modern, mechanized humanity and even from scientific discovery. They used the poet's traditional baggage of myths and allusions to earlier literature essentially to enrich their play of associations.

Responding to the new awareness of the role of the unconscious, they insisted on the spontaneous creation of imagery to the point of accepting incongruous, frequently absurd, and even shocking associations as a matter of course, always delighting in parallels with the inconsistencies and absurdities that were becoming increasingly apparent in the life of industrial society and in the latest scientific discoveries.

Jarry was so imbued with the principles of symbolism that he jestingly denied that any single material equivalent of a thought could be more poetically evocative than any other. "All gestures," he exclaimed "are aesthetic to the same degree, and we shall attach to all the same importance." This was tantamount to saying that all the symbols in Baudelaire's forest, the words in Delacroix's dictionary, and the ideas in Aurier's algebra had equal aesthetic value. Hence the often burlesque, sometimes tragic, incongruities they use to translate inner states. Even beyond that for Jarry, who had been influenced by Gourmont and Apollinaire, the signs could be made to signify outer as well as inner reality. As André Breton, the magus-to-be of surrealism, put it, Jarry was the poet in whom "the struggle between the two forces that have dominated art during the romantic period occurred and took a decisive turn: the one that led to a focus on the accidents of the external world and the one that led to a focus on the caprices of personality." This struggle evolved in what Breton called, far too restrictively, "objective humor."[10]

Apollinaire's use of the term *surrealist* in the program notes for his play *Les Mamelles de Tirésias* (1917) was linked to the myriad metaphors he borrowed from everyday life with a freedom that often resulted in incongruous effects: "When man wanted to imitate his walk, he invented the wheel, which does not look like a leg. In the process he practiced surrealism without knowing it." Referring to this play of associations based on the imagery of everyday life, he added: "I believe that one must go back to nature without imitating it like a photographer."[11] Apollinaire felt the poet should seek his inspiration in a field of experience "as vast as a daily newspaper, which refers on a single sheet to the most varied subjects and covers the most distant lands."[12] For the poet, he claimed, this hectic, exciting, often dramatic vision of the physical world and the phantasmagoria of the unconscious were complementary and interchangeable; he referred to "the divine games of life and the imagination that give rise to a totally new poetic activity."[13]

During World War I many of the future proponents of literary surrealism gathered around Apollinaire, who had returned from the front with a serious head wound (he was to die of influenza in 1919): Philippe Soupault, Louis Aragon, André Breton, Jean Cocteau, and others. Breton, in his

"Manifesto of Surrealism," written in 1924, three years after a visit to Freud in Vienna, advocated the free play of the unconscious, "the belief in the superior reality of certain hitherto neglected forms of association, in the almighty power of the dream, in the disinterested play of thought." And he called the process for achieving such associations "pure psychic automatism, by means of which one endeavors to express . . . the real functioning of thought. Dictation of thought outside any control exerted by reason, outside any aesthetic or moral preoccupation." [14]

The psychic automatism Breton defined manifested itself in the work of the surrealist poets and artists in a new stress on the chance impact of sensory impressions and the subconscious imagery they unleash and, conversely, on the apparently haphazard sequential imagery of dreams and the range of emotions they reveal—according to Freud. In both cases Breton postulates a sense of clinical detachment and scientific rigor intended to emulate Freud's, and he accepts the various associations and dissociations that arise under the conditions he describes as evidence of hitherto hidden truths, in keeping with the Freudian gospel.

The corresponding play of associations and dissociations takes two distinct forms among the surrealist artists. In the first, objects are rendered with deliberate visual accuracy, but create surprising, baffling, and even conflicting effects because they are associated in a hitherto untried and apparently incongruous way and are detached from their usual context.

Baudelaire had already isolated the first type of association: in the life of dreams, he wrote, quoting from Charles Asselineau's *La Double Vie* (The double life), aside from "fantastic regions, in which all accepted behavior has become confused, all preestablished ideas contradicted," situations arise whereby "(and this is even more frightening) the impossible mingles with the real." Beyond those, "what strikes me much more is the assent given these contradictions, the ease with which the most monstrous paralogisms are accepted as altogether natural, in such a way as to make one believe in faculties or notions of a special order, foreign to our world." [15] Theorists of surrealism have called this presentation of real-looking objects in impossible associations veristic surrealism (as in works by Duchamp, Delvaux, and Magritte).

The second form taken by the play of associations and dissociations is characterized by the frenzy, the sense of the fantastic, that may emerge from words that seem to piece themselves together according to rules beyond the intellectual control of the writer, or from forms and colors that generate themselves equally freely—evoking cosmic forces and the psychic turmoil of the individual. Aurier had sensed the convergence of the two in van Gogh's works when he described the artist as "a sort of drunken giant, more likely to move mountains than to handle bibelots on shelves, his feverish

brain spewing lava into all the hollows of art. He is a terrible maddened genius, often sublime, sometimes grotesque, always verging on the pathological."[16] Verhaeren detected a similar convergence in some of Ensor's work where the artist seems bent on filling the cosmos with psychic forces so great as to practically obliterate the figures and objects of daily life. "In the myths unfurled in the history of art, only gods and men exist. But as the idea of force has displaced and modified myth, humanity comprehends that a human being is but an eddy of thought in the tumultuous rush of cosmic powers; the importance of his gestures has diminished."[17]

The frenzied artist's association of cosmic and psychic forces through the freedom and vigor of graphic means and the corresponding depreciation of traditional figures and objects characterize what is known as absolute, or abstract, surrealism. The process of handling the graphic medium in a trancelike state to achieve such effects (as in works by Masson and Miró) has been called graphic automatism.

Post Impressionism (1911)
The French Post-Impressionists (1912)

Having distinguished himself as a science student at Cambridge University, Roger Fry (1866–1934) dedicated himself to art: he was at various times, sometimes simultaneously, a painter, a critic, an art historian, a museum curator, and a restorer. He was one of the founders, and later an editor, of the scholarly *Burlington Magazine.* He charmed London's high society with lectures that revealed the eye of a great connoisseur in areas as diverse as the art of ancient China and French impressionism. As early as 1906 he came to appreciate Cézanne, describing canvases he saw in London with pioneering, if moderate, enthusiasm;[18] he developed a lifelong devotion to the artist. From 1906 to 1910 he was a curator at New York's Metropolitan Museum of Art, as well as an adviser to major American collectors such as John Pierpont Morgan, Henry Clay Frick, and John G. Johnson, for all of whom he made extraordinary acquisitions.[19] He spent the summer of 1910 in Paris, in the company of his friend Clive Bell and the British literary critic Desmond MacCarthy, with whom he assembled an exhibition of recent French works that, for want of a better title, the three called Manet and the Post-Impressionists. It was presented at London's Grafton Gallery. In addition to Manet, it included the post-impressionists Seurat, Signac, Cézanne, Gauguin, van Gogh, and Denis; the fauves, Marquet, Vlaminck, and Puy; and Picasso among the cubists.

The first of the two texts that follow is made up of excerpts from a lecture by Fry, the last of a series presented in connection with the 1910–11 exhibition. It was intended, among other things, to respond to an earlier lecture by Walter Sickert, a gifted British artist then working in a shadowy naturalist technique owing much to Whistler and Degas.[20] Sickert was condescending toward Cézanne; appreciative of Gauguin, whose work was "sonorous but not shrill"; and interested in as well as stimulated by van Gogh's intensity. But he savaged the group for their distortions, for although he believed "deformation or distortion . . . a necessary quality in handmade art," thus echoing Ruskin's views, he only accepted such irregularities on

the condition that they "result from the effort and accuracy of an accomplished hand and the inevitable degree of error in the result."[21] In other words, distortions could not be intentional.

Fry in this text derides Sickert for this last contention. He postulates musicality as the point of departure and conceives the possibility of total abstraction: "There is no immediately obvious reason why the artist should represent actual things at all, why he should not have a music of line and color. Such a music he undoubtedly has and it forms the most essential part of his appeal." Fry referred to the impact of such an experience as "intense aesthetic pleasure." Representation had its place in the guise of "appropriate associated ideas," especially when the picture has a specific subject: "If I have to express the idea of a tiger attacking a man, it is essential that the spectator should realize the animal to be a tiger and not a hippopotamus."[22] But, in keeping with the tenets of the play of associations of symbolism, Fry went beyond the requirements (if any) of tangible representation and accepted the need for imagined associations—but with major reservations: "Like the poet, [the artist] can call up at will from out of the whole visible world, reminiscences and remembered images of any visible or visually conceivable thing . . . with all the enrichment of emotional effect which they bring." But such images should not interfere with the effects of musicality. The suitable match of form and musicality leads to what Fry considers the crowning triumph of post-impressionism over impressionism and, by extension, all earlier schools—that of Cézanne: "Working along the lines of Impressionist investigation with unexampled fervor and intensity, he seems, as it were, to have touched a hidden spring whereby the whole structure of Impressionist design broke down, and a new world of significant and expressive form became apparent." The phrase "significant and expressive form" was soon simplified into "significant form," and, in the second excerpt, was coupled with "aesthetic pleasure," now become "aesthetic emotion." Such was the genesis of the formalist concept whereby "significant" or "expressive form" is accompanied by "aesthetic emotion," both being largely independent of the impact of subject matter—a concept that can be traced back to Pater and the aesthetic movement. It is not too much to claim that "significant form" and its concomitant "aesthetic emotion" can be equated with the expressiveness of musicality. The harmonic component of musicality matters too; indeed, Fry was to stress its importance in various texts, particularly in connection with Seurat.

Fry conceived "significant and expressive form" as "linear design and color" as opposed to three-dimensional form in space achieved by means of "light and shade." In this respect he repudiated a major aspect of the naturalist trend in Western art from the early Renaissance to the advent of synthetism.

The formalist concept is enounced in its purest form as an absolute prin-

ciple in the second set of excerpts, in which Fry introduces the second Post-Impressionist Exhibition. It emerges along with a renewed stress on the expressive qualities of post-impressionist art.[23]

The second Post-Impressionist Exhibition, held in 1912, also at the Grafton Gallery, had a Russian avant-garde section, selected by a Russian friend of Fry's, Boris Anrep; a French section, which was much stronger in its twentieth-century coverage than in the earlier show, selected by Fry; and a British section in which Fry himself and some other members of what became known as the Bloomsbury group were represented, selected by Bell.

Fry adopted a much firmer tone in his introduction to the second exhibition. Ascribing "associated ideas" to romanticism, he praised the "classic spirit" of recent French avant-garde art, adding that it was "free and pure" of such associations. Bell himself referred outright to "pure form."

In addition to the linkage between "significant form" and "aesthetic emotion," Fry owed to Pater's aestheticism the notion that the truly creative artist achieved such a "concentration of feeling" as to evoke in the onlooker, as he was to put it in connection with Seurat's *Bathers, Asnières* (1883–84), "the quality of immediacy, of a thing actually seen and seized upon in a single ecstatic moment."[24] The relationship is to be compared with Pater's yoking of the form that "grows perfect in hand or face . . . , irresistibly real and attractive for us for that moment only," with the determination "to burn always with this hard gem-like flame" and so "maintain this ecstasy."[25] In keeping with his awareness of the harmonic component of musicality, Fry added that the painting created "a mood of utter withdrawal . . . into a region of pure and almost abstract harmony."

The first text is from Roger Fry, "Post Impressionism," *Fortnightly Review,* 89 (May 1911): 856–67. The second is from "The French Post-Impressionists. Preface to the Second Post-Impressionist Exhibition, Grafton Galleries, 1912," in *Vision and Design* (London: Chatto and Windus, 1923), 237–43. ✦

POST IMPRESSIONISM

I believe that even those works [in the exhibition] which seem to be extravagant or grotesque are serious experiments—of course, not always successful experiments—but still serious experiments, made in perfectly good faith towards the discovery of an art which in recent times we have almost entirely forgotten.

My object in this lecture is to try to explain what this problem is and how these artists are, more or less consciously, attempting its solution. It is to discover the visual language of the imagination. To discover, that is, what

arrangements of form and color are calculated to stir the imagination most deeply through the stimulus given to the sense of sight. This is exactly analogous to the problem of music, which is to find what arrangements of sound will have the greatest evocative power. But whereas in music the world of natural sound is so vague, so limited, and takes, on the whole, so small a part of our imaginative life, that it needs no special attention or study on the part of the musician; in painting and sculpture, on the contrary, the actual world of nature is so full of sights which appeal vividly to our imagination—so large a part of our inner and contemplative life is carried on by means of visual images, that this natural world of sight calls for a constant and vivid apprehension on the part of the artist. And with that actual visual world, and his relation to it, comes in much of the painter's joy, and the chief, though not the only, fount of his inspiration but also much of his trouble and a large part of his quarrel with the public. For instance, from that ancient connection of the painter's with the visual world it comes about that it is far harder to him to get anyone, even among cultivated people, to *look* at his pictures with the same tense passivity and alert receptiveness which the musician can count on from his auditors. Before ever they have in any real sense *seen* a picture, people are calling to mind their memories of objects similar to those which they see represented, and are measuring the picture by these, and generally—almost inevitably if the artist is original and has seen something with new intensity and emotion—condemning the artist's images for being different from their own preconceived mental images. That is an illustration of the difficulties which beset the understanding of the graphic arts, and I put it forward because to understand the pictures here exhibited it is peculiarly necessary that you should look at them exactly as you would listen to music or poetry, and give up for once the exhibition attitude of mind which is so often one of querulous self-importance. We must return to the question of the painter's relation to the actual visible world. . . .

[Fry then dismisses the artists who, through the ages, have succumbed to the tyranny of exact representation and singles out the artist "allowed to address himself directly to the imagination."]

Now it is precisely this inestimable boon that, if I am right, these artists, however unconsciously they may work, are gaining for future imaginations, the right to speak directly to the imagination through images created, not because of their likeness to external nature, but because of their fitness to appeal to the imaginative and contemplative life.

And now I must try to explain what I understand by this idea of art addressing itself directly to the imagination through the senses. There is no immediately obvious reason why the artist should represent actual things at all, why he should not have a music of line and color. Such a music he

undoubtedly has and it forms the most essential part of his appeal. We may get, in fact, from a mere pattern, if it be really noble in design and vital in execution, intense aesthetic pleasure. And I would instance as a proof of the direction in which the post impressionists are working, the excellences of their pure design as shown in the pottery at the present exhibition. In these there is often scarcely any appeal made through representation, just a hint at a bird or an animal here and there, and yet they will arouse a definite feeling. Particular rhythms of line and particular harmonies of color have their spiritual correspondences, and tend to arouse now one set of feelings, now another. The artist plays upon us by the rhythm of line, by color, by abstract form, and by the quality of the matter he employs. But we must admit that for most people such play upon their emotions, through pure effect of line, color, and form is weak compared with the effect of pure sound. But the artist has a second string to his bow. Like the poet he can call up at will from out of the whole visible world, reminiscences and re-membered images of any visible or visually conceivable thing. But in calling up these images, with all the enrichment of emotional effect which they bring, he must be careful that they do not set up a demand independent of the need of his musical phrasing, his rhythm of line, color, and plane. He must be just as careful of this as the poet is not to allow some word which, perhaps, the sense may demand to destroy the *ictus* [the recurring stress] of his rhythm. Rhythm is the fundamental and vital quality of painting, as of all the arts—representation is secondary to that, and must never encroach on the more ultimate and fundamental demands of rhythm. The moment that an artist puts down any fact about appearance because it is a fact, and not because he has apprehended its imaginative necessity, he is breaking the laws of artistic expression. And it is these laws, however difficult and un-discoverable they may be, which are the final standard to which a work of art must conform.

Now these post impressionist artists have discovered empirically that to make the allusion to a natural object of any kind vivid to the imagination, it is not only not necessary to give it illusive likeness, but that such illusion of actuality really spoils its imaginative reality. . . .

A great part of illusive representation is concerned with creating the illu-sion of a third dimension by means of light and shade, and it is through the relief thus given to the image that we get the sensual illusion of a third dimension. The intrusion of light and shade into the picture has always presented serious difficulties to the artist; it has been the enemy of two great organs of artistic expression—linear design and color: for though, no doubt, color of a kind is consistent with chiaroscuro, its appeal is of quite a different order from that made when we have harmonies of positive flat color in frank opposition to one another. Color in a Rembrandt, admirable

though it is, does not make the same appeal to the imagination as color in a stained glass window. Now if it should turn out that the most vivid and direct appeal that the artist can make to the imagination is through linear design and frank oppositions of color, the artist may purchase the illusion of third dimensional space at too great a cost. Personally I think he has done so, and that the work of the post impressionists shows conclusively the immense gain to the artist in the suppression or re-interpretation of light and shade. One gain will be obvious at once, namely, that all the relations which make up the unity of the picture are perceived as inhering in the picture surface, whereas with chiaroscuro and atmospheric perspective the illusion created prevents our relating a tone in the extreme distance with one in the near foreground in the same way that we can relate two tones in the same plane. It follows, therefore, that the pictures gain immensely in decorative unity. This fact has always been more or less present to the minds of artists when the decoration of a given space of wall has been demanded of them; in such cases they have always tended to feel the need for keeping the relations upon the flat surface, and have excused the want of illusion, which was supposed to be necessary for a painting, by making a distinction between decorative painting and painting a picture, a distinction which I believe to be entirely fallacious; a painting of any kind is bound to be decorative, since by decorative we really mean conforming to the principles of artistic unity. . . .

[Fry discusses several pictures.]

It appears then that the imagination is ready to construct for itself the ideas of space in a picture from indications even more vividly than it accepts the idea when given by means of sensual illusion. And the same fact appears to be true of plastic relief. We do not find, as a matter of empirical fact, that the outlines with which some of these artists surround their figures, in any way interfere with our imaginative grasp of their plastic qualities—particularly is this the case in Cézanne, in whom the feeling for plastic form and strict correlation of planes appears in its highest degree. His work becomes in this respect singularly near to that of certain primitive Italian artists, such as Piero della Francesca,[26] who also relied almost entirely upon linear design for producing this effect.

Many advantages result to art from thus accepting linear design and pure color as the main organs of expression. The line itself, its qualities as handwriting, its immediate communication to the mind of gesture, becomes immensely enhanced, and I do not think it is possible to deny to these artists the practice of a particularly vigorous and expressive style of handwriting.[27] It is from this point of view that Matisse's curiously abstract and impassive work can be most readily approached. In his *Woman with Green Eyes* we have a good example of this.[28] Regarded as a representation pure and

simple, the figure seems almost ridiculous, but the rhythm of the linear design seems to me entirely satisfactory; and the fact that he is not concerned with light and shade has enabled him to build up a color harmony of quite extraordinary splendor and intensity. There is not in this picture a single brush stroke in which the color is indeterminate, neutral, or merely used as a transition from one tone to another.

Again, this use of line and color as the basis of expression is seen to advantage in the drawing of the figure. As Leonardo da Vinci so clearly expressed it, the most essential thing in drawing the figure is the rendering of movement, the rhythm of the figure as a whole by which we determine its general character as well as the particular mood of the moment.[29] Now anything like detailed modeling or minute anatomical structure tends to destroy the ease and vividness with which we apprehend this general movement; indeed, in the history of painting there are comparatively few examples of painters who have managed to give these without losing hold of the general movement. We may say, indeed, that Michelangelo's claim to a supreme place is based largely upon this fact, that he was able actually to hold and to render clear to the imagination the general movement of his figures in spite of the complexity of their anatomical relief; but as a rule if we wish to obtain the most vivid sense of movement we must go to primitive artists, to the sculptors of the twelfth century, or the painters of the early fourteenth.

Now here, again, the Post Impressionists have recovered for us our lost inheritance, and if the extreme simplification of the figure which we find in Gauguin or Cézanne needed justification, it could be found in this immensely heightened sense of rhythmic movement. Perfect balance of contrasting directions in the limbs is of such infinite importance in estimating the significance of the figure that we need not repine at the loss which it entails of numberless statements of anatomical fact.

I must say a few words on their relation to the Impressionists. In essentials the principles of these artists are diametrically opposed to those of Impressionism. The tendency of Impressionism was to break up the object as a unity, and to regard the flux of sensation in its totality; thus, for instance, for them the local color was sacrificed at the expense of those accidents which atmosphere and illumination from different sources bring about. The Impressionists discovered a new world of color by emphasizing just those aspects of the visual whole which the habits of practical life had caused us to underestimate. The result of their work was to break down the tyranny of representation as it had been understood before. Their aim was still purely representative, but it was representation of things at such a different and unexpected angle, with such a new focus of attention, that its very novelty prepared the way for the Post Impressionist view of design.

How the Post Impressionists derived from the Impressionists is indeed a

curious history. They have taken over a great deal of Impressionist technique, and not a little of Impressionist color, but exactly how they came to make the transition from an entirely representative to a non-representative and expressive art must always be something of a mystery, and the mystery lies in the strange and unaccountable originality of a man of genius, namely, Cézanne. What he did seems to have been done almost unconsciously. Working along the lines of Impressionist investigation with unexampled fervor and intensity, he seems, as it were, to have touched a hidden spring whereby the whole structure of Impressionist design broke down, and a new world of significant and expressive form became apparent. It is that discovery of Cézanne's that has recovered for modern art a whole lost language of form and color. Again and again attempts have been made by artists to regain this freedom of imaginative appeal, but the attempts have been hitherto tainted by archaism. Now at last artists can use with perfect sincerity means of expression which have been denied them ever since the Renaissance. And this is no isolated phenomenon confined to the little world of professional painters; it is one of many expressions of a great change in our attitude to life. We have passed in our generation through what looks like the crest of a long progression in human thought, one in which the scientific or mechanical view of the universe was exploited for all its possibilities. How vast, and on the whole how desirable those possibilities are is undeniable, but this effort has tended to blind our eyes to other realities; the realities of our spiritual nature, and the justice of our demand for its gratification. Art has suffered in this process, since art, like religion, appeals to the non-mechanical parts of our nature, to what in us is rhythmic and vital. It seems to me, therefore, impossible to exaggerate the importance of this movement in art, which is destined to make the sculptor's and the painter's endeavor once more conterminous with the whole range of human inspiration and desire.

THE FRENCH POST-IMPRESSIONISTS

[Fry begins by noting the diversity of trends among the artists represented in the exhibition.] But however various the directions in which different groups are exploring the newly-found regions of expressive form they all alike derive in some measure from the great originator of the whole idea, Cézanne. . . .

Finally, I should like to call attention to a distinguishing characteristic of the French artists seen here, namely the markedly Classic spirit of their work. . . . I mean that they do not rely for their effect upon associated ideas, as I believe Romantic and Realistic artists invariably do.

All art depends upon cutting off the practical responses to sensations of ordinary life, thereby setting free a pure and as it were disembodied functioning of the spirit; but in so far as the artist relies on the associated ideas of the objects which he represents, his work is not completely free and pure, since romantic associations imply at least an imagined practical activity. The disadvantage of such an art of associated ideas is that its effects really depend on what we bring with us: it adds no entirely new factor to our experience. Consequently, when the first shock of wonder or delight is exhausted the work produces an ever lessening reaction. Classic art, on the other hand, records a positive and disinterestedly passionate state of mind. It communicates a new and otherwise unattainable experience. Its effect, therefore, is likely to increase with familiarity. Such a Classic spirit is common to the best French work of all periods from the twelfth century onwards, and though no one could find direct reminiscences of a Nicolas Poussin here, his spirit seems to revive in the work of artists like Derain. It is natural enough that the intensity and singleness of aim with which these artists yield themselves to certain experiences in the face of nature may make their work appear odd to those who have not the habit of contemplative vision, but it would be rash for us, who as a nation are in the habit of treating our emotions, especially our aesthetic emotions, with a certain levity, to accuse them of caprice or insincerity. It is because of this classic concentration of feeling (which by no means implies abandonment) that the French merit our serious attention. It is this that makes their art so difficult on a first approach but gives it its lasting hold on the imagination.

Cézanne's "Pure Form" (1914)

When approached by the British publishers Chatto and Windus in 1913 to write a book on post-impressionism, Fry, too busy at the time, recommended Clive Bell (1881–1964) instead.[30] The work (*Art,* 1914) has all the excitement and weaknesses of the writings of a bright sophomore enthralled by philosophical discourse.[31] But it makes its point and does so emphatically, however open-ended the reasoning is.

The connections with the aesthetic movement, notably Walter Pater, are manifest. Art has religious status: "Religion, as I understand it, is an expression of the individual's sense of the emotional significance of the universe; I should not be surprised to find that art was an expression of the same thing. Anyway, both seem to express emotions different from and transcending the emotions of life. Certainly both have the power of transporting men to superhuman ecstasies; both are means to unearthly states of mind."[32]

Bell starts out, in his chapter "The Metaphysical Hypotheses," by asserting that "when . . . a real artist looks at objects . . . he perceives them as pure forms in certain relations to each other, and feels emotions for them as such." He insists, in particular, that objects are seen "not as means shrouded in associations, but as pure forms . . . which ultimately comes to see[ing] them as ends in themselves." As for "the significance of the thing in itself [is it] the significance of Reality?" he asks. Some, in a moment of exaltation, will say "that there is in all things the stuff of which art is made—reality. [Yet] artists, even, can grasp it only when they have reduced things to their purest condition of being—to pure form." Ultimately, "the peculiarity of the artist would seem to be that he possesses the power of . . . seizing reality (generally behind pure form)." This end, however, will be achieved only when "criticism will be armed with a new weapon. . . . Going behind the emotion and its object, the critic will be able to surprise that which gives form its significance."

In the meantime, Fry's own attitude was evolving. He wrote in his review of Bell's book:

> I wish [Mr. Bell] had extended his theory, and taken literature (in so far as it is art) into fuller consideration, for I feel confident that great poetry arouses aesthetic emotions of a similar kind to painting and architecture. And to make his theory complete, it would have been Mr. Bell's task to show that the human emotions of *King Lear* and *The Wild Duck* were also accessory, and not fundamental and essential qualities in these works. . . .[33]
>
> Since, if in words, images may be evoked in such an order, and having such a rhythmic relation, as to arouse an aesthetic emotion, there is no apparent reason why images may not be similarly evoked by painting having a similar formal relation. This would be, as in literature, not a visible but an ideal form. If, on the other hand, it cannot be shown that the essence of poetry is also one of formal relations, but is due to an admixture of forms with content, then there would be nothing surprising in discovering that the art of painting was of a similar, composite nature.[34]

Fry took an even firmer stand against the aesthetics of "pure form" in a lecture he delivered in French in Brussels in the fall of 1933, a year before his death: "And such psychological values [those evoked by a work of art] only serve to complete and enrich the emotion already produced by the arrangement of the volumes in space."[35] In this statement he completely vindicated the aesthetics of the play of associations, a development not unduly surprising on the part of one who spent much of his later life translating Mallarmé's poetry into English.

The theory of significant form and its ability to give rise to aesthetic emotion were nevertheless to have a profound impact on the study of art through several decades of the twentieth century.

The excerpts that follow are from the chapter "The Debt to Cézanne," in Clive Bell, *Art* (New York: Stokes, [1914]), 208–14. ❦

He [Cézanne] was on the right side, of course—the Impressionist side, the side of the honest, disinterested artists, against the academic, literary pests. He believed in painting. He believed that it could be something better than an expensive substitute for photography or an accompaniment to poor poetry. So in 1870 he was for science against sentimentality.

But science will neither make nor satisfy an artist: and perhaps Cézanne saw what the great Impressionists could not see, that though they were still painting exquisite pictures their theories had led art into a *cul de sac* [dead end]. So while he was working away in his corner of Provence, shut off completely from the aestheticism of Paris, from Baudelairism and Whistler-

ism, Cézanne was always looking for something to replace the bad science of Claude Monet. And somewhere about 1880 he found it. At Aix-en-Provence came to him a revelation that has set a gulf between the nineteenth century and the twentieth: for, gazing at the familiar landscape, Cézanne came to understand it, not as a mode of light, nor yet as a player in the game of human life, but as an end in itself and an object of intense emotion. Every great artist has seen landscape as an end in itself—as pure form, that is to say; Cézanne has made a generation of artists feel that compared with its significance as an end in itself all else about a landscape is negligible. From that time forward Cézanne set himself to create forms that would express the emotion that he felt for what he had learnt to see. Science became as irrelevant as subject. Everything can be seen as pure form, and behind pure form lurks the mysterious significance that thrills to ecstasy. The rest of Cézanne's life is a continuous effort to capture and express the significance of form. . . .

The world into which Cézanne tumbled was a world still agitated by the quarrels of Romantics and Realists. The quarrel between Romance and Realism is the quarrel of people who cannot agree as to whether the history of Spain or the number of pips is the more important thing about an orange. The Romantics and Realists were deaf men coming to blows about the squeak of a bat. The instinct of a Romantic invited to say what he felt about anything was to recall its associations. A rose, for instance, made him think of old gardens and young ladies and Edmund Waller and sundials, and a thousand quaint and gracious things that, at one time or another, had befallen him or someone else.[36] A rose touched life at a hundred pretty points. A rose was interesting because it had a past. "Bosh," said the Realist, "I will tell you what a rose is; that is to say, I will give you a detailed account of the properties of *Rosa setigera,* not forgetting to mention the urn-shaped calyx-tube, the five imbricated lobes, or the open corolla of five obovate petals." To a Cézanne one account would appear as irrelevant as the other, since both omit the thing that matters—what philosophers used to call "the thing in itself," what now, I imagine, they call "the essential reality." For, after all, what is a rose? What is a tree, a dog, a wall, a boat? What is the particular significance of anything? Certainly the essence of a boat is not that it conjures up visions of argosies with purple sails, nor yet that it carries coals to Newcastle. Imagine a boat in complete isolation, detach it from man and his urgent activities and fabulous history, what is it that remains, what is that to which we still react emotionally? What but pure form, and that which, lying behind pure form, gives it its significance. It was for this Cézanne felt the emotion he spent his life in expressing. And the second characteristic of the new movement is a passionate interest, inherited from Cézanne, in things regarded as ends in themselves. In saying this I am say-

ing no more than that the painters of the movement are consciously deter-
mined to be artists. Peculiarity lies in the consciousness—the consciousness
with which they set themselves to eliminate all that lies between themselves
and the pure forms of things. To be an artist, they think, suffices. How
many men of talent, and even of genius, have missed being effective artists
because they tried to be something else?

REMY DE GOURMONT

The Funeral of Style (1902)
The Dissociation of Ideas (1900)

Poet, novelist, essayist, one of the sharpest literary critics of his time and a man of great erudition, Remy de Gourmont (1858–1915) had excellent credentials among the symbolists. He had been a frequent visitor at Mallarmé's Tuesdays, and a regular contributor to *Mercure de France* as well as its principal literary critic from its founding in 1890 to his own death. He was also a librarian at the Bibliothèque Nationale (French National Library) in Paris.

Although he claimed not to belong to any literary movement, he considered symbolism "the only art,"[37] and he devoted his *Livre des masques* (1896) and *IIᵉ livre des masques* (1898) to word portraits of the principal figures of literary and artistic symbolism. Furthermore, some of his theoretical essays are among the most subtle and rigorous appraisals of symbolism.

Gourmont, a serious student of poetic form, considered the handling of poetic imagery, particularly metaphor—an aspect of the play of associations—to have evolved historically. To an example of a vivid sensory impression used to heighten the drama of an action in Homer's *Iliad* he opposes a metaphor associating a battle scene with totally different activities in Flaubert's *Salammbô* (1862), a novel fancifully reconstructing the turmoil that followed the first Roman invasion of, and withdrawal from, the North African city of Carthage. And while he did not do justice to symbolist artists in general when he claimed that such metaphors were beyond their capabilities, he paid a justified tribute to Redon, whom he considered uniquely capable of introducing similarly bold associations in his work.

The title of Gourmont's article, "The Funeral of Style," is an ironic repartee to that of the book to which he is responding: *The Development of Style through the Assimilation of [Famous] Authors,* by Antoine Albalat.[38]

The excerpt that follows is from Remy de Gourmont, "Les Funérailles du style," *Mercure de France* 43 (August 1902): 354–55; reprinted in *Le Problème du style* (Paris: Mercure de France, 1907), 89–90. ✦

299

THE FUNERAL OF STYLE

[Homer] tells us: "A stream of blood rushed out of his nostril." Homer cannot say "bathed in his blood"; that is a metaphor. Two images, in this expression which is now banal, but was, at one time, new, are united in a single one: the image of an abundance of blood spilled around a man; the image of a man immersed in water. Homer is exact, unable as he is to lie. He cannot lie; impressions reach him one by one, and he describes them as they arise, without confusion. Flaubert, who has a capacity for lying, and consequently an infinite capacity for artistic creation, is not exact when he writes: "The elephants, . . . their chests like ships' prows, cut through the ranks of Roman soldiers, leaving them flailing in aimless swirls in their wake." He succeeds in amalgamating the two images (elephants and soldiers, ships and waves) so effectively only because he has seen them in a single glance. What he gives us is no longer two drawings that can be superposed on one another symmetrically but the visually absurd and artistically admirable confusion of a double and troubled/triple sensation.[39] Odilon Redon, who wanted to make visible certain images derived from Baudelaire and Flaubert, managed to do so, despite his genius for mystery, only by sacrificing visual logic to imaginative logic. One can illustrate Homer literally, making the text visible; any illustration of Flaubert, aside from Redon's inimitable method, is bound to be a stupid betrayal. Let one try to make visible the double image of elephants-prows, soldiers-waves! This would require rendering a rough sea that would be a real sea yet one made up, not of waves, but of the chests and heads of legionnaires; and of elephants that, aside from remaining elephants, would also be warships. With Homer, who treats the two pictures successively, there is no problem; an alternating series of panels and diptychs could render the *Iliad* line by line. Images can be translated into painting, an art that is direct and therefore geometric, only when they are not metaphors.

THE DISSOCIATION OF IDEAS

Earlier writers had been aware that stale metaphors could be as deadening to a language as new ones were essential to poetic creation and, ultimately, to the renewal of the language itself. Shelley had made precisely that point when he asserted in 1821 that the poet's "language is vitally metaphorical, that is, it marks the before unapprehended relations of things and perpetuates their apprehensions, until the words which represent them become, through time, signs for portions and classes of thought instead of pictures of integral thoughts; and then, if no new poets should arise to create afresh

the associations which have been thus disorganized, languages will be dead to all nobler purposes of human intercourse."[40]

Gourmont broached a similar thought, and developed it further when he asserted that the creative mind not only had to establish new associations but also had to seek actively to destroy old ones, since these could only interfere with original thought. True to his awareness of the role of the unconscious in the act of creation, he pointed out that the play of associations and dissociations in our minds escapes logical understanding and, by implication, that it pertains—at least until such imagery becomes commonplace—to the world of the subconscious. He even went a step further, and referred to a specific instance in which a major dissociation affected a whole nation.

Gourmont does not identify the incident, but it must have involved a matter of national importance, since it caused the temporary dissociation of the concepts of honor and military tradition. I suspect the reference is to the Dreyfus case as it stood from the time of Zola's protest against the wrongful condemnation of Captain Alfred Dreyfus for high treason by a military court to his exoneration.[41] It was a situation in which the people in power, responding to mass hysteria, allowed the long-established association of militarism and honor to be replaced with that of militarism and treason, creating an injustice of nightmarish proportions.

If my assumption is correct, Gourmont provided an example of the interplay between the irrationalities of life and the incongruities of the unconscious. He was heralding the surrealists' acceptance of both as major factors affecting human activities and personal lives. Because of the close connections the surrealists postulated between art and life, such irrationalities were also major sources of aesthetic creativity. Gourmont was also foreshadowing concerns of the theater of the absurd, not to mention the predicament of Kafka's heroes.

"The drama," Gourmont wrote, "like the novel, must be a poem, and the idea must be the flower of the poem and not the poem the flower of the idea. The poem must speak as if it did not know what it was going to say, and finally one must be surprised by the logic of its madness and the wisdom of its obscurity."[42]

A firm believer in art for art's sake, Gourmont appears to have heralded one of Fry's and Bell's most characteristic pronouncements: "There is a pure art, solely concerned with realizing itself. No definition can be given of it, as this would be achieved only by associating the idea of art with ideas that are foreign to it and would tend to obscure and dirty it."[43] But Gourmont did accept the aesthetic worth of associations conceived by the artist or the poet himself. He was perfectly willing, furthermore, to concede that in real life, at least, some dissociations and new associations could be nefarious,

especially when, as in the case of Captain Dreyfus, they were based on gross intrigue, prejudice, and faulty judicial procedure.

The excerpts that follow are from Remy de Gourmont, "Les mots et les idées," *Mercure de France* 33 (January 1900): 5–11. ❧

There are two modes of thinking: one can accept ideas and associations of ideas in the manner they are commonly used or indulge for oneself in new associations or—and this is rarer—in original dissociations of ideas. The intelligence capable of such efforts is, more or less, according to the degree, the abundance, and the variety of its other gifts, a more or less creative intelligence. It is a matter of either imagining new relationships between old ideas, old images, or breaking up the old ideas, the old images united by tradition, taking them into consideration one by one, to reunite them eventually in matrimony and to set up in orderly fashion an infinity of new couples, which a new operation will once again disunite, until such time as new links, always equivocal and fragile, are formed.

In the domain of facts and experience these operations were limited by the resistance of matter and the intolerance of the laws of physics; in the purely intellectual domain, they are subject to the laws of logic. But logic, being itself an intellectual tissue, offers a nearly infinite range of accommodations. In truth, the association and dissociation of ideas (or images, the idea being no more than a worn-out image) evolve according to indeterminate twists and turns whose general direction cannot readily be gathered. No ideas are so distant, no images so disparate that they cannot be joined in easy association at least for a moment. Seeing a rope that sailors protect with rags where it is in contact with a sharp edge, Victor Hugo visualizes the knees of a tragic actress that have been padded in anticipation of her fall during the fifth act; and these two objects, as distant as a rope tightened over a rock and the knees of an actress, are evoked, for as long as it takes us to read the passage, in a parallel we find appealing because the knees and the rope are equally "padded," the first above the bend, the second below, because the elbow created by a cable under such conditions sufficiently resembles a bent leg, because the situation of Giliatt is perfectly tragic, and, finally, because while we perceive the logic of these juxtapositions, we are no less aware of their delicious absurdity.[44]

Such associations are necessarily among the most fugitive, unless the language should adopt them and turn them into one of those figures of speech with which it likes to enrich itself. One should not find it surprising if such a bend in a cable were called a cable's knee. At any rate, the two images remain ready to divorce; divorce is permanently enthroned in the realm of

ideas, which is also that of free love. Simple people sometimes find reason to be shocked by such a state of affairs: the human being who, for the first time, according to whether the one or the other of these two terms is oldest, dared say "the mouth" or "the muzzle" of a cannon must without doubt have been accused of being either precious or vulgar. If it is unseemly to refer to the knee of a ship's rope, referring to the elbow of a pipe or the belly of a flask is perfectly acceptable. But these examples are only given by way of elementary types of a mechanism whose practice is more familiar to us than its theory. We shall set aside all the still-living images to occupy ourselves solely with ideas, those tenacious and ethereal shadows that, eternally startled, agitate in the brains of men.

Some associations are so durable that they seem to be eternal and so tightly linked that they resemble those double stars which the naked eye is incapable of differentiating. One readily calls them commonplaces. This expression—vestige of an old rhetorical term, *loci communes sermonis* [recurring formulas in a sermon]—has acquired, especially since the development of intellectual individualism, a pejorative sense it was far from having even as late as the seventeenth century. All along, while it was becoming debased, the meaning of *commonplace* was narrowing, becoming a variant of *banality,* the already seen, the already heard; and for the crowd of imprecise minds, *commonplace* is synonymous with *cliché*. Yet *cliché* is applicable to words and *commonplace* to ideas; the *cliché* pertains to form, or to the letter, the other word to the essence or the spirit. To confuse them is to confuse thought with the expression of thought. The cliché is immediately perceptible; the commonplace often conceals itself under an original adornment. There are not many examples, in any literature, of new thoughts expressed in a new way; the demanding spirit must content itself with one or the other of these pleasures, only too happy when it is not deprived of the one or the other at the same time—which happens all too often.

The commonplace is at once more and less than a banality: it is a banality, but one that is sometimes ineluctable; it is a banality, but one that is so universally accepted that it takes on the name of truth. Most truths that circle the globe (truths are great globe-trotters) can be regarded as commonplaces, that is, associations of ideas that are common to a large number of people, almost none of whom would deliberately dare to break them up. Despite his penchant for lying, man has a great respect for what he calls truth, because reality is the traveling stick he carries all through his life's journey and because commonplaces are the bread in his knapsack and the wine in his flask. Deprived of the truth of commonplaces, people would find themselves defenseless, without support and without food. They have such need of truths that they adopt new ones without rejecting the old; the brains of civilized people are museums of contradictory truths. They

are not bothered by this because they ruminate their truths in succession, one after the other. They think in the same way they eat. We would retch, horrified, if a large platter were presented to us on which were mixed with broth, wine, coffee, all the foods, from meats to fruits, intended for our "successive" meal; the horror would be just as strong if we were to be shown the repugnant amalgam of contradictory ideas lodged in our minds. . . .

The secret purpose of the commonplace, as it is being formed, is . . . to express a truth. Isolated ideas only represent facts or abstractions; to generate an ordinary truth requires that one have two elements—a fact and an abstraction. Almost all truths, almost all commonplaces come down to these two elements.

Concurrently with the term *commonplace,* one can almost always use the term *truth,* thus defined once and for all as "a commonplace that has not yet been dissociated," the dissociation being analogous to what one calls analysis in chemistry. Chemical analysis contests neither the existence nor the qualities of the bodies it dissociates into diverse elements, which are themselves often capable of being dissociated in their turn; it limits itself to liberating these elements and offering them to synthesis, which, by varying their proportions and introducing new elements, may produce entirely different bodies. With the debris of an idea, one can create another idea "identical and opposite," a work that would be a game, but an excellent one, like all the exercises that make the intelligence supple and raise it to the state of scornful nobility to which it must aspire. . . .

[Gourmont eventually gives the example of the formation of associations and dissociations of moral truths that I believe is linked with the Dreyfus case. The text was written two years after Zola protested the verdict and seven years before Dreyfus was finally exonerated.]

. . . One must understand the idea of honor; it contains several others, those of bravery, disinterestedness, discipline, sacrifice, heroism, probity, loyalty, frankness, good humor, directness, simplicity, and so forth. One would finally find in this word the summary of qualities the French race believes it expresses. To determine its origin would be, because of this belief, to determine when the French began to think of themselves as embodying all the strong virtues. The military man has remained in France, despite recent objections, the very type of the man of honor. The two ideas are energetically united; they form a truth that is contested now only by minds of mediocre talent or questionable sincerity. Although if one takes into account the whole nation, the dissolution of that truth has progressed very little, still it was fully carried out in certain minds for a minute at least, for the psychological minute. At that point, from the solely intellectual standpoint, a profound effort toward abstraction was made, which one cannot

help admiring when coldly observing the functioning cerebral machine. Without doubt, the result that was obtained was not the product of normal reasoning; the dissociation took place in a bout of fever; it was unconscious, and it was temporary, but it did take place, and that is important for the observer.

The idea of honor, with all its undertones, split from the idea of the military man, which is, in this case, the factual side of the idea, the female idea [so to speak] ready to receive all the qualificatives, and if there was between them a certain logical relationship, it was not a necessary one. That is the decisive point. A truth is dead when the relationships that link its elements are the outcome of habit and not of necessity; and inasmuch as the death of a truth is beneficial, this dissociation would have been very important if it had been definitive, if it had remained stable. Unfortunately, after this effort toward pure idea, the old mental habits recovered their ground. The old qualifying element was immediately replaced by an element that was hardly new; it was less logical than the older one and even less necessary. It appeared that the operation had aborted. The association of ideas remade itself into the previous one, even though one of the elements happened to have been turned inside out like an old glove: for honor dishonor was substituted, all the adventitious ideas attached to the old element now becoming cowardice, malice, indiscipline, falseness, duplicity, wickedness, and so forth. This new association of ideas can have a destructive value; it offers no intellectual interest.

What emerges from this anecdote is that the ideas that seem clearest and most evident to us—most palpable, so to speak—nevertheless lack the strength to impose themselves in their nakedness on human spirits. To assimilate the idea of an army, one of today's minds must surround it with elements that have only an incidental or a subjective correlation with the principal idea. . . .

. . . The work of dissociation tends . . . to free truth from its fragile component so as to obtain the pure idea, the unique idea, which will therefore be impervious to attack. But if one were to use words only according to their absolute and unique meaning, connections would become elusive in ordinary speech; so one must leave them some of the vagueness and flexibility with which past usage has endowed them and, in particular, not insist on the abyss that separates the abstract from the concrete. There is an intermediary stage between ice and fluid water, when needles start to form, when the ice cracks and gives way to the hand immersing itself. It may be that one must not even ask from the words of philosophy textbooks that they abdicate all pretense to ambiguity.

ALFRED JARRY

Barnum (1902)

Born in Laval in Western France, Alfred Jarry (1873–1907) completed his secondary education at the Rennes Lycée (high school). At the age of fifteen, in the company of his sister and a friend in the attic of his home, he devised a puppet play inspired by the incompetence of his physics teacher. It was the first version of *Ubu roi* (King Ubu), a devastating indictment of what he considered the laziness, hypocrisy, cruelty, and cupidity of the petite bourgeoisie among whom he was raised. The play was eventually performed at the Théâtre de l'Œuvre in Paris in 1896, with costumes designed after Jarry's sketches by the Nabi artist Pierre Bonnard.

Jarry wrote his own symbolist manifesto in *Minutes of Sand, Memorial* (1894). His purpose, he explained, was "to suggest rather than to tell." Although he valued "the diversity of attributable meanings," he cautioned against the possibility of "obscurity, easy chaos," and "this other condensed simplicity, the diamond [made from] coal, unique work made of all the possible ones." He added in a note: "Simplicity must not be simple, but complex, tightened and synthetized."[45]

In the text that follows Jarry asserts his intention to seek subjects of poetry in all aspects of life, however prosaic. By way of example, he evokes the effect on him of a performance by the American circus of P. T. Barnum, James L. Hutchinson, and James A. Bailey that had just set up its tent in Paris.[46] His insistence on the vastness, complexity, dynamism, and overall excitement of the performance and, as a corollary, all the need for personal skills and bravery on the part of the performers seems to hail the advent of a new civilization in which everything will be larger, faster, and potentially more lethal than the world of his day, demanding greater technical feats from individuals. As a physical entity, the circus is what Jarry would call a "gesture"—or rather several "gestures." These, the material components of metaphor, called forth associations of momentous import through an interplay the surrealists would utilize with particular daring and awesome results.

The excerpts that follow are from Alfred Jarry, "Barnum," *La Revue blanche,* January 1, 1902, 66–67. For a recent annotated edition, see *Alfred Jarry. Œuvres complètes,* ed. Michel Arrivé, Henri Bordillon, Patrick Besnier, and Bernard Le Doze, 3 vols. (Paris: Gallimard, 1972–88), 2:331–34. ❦

That newspapers and magazines devote a large number of pages, indeed all their pages, to recording, criticizing, or glorifying the outpourings of the human mind reflects a strangely partial point of view. It is tantamount to taking into account the activity of but one organ arbitrarily chosen from among all, the brain. There is no reason one should not study just as fully the functioning of the stomach or the pancreas or the gestures of any limb. . . .

All these gestures, indeed all gestures, are to the same degree aesthetic, and we shall attach equal importance to them all. . . .

. . . [A]s for the . . . traveling shows, always dear to the public, an exceptional competing occurrence dispenses me from celebrating them today: BARNUM is within our walls. . . . I want to say that he would fill them to bursting if he wished, through the abundance of his marvels, as easily as he has covered them with his posters.

It is only a large circus, some have said. So be it; but imagine a ring in which you drop three other fair-sized rings. Once they are in place, you realize they take up just as much space as three plates on a banquet table. In each ring you release a few elephant herds, and then you begin to perceive what the word *enormous* means. . . . In the air is a virgin forest of intertwined riggings needed for several dozen ropewalkers and acrobats, who fly uninterruptedly from one to another. Underneath there pullulates a population of clowns and a swarm of horses.

GUILLAUME APOLLINAIRE

The New Spirit and the Poets (1917–18)

The child of a Polish mother and an unknown father, Wilhelm Apollinaris de Kostrowitzki (1880–1919) was born in Rome. He attended several French schools and first appeared in Paris literary cafés in 1899. He spent a year in Germany as a tutor before settling in Paris in 1902, where he started publishing verses and critical pieces in avant-garde reviews under the pen-name Apollinaire. He soon joined a group of young men who gathered around Gourmont, and he counted Jarry among his friends. His keen interest in the latest artistic developments made him an early supporter and enthusiastic promoter, in the popular avant-garde periodicals as well as the popular press, of Matisse and Picasso as well as many other fauve and cubist artists. Chagall expressed the gratitude and admiration of many of his colleagues in *Homage to Apollinaire* of 1911–12 (Fig. 50), in which the poet's versatile imagination is suggested by his ability to empathize with both sexes and experience simultaneously the emotions of tempter and tempted symbolized by the biblical apple—all this against an equally ambiguous background of interpenetrating geometric fragments vaguely suggesting the dial of a clock and the passing of time. Besides Apollinaire's name one reads around the transpierced heart those of the Italian critic Ricciotto Canudo, the German critic and journalist Herwarth Walden, and the French poet Blaise Cendrars.

Apollinaire, in rejecting the name symbolist, bestowed on him by the philosopher Victor Basch in a review of *Les Mamelles de Tirésias* (1917), was actually contesting Basch's too-narrow definition of symbolism: "Victor Basch . . . insists that my work is symbolic. That is his opinion. But he adds that 'the first condition of a symbolic drama is that the relationship between the symbol, which is always a sign, and the signified object be immediately discernible.' That is not always the case, however; there are remarkable works whose symbolism lends itself to numerous interpretations that sometimes contradict one another."[47] Apollinaire stresses the

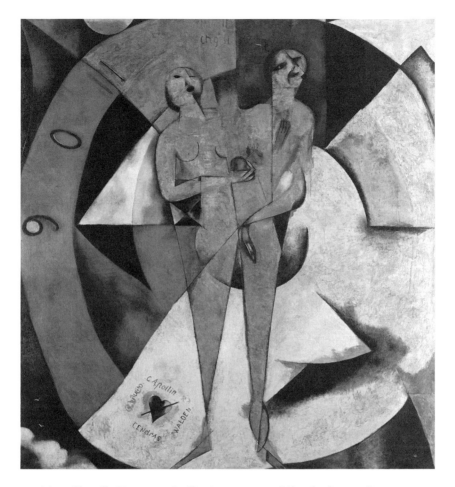

50. Marc Chagall, *Homage to Apollinaire*, 1911–12. Oil and other media on canvas, 200.0 × 189.5 cm. Collection, Stedelijk Van Abbemuseum, Eindhoven, Netherlands. Photo: Peter Cox.

It is not a decorative art, nor is it an impressionist art. It is fully dedicated to the study of external and internal nature; it consists entirely of an ardent pursuit of truth.

APOLLINAIRE

point even further in the text excerpted here: "The least fact, for the poet, is the postulate, the starting point, of an unknown immensity in which the flares of multiple significations shine."

There is no question that, in these respects at least, Apollinaire had remained a symbolist. But he was a symbolist determined not to detach himself from the realities of the present or the future.

Eight years after the Italian poet Marinetti wrote his "Initial Manifesto of Futurism,"[48] in which he urged his colleagues to find inspiration in the new energy released by science and technology as well as in the new spirit of adventure and achievement, Apollinaire accepted, in "The New Spirit and the Poets," all that the modern industrial world offered the image maker, from the cinema to the noises produced by machines, as the bases for a new realism fully in keeping with "an ardent search for truth." That search would focus, among other things, on the element of *"surprise . . . the greatest new spring."* And the element of surprise itself would require the substitution of new truths for old that was so significant a part of Gourmont's aesthetics: a modern astronaut's fate could well be that of Icarus. But the creative mind should avoid reinventing the old, lest it too suffer the destiny of Tantalus, Sisyphus, and the Danaids, who were compelled to repeat the same arduous task throughout eternity.

Finally, the process of discovery was external as well as internal. Apollinaire, like Gourmont, finds as much inspiration in the kaleidoscope of daily life as in the fluid dreams of the psyche and in the incongruities of physical reality as in the vagaries of the unconscious. Indeed, in an interview on the day *Les Mamelles de Tirésias* was first performed he pointed to "an art that is not photographic realism," for he wanted to uncover "nature itself." Nature had a double aspect, "what one sees of it and what it contains." The latter had to be intuited, and could be a source of great surprises: "this interior nature, endowed with unsuspected marvels, this imponderable, merciless, joyful nature."[49]

The interplay between the incongruities of everyday life and the phantasmagoria of the unconscious would inspire the dada and surrealist age, from Duchamp's ironic metamorphoses of common objects into unfamiliar ones to the arcane transfigurations of Breton and his brethren to the profound human drama of Charlie Chaplin's clowning. Its marks are much in evidence in the art of our own time.

The text that follows is from Guillaume Apollinaire, "L'Esprit nouveau et les poètes," *Mercure de France* 130 (December 1, 1918), 383–96. It was first delivered as a lecture at the Théâtre du Vieux-Colombier in Paris, November 26, 1917, and was published posthumously in *Mercure de France* as well as in the Catalan periodical *La Rivista,* after some editing by Apollinaire's widow. For a recent annotated edition, see *Apollinaire. Œuvres en prose complètes,* ed. Pierre Caizergue and Michel Décaudin, 2 vols. (Paris: Gallimard, 1977–91), 2:941–54. ◆

The new spirit accepts . . . literary experiments, even risky ones, and some of these experiments are hardly lyrical. This is why lyricism is but one of

the domains of the new spirit in today's poetry, which often contents itself with research and investigation, without concern for their lyrical significance. The poet amasses raw materials—so does the new spirit—and these eventually constitute a stock of truth whose simplicity and modesty must not put one off, for the consequences, the results, may be great, very great indeed.

Later, those who study the literary history of our time will find it astonishing that dreamers and poets, like alchemists but without even the pretext of a philosopher's stone, could have undertaken research and made notations that exposed them to the jeers of their contemporaries—of journalists and of snobs.

But their researches will be useful; they will constitute the bases of a new realism that might not be inferior to the poetic and learned realism of ancient Greece.

Since Alfred Jarry, we have also seen laughter rise from the lowly regions that used to send it forth, offering the poet a lyricism as bright as a new penny. When did Desdemona's handkerchief seem unacceptably ridiculous?[50] Today, ridiculousness itself is pursued; one tries to seize it, and it has its place in poetry because it is as much a part of life as heroism and all that once nourished the enthusiasm of poets.

The romantics have attempted to give gross-looking things a horrible or tragic meaning. One might even say that in their work they pursued only the horrible. They tried harder to acclimatize the horrible than the melancholy. The new spirit does not seek to transform the ridiculous but gives it a role that has piquancy. Similarly, the new spirit does not want to give the horrible the same meaning as the noble. It lets the horrible remain what it is without lowering the status of the noble. *It is not a decorative art, nor is it an impressionist art.* It is fully dedicated to the study of external and internal nature; it consists entirely of an ardent pursuit of truth.

Even if it is true that there is nothing new under the sun, the new spirit *does not give up investigating deeply everything under the sun.* Common sense is the new poet's guide, which leads to fields that, if they are not new, were at least hitherto unknown.

But is there nothing new under the sun? That remains to be seen. How could it be? An X ray was made of my head.[51] I, a living being, have seen my cranium—is that not something new? *Come on!*

Solomon probably spoke for the Queen of Sheba [when he claimed there was nothing new under the sun],[52] and he [himself] was so fond of the new that he had innumerable concubines.

The skies become filled with strangely human birds. Machines, motherless daughters of men,[53] live a life devoid of passions and feelings—and that is not new?

Scientists ceaselessly scrutinize the new universes that bare themselves at

every crossroad of matter—and there is nothing new under the sun. Maybe for the sun. But for men!

Thousands and thousands of natural combinations have never been used in a composition. Scientists imagine them and bring them about, composing, in partnership with nature, this supreme art that is life. These new combinations, these new works of the art of life, are precisely what is called progress. In the sense [that life itself gives examples of it] such an art exists. But if one thinks of progress as an eternal becoming [never raising man to a higher level], the sort of prophetic call as terrible as those fables of Tantalus, Sisyphus, and the Danaids,[54] in that case Solomon was right in opposing the prophets of Israel.[55]

The new does exist, however, independent of progress; it counts for everything in surprise, which is integral to the new spirit—what is newest and liveliest about it. *Surprise is the greatest new spring.*[56] The new spirit, through the element of surprise, because of the importance it attaches to surprise, distinguishes itself from all the artistic and literary movements that preceded it. Here it takes leave of them all and belongs strictly to our time.

We have established [the new spirit] on the solid bases of common sense and experience, which have led us to accept things and feelings strictly on the basis of truth. And on this basis we accept them, not seeking to render sublime what is naturally ridiculous or vice versa. And from these truths surprise most often arises because they conflict with commonly held opinion. Many of these truths have not been examined. To unveil them is enough to cause surprise.

One can also express a supposed truth that elicits surprise because no one has yet dared express it. But a supposed truth does not flout common sense; if it did, it would no longer be truth, not even supposed truth. Supposing I imagine that if women no longer produced children, men could do so, and I could demonstrate it.[57] I would express a literary truth that can only be regarded as a fable outside the domain of literature, and I would bring about surprise. But my supposed truth is no more extraordinary or implausible than that of the Greeks, who depicted Minerva, fully armed, coming out of Jupiter's head.

As long as planes did not crowd the sky, the fable of Icarus was but a supposed reality. Today it is no longer a fable. And our inventors have accustomed us to prodigies much greater than the delegating to men of women's capacity to bear children. Fables having mostly become reality and having even gone beyond it, it is now up to the poet to imagine new ones for inventors to implement in their turn.

The new spirit demands that one assume such prophetic tasks. This is why you will find traces of prophecy in most of the works conceived according to the new spirit. The divine games of life and the imagination give

rise to a totally new poetic activity because poetry and creation are one and the same thing. One must call the inventor, the creator—insofar as man can create—a poet. The poet is he who discovers new joys, even if they are difficult to withstand. One can be poet in all domains: one has only to be adventurous and set out on the path of discovery.

Because the richest, least-known domain, whose extent is infinite, is the imagination, the name of poet is naturally given to those who have looked for new joys in the vast spaces of the imagination.

The least fact, for the poet, is the postulate, the starting point, of an unknown immensity in which the flares of multiple significations shine. It is not necessary, in setting out on the path of discovery, to select by rules, even those of good taste, what is to be classified as sublime. One can start with a daily occurrence: a dropped handkerchief can be for the poet the lever with which to lift a whole universe.[58] One knows what the fall of an apple meant to Newton, whom one might call a poet. That is why today's poet despises no movement of nature, and his mind pursues discovery in the vastest and least graspable syntheses—crowds, nebulae, oceans, nations—as much as in the apparently simplest facts: a hand searching a pocket, a match struck, animal calls, the smell of gardens after rain, the first igniting of flame in a fireplace. Poets are not only men in pursuit of the beautiful; they are also, indeed they are especially, men seeking the true, inasmuch as the true is the key to the unknown. Thus surprise, the unexpected, is one of the principal springs of today's poetry. And who would dare say that, for those who are worthy of experiencing joy, what is new is not beautiful? Others will soon assume the duty of reviling this sublime newness, after which it can enter the realm of reason, but only within the limits that the poet—sole provider of the beautiful and the true—proposes.

The poet, because of the very nature of these explorations, is isolated in the new world he is the first to enter, and his only consolation is that while others in the last resort live by truth, despite the lies they pad it with,[59] he alone discovers and provides the stuff of life at the point where humanity finds that truth. That is why modern poets are the poets of a truth that is always new. And their task is infinite; they have surprised you and will surprise you still more. They already imagine motives even more Machiavellian than those that have given birth to the useful and awesome sign of money.

Those who imagined the fable of Icarus, so marvelously implemented today, will discover others. They will carry us fully alive and awake into the nocturnal and enclosed world of dreams; into the universes that ineffably palpitate above our heads; into these universes close to us and far from us that gravitate about the same point of infinity that we carry within ourselves. And marvels greater than those born since the birth of the most

ancient among us will cause the contemporary inventions of which we are so proud to turn pale and seem puerile.

The poets, finally, will be entrusted with giving, through lyrical teleologies and archlyrical alchemies, an ever purer meaning to the divine idea, which is so alive and so true within us, which is our perpetual renewal, this eternal creation, this ever-renascent poetry on which we live.[60]

NOTES

**PROLOGUE: BAUDELAIRE, DELACROIX, AND THE
PREMISES OF SYMBOLIST AESTHETICS**

1. The Salons were vast juried exhibitions of works by living French and foreign artists held annually or biennially in Paris. Although the juries were shielded from governmental pressure by a series of reforms, they reflected official taste through most of the nineteenth century.

2. Paul Verlaine, "Baudelaire," *L'Art* 1, no. 5 (1865): 4. The passage can be found in "Salon de 1859," in *Baudelaire: Œuvres complètes,* ed. Claude Pichois, 2 vols. (Paris: Gallimard, 1975–76), 2:620–21.

3. Baudelaire, *Curiosités esthétiques* (Paris: Lévy, 1868), *Les Fleurs du mal* (Paris: Lévy, 1868), *L'Art romantique* (Paris: Lévy, 1869).

4. Armand Moss, *Baudelaire et Delacroix* (Paris: Nizet, 1973).

5. Eugène Delacroix, *Journal,* 2d ed., ed. André Joubin, 3 vols. (Paris: Plon, 1960).

6. For a perceptive correlation of Delacroix's and Baudelaire's thought, see René Huyghe, "Le Poète à l'école du peintre," in *Baudelaire,* Génies et réalités (Paris: Hachette, 1961), 207–24; and Lloyd James Austin, "Baudelaire et Delacroix," *Baudelaire. Actes du colloque de Nice—Annales de la Faculté des Lettres et Sciences Humaines de Nice,* nos. 4–5 (1968): 13–23. Emile Bernard had already linked the aesthetics of the two men, in "Charles Baudelaire, critique d'art et esthéticien," *Mercure de France* 135 (Oct. 16, 1919): 577–600.

7. The date of the poem has been the subject of much discussion. Pichois cautiously suggests that the first quatrain might date from 1852–55 and the remainder from 1856 but adds that "Baudelaire continually rewrote and perfected his poems" (*Œuvres complètes,* 1:844).

8. Baudelaire, "Salon de 1846," in *Œuvres complètes,* 2:425.

9. Delacroix, "Réalisme et idéalisme," in *Œuvres littéraires,* 2 vols. (Paris: Crès, 1923), 1:63–64.

10. Baudelaire, "Salon de 1846," 2:425.

11. Baudelaire, "Le Peintre de la vie moderne," in *Œuvres complètes,* 2:697–98. Originally published in *Le Figaro,* Nov. 26, Nov. 29, and Dec. 3, 1863.

12. Paul Chenavard undertook in 1848 a vast cycle of pictures for the walls of the

Pantheon in Paris; the pictures were removed some three years later, when the government, now under Louis-Napoléon, returned the building to the Church. The cycle was intended to evoke the rise and fall of humanity and to lead onlookers to the social and moral lessons of historical events. Alfred Rethel, a German history painter, executed celebrated prints, distantly emulating Holbein's *Dance of Death* and commenting with bitter sarcasm on contemporary mores.

13. Baudelaire, "L'Art philosophique," in *Œuvres complètes*, 2:605 (the text, published posthumously, was worked on mostly between 1858 and 1860, according to Pichois, idem, 2:1378).

14. Delacroix, *Journal*, Oct. 20, 1853, 2:97. This text, like others, is later than the Baudelaire texts to which it is compared. There is ample evidence, however, that Delacroix's aesthetic theories were fully developed in the 1830s and that he jotted down felicitous formulations later with the intention of writing a dictionary of painting—which he never did.

15. Ibid., May 16, 1857, 3:100.

16. Baudelaire, "Salon de 1846," 2:433. The importance attached to the play of associations in Baudelaire's aesthetics was succinctly and convincingly established by Wolfgang Drost in "De la critique d'art Baudelairienne," *Baudelaire. Actes du colloque de Nice* (see note 6), 80–88. After giving credit to Huyghe, "Le Poète à l'école du peintre" (see note 6), for having first brought up this issue, he singled out three of the poet's devices: (1) "The illusory detail that by bringing out a particularly revealing trait entices the onlooker to empathize with the intimate life of the subject"; (2) "The transcending of reality by bringing out the extraordinary and fantastic side of life"; and (3) "The vast gamut of details that stimulate the imagination of the spectator in a direction unforeseen by the artist" (82). A combination of Professor Drost's second and third categories would play a significant role in symbolist aesthetics and the advent of surrealism: a juxtaposition of perfectly ordinary objects so unusual and in some cases so jarring that it constitutes an insuperable challenge to rational investigation and calls forth responses from the unconscious. See also, by Droste, "Kriterien der Kunstkritik Baudelaires: Versuch eine Analyzen," in *Baudelaire*, ed. Alfred Noyer Wiedner (Darmstadt: Wissenschaftliche Gesellschaft, 1976), 422–24.

17. Baudelaire, "Salon de 1859," in *Œuvres Complètes* 2:624–25. Although Delacroix was not specifically referred to in this instance, there can be little doubt that Baudelaire had him in mind.

18. Baudelaire, "Fusées" (posthumous), in *Œuvres complètes*, 1:659.

19. Henri Heine, "Salon de 1831," in *De la France* (Paris: Renduel, 1833), 309. The passage refers to a work by Decamps, whom Heine accused of missing the symbolism inherent in a subject. The passage immediately follows the critique of Delacroix's work, and it is inconceivable that Delacroix would not have read it.

20. Baudelaire, "Salon de 1846," 2:432.

21. Delacroix, *Journal*, Sept. 12, 1852, 1:485.

22. Ibid., Oct. 26, 1853, 2:102–3.

23. Baudelaire, "Réflexions sur quelques-uns de mes contemporains, I. Victor Hugo," in *Œuvres complètes*, 2:131–32 (first published in *La Revue fantaisiste*, June 15, 1861, according to Pichois, idem, 2:1138).

24. Baudelaire, "Edgar Poe, sa vie et ses oeuvres" (1856), in *Œuvres complètes*, 2:317.

25. Charles Asselineau, "La Jambe," in *La Double vie* (Paris: Poulet-Malassis and de Broise, 1858), quoted in Baudelaire, "La Double vie par Charles Asselineau" (1859), in *Œuvres complètes*, 2:89–90. One must wonder whether the following statement by Joseph Görres, addressed to Friedrich Creuzer, was known by the romantic generation in France: "The ambiguity of the symbol, which you continue to see as something accidental, is for me an absolutely necessary characteristic of every true symbol because it is the genus, and interpretations crawl out of it like so many species." The passage was printed in the second edition of Creuzer's *Symbolik und Mythologie der alten Völker, besonders der Griechen*, 4 vols. (Leipzig: Leske, 1819), 1:149 (other citations of Creuzer in this chapter refer to the first edition, which did not include the passage quoted).

26. Baudelaire, "Salon de 1846," 2:433.

27. Baudelaire, "L'Œuvre et la vie d'Eugène Delacroix," in *Œuvres complètes*, 2:744 (originally published in *L'Opinion nationale*, Sept. 2, Nov. 14, and Nov. 22, 1863).

28. Delacroix, *Journal*, Jan. 25, 1857, 3:48.

29. Baudelaire, "Edgar Poe, sa vie et ses œuvres," in *Œuvres complètes*, 2:317.

30. Baudelaire, "De l'essence du rire" (1852–57), in *Œuvres complètes*, 2:543, 1342.

31. Baudelaire, "Hygiène" (posthumous), in *Œuvres complètes*, 1:668.

32. See the text at note 18. Whether or not the trancelike quality of symbolist imagery had pathological overtones has been a subject of debate between supporters and detractors of the movement. Rodolphe Rapetti, in "Pour une définition du symbolisme pictural: Critique et théories à la fin du XIXe siècle," *Quarante-huit/Quatorze. Conférences du Musée d'Orsay*, no. 5 (Paris: Réunion des Musées nationaux, 1992), 69–82, points to Marcel Béja (Dr. Paul Meunier), an essayist, poet, and psychiatrist he considers part of "the last wave of the symbolist generation," as the first to study the artistic work of the insane and to establish for it "a classification based on its aesthetic interest."

33. See, in particular, Jean Pommier, *La Mystique de Baudelaire* (Paris: Belles Lettres, 1932); Lloyd James Austin, *L'Univers poétique de Baudelaire: Symbolisme et symbolique* (Paris: Mercure de France, 1956); Jean Prévost, *Baudelaire: Essai sur la création et l'inspiration poétique* (Paris: Mercure de France, 1964).

34. Baudelaire, "Réflexions sur quelques-uns de mes contemporains: I. Victor Hugo," in *Œuvres complètes*, 2:132–33.

35. Pierre Leroux, "De la poésie de notre époque," *Revue encyclopédique* 52 (1831): 404. Leroux's use of the terms *vibrations* and "harmonic vibrations" reflects the growing awareness among physicists of the day that many natural phenomena are characterized by simple harmonic motion (sine or cosine waves). These phenomena include musical notes as well as spring mechanisms. Baron Joseph Fourier caused considerable excitement by proving that any periodic motion (i.e., one repeated at regular intervals) could be represented by the series of simple harmonic motions that now bears his name. Superficially, at least, it looked as if harmony could be found anywhere, if only one could analyze motion in Fourier's terms.

Such a belief may well have prompted one of the baron's distant relatives, Charles Fourier, to advocate a social system based on strict numerical rules intended to bring about "universal harmony" among constituent groups. He never said how those numerical rules would be determined, but his preaching and writing had such im-

pact that men like Leroux accepted harmonic vibrations as a link between the material and the spiritual and as the explanation for some elements of the aesthetic experience, and both Leroux and Baudelaire believed that the same kind of harmonics ruled the aesthetic responses of our various senses.

36. Immanuel Kant, *The Critique of Judgment,* trans. Jack Creed Meredith (Oxford: Clarendon Press, 1969), 177–78.

37. Friedrich Creuzer, *Symbolik and Mythologie der alten Völker, besonders der Griechen,* 4 vols., 1st ed. (Leipzig: Leske, 1810–12).

38. Joseph-Daniel Guigniaut, introduction to Friedrich Creuzer and Joseph-Daniel Guigniaut, *Religions de l'antiquité,* 10 vols. (Paris: Treuttel and Würtz, 1825–51), 1, pt. 2, 532.

39. Ibid., 1, pt. 2, 546–49. The authors give credit to *Histoire et description de la cathédrale de Cologne . . .* (Stuttgart: Cotta, 1821–23), by Sulpiz Boisserée, Creuzer's "compatriot and friend."

40. David Owen Evans has already drawn the parallel in *Le Socialisme romantique, Pierre Leroux et ses contemporains* (Paris: Rivière, 1948), 138. Claude Pichois and Jean Ziegler, in their *Baudelaire* (Paris: Julliard, 1987), 194, allude to Leroux in this connection and ask whether "the invention of the term *symbolism* had not been attributed to him."

41. Edgar Quinet translated the principal work of the dean of German historians of religion, Johann Gottfried Herder, *Ideen zur Philosophie der Geschichte der Menschheit,* 1784–87. The translation appeared in France in 1825. Quinet subsequently wrote a series of essays on his intellectual exchanges during a long stay in Germany in "Allemagne et Italie" (1838), *Œuvres complètes de Edgar Quinet* (Paris: Pagnerre, 1857–83), vol. 6. Benjamin Constant's *De la religion considérée dans sa source, ses formes et ses développements* (Paris: Bossange, 1824–31) was also influential.

42. Hegel said of symbols drawn from nature: "But what must be taken into account in [the context of poetry] is a natural phenomenon, an occurrence, containing a particular relation or an issue, which can be taken as a symbol for universal meaning from the sphere of human activity and doings, for an ethical doctrine, for a prudential maxim" (Georg Wilhelm Friedrich Hegel, *Aesthetics. Lectures on Fine Arts,* trans. T. M. Knox, 2 vols. [Oxford: Clarendon Press, 1975], 1:383–84). The idea that the objects of everyday life can be taken as metaphors also occurs in the writings of Delacroix and Shelley. Chances are that Hegel, whose *Aesthetik* evolved from lectures given over a long period, is at the root of this notion.

43. "A Defence of Poetry (1821), in *The Complete Works of Percy Bysshe Shelley* [1826–30], ed. Roger Ingpen and Walter E. Peck, 10 vols. (New York: Gordian, 1965), 7:117.

44. Joseph Görres, *Mythengeschichte des asiatischen Welt,* 2 vols. (Heidelberg: Mohr and Zimmer, 1810), 2:644.

CHAPTER 1: ROMANTIC SYMBOLISTS

1. Albert Mockel, "La Littérature des images," *La Wallonie* (Dec. 1887): 402. Mockel was a leader of the Belgian symbolist movement in literature and the editor of *La Wallonie,* one of that movement's principal periodicals. He was a frequent participant in Mallarmé's gatherings in Paris, the Tuesdays. Mockel's repudiation of Emile Zola, the much acclaimed leader of the naturalist movement in literature, is somewhat paradoxical, for Zola was a master at sketching powerful emotions under

the pretext of studying detail, such was the associative power of his words. Moreover, Zola wrote an appealing novel in the symbolist mode, *Le Rêve* (Paris: Charpentier, 1888). And he had already made an important concession to subjectivity in defining the goal of naturalism: to show "a corner of creation seen through a temperament" (Emile Zola, "Proudhon et Courbet, I," *Le Salut public,* July 26, 1865; reproduced in Henri Mitterand, *Zola journaliste* [Paris: Colin, 1962], 45). Zola repeated the definition, occasionally replacing *creation* with *nature.*

In 1892 the symbolist G.-Albert Aurier made a similar point "To be the genesis of a work of art, reality, we are told, must be deformed by a temperament. In the last analysis, what is the completed work if not a *visible sign* of this temperament, the SYMBOL of the *ideic* and sensitive whole of the executant?" ("Beaux-Arts—les symbolistes" in *Revue encyclopédique* [Apr. 1892]: 477). Remy de Gourmont found Zola's works "always pregnant with allegorical meaning. . . . The idealist revolution, therefore, took aim, not so much at the works (except perhaps the crude tones) of naturalism as at the theories" (*Le Livre des masques,* 2 vols. [Paris: Mercure de France, 1896], 2 : 10).

2. Paul Bourget, "L'Esthétique du Parnasse," in *Etudes et portraits* (Paris: Lemerre, 1889, 229–32).

3. Paul Verlaine, "A propos du livre de M. Catulle Mendès sur le Parnasse contemporain," *La Revue indépendante* 2, ser. 3 (between Nov. 1884 and Apr. 1885): 143.

4. Achille Delaroche, "Les Ecoles littéraires, le Parnasse," *Le Sagittaire* 10 (Mar. 1901): 326. Delaroche became a regular participant in Mallarmé's Tuesdays; his correspondence with the symbolist poet reveals a warm and sustained relationship. In an important article on Gauguin, Delaroche fully recognized the musical suggestiveness of the artist's compositions as well as the associative power of his imagery ("D'un point de vue esthétique, à propos du peintre Paul Gauguin," *L'Hermitage* [Jan. 1894]: 35–39). See Stéphane Mallarmé, *Correspondance,* ed. Henri Mondor and Lloyd James Austin, 11 vols. (Paris: Gallimard, 1859–95), 4 : 246 n. 1.

5. *Verlaine: Œuvres poétiques complètes,* ed. Yves-Gérard Le Dantec and Jacques Borel (Paris: Gallimard, 1992), 96, "Epilogue. Poèmes saturniens": "Est-elle en marbre ou non, la Vénus de Milo?" [1867]. Intentional parody? inquire the editors, 1086. Leconte de Lisle's poem begins: "Sacred marble, clothed with strength and genius" (Marbre sacré, vêtu de force et de génie; see Charles Leconte de Lisle, "Vénus de Milo" [1852] in *Poèmes antiques, Œuvres de Leconte de Lisle,* ed. Edgard Pich, 2 vols. [Paris: Belles Lettres, 1977], 1 : 132).

6. Théodore de Banville, *Petit traité de poésie française* (Paris: Bibliothèque de l'écho de la Sorbonne, [1881]), 3.

7. Louis Ménard, *Du Polythéisme hellénique* (Paris: Charpentier, 1863), 296–97.

8. Professor Christopher Mead pointed out to me the morphological symbolism of the women.

9. Delacroix, in the catalogue of the 1827–28 Salon.

10. Alastair I. Grieve, *The Art of Dante Gabriel Rossetti* (Norwich: Real World Publications, 1976), remains the best introduction to Rossetti. *Letters of Dante Gabriel Rossetti,* ed. Oswald Doughty and John Robert Wahl, 4 vols. (Oxford: Clarendon Press, 1965–), offers a wealth of information. See also Virginia Surtees, *The Paintings and Drawings of Dante Gabriel Rossetti (1828–1882): A Catalogue Raisonné,* 2 vols. (Oxford: Clarendon Press, 1971).

11. William Holman Hunt, *Pre-Raphaelitism and the Pre-Raphaelite Brotherhood,*

2 vols. (London: Macmillan, 1905), 1:87. (Hunt's volumes comprise articles written for the *Contemporary Review* in 1886). For an introduction to the Pre-Raphaelite movement, see the exhibition catalogue *The Pre-Raphaelites* (London: Tate Gallery, 1984).

12. See Keith Andrews, *The Nazarenes—A Brotherhood of Painters in Rome* (Oxford: Clarendon Press, 1964). See also the exhibition catalogue *Die Nazarener* (Frankfurt am Main: Städelsches Kunstinstitut, 1977).

13. William Vaughan, *German Romanticism and English Art* (New Haven: Yale University Press, 1979), effectively made this point, rebutting the Pre-Raphaelites' own vociferous denials in later life. The influence of the Nazarenes on the early work of Rossetti, and the corresponding "cold symbolism and abstract personifications" in the art of his alter ego, Chiaro (see the text of "Hand and Soul"), were pointed out by B. J. Morse, "A Note on the Autobiographical Elements in Rossetti's 'Hand and Soul,'" *Anglia* (1930): 332–33.

14. John Ruskin in the *Times,* May 13, 1851, 8–9; reprinted in *The Works of John Ruskin,* ed. E. T. Cook and Alexander Wedderburn, 39 vols. (London: Allen, 1903–12), 12:319–23.

15. See Robert Stahr Hosmon, "Introduction: The Rise and Decline of *The Germ,*" in *The Germ: A Pre-Raphaelite Little Magazine* (Coral Gables, Fla.: University of Miami Press, 1970), 1–23. Only four issues appeared.

16. "I must also have read that winter [1844] Rio's *Poésie chrétienne* and Lord Lindsay's introduction to his Christian Art [which had not yet been published], and perceiving thus in some degree what a blind bat and puppy I had been, determined that at least I must see Pisa and Florence again before writing another word of *Modern Painters*" (Ruskin, *Praeterita* [1887], vol. 35 of *Works,* 340). Ruskin added later that he was "much impressed by Pisa's Campo Santo. . . . [I] spent a fortnight copying details of it" (idem, 353). Alexis-François Rio was the author of *De la poésie chrétienne, dans son principe, dans sa nature et dans ses formes,* 2 vols. (Paris: Debécourt, 1836). Lord [A. W. C.] Lindsay wrote *Sketches of the History of Christian Art,* 3 vols. (London: Murray, 1847). Rio wanted to foster the revival of Christian art that was spearheaded in France by comte Charles de Montalembert, himself a great admirer of the Nazarenes. Lord Lindsay had similar intentions in Britain. Ruskin must have seen the latter's book in manuscript for or been confused about the date—1847, not 1844.

For a perceptive evaluation of Ruskin's ever-changing aesthetic theories, see George P. Landow, *The Aesthetic and Critical Theories of John Ruskin* (Princeton: Princeton University Press, 1971).

17. Ruskin, "The Three Colors of Pre-Raphaelitism" (1878), *Works,* 30:155. In his earlier writings, Ruskin was much more likely to refer to the "imagination" of modern artists than to their symbolism. He did praise the symbolism of medieval works in *Stones of Venice,* completed in 1853, and made allowances for the use of allegory by modern artists in the third volume of *Modern Painters* of 1856, as pointed out by Landow, 392–93. For him allegory and symbol were to become inextricably related (idem, 370–74). Ruskin was also familiar with the principle of musicality, which he enunciated in 1853; see "The Nature of the Gothic," in *The Stones of Venice,* vol. 2, *The Works of John Ruskin,* ed. E. T. Cook and Alexander Wedderburn, 39 vols. (London: Allen, 1903–12), 10:215–16.

18. With the exception of the opening page or two, according to T. Hall Caine,

Recollections of D. G. Rossetti (London: Stock, 1882), 134, the text was written in the early hours of a December morning, 1849, which may account for both the exalted tone and some awkwardness in the phrasing.

19. In particular, *The Girlhood of Mary Virgin* (1848–49). See the exhibition catalogue *The Pre-Raphaelites*.

20. Dante Gabriel Rossetti, "Hand and Soul," *The Germ*, no. 1 (Jan. 1850): 30. Dante saw Beatrice for the first time when she was nine. See his *Vita Nuova*, in *Opere di Dante Alighieri*, ed. Fredi Chiapelli (Milan: Mursia, 1965), 5.

Erma, which means "herm" in Italian, may be a shortened version of *ermafrodito*, "hermaphrodite," in the same language, which Rossetti knew. The play on words was a harbinger of later Pre-Raphaelite wordplay.

21. Rossetti's own translation of Dante's *Vita Nuova*, a work strongly marked by Neoplatonic strains of thought, was published as part of his *Early Italian Poets* (London: Smith and Elder, 1861); he completed the translation in the winter of 1848, according to Alastair Grieves, introduction to the exhibition catalogue *Dante Gabriel Rossetti* (Newcastle upon Tyne: Laing Art Gallery, 1971), 5. Furthermore, Rossetti's father, Gabriele Rossetti, a Dante scholar who had taught at the University of London, wrote two works that stressed Dante's Neoplatonism: *La Divina comedia di Dante Alighieri con comento analitico*, 6 vols. (London: Murray, 1826), and *La Beatrice di Dante. Ragionamenti critici* (London, 1842). For more on Neoplatonism, see note 32, below.

22. Rossetti, "Hand and Soul," 26; subsequent quotations from this work are from pp. 26, 31, 29, and 31 (the last two quotations).

23. The idea is reminiscent of Saint Augustine's "Descend that ye might ascend" (*Confessions* 4.19).

24. Ruskin himself understood the principle of musicality: "The arrangement of colors and lines is an art analogous to the composition of music, and entirely independent of the representation of facts" (*The Stones of Venice* [1853], *Works*, 10:215–16).

25. All of Rossetti's figures can be regarded as the spiritual equivalent to Chiaro's visitor. He conceived his models as effigies of diverse aspects and states of his own soul.

26. Christina Rossetti, "In an Artist's Studio," in *The Complete Poems of Christina Rossetti*, ed. Rebecca W. Crump (Baton Rouge: Louisiana State University Press, 1990), 264.

27. It is not unduly surprising that Walter Pater used the term *somnambulistic* to describe the ethereal character of medieval Provençal poetry; see the excerpt in this chapter from his "Poems by William Morris."

28. Virginia Surtees, *Paintings and Drawings of Rossetti* (as in note 10), 1:93–94, no. 168.

29. Dante quotes Lamentations 1:1 from the Old Testament: "How doth the city sit solitary, *that was* full of people! *how* is she become as a widow!" (*Vita Nuova*, [as in note 20], 41).

30. Ibid., 56. In the original "che" is "la quale," and "soecula" is "secula."

31. The best introduction to Burne-Jones is Martin Harrison and Bill Waters, *Burne-Jones* (London: Barrie and Jenkins, 1973).

32. The Alexandrian philosopher Philo, a Jew of Greek culture who was particularly influenced by Plato and can be considered one of the precursors of Neoplato-

nism, claimed that the Supreme Being is "suprarational" and can be reached only through "ecstasy." Plotinus, the principal Neoplatonist of late antiquity, claimed that "it is not enough to be sinless, one must become God. This [state] is reached through contemplation of the primeval Being, the One, in other words, through an ecstatic approach to it" (*Encyclopaedia Britannica*, 11th ed., s.v. "Neoplatonism"). Although it developed in opposition to Christianity, the School of Alexandria eventually came to accept the new religion and even contributed to it some of its own, primarily Greek, Neoplatonic concepts.

33. Godstow was a medieval convent on the Thames near Oxford, of which only a few walls remain. Fair Rosamond, whom Henry II had courted, retired there.

34. According to Georgiana Burne-Jones, *Memorials of Edward Burne-Jones*, 2 vols. (London: Macmillan, 1904), 1:99, the book was Ruskin's *Edinburgh Lectures*. The lecture "Pre-Raphaelitism," delivered by Ruskin in Edinburgh on Nov. 18, 1853, stressed the group's "absolute and uncompromising truth in all it does"; it was printed in *Lectures on Architecture and Painting, Delivered at Edinburgh* (London: Smith and Elder, 1854). See Ruskin, *Works*, 12:134–64 (quoted passage p. 157).

35. Pater gave the text the title "Aesthetic Poetry" when he included it in his *Appreciations, with an Essay on Style* (London: Macmillan, 1889). The passage from "The service of philosophy" to the end was incorporated into the conclusion of his book *The Renaissance* (New York: Random House, [1873]), 196–99.

36. For an up-to-date study on Pater, see Michael Levey, *The Case of Walter Pater* (London: Thames and Hudson, 1978).

37. Thomas Maitland [Robert Buchanan], "The Fleshly School of Poetry," *Contemporary Review* (Oct. 1871): 334–50.

38. For "artificial . . . 'paradise,'" see *Baudelaire: Œuvres complètes*, ed. Claude Pichois, 2 vols. (Paris: Gallimard, 1975–76), 1:375. For "disorder of the senses," see the Prologue at note 30: "I have cultivated my hysteria with delight and terror."

39. Published in 1842, written Sept. 1833, according to Ricks, in *The Poems of Tennyson*, ed. Christopher Ricks, 3 vols. (Berkeley and Los Angeles: University of California Press, 1987), 1:604. For the original ballad, see Thomas Percy, *Reliques of Ancient English Poetry* [1765] (London: Routledge, 1859, 93–96). Burne-Jones must have known this version, which specifies that the beggar was "all in gray."

40. I was unable to locate the passage attributed to Bourget in the anthologies of his articles.

41. Théophile Thoré, "Artistes contemporains, Eugène Delacroix, suite," in *Le Siècle*, Feb. 26, 1837. Thoré was referring to Delacroix's *Liberty Guiding the People* (1831); the core of Thoré's views on iconography remained the same throughout his life. He introduced an interesting variant in 1861 ("Salon de 1861—de l'avenir de l'art," *Revue germanique* 14, no. 2, [1861]: 248–59), when he acknowledged, "There is not one word, one image, that does not pass from a specific concrete significance to an analogous harmony, more or less collective and abstract." Aware, perhaps, of the latest developments in poetry, he referred to "unforeseen metaphors, fables engendered by the mutual accord of all intelligences," but he had little sympathy for mystery: of metaphors and fables he wrote, "everyone would be in a position to lift their veil." I discuss Thoré's views on symbolism in my "Trois articles de Thoré-Bürger: Du saint-simonisme à un historique naturaliste," *Bulletin de la Société de l'Histoire de l'Art français* (1991): 177–89.

42. The best introduction to Pierre Puvis de Chavannes and his work is the exhibition catalogue *Puvis de Chavannes,* by Louise d'Argencourt and Jacques Foucart

(Paris: Grand Palais; Ottawa: National Gallery of Canada, 1977). Also important, in that it traces the great impact of Puvis on later artists, is the catalogue *Puvis de Chavannes and the Modern Tradition,* by Richard J. Wattenmaker (Toronto: Art Gallery of Ontario, 1977).

43. Théophile Thoré, "Salon de 1861," in *Salons de Thoré-Bürger de 1861 à 1868,* 2 vols. (Paris: Renouard, 1870), 2:40–41. For information on some of the critics whom I discuss, see Jean-Paul Bouillon, Nicole Dubreuil-Blondin, Antoinette Erhard, and Constance Naubert-Riser, *La Promenade du critique influent* (Paris: Hazan, 1990).

44. The decorations of the royal palace of Fontainebleau by the leading Italian mannerists Giovanni Battista de' Rossi, called Rosso Fiorentino, and Francesco Primaticcio and their following had been somewhat insensitively restored in the 1830s.

45. Gautier stressed the mannerism rather than the archaizing elements of the pictures; the linear forms and the relative flatness of composition, however, have roots in the early Renaissance tradition, and the works are therefore somewhat archaizing in relation to naturalist trends.

46. The fresco cycle *Cupid and Psyche* by Raphael decorates a room in the Farnesina Palace, Rome.

47. See above, note 44.

48. The *Nibelungenlied* is a German medieval epic poem that had inspired Nazarene artists and would later inspire Richard Wagner.

49. Quoted in Charles Chassé, *Le Mouvement symboliste dans l'art du XIXᵉ siècle* (Paris: Floury, 1947), 36.

50. Interview of Puvis de Chavannes in *Le Salut public,* Jan. 18, 1895.

51. Jean Moréas; "Peintres," *Le Symboliste* 1 (Oct. 22–29, 1886).

52. Félix Fénéon, "Calendrier. Société des Pastellistes français," *La Revue indépendante* 7, ser. 3 (Apr. 1888): 377.

53. Jules Laforgue, "L'Art impressionniste" (Dec. 1883), in *Œuvres complètes,* ed. G. Jean-Aubry, 3 vols. (Paris: Mercure de France, 1925), 3: 61.

54. Edouard [Eduard] von Hartmann, *Philosophie de l'inconscient,* trans. D. Nolen, 2 vols. (Paris: Germer, Baillère, 1877), 1:308.

55. For the quotation, see Hartmann, *Philosophie de l'inconscient,* 1:33–34.

56. Laforgue, "L'Art impressionniste," in *Œuvres complètes,* 2:141.

57. In one of La Fontaine's fables the Peasant of the Danube made an appeal to the Roman Senate so impressive in its clumsy naïveté and forthrightness that he was immediately elected senator. Laforgue here refers to the appealingly sophisticated awkwardness of Puvis's style. The word *salon* refers both to the drawing rooms of the Parisian upper classes, in which Puvis held considerable sway, and to the annual exhibitions, the Salons, at which he was gaining ever-growing acclaim.

58. For recent studies on Huysmans's aesthetic views, see André Guyaux, ed., *Une Esthétique de la décadence, Actes du colloque de Bâle, Mulhouse et Colmar* (Paris: Champion, 1987).

59. The most comprehensive volume on Moreau is a catalogue of works not at the Moreau Museum in Paris: Pierre-Louis Mathieu, *Gustave Moreau: With a Catalogue of the Finished Paintings, Watercolors, and Drawings,* trans. James Emmons (Boston: New York Graphic Society, 1976).

60. Jules-Antoine Castagnary, "Salon de 1864," in *Salons,* 2 vols. (Paris: Charpentier, 1892), 1:199.

61. May, month of the first blossoms in Western Europe, has traditionally been

dedicated to the Virgin Mary. It was also the month the Salons traditionally opened. According to Huysmans, Moreau had stayed away from the Salons, whose "great art" Huysmans compared to the purgative ipecac. Moreau in fact had ceased to exhibit in the Salons after 1880 and held only two exhibitions of his watercolors (including the illustrations for La Fontaine's *Fables*) after that time, both in commercial galleries.

Nineteenth-century exhibition halls were, to all intents and purposes, large hothouses of cast iron and glass. Because direct sunlight could make individual works of art look garish, muslin was hung over the display areas.

62. Huysmans wrote "les Goupils," thus correctly referring to Goupil & Cie as a family business. It was the most successful commercial gallery of the time in Paris and had established branches in several other capitals around the world. It offered mostly the works of established Salon painters.

63. Auto-da-fé is the ceremony, practiced mostly in the Middle Ages and the Renaissance but surviving through to the early nineteenth century, of publicly burning alive those convicted of heresy by the Inquisition, to the accompaniment of prayers and religious chant. In the beginning the victims were mostly Jews and Muslims who had refused to convert to Christianity.

64. Huysmans was undoubtedly referring to the intensive rebuilding of Paris under Napoleon III that he and like-minded intellectuals deplored. It was carried out by the ambitious and energetic spendthrift baron Eugène Haussmann, préfet de la Seine—in effect mayor of Paris.

65. During the 1880s Stéphane Mallarmé, considered by younger poets the leader of the symbolist movement in literature, started holding literary and artistic receptions in his apartment on Tuesdays.

66. Emile Hennequin, *La Critique scientifique* (Paris: Perrin, 1888), 3. For a study on Hennequin, see Enzo Caramaschi, *Essai sur la critique française de la fin de siècle* (Paris: Nizet, 1974).

67. For an introduction to the artist, see Richard Hobbs, *Odilon Redon* (Boston: New York Graphic Society, 1977). For a pioneering study on the symbolic aspects of his work, and particularly the play of associations, see Sven Sandström, *Le Monde imaginaire d'Odilon Redon* (Lund: Gleerup, 1955). Dario Gamboni, *La Plume et le pinceau: Odilon Redon et la littérature* (Paris: Minuit, 1989), is a comprehensive study of Redon's theories and his relation to the literary circles of his time.

68. Odilon Redon, "De soi-même," in André Mellerio, *L'Œuvre graphique complet de Redon* (Paris: Société pour l'étude de la gravure française, 1913), 56. Information on Clavaud is given by Stephen E. Eisenman in *The Temptation of Saint Redon: Biography, Ideology, and Style in the "Noirs" of Odilon Redon* (Chicago: University of Chicago Press, 1992), 20; Eisenman relies on H. D. Schotsman, "Clavaud, sa vie, son œuvre," *Bulletin du Centre de Recherches Scientifiques de Biarritz* 8, no. 4 (1971): 755.

69. Jules Boissée, "Les dessins d'Odilon Redon," *La Revue du progrès* 14 (May 2, 1881): 335-36.

70. "There is no excellent beauty that has not some strangeness in the proportion" (Francis Bacon, *Essays, Civil and Moral,* vol. 1 of *The Works of Francis Bacon,* 3 vols. [Philadelphia: Parry & McMillan, 1859], 49).

71. An allusion to the transformations inherent in the Darwinian theory of evolution in *Origin of Species* (1859).

72. "Excrescences" alludes to the theories of phrenology, developed in the late eighteenth century and the early nineteenth, primarily by Gall, Lavater, and Spurzheim, according to which the configuration of the skull revealed character traits and intellectual potential.

73. Victor Hugo used the expression *frisson nouveau* in a letter to Baudelaire, Oct. 6, 1859, complimenting him on his poetry after receiving his article on Théophile Gautier; see *Lettres à Charles Baudelaire,* ed. Claude Pichois (Neuchâtel: La Baconnière, 1973), 188.

74. *Fleurs animées* is the title of a book of illustrations by J.-J. Grandville, text by Taxile Delord (Paris: de Gonet, 1847), humorously depicting fancifully anthropomorphic plants in human situations. Redon gives his animated flowers a brooding expression to convey the drama of evolution as he intuited it.

75. See the excerpt from Bourget, "Baudelaire and the Decadent Movement," in Chapter 3.

76. Mallarmé to Odilon Redon, Feb. 2, 1885, CDXVII, in *Stéphane Mallarmé: Correspondance,* ed. Henri Mondor and James Lloyd Austin, 11 vols. (Paris: Gallimard, 1959–69), 2:279.

77. For Redon's attitude toward critics, as well as changes in the expressive content of his work over the years, see Gamboni, *La Plume et le pinceau* (as in note 67), particularly 170–223. Redon had encouraged the assimilation of his earlier work into the literature of decadence that had been sparked by Huysmans's *A Rebours* in 1884 (see the headnote to Huysmans, "Gustave Moreau," in this chapter) and later by Hennequin (see "Fine Arts: Odilon Redon," in this chapter). For the young symbolists' espousal of decadent trends initiated by Baudelaire, see the introduction to Paul Bourget, "Baudelaire and the Decadent Movement," in Chapter 3.

78. The text was published in Picard's avant-garde *L'Art moderne* (Brussels), Aug. 25, 1894, 267–71, as "Confidences d'artiste."

79. The text is discussed in Redon's letters to André Bonger, Mar. 22 and May 8, 16, and 25, 1909. (Bonger, who had lived in Paris, was the brother of Johanna van Gogh–Bonger, wife of Theo van Gogh, Vincent's brother.) When Bonger returned the text (as Redon mentioned in his letter of May 16), the artist added a few paragraphs, including the one referring to Gourmont (which was not in the 1898 text shown me through the courtesy of the late Mrs. André Bonger). This dates that paragraph May 16/25, 1909. Gourmont's "Les Funérailles du style" appeared in *Mercure de France* 43 (July–Sept. 1902): 5–35, 329–68, 640–73, and was reprinted in *Le Problème du style* (Paris: Mercure de France, 1907). An excerpt from Gourmont's "Funeral of Style" that includes the reference to Redon appears in the Epilogue.

80. Redon, "Van Odilon Redon," *Van Onzen Tijd* 9–10 (1909): 3–23, and 22 (1913): 41–54.

81. See the introduction to Hennequin, "Fine Arts: Odilon Redon" in this chapter.

82. The expression "suggestive art" seems to have been coined by the novelist Maurice Barrès, who called authors' attempts to go beyond naturalism by searching their own souls *art suggestif* in an article by that title, which first appeared in French in Amsterdam's *Nieuwe Gids* 1 (1885–86): 140–47.

83. Redon is likely to have consulted Léonard de Vinci, *Textes choisis, pensées, théories, preceptes et facéties, traduits dans leur ensemble pour la première fois d'après les*

manuscrits originaux . . . , ed. and trans. Joséphin Péladan (Paris: Mercure de France, 1907), 108, no. 226. Péladan gives Richter as a source, and indeed the passage is to be found in Leonardo da Vinci, "Philosophical Maxims," *The Literary Works of Leonardo da Vinci,* ed. Jean-Paul Richter and Irma A. Richter, 2 vols. (London: Oxford University Press, 1939), 2:240, no. 1151 (ms. I² at the Institut de France).

84. Compare with the text by Gourmont, also of 1902: "What he gives us is no longer two drawings that can be superposed on one another symmetrically but the visually absurd and artistically admirable confusion of a double and troubled/triple sensation. Odilon Redon, who wanted to make visible certain images derived from Baudelaire and Flaubert, managed to do so, despite his genius for mystery, only by sacrificing visual logic to imaginative logic" (from "Les Funérailles du style," *Mercure de France* 43 [Aug. 1902]: 354–55; see the Epilogue, note 39).

85. André Mellerio, *L'Œuvre graphique complet de Redon* (Paris: Société pour l'étude de la gravure française, 1913), and idem, *Odilon Redon, peintre, dessinateur et graveur* (Paris: Floury, 1923).

86. Dario Gamboni, *La Plume et le pinceau,* 196, refers to Redon's change in subject matter around 1900.

87. Emile Bernard, "Odilon Redon," *L'Occident* (May 1904): 223–34. Redon's annotated copy was reproduced by John Rewald, "Quelques notes et documents sur Odilon Redon," *Gazette des Beaux-Arts* (Nov. 1956): 81–124.

88. Roseline Bacou, *Odilon Redon,* 2 vols. (Geneva: Cailler, 1956), 1:23.

89. For a detailed account of the exhibitions of Les XX and their sequel, the exhibitions of La Libre Esthétique, along with responses to them, see Madeleine Octave-Maus, *Trente années de lutte pour l'art: Les XX, 1884–1893. La Libre Esthétique, 1894–1914* (Brussels: L'Oiseau bleu, 1926); the author was the daughter of the society's secretary, the lawyer Octave Maus. Picard, in close collaboration with Verhaeren, was editor of *L'Art moderne* from its inception in 1884.

90. See the excerpt from Verhaeren, "Ensor's Vision," in Chapter 4.

91. See the excerpt from Khnopff, "Memories of Burne-Jones." The best introduction to the work of Khnopff is Jeffery Howe, *The Symbolist Art of Fernand Khnopff* (Ann Arbor: UMI Research Press, 1982). The catalogue raisonné of his work is an essential tool: Gisèle Ollinger-Zinque and Catherine de Croës, *Fernand Khnopff* (Brussels: Lebeer, Hossman, 1987); it includes an essay by Robert L. Delevoy.

92. Verhaeren gives no source for the quotation; the statement may well be his own.

93. "Corners" is an allusion to Zola's definition of the naturalist's goal: to depict "a corner of creation seen through a temperament" (see note 1).

94. Auguste Comte, trained as a mathematician, was the author of *Cours de philosophie positive,* published from 1839 to 1842. Positivism, purporting to leave theology to theologians and metaphysics to metaphysicians, rejected the absolute to establish human thought as based entirely on empirical knowledge. The theory established the groundwork of sociology, postulating that studying the facts could lead to the resolution of problems. The theory appealed to naturalists, who believed that their primary role was to observe humans and the universe with near-scientific objectivity. Ironically, Comte's awareness of the need for moral development led him to found a religion of positivism.

Emile Littré, an enthusiastic disciple of Comte, was a distinguished philologist in his own right and the author of the splendid *Dictionnaire de la langue française,* 4 vols.

(Paris: Hachette, 1875). In 1867, with G. Wyrouboff, he founded the periodical *La Philosophie positive,* which was published until 1883. It did much to spread the ideas of Comte.

Immanuel Kant, reacting against the sensualist-materialist eighteenth century, claimed that our knowledge is contingent upon what our perceptions and reasoning can reveal to us of systems of laws and ideals (including spiritual ideals). Kant associated these systems with the absolute and the divine, which are essentially beyond our reach except through aesthetics and in the measure that we can search for ultimate causes. His philosophy was thus essentially idealistic.

Johann Fichte, a disciple of Kant, shared the older philosopher's idealism, contributing the additional notion that only through the self can the ideal be apprehended, thus postulating emphatically the principle of subjectivity that was to be so important to symbolist theory.

95. "Willpower" probably alludes to the philosophy of Arthur Schopenhauer, who had developed a pessimistic system that accounted for the unconscious forces determining human volition and conceived phenomenal existence as determined by the contest of wills. See *Die Welt als Wille und Vorstellung,* 4 vols. (Leipzig: Brockhaus, 1819).

96. Khnopff was inspired to paint this work by Gustave Flaubert's *La Tentation de Saint Antoine,* a first version of which appeared in 1849, partly serialized in *L'Artiste* in 1857. A much altered version appeared in 1874 (Paris, Charpentier). It narrates the challenges to the faith and willpower of an ascetic saint. One is aware in reading it that Flaubert himself is questioning all beliefs and endeavors, constructive as well as destructive, to confirm his own pessimism. Khnopff's picture (Ollinger-Zinque and Croës, *Fernand Khnopff,* cat. no. 51, oil on canvas, 1883) shows the pathetic-looking saint facing the radiant and beautiful but haughty Queen of Sheba (1 Kings 10:1-13) who offers herself to him.

Flaubert's Parnassian affinities are reflected in the mythical subject of this picture and the reference to the goldsmith-like finish of Moreau, itself reminiscent of the precision and ornateness of Parnassian versification.

97. Verhaeren quotes Flaubert's text of 1874: *La Tentation de Saint-Antoine,* in *Œuvres,* ed. Albert Thibaudet and René Dumesnil, 2 vols. (Paris: Gallimard, 1989, 1:49-52. The final sentence of the quotation is not Flaubert's.

98. Ollinger-Zinque and Croës, *Fernand Khnopff,* cat. no. 70. The finished work had been exhibited in the Brussels equivalent of the Paris Salon, the Exposition générale des Beaux-Arts, in 1884.

99. The best short introduction is Denys Sutton, *James McNeill Whistler* (London: Phaidon, 1966). For a complete catalogue of the paintings, see Andrew McLaren Young, Margaret MacDonald, and Robin Spencer, *The Paintings of James McNeill Whistler* (New Haven: Yale University Press, 1980).

100. James McNeill Whistler, *Mr. Whistler's Ten O'Clock* (London: Chatto and Windus, 1888), 23.

101. Later called *Symphony in White No. 1: The White Girl.* It was painted in 1862 in Chelsea and exhibited at the 1863 Salon des Refusés in Paris along with Manet's *Luncheon on the Grass.* This exhibition was organized by order of Napoleon III for the benefit of the artists who had been turned down that year by the Salon jury.

102. Thoré, "Salon de 1863," in *Salons de Thoré-Bürger de 1861 à 1868* (as in note 43), 1:424.

103. Jules-Antoine Castagnary: "Année 1863," in *Salons* (as in note 60), 1:179.

104. Reported by Jacques-Emile Blanche in "James Mac [*sic*] Neill Whistler," *La Renaissance latine* 4 (June 1905): 365.

105. Among these critics were Roger Fry, for a time, and Clive Bell. Excerpts by both are in the Epilogue.

106. The term *synthetism* was frequently used to refer to the evocative simplification of a linear design. Comparing Greek sculpture to Egyptian art at the British Museum, Lucien Pissarro wrote his father, Camille, on Dec. 20, 1883: "It is no longer synthesis: everything is analyzed! The bodies are studied from the point of view of muscles and detail, whereas the Egyptians constitute wholes" (*Lettres de Camille Pissarro à son fils Lucien,* ed. John Rewald [Paris: Albin Michel, 1950], 71). Ironically, Camille Pissarro, in his reply of Dec. 25, called the Parthenon frieze "as synthetic as can be" (*Correspondance de Camille Pissarro,* ed. Janine Bailly-Herzberg, 5 vols. [Paris: Presses universitaires de France, and Paris: Valhermeil, 1980–91], 1:264, no. 202). The association of synthesis with the Egyptian tradition brings to mind Baudelaire's use of the word *synthetic* (see the headnote to the Prologue) and announces Owen Jones's simplifications based on ancient Egyptian and other non-Western traditions (see Chapter 2). Of Whistler himself, Lucien Pissarro, after seeing an exhibition of his work in London, wrote to his father on Feb. 26, 1883: "He does ravishing things with a few strokes. He is a synthetist" (Rewald, *Letters,* 31).

107. Elizabeth R. Pennell and Joseph Pennell, *The Whistler Journal* (Philadelphia: Lippincott, 1921), 318.

108. Carl Paul Barbier, Avant-propos, *Correspondance Mallarmé–Whistler* (Paris: Nizet, 1964), 5–6.

109. This particular attack is directed against literary-minded art critics in general, but Whistler goes on to chastise "the Preacher appointed," the "Sage of the Universities" who was "exhorting—denouncing—directing" (pp. 19–20), scathing criticism that can only have been directed at Ruskin, whose Slade professorship at Oxford figured prominently in arguments for the defense at the trial.

110. Hokusai was one of the finest artists of nineteenth-century Japan and one of the most prolific designers of the popular ukiyo-e woodcuts. He was already well known in Europe for the woodcuts he designed and the scrolls and screens he painted. This sentence of the lecture was among those that most infuriated Whistler's fellow aesthete and erstwhile friend Swinburne, who wrote in "Mr. Whistler's Lecture on Art" (*Fortnightly Review* [June 1888]: 745–51): "Mr. Whistler concedes Greek art a place beside the Japanese. . . . Assuredly Phidias thought of other things than 'arrangements,' in marble—as certainly as Aeschylus thought of others things than 'arrangements' in meter" (746). This was a potent argument against too single-minded a pursuit of musicality in art.

111. The best introduction is the exhibition catalogue *Arnold Böcklin* (Basel: Kunstmuseum, 1977), and, in English, *Arnold Böcklin* (London: Hayward Gallery, 1971). The catalogue raisonné of the pictures is Rolf Andrée, *Arnold Böcklin* (Basel: F. Reinhart, 1977).

112. Jules Laforgue, "Exposition du centenaire de l'Académie Royale des Arts de Berlin," *Gazette des Beaux-Arts* (Oct. 1886): 344.

113. Magna Graecia was the name the inhabitants gave to the cities of southern Italy that were originally Greek colonies: roughly speaking, from Naples to Reggio Calabria, sometimes including the ancient Greek cities of Sicily.

114. Originally a private collection in its owner's residence in Munich, it is now a public museum.

115. The reference to the Iphigenia of Greek mythology is likely to have been inspired by Goethe's "Iphigenie auf Tauris" [1787], *Goethes Werke,* ed. Erich Trunz, 14 vols. (Munich: G. H. Beck, 1977), 5:7–67.

116. The sentence is from Goethe's semiautobiographical *Wilhelm Meisters Lehrerjahre* (1786), ibid., 8:239.

117. Secession was the name adopted by groups of avant-garde artists in German-speaking lands who organized to exhibit their works independent of the art academies of their city or state. The first, founded in Munich, held its initial exhibition in 1892.

118. Hans Sandreuter was a Swiss landscape artist.

119. Gerard de Lairesse was a Dutch painter. When their Greek fleet was becalmed in Aulis on the eve of the Trojan venture, Agamemnon and his fellow Greek kings were told by a seer that only Artemis could rouse the wind and that she demanded the sacrifice of Agamemnon's daughter, Iphigenia, to atone for her father's having slighted the goddess. Brought there under the pretense that she would marry Achilles, Iphigenia was taken to the sacrificial altar but was rescued at the last moment by Artemis, who flew away with her into the clouds and presumably took her to Tauris (see note 115). The ships sailed after much anxious waiting by all concerned.

120. Léon Berthoud was a French landscape painter.

121. This work by Luc Olivier Merson was acclaimed at the Paris Salons as one of the glories of art.

122. The most recent scholarly study on Rodin is the exhibition catalogue by Albert Elsen et al., *Rodin Rediscovered* (Washington, D.C.: National Gallery of Art, 1982).

123. Ibid., 243.

124. The English critic Arthur Symons specified that the idea came to Rodin as a result of his trip to Italy in 1875; see Symons's "Auguste Rodin," *Land and Water,* Dec. 6, 1917, p. 9.

125. Auguste Rodin, *L'Art: Entretiens réunis par Paul Gsell* (Paris: Grasset, 1911), 29.

126. Ibid., 31.

127. Ibid., 226–27.

CHAPTER 2: DECORATIVE ARTS AND ARCHITECTURE

1. Léon de Laborde, *De l'union des arts et de l'industrie,* 2 vols. (Paris: Imprimerie impériale, 1856), 1:2, 400. Although Laborde had adopted some of the anti-eclectic, antitraditionalist vehemence of the British reformers of industrial design, such as Owen Jones, his writings on the 1851 Great Exhibition were in some measure a pretext for articulating a centralized program of public works for the Second Empire, to be carried out "by a powerful hand" (2:529). Besides insisting on the centralized control of education in the arts and industry, he proposed that a model governmental manufacture be set up as an example, and he counted on Napoleon and Eugénie's court to set new standards of taste. His advocacy of city beautification was in keeping with Haussmann's vast program for rebuilding Paris, then in full swing. See also "Quelques idées sur la direction des arts," in *Rapport sur l'Exposition de Londres* (Paris: Imprimerie Impériale, 1856), viii.

2. John Ruskin, "The Nature of Gothic," in *The Stones of Venice,* vol. 2 [1853], *The Works of John Ruskin,* ed. E. T. Cook and Alexander Wedderburn, 39 vols. (London: Allen, 1903–12), 10:194. Citations for subsequent quotations from this work are given parenthetically in the text.

3. Ruskin's awareness of the ties that link the nature-loving artist to his surroundings heralds Taine's approach to aesthetics in his *Philosophie de l'art, . . . leçons professées à l'Ecole des Beaux-Arts* (Paris: Ballière, 1865).

4. For a good introduction, see Gillian Naylor, *The Arts and Crafts Movement, a Study of Its Sources, Ideals, and Influence on Design Theory* (Cambridge, Mass.: M.I.T. Press, 1971).

5. J.-L.-N. Durand, *Précis des leçons d'architecture données à l'Ecole Royale Polytechnique,* 2 vols. (Paris, 1818), 1:18–21.

6. Eugène Viollet-le-Duc, "Construction," in *Dictionnaire raisonné de l'architecture française du XI^e au XVI^e siècle* [1854–58], 10 vols. (Paris: Morel, 1868–75), 4:58.

7. Viollet-le-Duc, *Dictionnaire raisonné de l'architecture,* 4:57–58. For his generation, *modern* meant "postantique."

8. Owen Jones, *Plans, Elevations, and Details of the Alhambra,* 2 vols. (London: Owen Jones, 1842–46). For details on the printing technique as well as information on the illustrations by Jones and his British contemporaries, see Ruari McLean, *Victorian Book Design and Colour Printing* (London: Faber and Faber, 1972).

9. See the excerpt from Edouard Dujardin, "Cloisonism," in Chapter 4.

10. This was a misconception. Although human figures are rare in the monumental decoration of Islam, they appear in abundance in objects intended for private use, especially illuminated manuscripts.

11. An outline of Saint-Simon's views on the arts can be found in a pamphlet by one of his disciples, Emile Barrault, *Aux artistes, du passé et de l'avenir des Beaux-Arts, doctrine de Saint-Simon* (Paris, 1830).

12. For hue and value, see Chapter 4, notes 38, 39.

13. This becomes one of the avowed technical goals of the impressionists and the neo-impressionists. Camille Pissarro, comparing a small canvas in the neo-impressionist manner, executed in multicolored dots, with others in the impressionist manner, wrote to his son Lucien: "It has great unity, creating a very gentle and harmonious pearly gray effect; the execution is absolutely superior to the large strokes [of impressionism]," letter dated [May 2, 1887] by Bailly-Herzberg in *Correspondance de Camille Pissarro,* ed. Janine Bailly-Herzberg, 5 vols. (Paris: Presses universitaires de France, and Paris: Valhermeil, 1980–91) 2:156, no. 418.

14. The acanthus leaf is an important characteristic of the Corinthian order of antiquity; this statement thus constitutes a rejection of the blind emulation of ancient Graeco-Roman motifs.

15. The fifth principle seems to foretell Cézanne's modulations by means of colored planes (see the first of the two excerpts from Cézanne's letters in Chapter 4). Gauguin, van Gogh, the Nabis, and the fauves made statements to the effect that traditional value modeling (by the gradual darkening or lightening of surfaces) must be banned. Roger Fry discussed the elimination of shadows, furthermore, in his "Post Impressionism" essay (1911), excerpted in the Epilogue.

16. Primary colors are obtained by dividing the color circle into three parts; secondary, by dividing each resulting segment into two; tertiary, by further subdividing each resulting segment into two. These divisions are all deemed harmonious by

Charles Henry, whose theories Seurat and his fellow neo-impressionists respected and, in some cases, followed conscientiously.

17. For an introduction to Morris's life and work, see the exhibition catalogues *William Morris Today* (London: Institute of Contemporary Arts, 1984); and *Morris and Company, 1861–1940: A Commemorative Centenary Exhibition* (London: Art Council of Great Britain at the Victoria and Albert Museum, 1961). The two standard reference works are Paul Richard Thompson, *The Work of William Morris* (New York: Viking, 1967); and Philip Henderson, *William Morris, His Life, Work, and Friends* (London: Thames and Hudson, 1967). For a recent critical anthology, see William Morris, *William Morris by Himself: Designs and Writings,* ed. Gillian Naylor (Boston: Little, Brown, 1988).

18. According to Eugene D. LeMire, "A Calendar of William Morris's Platform Career," in *Unpublished Lectures of William Morris,* (Detroit: Wayne State University Press, 1969), 234, the text was written for a lecture delivered on Mar. 2, 1877, before "the Trades Guild of Learning, probably in the Co-operative Hall, Castle Street, Oxford Street, London. The original title of the lecture was 'The Decorative Arts: Their Relation to Modern Life and Progress'" (idem, 292).

19. The best introductions are Aymer Vallance, "Mr. Arthur Mackmurdo and the Century Guild," *Studio* 16 (1899): 183–92; and *Catalogue of A. H. Mackmurdo and the Century Guild Collection* (Walthamstow, London: William Morris Gallery, 1967).

20. The manuscript is at the Morris Museum, Walthamstow, London.

21. The frontispiece, probably by Mackmurdo himself, consists of an amorphous linear design vaguely evoking a human body. The reference to Shelley is to the following passage:

> [Poetry] makes us the inhabitants of a world to which the familiar world is a chaos. It reproduces the common Universe of which we are portions and percipients, and it purges from our inward sight the film of familiarity which obscures from us the wonder of our being. It compels us to feel that which we perceive, and to imagine that which we know. It creates anew the universe, after it has been annihilated in our minds by the recurrence of impressions blunted by reiteration.

Percy Bysshe Shelley, "A Defense of Poetry" (1821), in *The Complete Works of Percy Bysshe Shelley* [1826–30], ed. Roger Ingpen and Walter E. Peck, 10 vols. (New York: Gordian, 1965), 7:137.

22. Myles Birket Foster first became famous as an illustrator, turning in 1861 to watercolors and paintings of landscapes and rustic subjects, his work being "memorable for its delicacy and minuteness of finish, and for its daintiness and delicacy of sentiment" (*Encyclopaedia Britannica,* 11th ed., 1910, 10:733). His house in Surrey was decorated by Burne-Jones, Morris, and their friends.

George Vicat Cole, who became an associate of the Royal Academy in 1870 and an Academician in 1880, had gained renown as a landscapist for his keen eye for the picturesque and his meticulous observation of nature, as pointed out by Michael Bryan, *Dictionary of Painters and Engravers,* 5 vols. (New York: Macmillan, 1925–27), 1:312.

23. Joris-Karl Huysmans, "Le Salon officiel de 1879," in *L'Art moderne* (Paris: Charpentier, 1883), 75–77. In "Le Salon officiel de 1881," in the same volume

(p. 214), Huysmans referred to both Viollet-le-Duc and Boileau. Louis Auguste Boileau's first major architectural achievement was the Gothic-revival Church of Saint Eugène in Paris, built almost entirely of cast iron in 1854–55. His books *Le Fer, principal élément constructif de la nouvelle architecture* (Paris, 1871) and *Classification méthodique des œuvres de l'art monumental au point de vue du progrès et de son application à la composition de nouveaux types architectoniques dérivant de l'usage du fer* (Paris: Dunod, 1886) were seminal.

24. Huysmans, "Le Salon officiel de 1879," 75–76. The architect of the Gare du Nord (railway station) was Jacques-Ignace Hittorff; the station was built in 1861–65. Les Halles Centrales, then Paris's principal food market, was partly built in 1853–58 by Victor Baltard, architect in chief of the city of Paris—the remainder being completed in two stages, in 1870 and 1930. The market was moved to the outskirts of Paris in the 1960s and the building destroyed despite heated protests in the press.

The Cattle Market, erected in 1865–67, was designed by Jules de Mérindol. See Bernard Marrey, *Le Fer à Paris* (Paris: Picard, 1989), 40–42. According to Ernest Thomas, *Le Marché aux bestiaux de la Villette et les abattoirs de la ville de Paris* (Paris: Librairie Agricole de la Maison Rustique, 1873), the work was started on Jan. 20, 1865, under the architect Janvier, after preliminary plans by Baltard. According to Marrey, the building underwent a major reconstruction in 1983–85 under the supervision of Bernard Reichen and Philippe Robert (40–42).

The Nouvel Hippodrome, with its retractable glass and metal roof, was situated on the place de l'Alma. The architect was Alfred Leroux, and the engineer, Lantrac. Built in 1877–79, it was demolished in 1892. See Marrey, *Le Fer à Paris,* 78.

25. Huysmans, "Le Fer," in *Certains* (Paris: Tresse et Stock, 1889), 171, 174–75, 178–79.

26. See Henri Loyrette, *Gustave Eiffel* (New York: Rizzoli, 1985); and E. Nouguier, M. Koechlin, and S. Sauvestre, *Projet présenté par M. Eiffel dréssé par . . . Tour en fer de 300 mètres* (Paris: E. Capiomont et V. Renault, 1885).

27. See Owen Jones, "Gleanings from the Great Exhibition."

28. For the relationship between Gauguin and Chaplet, see Merete Bodelsen, *Gauguin's Ceramics* (London: Faber and Faber, 1964), 11–14.

29. See in particular Flora Tristan, *Promenades dans Londres* (Paris and London: Delloye-Jeffs, 1840). For an introduction to the writings of Flora Tristan and the impact her ideas had on Gauguin, see Dorra, "Gauguin et l'émancipation de la femme," in *Actes du Colloque Gauguin* (Paris: La Documentation Française, 1991), 185–99.

30. See Bengt Danielson and Patrick O'Reilly, *Gauguin journaliste à Tahiti* (Paris: Société des Océanistes. Musée de l'Homme, 1966).

31. Paul Gauguin, *Le Sourire,* ed. J.-L. Bouge (Paris: G.-P. Maisoneuve, 1962), n.p.

32. Huysmans wrote of the Eiffel Tower that "it has, indeed, the color of veal 'en Bellevue' [cold veal in gelatin] served in restaurants; that is the jelly under which appears, as on the second storey of the tower, the disgusting hue of yellow grease" ("Le Fer," 175).

33. Luke 23:34: "Father, forgive them; for they know not what they do."

34. City in eastern France known for its ceramics production.

35. This paragraph and those that follow are particularly pertinent to Gauguin's own ceramics. See Christopher Gray, *Sculpture and Ceramics of Paul Gauguin* (Baltimore: Johns Hopkins University Press, 1963); and Bodelsen, *Gauguin's Ceramics.* Both works contain catalogues raisonnés.

36. Chaplet had achieved remarkable *flammé* (flamelike) effects with glazes on stoneware. Gauguin was much in his debt as a ceramist, matching or even surpassing him in his bold firing of glazes yet differing from him in that he came to treat ceramics as sculpture.

Auguste Delaherche is another distinguished turn-of-the-century ceramist who made imaginative use of glazes. He took over Chaplet's Paris workshop in late 1887, and Gauguin must initially have drawn inspiration from him as well as Chaplet.

37. The factory could only be that of the art nouveau designer and craftsman Emile Gallé, whose workshop in Nancy, in eastern France, attracted worldwide fame.

38. The Centennial Exhibition, conceived within the framework of the Universal Exhibition, gathered French masterpieces of the preceding one hundred years.

39. The following year (1890) Manet's *Olympia* was acquired by public subscription for the Musée du Luxembourg, then Paris's modern art museum.

40. Paul-Louis Courier, a soldier by profession, was also a learned humanist and a scathing liberal political pamphleteer.

41. The most recent and complete study on Sullivan is Robert Twombly, *Louis Sullivan, His Life and Work* (New York: Viking, 1986); the bibliography covers Sullivan's extensive writings. *Louis Sullivan: The Public Papers,* ed. Robert Twombly (Chicago: University of Chicago Press, 1988) is an essential compendium of Sullivan's public addresses and articles.

42. See the introduction to this chapter for the full quotation.

43. Letter from Louis Sullivan to Claude Brangdon, July 25, 1905, "Letters from Louis Sullivan," ed. Claude Brangdon, *Architecture* 65, no. 1 (July 1931): 8.

44. Louis H. Sullivan, *The Autobiography of an Idea* (New York: AIA Press, 1924), 298.

45. Sullivan listed as one of several acceptable premises "the theory that the true prototype of the tall office building is the classical column" (Sullivan, "The Tall Office Building Artistically Considered," *Lippincott's Monthly Magazine* 57 [March 1896]: 406).

46. Ibid., 408-9.

47. See the discussion of Durand's theories in the introduction to this chapter.

48. Louis H. Sullivan, "The Young Man and Architecture," *Inland Architect and News Record* 35 (June 1900): 40.

49. See David A. Hanks, *The Decorative Design of Frank Lloyd Wright* (New York: Dutton, 1979), 63.

50. The first volume of the complete catalogue of van de Velde's work has appeared: Wolf D. Pecher, *Henry van de Velde: Das Gesamtwerke* (Munich: Factum, 1981). For an introduction, see Klaus-Jürgen Sembach, *Henry van de Velde* (New York: Rizzoli, 1989); see also Abraham M. Hammacher, *Le Monde de Henry van de Velde,* trans. C. Lemaire (Paris: Hachette, 1967).

51. These last biographical details are drawn from a manuscript in the van de Velde Collection, Bibliothèque Royale des Beaux-Arts, Brussels, binder 4.

52. Gabriel P. Weisberg, *Art Nouveau Bing: Paris Style 1900* (Washington, D.C.: Smithsonian Institution; New York: Harry N. Abrams, 1986), 70, 77.

53. Nikolaus Pevsner, *Pioneers of Modern Design: From William Morris to Walter Gropius* (Harmondsworth: Penguin Books, 1961), 35-40.

54. Octave Maus was its director, and Edmond Picard edited a publication by that name which succeeded *L'Art moderne.* See Chapter 1, n. 89.

55. The neo-impressionist technique had frequently been compared to tapestry and the fully synthetist approach, to stained glass and cloisonné work.

56. The impressionists advocated and used the white frame.

57. A reference to the technique, initiated by Seurat, that consisted in painting on the edges of the picture itself a border of characteristic small dots. At first (around 1885) the hues were mostly complementary to those of adjoining parts of the picture. Afterward (around 1888), cyanide blue usually dominated so as to complement the orangy yellow of sunlight in the picture. Such borders were sometimes painted over earlier ones. At times, a wood frame similarly painted was added.

58. Van de Velde is claiming for the plastic arts characteristics the symbolist poets claimed for their prosody and imagery.

59. The French word *édification* has two meanings. "Pour l'édification de nos appartements" could mean "for the moral elevation of our dwellings" as well as "for the construction of." "Design" seemed the most appropriate translation.

CHAPTER 3: LITERARY SYMBOLISM

1. Félix Fénéon, "Gustave Kahn," in *Les Hommes d'aujourd'hui* 7, no. 360 [1890].

2. Théophile Gautier, preface to *Les Fleurs du mal* [1868] (Paris: Calmann Lévy, 1896), 17.

3. Chronologie, in *Stéphane Mallarmé: Œuvres complètes,* ed. Henri Mondor and G. Jean-Aubry (Paris: Gallimard, 1974), xxiv, xxv.

4. See note 11 for the parody; Paul Bourde, "Les Poètes décadents," *Le Temps,* Aug. 6, 1885.

5. Jean Moréas, "Les décadents," *Le XIXe siècle,* Aug. 11, 1885.

6. Hennequin actually used the term *association* in his definition of Mallarmé's symbolism at an early date: "He uses words and imagery not according to their first and obvious signification, but according to what they suggest through an often distant association" (Emile Hennequin, "Les poètes symboliques," *Revue de Genève,* Jan. 20, 1886, 232).

7. For an introduction to the various periodicals and their writers, see John Rewald, *Post-Impressionism: From van Gogh to Gauguin,* 3d ed. (New York: Museum of Modern Art, 1978), chap. 3 and bibliography, section 4. Remy de Gourmont, an active participant in the literary life of this period, wrote *Les Petites revues; essai de bibliographie* (Paris: Mercure de France, 1900). A multivolume work now in progress is already indispensable: Jean-Michel Place and André Vasseur, *Bibliographie des revues et journaux littéraires des XIXᵉ et XXᵉ siècles* (Paris: Chronique des lettres françaises, 1973–).

8. Paul Bourget was a poet, novelist, and critic whose worldly wisdom and (eventual) conservatism, as well as his talent, won him a seat in the French Academy—an honor denied every other literary figure mentioned in this chapter. (The Goncourt brothers, however, founded their own academy, intended to be bolder and broader in its tastes than the French Academy, and Maeterlinck won the Nobel Prize in 1913.) Bourget's acute interest in the literary life of his time led him to study the major participants and their impact on younger generations. His study of Baudelaire, in particular, sympathetically evokes that poet's influence on decadent circles. The early decades of Bourget's career are described in Lloyd James Austin, *Paul Bourget, sa vie et son œuvre jusqu'en 1889* (Paris: Droz, 1940).

9. Gautier, Preface to *Baudelaire: Les Fleurs du mal,* 17.

10. "But the symbol is the metaphor. It is poetry itself," Verlaine told a journalist, who quoted him as follows: "'I nevertheless refuse,' said he, not without a touch of irony, 'to bother with symbolism. I prefer *décadisme*'" (Adolphe Possien, "Une conversation avec Paul Verlaine," *Le Figaro,* Apr. 4, 1891. The term *décadisme* had been coined by Anatole Baju; see below, note 12. For "Langueur" [1883], see *Verlaine: Œuvres poétiques complètes,* ed. Yves-Gérard Le Dantec and Jacques Borel (Paris: Gallimard, 1992), 370–72.

11. Marius Tapora [Henri Beauclair and Gabriel Vicaire], *Les Déliquescences d'Adoré Floupette* (Paris: Lion Vanné ["Exhausted lion," for the avant-garde editor Léon Vannier]), 1885. The critic Félix Fénéon may have inspired the two journalists when he quoted Flaubert's earlier, ironic, use of the term *déliquescent:* "Je me sens bedolle, vache, éreinté, scheik; déliquescent, enfin calme et modéré, ce qui est le dernier mot de la décadence" (I feel bedolle [Flaubert's own invention, suggesting flabby and useless, probably from *bedon* colloq. for "paunch," and *molle,* feminine form of *mou,* "soft"], cow-like, exhausted, indolent and depraved as an oriental potentate, deliquescent, in the end calm and moderate, which is the last word in decadence). See Fénéon's review of *Lettres de Gustave Flaubert à George Sand* (Paris: Charpentier, 1884), in *La Libre revue* 1, no. 10 (Dec. 16, 1884): 331. For the full text of Flaubert's letter to George Sand, May 26 [1874], see *Œuvres complètes de Gustave Flaubert,* 12 vols. (Paris: Conard, 1930), 5:210.

12. The first, founded by the opportunist Anatole Baju, came to an end after a few issues but received a new lease on life, once again under Baju's management. "If *décadisme,*" he wrote, using Verlaine's appellation in the first issue of the revived series (3 [Dec. 1887]: 3) "is not the final word, at least it is a high and elevated conception. . . . We shall pursue the fight against naturalism for the sake of art." His ideas were further developed in a manifesto, "Caractéristiques des décadents," in *Le Décadent* 3 (Oct. 1–15, 1888): 1–3, in which he associated the title with "all that interferes with the digestion" of the bourgeois public and, more specifically, with the aura of decadence that characterized "this end of the century." He also associated the new movement with "logic and, above all, literary probity" and urged young writers to strive for nothing less than "social perfection." The periodical published a few important articles on the symbolist movement, as did *La Décadence.*

13. Jean de La Bruyère was the psychologically astute, sometimes cynical, and usually pessimistic seventeenth-century moralist, author of *Les Caractères* of 1688. Alfred de Musset was a romantic poet, novelist, and playwright whose works are characterized by gentle irony and suffused sadness.

14. The example of Hadrian may well echo Verlaine's poem "Langueur"; see above, note 10, and below, note 18.

15. Edmond and Jules de Goncourt were novelists (authors of bold naturalistic novels), critics (Edmond was an astute appreciator of the delicacies of eighteenth-century art), and connoisseurs who assembled an exquisite collection of Asian art objects as well as eighteenth-century drawings and prints.

16. Baudelaire, "L'Amour du mensonge" [The love of lying], in *Baudelaire: Œuvres complètes,* ed. Claude Pichois, 2 vols. (Paris: Gallimard, 1976), no. XCVIII, 1:98. The ellipsis is Bourget's.

17. In a footnote, Bourget cites Gautier's preface to *Les Fleurs du mal.* See above, note 2.

18. With the publication of "Langueur" in the May 26, 1883, issue of *Le Chat noir* (published by Rodolphe Sallis, the owner of the cabaret of that name), Verlaine set the tone for decadence, expressing sympathetic admiration for an imaginary ancient Roman patrician and poet who wrote "playful, indolent verses [*acrostiches*] in a golden style in which the languid sun dances"; too taken up by his life of worldly pleasure and the attendant lassitude and boredom, this poet dismisses the threat of barbarian invasion with sighs of self-pity (see above, note 10).

According to Jacques Borel, ed., *Œuvres en prose de Verlaine* (Paris: Gallimard, 1972), 1158, Verlaine took in earnest the flattery he received from Baju and assumed the leadership of Décadisme, crediting Baju with creating the movement ("Lettre au Décadent, nommément à Anatole Baju," *Le Décadent* 3 [Jan. 1–15, 1888]: 1–2; reprinted in Borel, idem, 695).

19. "Poètes maudits," in *Œuvres en prose de Verlaine,* 643–78. The articles, beginning in 1883 in *Lutèce* and continuing through 1886 in *La Vogue,* were reprinted in a booklet published by Léon Vannier in 1884 and reissued, with additions, in 1886. Of the poets included, only Mallarmé, Rimbaud, and Verlaine himself can truly be classified as symbolists.

In 1889 Verlaine joined Moréas in the effort that led to the Ecole Romane (see below, note 54)—only to break with him in 1891. In "La ballade de l'Ecole Romane" (*Verlaine: Œuvres poétiques complètes* [as in note 10], 908 [see also 1308]), Verlaine wrote:

> Down with symbolism, myth
> And termite, and again, down
> With this parasitical *décadisme.*
>
> A bas le symbolisme, mythe
> Et termite, et encore à bas
> Ce décadisme parasite.

20. Verlaine, "Critique des poèmes saturniens," Jan. 1890, in *Œuvres en prose de Verlaine,* 720.

21. The widespread repudiation of historical, mythological, and religious themes by the post-impressionists will be discussed in Chapter 4. Verlaine made frequent allusions to myth and religion and wrote some religious poems, such as those in *Sagesse,* first published in 1880; he never stopped exploring the states of his soul, however physical the sensations that may have sparked them.

22. For the letter not reprinted here, see Arthur Rimbaud to Paul Demeny, May 15, 1871, in *Arthur Rimbaud: Œuvres complètes,* ed. Antoine Adam (Paris: Gallimard, 1972), 249–54.

23. See Prologue at note 31.

24. See Prologue at note 29.

25. See Prologue text at note 30.

26. Rimbaud to Georges Izambard, Nov. 2, 1870, in *Arthur Rimbaud: Œuvres complètes,* 245–46.

27. Adam, Introduction to ibid., xxv.

28. Adam, ibid., 1074, points out that *filles* in the French text is more likely to be local vernacular for "bottles of wine" than "girls."

29. The liturgical text begins with "Stabat." The line could well be a half-ironic

allusion to Rimbaud's difficult relations with a domineering mother, who seems to have been equally distressed by her son's behavior and her own inability to understand his torment or, for that matter, his genius.

30. Rimbaud is referring to the fighting at the outskirts of Paris during the Commune. The city had effectively seceded from France on Mar. 18, 1871, after the siege by the Prussians was lifted. Its population soon elected an extreme left-wing body of representatives calling themselves the Commune. The central government reasserted itself by sending in its troops, May 21-28.

31. "Il est faux de dire: Je pense: on devrait dire on me pense." *Pense,* meaning "thinks," sounds almost the same as *panse,* for "dresses [a wound]." The meaning could therefore be understood as both "My wound is being dressed," implying that his suffering is being assuaged, and "Someone else conceives me in his thoughts." The latter meaning is in line with the notion of *dédoublement.*

32. Rimbaud wrote two days later to another, older, friend: "Je est un autre. Si le cuivre s'éveille clairon il n'y a rien de sa faute" (I is another. If copper wakes up a clarion, it is not its fault). In both cases Rimbaud seems to imply that his *dédoublement* is related to his new awareness that he is an artist (violin, clarion) rather than an ordinary human being. *Arthur Rimbaud: Œuvres complètes,* 250.

33. "Le cœur du pitre" (The fool's heart) is the title of the poem in published editions (*Arthur Rimbaud: Œuvres complètes,* 46-47).

34. For Mallarmé's relations with Manet, see Chronologie (as in note 3), xxiii; for his relations with Whistler, see Carl Paul Barbier, *Correspondance Mallarmé–Whistler* (Paris: Nizet, 1964), 5-8. Mallarmé's two articles on Manet are "Le Jury de peinture pour 1874 et M[onsieur] Manet," *Mallarmé: Œuvres complètes,* 695-704, and "The Impressionists and Edouard Manet, 1876," in *Documents Stéphane Mallarmé,* ed. Carl Barbier, 5 vols. (Paris: Nizet, 1968), 1:66-86.

35. "Richard Wagner. Rêverie d'un poëte français" (1885), in *Mallarmé: Œuvres complètes,* 545.

36. Huret, in a letter to Mallarmé, Mar. 1, 1891, indicates he would visit him the following day, Tuesday, at 5:00. In another letter, Mar. 18, he thanks Mallarmé for the interview and for correcting the text. He announces the article for the following day (Bibliothèque littéraire Doucet, Paris; documents made available through the courtesy of the curator, François Chapon).

37. See Prologue at note 16.

38. Mallarmé writes of "the verse that reconstitutes out of several vocables a complete new word, foreign to the language and incantatory" (Avant-Dire au *Traité du verbe* de René Ghil" [1886], in *Mallarmé: Œuvres complètes,* 858 n. 1).

39. *Sagesse* was published in 1880 (Paris: Société Général de Librairie catholique). Victor Hugo died in 1882.

40. Camille Mauclair, *Mallarmé chez lui* (Paris: Grasset, 1935), 43-44.

41. Maeterlinck's response was, "This comes too early, I am too young, this is not right, and I believe that these moments call for a retribution, God knows which and how terrible it will be" (quoted in Marcel Postic, *Maeterlinck et le symbolisme* [Paris: Nizet, 1970], 42).

42. Mauclair, *Servitude et grandeur littéraires. Souvenirs d'arts et de lettres de 1890 à 1900.—Le symbolisme; les théâtres d'avantgarde; peintres, musiciens.—L'anarchisme et le Dreyfusisme.—L'arrivisme, etc.* 6th ed. (Paris: Ollendorff [1922]).

43. See the text at note 35.

44. See the excerpt from Pater, "Poems by William Morris," in Chapter 1.

45. Gauguin's *Portrait of Marie Derrien* is in the Art Institute of Chicago. See Georges Wildenstein, *Paul Gauguin. Catalogue* (Paris: Les Beaux-Arts, 1964), 1, no. 387. For Cézanne's *Portrait of Madame Cézanne*, see Lionello Venturi, *Cézanne, son art, son oeuvre; 1,600 illustrations*, 2 vols. (Paris: P. Rosenberg, 1936), 2, no. 369.

46. See the excerpt from Verhaeren, "Ensor's Vision," in Chapter 4.

47. Jules Destrée, a journalist and socialist political writer, was also an art critic and was the first to compile a catalogue of Odilon Redon's lithographs, *L'Œuvre lithographique de Redon*, (Brussels: Deman, 1891).

48. A reference to *Peter Schlemihl*, by Adelbert von Chamisso, a novella of 1813 whose principal character sells his shadow to the devil and is distressed by the impact of this act on others. This is but one instance of Maeterlinck's interest in the more imaginative, even otherworldly, aspects of German romanticism. It is also significant that he translated the most mystically inclined of the German romantic poets, Novalis: *Les Disciples à Saïs et les Fragments de Novalis* (Brussels: Lacomblez, 1894). He had been inspired, moreover, by such Flemish mystics as Jan van Ruysbroeck, whose *Adornment of the Spiritual Marriage* he also translated (*L'ornement des noces spirituelles de Ruysbroeck l'admirable* [Brussels: Lacomblez, 1891]).

49. Richard Wagner, *Art-Work of the Future*, in *Richard Wagner's Prose Works*, ed. and trans. William Ashton Ellis, 8 vols. (London: Routledge and Kegan Paul, 1893), 1:95.

50. See *Opera and Drama*, in *Richard Wagner's Prose Works*, 2:198–212. For Schopenhauer, see Chapter 1, text at note 55; see also Chapter 1, note 95.

51. *Opera and Drama*, in *Richard Wagner's Prose Works*, 2:208.

52. See above, notes 4, 5.

53. There can be no question regarding Moréas's thorough knowledge of Baudelaire's theoretical thought. He quoted the poet's review of the Salon of 1846 in his own early critical foray, Jean Moréas, "Le Salon de 1883, II," *Lutèce* 2 (May 1883): 18–25.

54. Robert A. Jouanny, *Jean Moréas, Ecrivain français* (Paris: Minard, Lettres Modernes, 1969), 550. In a letter of May 1891 Moréas, after explaining that the torch of French poetry came from ancient Rome and, before that, ancient Greece, advocated "the *Roman* spirit that presides over the genesis of poetry in France. . . . It carries the germ of the only legitimate innovations; beyond it is nothing but miscegenation [*bâtardise*]. This is why I call the renovation I am attempting *ROMAN*" (Moréas to Jules Huret, May 19, 1891, in Huret, *Enquête sur l'évolution littéraire* [Paris: Charpentier, 1891], 347). *Roman* in French does not mean Roman (*Romain*) and must be understood as referring to a language once assumed to have been common in Italy, Spain, and France in the early Middle Ages and to have constituted a link between Latin and the late medieval languages of those countries.

55. See in particular Jacques Lethève, *Impressionnistes et symbolistes devant la presse* (Paris: Colin, 1959), 191–216.

56. Remy de Gourmont, interviewed by Huret, *Enquête sur l'évolution littéraire*, 133.

57. See the excerpt from Gourmont, "The Dissociation of Ideas," in the Epilogue.

58. Gourmont, interviewed by Huret, *Enquête sur l'évolution littéraire*, 134. Gourmont was responding to Anatole France, whose article "Le Symbolisme,—déca-

dents et déliquescents,—simples observations sur le manifeste de M[onsieur] Jean Moréas" (*Le Temps,* Sept. 26, 1886) singled out Moréas in attacking the whole movement.

59. Moréas gives no citation; the words in quotation marks may be his own.

60. Claude Favre de Vaugelas was a grammarian who contributed much to present French usage. Nicolas Boileau-Despréaux, in his *Art poétique* of 1674, codified the prosody inspired by classical antiquity that had found great favor during the baroque period. He set the rules that the romantics and then the symbolists took delight in contravening in the name of self-expression. Moréas accuses both men of stultifying the vigorous and earthy inspiration and style of writers like François Rabelais, François Villon, and Rutebeuf.

CHAPTER 4: THE POST-IMPRESSIONISTS

1. The name post-impressionist was coined by the critic Roger Fry for the exhibition of French art that he organized for the Grafton Gallery in London in 1910–11. (See the excerpts from Fry's accounts of the post-impressionists in the Epilogue.) John Rewald, in the first volume of what is intended to be a two-volume work, *Post-Impressionism: From van Gogh to Gauguin* (New York: Museum of Modern Art, 1978), includes romantic symbolists such as Puvis de Chavannes, Moreau, and Redon, and the three major artists (along with members of their circle) who, after an impressionist phase, developed a synthetist approach: Seurat, van Gogh, and Gauguin. But Rewald intends to include in the second volume "above all Toulouse-Lautrec, the *douanier* Rousseau, the Nabis . . . , and Cézanne." To these he proposes to add "the Fauves and the young Picasso, as well as Gauguin during his second and last trip to Tahiti" (idem, 9).

While roughly adhering to Rewald's scheme, I have not included Lautrec. His links to symbolism are no stronger than those of all great caricaturists (indeed, a case could be made for counting Daumier among the significant precursors of symbolism), and his allegiance to the naturalist ideal of the slice of life remained strong throughout his career, even though his execution was affected by a synthetist simplification owing much to the Japanese and paralleling that of the Nabis (see the excerpts from Paul Sérusier and Maurice Denis in this chapter). The fauves, "the *douanier* Rousseau," and Picasso, moreover, despite their debt to symbolism, made their major contribution in the twentieth century. Such non-Parisian artists as James Ensor, Edvard Munch, and Ferdinand Hodler, however, played a leading role among the symbolists, along with others who could not be included in this work: Gustav Klimt, Jan Toorop, Johan Thorn-Prikker, and Charles Rennie Mackintosh, to mention but a few.

2. Several post-impressionists were profoundly affected by turn-of-the-century mystical currents, which manifested themselves in an ethereal, one might say otherworldly, handling of figures. Most notable among these are the Dutch painters Jan Toorop and Johan Thorn-Prikker. Christian imagery is frequent in their work but is meant to evoke inner states rather than convey traditional religious messages (see Bettina Polak, *Het Fin-de-Siècle in de Nederlandse Schilderkunst* [The Hague: Martin Nijhoff, 1955]). Among the Nabis, Maurice Denis was a devout Catholic and endeavored to instill a new life into traditional imagery by synthetist stylization and sometimes even improvised iconographic schemes (see Fig. 40). Other Nabis were

more esoteric, showing a particular interest in theosophy (see George L. Mauner, *The Nabis: Their History and Their Art, 1888–1896* [New York: Garland, 1978]). Gauguin is a case unto himself. The expressiveness of his religious subjects is primarily intended to convey states of his soul, the religious iconography merely corroborating the message. But with the zeal of an anthropologist, he did study the religious traditions (as well as the style) of the people among whom he lived. Van Gogh, devoutly Protestant at first, developed over the years what can be called a religion of humanity, which, it could be argued, practically every one of his mature paintings reflects. The traditional religious subjects he tackled were mostly inspired by older masterpieces.

3. Themes such as those in Munch's *The Kiss* (see Fig. 42) or Hodler's *Eurythmy* (see Fig. 43), for instance.

4. See the text of the Prologue at note 18.

5. [Paul Signac,] "Variétés. Impressionnistes et révolutionnaires," *La Révolte, supplément littéraire,* June 13–19, 1891, 4. The author was identified as Signac by Robert L. Herbert and Virginia Herbert, "Artists and Anarchism: Unpublished Letters of Pissarro, Signac, and Others, I" *Burlington Magazine* 102 (Nov. 1962): 479 n. 36.

6. Gustave Kahn, "Seurat," *L'Art moderne* (Brussels), Apr. 5, 1891, 109–10. Passages from this article are included in this chapter.

7. See the excerpt from Aurier, "Symbolism in Painting: Paul Gauguin," in this chapter.

8. See the excerpts from van Gogh, "Letters on *The Night Café,*" in this chapter.

9. Paul Cézanne to Louis Aurenche, Jan. 25, 1904, in *Paul Cézanne: Correspondance,* ed. John Rewald (Paris: Grasset, 1978), 298.

10. Cézanne to Emile Bernard, May 12, 1904, ibid., 301–2.

11. Cézanne to Joachim Gasquet, Sept. 26, [1897], ibid., 262.

12. Paul Gauguin to his wife, Mette, 1892, in *Lettres de Gauguin à sa femme et à ses amis,* ed. Maurice Malingue, 2d ed. (Paris: Grasset, 1949), 238.

13. Vincent van Gogh to his brother, Theo, in *Letters of Vincent van Gogh (1886–1890): A Facsimile Edition,* Vincent van Gogh Foundation, Amsterdam, 2 vols. (London: Scolar Press, 1977), 1:539, 4/8. The dating of van Gogh's letters is that of Jan Hulsker, *Van Gogh door van Gogh* (Amsterdam: Meulenhoff, 1973); this is the dating relied on in the Vincent van Gogh Foundation's edition. For the letters from Feb. 2, 1888, through May 3, 1889, however, the dating is that of Ronald Pickvance, in the exhibition catalogue *Van Gogh in Arles* (New York: Metropolitan Museum of Art and Harry N. Abrams, 1984). I follow Hulsker and Pickvance where they bracket the dates of van Gogh's letters. This letter was dated [circa Sept. 17, 1888] by Pickvance (263).

14. Vincent van Gogh to his brother, Theo, dated [Sept. 1889] by Hulsker, in the Vincent van Gogh Foundation's edition, *Letters of Vincent van Gogh* 2:604, 3/12.

15. Gauguin to Mette, 1892, in *Lettres de Gauguin à sa femme et à ses amis,* 238.

16. The five manuscripts are available to scholars at the Oslo Municipal Collections, Munch Museum. A copy of important passages in rough translation into English exists at the museum.

17. New York, Museum of Modern art. See J.-B. de la Faille, *The Works of Vincent van Gogh* (New York: Reynal and Co., 1970), 46, no. 612.

18. Vincent van Gogh to his brother, Theo, no. 556 [Oct. 21, 1888], in Vincent

van Gogh Foundation, *Letters of Vincent van Gogh,* 2:714, 2/4; dated Oct. 21 by Pickvance, *Van Gogh in Arles,* 263.

19. Cézanne to Emile Bernard, July 25, 1904, and Oct. 23, 1905, in *Cézanne: Correspondance* (as in note 9), 265, 277. P. M. Doran, in *Conversations avec Cézanne* (Paris: Macula, 1978), 193–94 n. 1, surmises that *concentrique* in the letter might have been an error for *concentré* (concentrated). Reff accepts *concentrique* and even points out that Cézanne is reported to have told his son: "Bodies in space are all convex." See Theodore Reff, "Painting and Theory in the Last Decade," in the exhibition catalogue *Cézanne: The Late Work,* ed. William S. Rubin (New York: Museum of Modern Art, 1977), 48.

20. *The Literary Works of Leonardo da Vinci,* ed. Jean-Paul Richter and Irma A. Richter, 2 vols. (London: Oxford University Press, 1939), 1:129–32, 323.

21. See the Chronologie, in *Félix Fénéon: Œuvres plus que complètes . . . ,* ed. Joan U. Halperin, 2 vols. (Paris: Droz, 1970), 1:xi–xxx. See also Halperin, *Félix Fénéon and the Language of Art Criticism* (Ann Arbor, Mich.: UMI Press, 1980), and *Félix Fénéon: Aesthete and Anarchist in Fin-de-siècle Paris* (New Haven: Yale University Press, 1988).

22. Glazing consists of applying diluted paint (glaze) in layer upon layer of strips of various widths so as to build up the desired hue and value through gentle gradations. It was the traditional manner of painting of the Renaissance, until artists such as Giorgione and, more important, Titian, Veronese, and El Greco started juxtaposing visible individual brushstrokes of diverse hues over the ground colors. Some impressionists used the glazing technique for parts of the skin of their figures.

23. Chronologie, in Halperin, *Félix Fénéon: Œuvres plus que complètes,* 1:xv.

24. Fénéon, "VIIIᵉ Exposition impressionniste," in Halperin, *Felix Fénéon: Œuvres plus que complètes,* 1:35; originally published in *La Vogue,* June 13–20, 1886, 261–75.

25. "1886, January or February, small canvas according to the division into pure hues by Pissarro . . . definitively affecting Signac," wrote Seurat in a document quoted by Anne Distel, Chronologie, in the exhibition catalogue *Seurat,* ed. Robert L. Herbert (New York: Metropolitan Museum of Art and Harry N. Abrams; Paris: Musée d'Orsay, 1991), 402. This catalogue is the most recent scholarly study of Seurat and is a good introduction to the artist (but see notes 34 and 52 for reservations); so is Richard Thomson, *Seurat* (Salem, Mass.: Salem House/Phaidon, 1985).

26. William Innes Homer, *Seurat and the Science of Painting* (Cambridge, Mass.: MIT Press, 1964), 143–45.

27. Fénéon, "VIIIᵉ Exposition impressionniste," 1:37.

28. See the excerpts from Owen Jones, "Gleanings from the Great Exhibition," in Chapter 2; for the quotation from Baudelaire, see the Prologue at note 11. Bogomila Welsh-Ovcharov, in the exhibition catalogue *Vincent van Gogh and the Birth of Cloisonism* (Toronto: Art Gallery of Ontario: Amsterdam: Rijksmuseum Vincent van Gogh, 1981), pp. 17–41, presents a succinct history of the trends that led to cloisonism, which is another name for synthetism, the stress on uniform color areas delimited by continuous outlines, found in medieval stained glass, cloisonné enamel, Japanese prints, and, ultimately, the work of Courbet and Manet among other artists of the 1880s. The catalogue mentions Puvis, but not for the admittedly Renaissance-inspired stylization that led Gautier to say his work was conceived in a "synthetic sense" (see the excerpt from Gautier in Chapter 1). Welsh-Ovcharov, however,

points to the importance of Seurat's simplifications, in which Fénéon recognized a "synthetic" approach (idem, 36). Indeed, even without the dots neo-impressionist works, with local colors applied fairly uniformly, would have a synthetist, or cloisonist, look.

29. See Robert L. Herbert, "Seurat and Puvis de Chavannes," *Yale University Art Gallery Bulletin* 25 (Oct. 1959): 22–29. See also the exhibition catalogue *French Symbolist Painters* (London: Hayward Gallery; Liverpool: Walker Art Gallery, 1972), 22.

30. Fénéon, "VIIIᵉ Exposition impressionniste," 1:37.

31. Ibid.

32. Fénéon, "L'Impressionnisme aux Tuileries," *L'Art moderne* (Brussels), Sept. 19, 1886, in Halperin, *Felix Fénéon: Œuvres plus que complètes*, 1:55. The neo-impressionists, in fact, replaced the mostly opaque surfaces of the figures and objects of daily life with semitranslucent, luminous, harmoniously undulating ones. Rodolphe Rapetti, in "Pour une définition du symbolisme pictural: Critique et théories à la fin du XIXᵉ siècle," *Quarante-huit/Quatorze. Conférences du Musée d'Orsay*, no. 5 (Paris: Réunion des Musées nationaux, 1992), 69–82, refers to this transformation as a dissolution of the object by light and considers it an important manifestation of the antimaterialist tendency of symbolism.

33. Fénéon, "Le Néo-impressionnisme à la IVᵉ Exposition des Artistes Indépendants," *L'Art moderne* (Brussels), Apr. 15, 1888, in Halperin, *Felix Fénéon: Œuvres plus que complètes*, 1:84–85. Although Fénéon devoted an article to Charles Henry ("Une Esthétique scientifique," *La Cravache parisienne*, May 18, 1889, idem, 1:145–58), he did not mention any of the neo-impressionists in it. Signac nevertheless was to illustrate the tediously methodical application of Henry's theories reproduced in Henry's *Application de nouveaux instruments de précision* (Paris: Leroux, 1890), 20–31, and Fénéon was to refer to it in "Signac," *Les Hommes d'aujourd'hui* 8, no. 373 [1890].

34. Was Fénéon unaware of Seurat's and Signac's reliance on Japanese prototypes? Or did he hint at their use without revealing what his friends must have regarded as a trade secret? The second hypothesis is more likely in view of Fénéon's comment (Signac, like musical composers, numbered his works) that he preferred Signac's *Opus 198*, of May 1889, to either *Opus 180* or *190*. For Fénéon, *Opus 198* was "rich in the promise of a new art. The vigor of the forms, the decorative expansiveness, the large areas of regular gradations link this marine with the lake landscapes of the Japanese; yet the potential japanism of this painting owes nothing to Japan. It is but a logical stage in the development of Signac" ("Critique d'art. Exposition des Neo-Impressionnistes," in Halperin, *Félix Fénéon: Œuvres plus que complètes*, 1:165).

For evidence of Japanese influence on Seurat, see Henri Dorra and Sheila C. Askin, "Seurat's japonisme," *Gazette des Beaux-Arts* (Feb. 1969): 81–94. That Robert L. Herbert and the circle of Seurat scholars responsible for the recent New York and Paris Seurat exhibition (see above, note 25) ignored Japanese influences while they went to great lengths to establish others reveals that they adopted Fénéon's attitude, though without the critic's justifications, which no longer have any validity.

35. In the sentence that follows, Fénéon refers to his article "L'impressionisme aux Tuileries," of 1886.

36. For "value," see note 39.

37. All the artists named received much popular acclaim at the official Salons. Although the painters among them had lightened their palettes and the sculptor

(Albert-Ernest Carrier-Belleuse, the only sculptor named) occasionally stressed a new fluidity of modeling in order to claim a place among the avant-garde, they all remained faithful to traditional concepts of form and subject.

38. Hue is the property of colors that permits them to be classified as red, yellow, green, blue, and so forth. "Cool" hues are in the green–purple range of the color wheel; "warm," in the red–yellow range.

39. Chevreul enunciated his law of simultaneous contrast before the Academy of Science in Paris in 1829; it was published as *De la loi du contraste simultané et de l'assortiment des objets colorés* (Paris: Pitois-Levrault, 1839). According to this law an area covered by any one hue appears to be surrounded by a halo of its complementary. (Buffon had clearly formulated this law in 1743, as Chevreul himself acknowledged. See Dorra, "Valenciennes's Theories: From Newton, Buffon, and Diderot to Corot, Chevreul, Delacroix, Monet, and Seurat," forthcoming in *Gazette des Beaux-Arts*.) When two complementary hues are placed side by side, each appears to strengthen the other where they meet. When the areas of complementary hues create a small imprint on the retina, however, they cancel out. Chevreul's law also holds for values (value is the relative darkness [low value] or lightness [high value] of a color). For all the theories on which Seurat relied, see Homer, *Seurat and the Science of Painting* (as in note 26). While directing the national tapestry factory of the Gobelins, Chevreul determined that the optical effect of mixing threads treated in three different pure dyes was more luminous than that of threads treated in a mixture of the individual dyes, a point also made in the book.

40. The hue of the reflected component is determined by the optical mixture of the first two and lies between them on the color circle. Fénéon's pointing out earlier that red calls forth blue-green (i.e., is the complementary of blue-green— diametrically opposite on the color circle) indicates that he has in mind the color circle of Helmholtz, who was the first to establish an accurate color circle based on frequencies measured for various hues. Seurat based his own color circle on one published by Ogden Rood (Homer, *Seurat and the Science of Painting,* 39–41 and diagrams), which is based on Helmholtz's earlier measurements. The original edition was Hermann von Helmholtz, *Handbuch der physiologischen Optik* (Leipzig: Voss, 1867).

41. A reference to Chevreul's law of simultaneous contrast. See note 39.

42. Jules Christophe, "Georges Seurat," *Les Hommes d'aujourd'hui* 8, no. 368 [1890].

43. At one time a steady contributor to avant-garde periodicals—symbolist ones among them—Maurice Beaubourg gained moderate popular acclaim with his novels. For the conclusion that the letter was not sent, see Herbert, ed., *Seurat* (as in note 25) 381–82. Four variants of the text exist. The one reproduced here is labeled "version d" in Herbert, 430–31.

44. See the introduction to the excerpt from Charles Henry, "Introduction to Scientific Aesthetics," at note 53, for Seurat's share of borrowings from Humbert de Superville and Charles Henry.

45. For a conclusive discussion of Chevreul's theory of the relative impact of gradations and oppositions or contrasts, see Homer, *Seurat and the Science of Painting,* 20–28. According to Seurat, lines at right angles, strong value (light-dark) oppositions, and hues that are diametrically opposite on the color circle (complementaries) all constitute contrasts, or what he calls "analogies of similar entities."

46. See notes 38 and 39 above.

47. Even Seurat could be absent-minded! The complementary of red is blue-green. See Fénéon's analysis in the preceding section of this chapter.

48. Irradiation is either the application of Chevreul's law of simultaneous contrast to color values (see Homer, *Seurat and the Science of Painting,* 43) or the name of the phenomenon in which brighter objects appear to spread their light over the neighborhood (idem, 215).

49. For a careful analysis of the sources of this text, see ibid., 202–14.

50. Charles Henry, "Wronski et l'esthétique musicale," *La Vogue* 2 (Oct. 4–11, 1886): 405–6. Józef Maria Wroński's major utopian opus was *Messianisme, ou réforme absolue des passions humaines,* 3 vols. (Paris: Didot, 1847).

51. I have highlighted the flaws in Charles Henry's reasonings in "Charles Henry's 'Scientific' Aesthetic," *Gazette des Beaux-Arts* (Dec. 1969): 345–56. I have also pointed out that dominant directions in the compositions of Seurat, starting with *Les Poseuses* of 1886–88, correspond to those Henry found harmonious; see Dorra, "L'evolution de style de Seurat," in Henri Dorra and John Rewald, *Seurat: L'Œuvre peint, biographie et catalogue raisonné* (Paris: Les Beaux-Arts, 1959), lxxix–cxxii. Important new contributions were made by Homer, *Seurat and the Science of Painting.*

As for written sources other than Fénéon, "Le Néo-impressionnisme à la IVe Exposition des Artistes Indépendants" (as in note 33), the following anonymous passage is also instructive: "Georges Seurat . . . also tries to cause the directions of the lines and their intersection to relate certain angles to the dominant idea of the painting. . . . This quest for a harmony of lines and colors, to achieve an expression that is specific to the point of exaggeration of the dominant idea of the picture, will lead to powerful effects of decorative painting if the nature of the procedure is made less obvious" ("L'Exposition des Neo-Impressionnistes du Pavillon de la Ville de Paris," *Art et critique,* Mar. 29, 1890, 204).

Signac too was influenced by Henry's theories. Besides practicing Henry's tedious graphic method when he illustrated Henry's *Application de nouveaux instruments de précision* (Paris: Leroux, 1890) and "L'Esthétique des formes" (see *La Revue blanche* 7 [Aug. 1894]: 118–29; [Oct. 1894]: 308–22; [Dec. 1894]: 511–25, and 8 [1st sem. 1895]: 117–20), Signac, as the quotation that follows further confirms, applied at least some of Henry's methods (the passage is written in the telegraphic style favored by the neo-impressionists and their friends. Henry's "rhythms and measures" correspond to divisions of angles and dimensions according to the Gauss-based formula): "Luminist technique of the neo-impressionists with application of the recent discoveries of Charles Henry on the rhythms and measures of lines and colors. [Paul Signac] has collaborated with this scientist in [preparing] 'L'Education du sens des formes' [The education of the sense of forms]." A list of pictures follows the quoted passage (S.P., "Catalogue de l'exposition des XX," *Art et critique,* Feb. 1, 1890, 76–78). "L'Education du sens des formes" was never published. Signac's *Women at the Well* of 1892 (see Françoise Cachin, *Paul Signac* [Greenwich, Conn.: New York Graphic Society, 1971], pl. 49, p. 64) seems to be among the last of his pictures to have been composed according to a rigid mathematical framework. It is significant that Signac made no mention of Charles Henry and his theories in his *De Delacroix au néo-impressionnisme* (Paris: Revue Blanche, 1899).

52. Such a grid is visible, in fine blue lines, over most of Seurat's *Circus.* I have established that the grid in *The Circus* and some other pictures is obtained by marking on the base of the picture the golden section point (.618 . . . of the width),

starting from one end, and doing the same from the other. The distance between these two points is the width of the square serving as a module for the horizontal and vertical elements. Diagonals (45 and 135 degrees) pass through all the grids' intersections. The left vertical golden section line plays a particularly important role in the composition, dividing it just to the left of the figure of the leaning equestrienne that dominates the picture. The fact that the axis of the equestrienne's body is at 60 degrees to the horizontal and that many other elements in the design are parallel to the horizontals, verticals, and diagonals of the grid—at 0 degrees, 45 degrees, 90 degrees, and 135 degrees, that is—is also significant. These angles are harmonious according to Charles Henry. See Dorra and Rewald, *Seurat,* xciii–cvii.

Anne Distel, however, in the catalogue of the New York–Paris Seurat retrospective (as in note 25), 364 and n. 7, sees little use for *The Circus's* grid, except perhaps as the basis for transferring linear designs from preparatory sketches to the painting by means of the "squaring up" method. But she does point out that in a recent thesis Marguerite Neveux accounts for that grid on the basis of a module derived from the ratio of the height to the width of the canvas, "but not necessarily on the golden section," while noting that the proportions of the canvas are such that the grid is indeed related to the golden section "within one millimeter." Thus, willy-nilly she confirms my findings.

53. André Chastel, "Une source oubliée de Seurat," *Etudes et documents sur l'art français* 22 (1959): 400–407, first established the connection with D. P. G. Humbert de Superville's *Essai sur les signes inconditionnels dans l'art* (Leyden: van der Hoek, 1827–32). For a detailed discussion, see Homer, *Seurat and the Science of Painting,* 202–14.

54. Homer, ibid., 206.

55. Pierre Dax, "Chronique," *L'Artiste* 50, no. 1 (1879): 215.

56. In the feature titled "Nouveaux périodiques," *La Revue indépendante* 2, ser. 3 (Nov. 1884): 268.

57. Fénéon, "Le Néo-impressionisme" (as in note 33).

58. Charles Henry, *Le Cercle chromatique* (Paris: Verdin, 1889), 4–5.

59. As against arithmetically, i.e., by means of a numerical division.

60. Henry's "I shall prove" deserves notice. His later texts imply that the proof was established.

61. This quadratic equation can be shown to have either of two solutions: $a/b = .618\ldots$ or $1.618\ldots$

62. Wavelength and frequency (or vibrations per second) are inversely proportional. Red has a long wavelength and a low frequency, blue a short wavelength and a high frequency.

63. A series of such concentric circles can provide a color disc giving hues, values, and intensities. See Charles Henry, *Le Cercle chromatique.*

64. The metaphors are drawn from "Une Martyre," line 43; "La Destruction," line 1; "Causerie," line 1; and "Sed non satiata," line 7.

65. See the excerpt from Moréas, "A Literary Manifesto—Symbolism," in Chapter 3.

66. The implication is that as a priestess of love she is a prostitute as well as a dancer.

67. Halperin, Chronologie (see note 21), 1:xxi–xxii. Fénéon was probably storing such materials to help out their owner, an anarchist under police surveillance.

68. Quoted by Cachin, *Paul Signac* (as in note 51), 73. The political involvement

of the literary and artistic circles of the time is discussed in Eugenia W. Herbert, *The Artist and Social Reform* (New Haven: Yale University Press, 1961).

69. Herbert, *Art and Social Reform*, 190 n. 38.

70. The Norwegian poet and playwright Henrik Ibsen wrote this play in 1882. It is as lifelike as any naturalist would wish but its ominous conflicts of emotions and ideas are developed in a pattern so masterly as to border on symbolism. The play pits a small community determined to build a dam to ensure its water supply against a lone physician advising it to build a more expensive one higher up in the mountains to protect the water from organic contamination by pasturing cattle. For Signac and his political companions the play must have represented the struggle between the enlightened anarchist and everyone else. The curtain falls as a violent crowd bursts into the doctor's living room.

71. Georges Clemenceau, the former socialist mayor of Montmartre, on a hill northeast of Paris, was an ardent spokesman for the extreme Left in the Chamber of Deputies. He was the prime minister who led France at the end of World War I.

72. An academically trained illustrator named Thévenot is listed in Emmanuel Bénézit, *Dictionnaire critique et documentaire des peintres, sculpteurs, dessinateurs et graveurs de tous les temps et de tous les pays* (Paris: Grund, 1948–55). Elisée Reclus and the Russian prince Pyotr Alekseyevich Kropotkin were geographers of worldwide repute as well as dedicated anarchists. Each spent time in prison and many years in exile. Their political writings can be regarded as significant underpinnings of anarchist thought.

73. Charles Gallo threw a bottle of hydrocyanic acid, then fired a revolver three times at traders on the floor of the Paris Bourse (stock market) in 1886. He was imprisoned in the penitentiary of New Caledonia, where he died. Ravachol, responsible for explosions in the homes of two magistrates in 1892, was sentenced to forced labor for life. Subsequently tried for earlier crimes, he was condemned to death and executed. Auguste Vaillant set off explosives in the Chamber of Deputies in 1893 and was executed. In 1892 a bomb deposited in an office building by Emile Henry was removed to the local police station, where it exploded. Expecting to be prosecuted, Henry fled to England but in 1894 was back in Paris, where he set off an explosion in the café of the Saint-Lazare Station. He took sole responsibility for the first incident, for which he was subsequently executed. Jeronimo Caserio Santo killed the president of the Republic, Sadi Carnot, who was visiting the Lyons Universal Exhibition of 1894. His was the last of these attempts to promote anarchy by violent means. See Jean Maitron et al., *Dictionnaire biographique du mouvement ouvrier, 1871–1914*, 6 vols. (Paris: Editions Ouvrières, 1973–77).

74. Welsh-Ovcharov, *Vincent van Gogh and the Birth of Cloisonism* (as in note 28), 28, 230.

75. See note 24 for the source of the quotation.

76. Vincent van Gogh to his brother, Theo, July 22, 1886, no. 511, in Vincent van Gogh Foundation, *Letters of Vincent van Gogh* (as in note 13), 1:1/6. Dated Oct. 22 by Pickvance, *Van Gogh in Arles* (as in note 13), 263.

77. See the excerpt from Fénéon, "Neo-Impressionism," part 3.

78. Ibid.

79. Armand Guillaumin, after taking part in the first impressionist exhibition in 1874 and several others, participated in the first exhibition of the *Indépendants*. He was a personal friend of several impressionist and post-impressionist artists. Jacques Emile Blanche received academic training, adopted a Manet-like brushstroke, and

was influenced by the fresh coloration and aristocratically aloof attitude of eighteenth-century British portraitists. As the son of a fashionable physician, he was ideally suited for a career as a successful society painter. Paul Helleu, also academically trained, developed a manner stressing long wavy lines flowing in continuous vaporous streams that helped bring out the grace of his models. He too achieved considerable success as a portraitist of the rich and famous.

80. Léon Bonnat had received academic training and himself became a member of the Academy of the Fine Arts. His somewhat Caravagesque naturalism attracted a vast number of students. He had a connoisseur's eye for older masters as well as fairly new ones and as a result has left a collection of considerable interest, now at the Musée Bonnat in Bayonne.

81. On Anquetin, see Welsh-Ovcharov, *Vincent van Gogh and the Birth of Cloisonism* (as in note 28), 227-58.

82. It was also a nightclub. The owner, Aristide Bruant, who was to be masterfully portrayed by Lautrec, held forth as a singer and a witty commentator on social and political developments.

83. Dujardin used the word *imagerie,* referring to such work as that of the artisans of Epinal, a city in eastern France that was still producing woodcuts in a retardataire medieval style in the nineteenth century. The raised lines of the woodcuts created continuous dark outlines on the surface of the paper, forming compartments that were filled, mostly by hand, with uniformly applied watercolor hues, thus, like medieval stained glass, heralding cloisonist or synthetist effects.

84. The parenthetical phrase alludes to Emile Zola's definition of the goal of naturalism of 1865, which is to show "a corner of creation seen through a temperament." See Chapter 1, note 1. Trompe l'oeil is a mode of painting so accurate in representing objects that it fools the eye.

85. The futile pretext was advanced by none other than Leonardo: "The boundaries of bodies are the least of all things. . . . Oh, painter! do not surround your bodies with lines" ("Linear Perspective," in *The Literary Works of Leonardo da Vinci* [as in note 20], 1:129, no. 49).

86. Dujardin had written "the circumscription of line and color."

87. See Diane Lesko, *James Ensor: The Creative Years* (Princeton: Princeton University Press, 1985).

88. Both the nervous and energetic handling of line Verhaeren detected in works such as *Christ Quelling the Tempest* and the relative unimportance of figurative elements presage the graphic automatism of the surrealists. The very notion of the artist ignoring all the rules, presumably to give free rein to his intuition, is basic to that element of surrealism. Even the notion of the artist as a seer, so close to Rimbaud's concept of 1871 (see "The Unsettling of All the Senses" in Chapter 3), became part of the surrealist credo.

89. The most up-to-date introduction to Gauguin is the exhibition catalogue by Isabelle Cahn, *Gauguin* (Paris: Réunion des Musées nationaux, 1989); see also the exhibition catalogue in English: Richard Brettell, Françoise Cachin, Claire Frèches-Thory, Charles F. Stuckey, *The Art of Paul Gauguin* (Washington, D.C.: National Gallery of Art, 1988).

90. *Paul Gauguin, a Sketchbook* [*Notes synthétiques*], ed. Raymond Cogniat, foreword by John Rewald (New York: Hammer Galleries, 1962). Rewald suggested that this text dates from 1884 or 1885 (idem, 51-52).

91. Charles de Couëssin minimizes the importance of the vase shown in Figure

22 in Gauguin's evolution toward synthetism, stressing instead the influence of Pissarro's practice of reducing the thickness of colored paste applied near the edges of an object so as to let the canvas show through. The edges are then traced over in low-value lines. Couëssin notes similar procedures in the work of Gauguin and Cézanne and attributes them to the lessons Pissarro gave both ("Le Synthétisme de Paul Gauguin, hypothèses," in *Gauguin. Actes du colloque Gauguin, Musée d'Orsay, January 11–13, 1989* [Paris: La Documentation Française, 1991], 81–97).

92. The pronoun in Gauguin's clause "qu'aucune éducation ne peut détruire" has "an infinity of things" for its antecedent, a case of grammatical sloppiness on his part. It is undoubtedly the sensations that no education can suppress, and the translation reflects this reading.

93. Charles Blanc wrote in his *Grammaire des arts du dessin* [1867] (Paris Renouard, 1885), 35: "The straight line, as postulated by Pythagoras, could symbolize infinity. The curved line, on the contrary, could only represent the finite." Drawing a parallel between other passages, Mark Roskill proposed this source in *Van Gogh, Gauguin, and the Impressionist Circle* (Greenwich, Conn.: New York Graphic Society, 1970), 267.

94. On several later occasions Gauguin insisted that the symbolism of his compositions could be compared to that of parables. His works had what he called a *sens figuratif* (figurative sense), which was the representational side of the picture, often irrational and incongruous as in the Breton women confronting Jacob and the Angel in *The Vision after the Sermon, or the Struggle of Jacob and the Angel* (Fig. 34). They also had what he called a *sens figuré* (evoked sense), which was the philosophical content, rational and consistent. See Ewald M. Vetter, "Sens figuratif et sens figuré bei Gauguin," in *Festschrift Wolfgang Braunfels,* ed. Friedrich Piel and Jorg Träger (Tubingen: Wasmuth, 1977), 419–31. The idea had clearly occurred to Gauguin at the time of this meditation on Cézanne. At the end of the sentence in the text the French word Gauguin had written was the plural of *imaginatif,* which means "endowed with a fertile imagination." He undoubtedly meant that Cézanne's wallpaper designs were as much a product of that artist's imagination as they were things pertaining to the real world. "Imaginary" is therefore a more appropriate translation.

95. Gauguin wrote "é c r i t u r e séparée mystique." Victor Merlhès, in *Correspondance de Paul Gauguin,* ed. Victor Merlhès, 3 vols. announced (Paris: Fondation Singer-Polignac, 1984–), 1:409, has traced this passage to Jean Hippolyte Michon, *Système de graphologie* (Paris: Comon, 1852). Michon associated Western writing, which he assumed links letters, with a tendency to be deductive, logical, and argumentative; for him, Eastern writing, which he assumed detached individual letters, reflected "mysticism and sensuality. [The Orient] has a special fondness for imagery, idealizes everything: profoundly religious, it is drawn to ecstasy, to illuminism, to prophecy. The man of the Orient sees God." Yet Arabic characters are linked; not so Greek and Roman ones!

96. Gauguin appears to be inconsistent in his use of the term *literature* in connection with painting. In the preceding paragraph, regarding Cézanne, he seemed to imply that the artist's message was intuitive, like that of symbolist poetry, and affected the viewer through evocation; here he appears to refer derogatorily to literal description.

Such contemptuous use of the term *literature* has already been encountered at the

end of Verlaine's "Art of Poetry" ("Art poétique") in Chapter 3. In both cases the writers seem to have distinguished between poetic creation, on the one hand, and naturalism in literature, which, at least in the eyes of its opponents, concerned itself mostly with factual description. In other words, Gauguin favored a literary approach in art when he conceived that approach as primarily evocative, and he opposed it when he conceived it as essentially prosaic and literal.

97. By stressing the presumed linkage between Raphael's intuitive awareness of his own soul and his ability to create exceptional harmonies, Gauguin was taking a stand against both purely rational intellectual processes and an objective vision of physical reality.

98. Carolus-Duran (Charles Durand) was a successful portrait painter who became a member of the Academy of the Fine Arts. His technical borrowings from such painterly masters as Velázquez and Courbet did not make up for the triviality of his expressive content.

99. The Société des Artistes Indépendants, founded in 1884, was organizing its annual exhibition at the time Gauguin wrote.

100. Henri Gervex was a fashionably successful artist whose shallow subjects were livened by a light palette.

101. Jean-François Raffaëlli had adopted a restrained version of impressionism but continued to produce anecdotal art. He took part in some of the impressionist exhibitions. He usually sided with those opposing Gauguin in the quarrels among the impressionists.

102. Charles Blanc referred to "the tender character of . . . the *weeping* willow" (*Grammaire des arts du dessin*, 630).

103. Although Gauguin already considered himself first and foremost a painter, he had agreed to represent a French manufacturer of tarpaulins in Denmark.

104. The question of Gauguin's first use of the term *synthetism* depends on whether his "Notes synthétiques" (see note 90) dates from 1884/85 or later. In a letter to Schuffenecker dated Aug. 14, 1888, he states: "You will find [in my recent work] the affirmation of my earlier research, or synthesis of a form and a color, only considering the dominant" (*Correspondance de Paul Gauguin*, 1:210). He was implying that his synthetist approach was developed in connection with earlier work; *The Bathers,* painted in Dieppe in 1885, comes to mind.

105. Paul Gauguin to Theo van Gogh, Sept. 29, 1888, in *Paul Gauguin: 45 Lettres à Vincent van Gogh,* ed. Douglas Cooper (Lausanne: Bibliothèque des Arts, 1983), no. 6³; and to Vincent van Gogh, idem, circa Sept. 25, 1888, no. 33₁). See also Vincent van Gogh to Gauguin, dated [circa Oct. 3, 1888] by Pickvance (as in note 13), no. 553a, in *Verzamelde Brieven van Vincent van Gogh,* ed. Johanna van Gogh–Bonger, 4 vols. in 2 (Amsterdam: Wereld, 1955), 3:345.

106. The idea was proposed by Sven Loevgren, *The Genesis of Modernism: Seurat, Gauguin, van Gogh, and French Symbolism in the 1880s* (1959; rpt. New York: Hacker Art Books, 1983), 140 nn. 50, 51. The term *messianic* is Loevgren's.

107. Welsh-Ovcharov, *Vincent van Gogh and the Birth of Cloisonism* (as in note 28), 92.

108. Gauguin was fully aware of his stylistic and intellectual break with impressionism; by *impressionist* he meant an artist who had broken with officialdom.

109. Van Gogh's *Self-Portrait* of 1887 is at the Art Institute of Chicago; see J.-B. de la Faille, *The Works of Vincent van Gogh* (as in note 17), no. 345. For van Gogh's

phrase "emotion of an ardent temperament," see the excerpts from letters on *The Night Café* in this chapter). *Ardeur,* from the Latin *ardor,* has "burning heat" as its principal meaning.

110. The French term *grand feu* (high fire) refers to the high temperatures necessary for making stoneware.

111. See the excerpt from Gourmont, "The Funeral of Style," in the Epilogue.

112. Gauguin shared Owen Jones's view that Middle-Eastern decorative patterns were essentially symbolic.

113. Although no longer under the direct control of the Academy of the Fine Arts, the Ecole des Beaux-Arts to which Gauguin refers counted among its instructors many members of that body and remained a bastion of conservatism. It constituted the first step for young artists seeking official recognition.

114. Theo van Gogh, Vincent's brother, was then managing the modern-art branch of Boussod & Valadon, international art dealers, successors of Goupil & Cie, for whom his uncle had worked.

115. See the first of the two excerpts from Gauguin's letters to Schuffenecker in this chapter.

116. See Mathew Herban III, "The Origin of Paul Gauguin's *Vision after the Sermon: Jacob Wrestling with the Angel,*" *Art Bulletin* 59, no. 3, (Sept. 1977): 415–20. Herban determined that a sermon on the subject had just been delivered at the parish church of Pont-Aven. See also Denise Delouche, "Gauguin et le thème de la lutte," in *Gauguin. Actes du colloque Gauguin* (as in note 91), 157–71.

117. Quotation from Delacroix's invitations to the opening of the Chapel of the Angels at Saint Sulpice, whose walls are decorated with his paintings (Maurice Sérullaz, *Mémorial de l'exposition Eugène Delacroix* [Paris: Musée du Louvre, 1963], 391).

118. In *Gauguin's Ceramics,* Merete Bodelsen tentatively proposed that Gauguin was indeed the priest (London: Faber and Faber, 1964), 182. The evidence appears convincing.

119. G.-Albert Aurier, "Essai sur une nouvelle méthode de critique," in *Albert Aurier: Œuvres Posthumes,* ed. Remy de Gourmont (Paris: Mercure de France, 1893).

120. Aurier claimed that "Taine, while not specifically admitting it, cares very little for the intrinsic and absolute value of the work of art" (Aurier, "Préface pour un livre de critique d'art," in *Mercure de France* 6 [Dec. 1892]: 310).

121. Moréas wrote that "symbolist poetry endeavors to clothe the Idea in a form perceptible to the senses" ("Le Symbolisme," 1886, excerpted in Chapter 3).

122. See Verhaeren's similar notion of "an immense algebra the key to which was lost" in the excerpt in Chapter 1 at note 92.

123. See Aurier, "Préface pour un livre de critique d'art," 331. This point is convincingly developed by Patricia Townley Mathews, *Aurier's Symbolist Art Criticism and Theory* (Ann Arbor, Mich.: UMI Research Press, 1986), 89, who refers the reader to Aurier's "Trois Salons," in *Albert Aurier: Œuvres posthumes,* 348: "Just as the artist's soul shivers before the Ideas revealed to him, the viewer must 'shiver in unison with the dreamer who created' the work of art." It is also likely that Aurier was somehow aware of Delacroix's thought, quoted in the introduction to the Prologue: "The principal source of interest [of the work of art] derives from the soul [of the artist] and irresistibly reaches the soul of the onlooker."

That Fénéon, positivist and rationalist though he was, referred to "a superior sublimated reality into which [the artists'] personality transfuses itself" in an

article written four years earlier, in 1887, can be taken as a harbinger of Aurier's Neoplatonism.

124. See the excerpt from Pater, "Poems by William Morris," and its introduction in Chapter 1.

125. Bibliothèque littéraire Jacques Doucet, Paris. Courtesy of François Chapon, conservateur.

126. Translated from Aurier's paraphrase; see Plato, *Republic,* ed. and trans. I. A. Richards (Cambridge: Cambridge University Press, 1966), 123–24.

127. Gauguin's scene is not set on a hill. The ground appears to rise because, in keeping with Japanese precedent, the artist placed the horizon line at the top of the picture. In so doing he turned the ground into an inclined surface that filled the height and width of the canvas, thus providing a large flat area on which to create decorative patterns.

128. Jacques Bénigne Bossuet, bishop of Meaux, was the most eloquent preacher at the court of Louis XIV and, because of the respect in which that king held him, one of the most powerful figures in France.

129. Not literally true if one accepts Bodelsen's proposal that the artist has represented himself as the preacher; see above, note 118.

130. "Petit bourgeois" is an uncomplicated translation of *prudhommesque.* The term *prudhomme* originally referred to a wise and honest man. Around 1830 Henri Monnier became the first of a number of caricaturists who embodied all the pretentiousness and pettiness of the self-satisfied bourgeoisie in a figure they called Monsieur Prudhomme. Edouard Detaille was a painter who specialized in military subjects. Both French and foreign dignitaries appreciated his works for their meticulous precision. Loustauneau (Loustauleau in Aurier's text) is probably Auguste Loustauneau, a pupil of the successful artist Léon Gérôme and member of the Academy of the Fine Arts.

131. Ploërmel is a city in southern Brittany.

132. Aurier paraphrases Swedenborg: "I have been called to a holy office by the Lord Himself, who most mercifully appeared before me, His servant, in the year 1743; when he opened my sight into the spiritual world, and enabled me to converse with spirits and angels, in which state I have continued to the present day. From that time I began to print and publish the various arcana that were seen by me or revealed to me, concerning Heaven and Hell" (Emanuel Swedenborg to the Rev. Thomas Hartley, in *Documents Concerning the Life and Character of Emanuel Swedenborg,* ed. and trans. R. L. Tafel, 2 vols. [London: Swedenborg Society, 1875], 1:9).

133. Plato, *The Republic,* 123.

134. During the nineteenth century, and even the early twentieth, the term *primitive* referred to the art of the Middle Ages and the early Renaissance.

135. The allegation is not as outrageous as it might seem, when considered in light of two works: Jules-Antoine Castagnary, "Philosophie du Salon de 1857," *Revue moderne* (July 10 and monthly through Oct. 1857); printed in book form (Paris: Poulet-Malassis, 1858); reprinted in Jules-Antoine Castagnary, *Salons,* ed. Eugène Spuller, 2 vols. (Paris: Charpentier, 1892); and Théophile Thoré, "Nouvelles tendances de l'art," in *Salons de Théophile Thoré* (Paris: Renouard, 1870). Both texts treat art history as a series of revolutionary leaps toward a more truthful rendition of nature, including man's character and temperament. Like Castagnary's text, Thoré's also seems to have been written in 1857. See Dorra, "Trois textes de Thoré, du

saint-simonisme à un historique naturaliste," *Bulletin de la Société de l'Histoire de l'Art français* (1989: 178–89). Both critics, incidentally, acknowledged the importance of the symbol, nevertheless specifying that it must be drawn from nature.

136. Gustave Boulanger specialized in highly detailed and smoothly rendered scenes of classical antiquity.

137. What Aurier says about simplification is tantamount to establishing the need for synthesis as a principle.

138. Aurier refers here to a sine qua non of Neoplatonic mysticism; see above, note 123. The superior being enlightened by "ecstasy," who alone "stroll[s] like a master in the fantastic temple" of symbolism, is comparable to the Alexandrian Neoplatonist whose own state of ecstasy enabled him to apprehend spiritual truths.

139. See Baudelaire's "Correspondences" in the Prologue. Aurier wrote *la forêt* instead of *des forêts*.

140. Aurier may have been overinfluenced by Baudelaire's statement: "I find it useless and tedious to represent what is, because nothing that is satisfies me. Nature is ugly, and I prefer the monsters of my fantasy to the triviality of positive reality" ("Salon de 1859," in *Baudelaire: Œuvres Complètes,* ed. Claude Pichois, 2 vols. [Paris: Gallimard, 1975–76], 2:360).

141. The term *deliquescent* had been used derogatively by Beauclair and Vicaire in their parody *Les Déliquescences d'Adoré Floupette* of 1885; see the introduction to Bourget, "Baudelaire and the Decadent Movement," in Chapter 3.

142. Aurier takes the reader back to two of Baudelaire's formulations: "I want to talk of an inevitable, synthetic, childlike barbarity, which often remains visible in a perfect art (Mexican, Egyptian, or Ninevite) and which derives from the need to see things on a grand scale and to consider them primarily in their overall effect" (see the introduction to the Prologue at note 11); and "the innumerable barbaric conventions of hieratic art" (see the introduction to the Prologue at note 13).

143. Aurier occasionally falls back on the traditional notion of the allegory, which had to have a single possible interpretation, as against the broader, more fluid, often ambiguous, and sometimes conflicting range of interpretations implied by the play of associations developed by the symbolists.

144. Aurier insists again on the concept of ecstasy.

145. The sculptor Pygmalion in Greek mythology fell in love with his creation, the marble Galatea; the goddess Aphrodite then gave her the spark of life. In Greek mythology a daimon is a spiritual being, not necessarily evil.

146. Aurier's word, highly original and imaginative, is *artisaillerie.*

147. As Loevgren points out, p. 142, *The Garden of Olives* was inspired by poems by Aurier (see n. 106).

148. *Polytechnicien* refers to a pupil or former pupil of the Ecole Polytechnique in Paris, a rigorous institution of higher learning intended primarily to educate and train scientists, engineers, and artillery officers. It had also become a spawning ground for leaders of finance, industry, and government.

149. Boeotia, a region of ancient Greece, was noted for the rustic clumsiness of its inhabitants. The Church of Sainte Geneviève, turned into a burial site for the nation's great men, had been renamed the Pantheon. Eugène Lenepveu, an academically inclined muralist, had been asked to paint murals on the life of Joan of Arc for the Pantheon, a commission originally given to Paul Baudry, who died in 1886. Much of the available surface had already been assigned to Puvis de Chavannes.

"Thingamajigs," for the French *machins*. The institute includes the five national academies, one of which is the Academy of the Fine Arts.

Other reviews similarly requested walls for artists lacking official commissions. The first entirely favorable review of Courbet's work by Castagnary, in *L'Opinion nationale,* May 19, 1860 ("Beaux-Arts. Exposition de tableaux de l'école moderne tirés de collections d'amateurs—M[onsieur] Courbet"), concludes: "Let him be given in a palace, or in any castle whatsoever, the walls of a dining room to cover with hunting scenes, still lifes, and one will see with what superior talent he will accomplish his task." See Gautier's similar request that Puvis de Chavannes be offered walls to cover with his work ("An Early Appraisal of Puvis de Chavannes," Chapter 1).

150. André Fontainas, "Art moderne—Exposition Gauguin," *Mercure de France* 29 (Jan. 1899): 235–38.

151. Richard Brettell et al., *The Art of Paul Gauguin* (as in note 89), 49. Charles Morice later collaborated with Gauguin in a version of the painter's poetic evocation of Tahiti, *Noa-Noa,* first published in serial form in *La Revue blanche* 14 (Oct. 15, 1897): 81–103, and (Nov. 1, 1897): 166–90.

152. Henri Mondor, *Vie de Mallarmé* (Paris: Gallimard, 1950), 588–90. The article appeared in *L'Echo de Paris,* Feb. 15, 1891, and was used as a preface to the catalogue for the sale. Mirbeau was so taken by Gauguin that he wrote another, even more laudatory, article, which appeared three days later in the prestigious *Figaro.* Gauguin's works were displayed at Theo van Gogh's gallery, Boussod & Valadon, on Feb. 22, and the sale took place Feb. 23, 1891, Salle Drouot, according to Bengt Danielson, *Gauguin à Tahiti et aux îles Marquises* (Papeete-Tahiti: Editions du Pacifique, 1965), 46.

153. For an aesthetic parallel between Mallarmé and Gauguin, see Gudrun Inboden, *Mallarmé und Gauguin, absolute Kunst als Utopie* (Stuttgart: J. B. Metzler, 1978).

154. Gauguin copied this story into his manuscript: "Ancien culte mahorie," in *Présentation de l'Ancien culte mahorie, la clef de Noa-noa* (includes facsimile reproduction), ed. René Huyghe (Paris: La Palme, 1951), 13.

155. Vetter, "Sens figuratif et sens figuré bei Gauguin" (as in note 94), 427, pointed out that "la vie commune" in Gauguin's letter to Charles Morice, July 1901, as first transcribed by Maurice Malingue, ed., *Lettres de Gauguin à sa femme et à ses amis* (Paris: Grasset, 1946), 301, reads in the original "la vie commence" (life begins).

156. Gauguin to Daniel de Monfreid, Feb. 1899, in *Lettres de Gauguin à Daniel Monfreid* (Paris: Falaize, 1950), 118.

157. The original epigraph reads: "Un grand sommeil noir / Tombe sur ma vie: / Dormez tout espoir, / Dormez toute envie!"

158. The work is actually on canvas.

159. The Durand-Ruel family of Parisian art dealers had their first success handling Barbizon works. They then took enormous chances backing the budding impressionists and were on the verge of bankruptcy in the mid-seventies. Their financial fortunes improved in the eighties as collectors increasingly appreciated the works of these artists. They held a one-man exhibition of Gauguin's work, Œuvres récentes de Gauguin, after the artist returned from his first stay in Tahiti in 1893.

160. In the fable by Jean de La Fontaine, the scraggly, hungry wolf, given a

chance to lead a life of comfort as a watchdog, turned down the offer when he realized he would have to wear a collar.

161. The catalogues of the exhibition of van Gogh's paintings and drawings to mark the centennial of his death are appropriate points of departure for the study of the artist: Evert van Uitert, Louis van Tilborgh, Sjraar van Heutgen, *Vincent van Gogh—Paintings* (Amsterdam: Rijksmuseum Vincent van Gogh, 1990); Johannes van der Wolk, Ronald Pickvance, E. B. F. Pey, *Vincent van Gogh—Drawings* (Otterlo: Rijksmuseum Kröller-Müller, 1990).

162. Vincent van Gogh to his brother, Theo, dated [July 1885] by Hulsker (as in note 13), no. 418, in *Verzamelde Brieven* (as in note 105), 3:52. Van Gogh was specifically referring to the Barbizon artists Millet and Lhermitte and to Michelangelo.

163. Vincent van Gogh to his brother, Theo, dated Nov. 16, 1883, by Hulsker, no. 340, ibid., 2:333.

164. Vincent van Gogh to his sister, Will, no. 7, Sept. 9 and 16, 1888, *Verzamelde Brieven*, 4:159. The dating is from Ronald Pickvance, *Van Gogh in Arles* (as in note 13), 263.

165. Vincent van Gogh to his brother, Theo, Sept. 3, 1888, no. 531, in Vincent van Gogh Foundation, *Letters of Vincent van Gogh* (as in note 13), 1:4/6.

166. The logic of the brothel pimp in this connection seems to be that of simple practical people who have to get things done without becoming overconcerned with metaphysics. Ironically, van Gogh bases his claims for the existence of an afterlife on such "commonsense" reasonings, in contrast to the much more complex arguments of those opposing the belief.

167. Van Gogh implies that although a puritanical Protestant mother would grant Delacroix and Goncourt the moral standing of a hackney cab horse, for him the breadth of their humanity made up for their failings.

168. Van Gogh refers to the crude matter-of-fact yet "commonsense" rhetoric of simple believers.

169. "Physicians" here suggests the proponents of rationalist positivism who opposed any belief in an afterlife.

170. For *Potato Eaters* (Sept.–Oct. 1885), see de la Faille (as in note 17), 3, no. 82.

171. "Orangy yellow" for *orangé,* the neo-impressionist term for the orange-yellow of sunlight at noon.

172. "Discreet green" for *petit vert.*

173. Paul Mantz was a critic whose thorough knowledge of earlier traditions made him receptive to the innovations first of Delacroix and then of the naturalists and even the impressionists. Mantz described *Christ Asleep in the Boat* in one of a series of articles on the Centennial Exhibition of the Arts at the 1889 Exposition Universelle, where it was displayed, as "One of the paintings in which Delacroix has said with the authority of science that color can be the vehicle of emotion and of drama" ("Exposition Universelle—La Peinture française," *Gazette des Beaux-Arts* [Aug. 1889]: 105–22).

174. Katsushika Hokusai was one of the most prolific, skillful, and imaginative of the Japanese painters and print designers of his time. The design to which van Gogh refers is undoubtedly his spectacular color woodcut *The Great Wave off Kanagawa,* from *Thirty-six Views of Mount Fuji,* 1823–29.

175. The French word *crépon* was used for Japanese prints and drawings because of the thin crinkled paper used as support.

176. Jean Seznec, "Literary Inspiration in van Gogh," *Magazine of Art* 43 (1950): 286, points out that although it is not capitalized, the phrase "the power of darkness" undoubtedly refers to Leo Tolstoy's play of that name. It was performed in Paris in February 1888 at the Théâtre-Libre (information courtesy of Melinda Gandara). It was a dramatic indictment of the avariciousness, habitual drunkenness, and debauchery of Russian peasants. Likewise, *assommoir* must refer to Zola's 1877 novel of that name, as Seznec also points out. The word *assommoir*, "bludgeon" in English, meant a low drinking joint; such a place in the novel symbolized the gradual decay of the characters, all members of the working class. Rewritten as a play, Zola's *L'Assommoir* was performed at the Théâtre de l'Ambigu in Paris in January 1879.

177. The most widely known Japanese works of art in Europe at the time were the popular woodcuts known as ukiyo-e, or images of the floating world, which often consisted of humorous descriptions of everyday life. *Tartarin de Tarascon,* Alphonse Daudet's novel of 1872, was a good-humored satire of the Provençal character. It was particularly relevant to van Gogh because Arles, where he had chosen to stay, is only some ten miles from Tarascon; he was probably attracted to Provence at least in part by his enthusiasm for the novel.

178. Mr. Tersteeg succeeded Vincent's uncle (also Vincent van Gogh), a successful art dealer whose business in The Hague had been purchased by the French-based international art dealers Goupil & Cie. Tersteeg became the manager Goupil's new branch in The Hague, and the uncle eventually became a partner in Goupil & Cie in Paris. Tersteeg was in charge of the branch in The Hague when the van Gogh brothers served as apprentices there and was responsible for their initial training (Johanna van Gogh–Bonger, introduction to *The Complete Letters of Vincent van Gogh,* 3 vols. (Greenwich, Conn.: New York Graphic Society, 1958), 1:xviii.

179. Alfred Sisley, with Monet, Renoir, and Bazille, all of whom studied with the traditionalist Charles Gleyre, belonged to the central core of the impressionist group.

180. See Huret's interview with Mallarmé in Chapter 3, which, however, took place in 1891, three years after this text was written. Imagery recalling jewelry is frequent in Mallarmé's early poetry.

181. The notion of the Idea clothed "in a form perceptible to the senses" goes back to Moréas's "Le Symbolisme," of 1886; see the excerpt in Chapter 3.

182. Vincent van Gogh to his brother, Theo, dated Oct. 28, 1888, by Pickvance, in Vincent van Gogh Foundation, *Letters of Vincent van Gogh* (as in note 13), 2:558b, 2/4 and 3/4, and 2:558, 5/6. See also below, note 189.

183. Van Gogh to Aurier, dated [Feb. 11, 1890] by Hulsker, no. 626a, in *Verzamelde Brieven* (as in note 105), 3:500–501. Pickvance dates the letter [Feb. 10, 1889].

184. Adolphe Monticelli chose subjects like those of the more freely imaginative Barbizon artists but cultivated more than they did jewel-like colors, which gave his painting a near-magical aura. Although he lived and died in relative obscurity, he won the admiration of the van Gogh brothers. It is likely that his use of color deeply affected Vincent.

185. Ernest Meissonier acquired an enviable reputation and was showered with official honors on the basis of minutely detailed genre, historic, and military scenes often executed in small scale, sometimes on large canvases.

186. The book of emblems was Georgette de Montenay, *Emblèmes ou devises chrétiennes* (1717), 256; first published in 1571.

187. L'ennivrante monotonie
Du métal, du marbre et de l'eau . . .
Et tout même la couleur noire,
Semblait fourbi, clair, irisé
Le liquide enchâssait sa gloire
Dans le rayon crystallisé . . .
Et des cataractes pesantes
Comme des rideaux de crystal
Se suspendaient, éblouissantes,
A des murailles de métal . . .

The poem, perhaps by Aurier himself, is described by Welsh-Ovcharov as "freely transposed verses from Baudelaire's *Fleurs du mal*" (*Vincent van Gogh and the Birth of Cloisonism* [as in note 28], 54).

188. The names are those of seventeenth-century Dutch painters noted for their precise rendering of physical reality. Although Aurier included some of the greatest artists among his favorites, modern connoisseurship would probably not be as enthusiastic about all of them.

189. The urge to flee Europe for a paradisaical tropical land, which turned into a veritable obsession, was undoubtedly Gauguin's. See Gauguin's letter to Emile Bernard, dated [Nov. 9–12, 1888] by Merlhès (I retain his brackets) in his edition of *Correspondance de Paul Gauguin* (as in note 95), no. 178, 1:274, "I shall go to Martinique. . . . I share the opinion of Vincent, who believes that the future belongs to the painters of the tropics, which have not yet been painted." The idea of founding an "atelier of the tropics" seems to have been van Gogh's. He wrote of such a venture, with Gauguin and himself "as permanent residents; but we will turn it into a shelter and a refuge for our pals when they are desperate"; Vincent van Gogh to Gauguin, dated [Arles, Oct. 3, 1888] by Merlhès, 238.

190. All three artists specialized, at least during part of their careers, in North African subjects. All won considerable acclaim, particularly Gérôme.

191. Aurier wrote *la laïque,* the popular term for the national system of secular education that had gained hold in France under the Second Empire and the Third Republic, supplanting the old system administered by the Catholic church. Péladan ended his 1881 "Du matérialisme dans l'art" (see the excerpt in Chapter 5) with a similar parting shot at the government's educational system, albeit for different reasons, since Péladan proclaimed his fervent Catholicism. One might nevertheless suspect that Aurier had read Péladan's article.

192. The most informative general introduction to Cézanne, much revised since its first appearance in 1948, remains John Rewald, *Cézanne: A Biography* (New York: Harry N. Abrams, 1986).

193. Lionello Venturi, *Cézanne, son art, son oeuvre, 1,600 illustrations,* 2 vols. (Paris: P. Rosenberg, 1936), nos. 379, 380, 897.

194. See the excerpt from Gauguin's letter to Emile Schuffenecker, Jan. 14, 1885, earlier in this chapter.

195. In *Correspondance de Camille Pissarro,* ed. Janine Bailly-Herzberg, 5 vols. (Paris: Presses universitaires de France, and Paris: Valhermeil, 1980–91), 1:207–8 n. 1, in response to Pissarro's letter of May 9, 1883.

196. Since there can be no question of associating Cézanne's execution with that of the neo-impressionists and therefore no possibility of thinking of it as small dots, *au point* has been translated "in dabs." Chevet was, perhaps, a fashionable fruit merchant of the day.

197. *Repoussoir* is the accepted art-historical term for a dark mass in the foreground of a picture that makes lighted objects in the background appear brighter by contrast. A pun is intended, as *repoussoir* also connotes "uninviting."

198. The third group exhibition of the impressionists was held in the gallery of their principal dealer, Durand-Ruel, 11, rue Le Peletier. Actually, one of Cézanne's pictures was accepted for the 1882 Salon (John Rewald, *The History of Impressionism* [New York: Museum of Modern Art, 1961], 366, 604).

199. Cézanne to Joachim Gasquet, Talloires, July 21, 1896, in John Rewald, *Cézanne, Geffroy et Gasquet, suivi de souvenirs sur Cézanne de Louis Aurenche et de lettres inédites* (Paris: Quatre-Chemins-Editart, 1959), 27.

200. Quoted in Jules Borély, "Cézanne à Aix," *L'Art vivant,* no. 2 (1926): 491–93, from an interview of July 1902. Reproduced in Doran, *Conversations avec Cézanne* (as in note 19), 20. Bitumen was a dark brown color; glossy and vitreous when first applied, it turned black with age, never quite dried (unless applied very thinly), and, as a result, frequently developed large cracks. Much favored by the Barbizon artists who used it to create glowing dark brown areas of underbrush, it was despised by the impressionists, who were endeavoring to achieve luminous effects through the use of pure hues and were aghast at the deterioration of the medium over the years. Cézanne here claimed that, if handled properly, even bitumen could help him achieve the equivalent of his impressions of Provence.

201. Cézanne to Gasquet, Tholonet, Sept. 26 [1897], in Rewald, *Cézanne, Geffroy et Gasquet,* 33; I retain his brackets around the year.

202. Cézanne to Emile Bernard, Aix, Oct. 23, 1905, *Cézanne: Correspondance* (as in note 9), 314.

203. Cézanne to Louis Aurenche," Aix, Jan. 25, 1904, ibid., 298.

204. Jean Metzinger, "Cubisme et tradition," *Paris-Journal,* Aug. 16, 1911. Reproduced in Edward Fry, *Cubism* (New York: McGraw-Hill, 1966), 66–67.

205. Cézanne is identifying his approach to nature with his pictorial achievement. *Lucide* could just as well mean "luminous" as "clearly articulated." Chances are that the artist meant both, his late works being characterized by distinct planes of colors modeling forms in space that are also translucent and therefore luminous because they allow the white of the canvas to show through.

206. Armand Fallières had been elected president of the Republic in 1906.

207. John Rewald, in *Cézanne: Correspondance,* 288 n. 1, indicates that Cézanne was referring to Joachim Gasquet, an Aixois poet, once a friend, whom Cézanne had come to distrust (*Cézanne, Geffroy et Gasquet,* 51). The allusion here is to Gasquet's worldly ambition.

208. Pierre Louis [Maurice Denis], "Définition du néo-traditionisme," *Art et critique,* Aug. 12, 1890, 540–42, and Aug. 30, 1890, 556–58.

209. A card from Mallarmé saying that Denis was "impatiently awaited" is preserved in the Denis family archives.

210. See the excerpts from Gauguin, "At the Universal Exhibition," in Chapter 2.

211. Sérusier had accused Gauguin in an earlier letter of a number of artistic failings, including "a search for originality bordering on the spurious" (Paul Sérusier, *ABC de la peinture* [Paris: Floury, 1950], 39).

212. The term was applied at the time to every artist working earlier than the High Renaissance, including Fra Angelico, Benozzo Gozzoli, and Perugino.

213. The most detailed and informative study on the Nabis is Mauner, *The Nabis* (as in note 2).

214. See above, note 208.

215. The letter, dated 1891 in the book, must have been written before Aug. 12, 1890, because of the indication that Maurice Denis's article in *Art et critique* had not yet appeared. See note 208.

216. Pierre Bonnard had just returned from military service. He was sharing a studio with Vuillard and Denis (see the exhibition catalogue *Bonnard and His Environment* [Los Angeles: Los Angeles County Museum of Art; Chicago: Art Institute of Chicago, 1964], 14). Auguste Cazalis, who was a student of languages, particularly Hebrew, and a self-proclaimed expert on esoteric religions, was also a painter—repeated assertions by earlier writers notwithstanding—as attested by his oil *Le Chemin* (The path) of 1892 at the Musée du Prieuré, Saint-Germain-en-Laye. The other Nabi artists considered him one of them (Mauner, *The Nabis,* 21).

217. Maurice Denis was living with his family in Saint-Germain, on the western outskirts of Paris.

218. Denis took the Ecole des Beaux-Art's entrance examination and was accepted (see the exhibition catalogue *Maurice Denis* [Paris: Orangerie des Tuileries, 1970], 90).

219. The friend was doubtless the young actor Aurélien Lugné-Poe, a student of acting at the Conservatoire, the government-sponsored school of music and the performing arts, who had acted at the avant-garde Théâtre-Libre since 1888 (Mauner, *The Nabis,* 44). He must have introduced Denis to a group of literary symbolists. Denis refers to him again as "my friend" in the succeeding paragraphs.

220. Born in Hempstead, Long Island, Stuart Merrill was the son of a counselor at the U.S. embassy in Paris who studied at the Lycée Condorcet, where he met a number of future symbolists. Although he was in New York between 1885 and 1889, he contributed poetry to French symbolist periodicals and on his return was welcomed by the French symbolist avant-garde groups. He was a member of Mallarmé's circle.

221. The art dealer and publisher Ambroise Vollard had suggested an edition of Verlaine's *Sagesse* to be illustrated with lithographs by Denis, who executed the prints. Verlaine, however, apparently did not find Denis's work to his taste, and the projected edition appeared only in 1911. See Mauner, *The Nabis,* 33.

222. Undoubtedly the Exposition du groupe impressionniste et synthétiste, held at the Grand Café des Beaux-Arts (Volpini) at the time of the 1889 Universal Exhibition.

223. Lugné-Poe's efforts to introduce the Nabis to the theatrical avant-garde eventually helped Denis, Bonnard, and Vuillard obtain commissions for costume and stage designs for symbolist plays.

224. For the first two, see Georges Wildenstein, *Gauguin. Catalogue I* (Paris: Les Beaux-Arts, 1964), nos. 328 and 245. For the third, see Christopher Gray. *Sculpture*

and Ceramics of Paul Gauguin (Baltimore: Johns Hopkins University Press, 1963), no. 76.

225. Gauguin and Sérusier were staying in the fishing village of Pouldu in Brittany.

226. No notes appeared following Denis's article in *Art et critique.*

227. According to Sérusier, *ABC de la peinture* (as in note 211), 52 n. 1, the young priest is the Abbé Ackermann.

228. For an introduction see Reinhold Heller, *Munch: His Life and Work* (Chicago: University of Chicago Press, 1984); and Arne Eggum, *Edvard Munch: Paintings, Sketches, and Studies,* trans. Ragnar Christophersen (New York: C. N. Potter, 1984). The exhibition catalogue *Munch et la France* (Paris: Musée d'Orsay; Oslo: Munch Museum, 1992), is notable for its study of Munch's place in the symbolist movement. Munch's writings are preserved at the Munch Museum in Oslo.

229. Christian Krohg, Munch's onetime teacher and friend, remarked the connection with French symbolist developments in a note on one of first pictures in Munch's new manner, "Thank You for the *The Yellow Boat,*" *Verdens Gang,* Nov. 27, 1891; reproduced in Krohg's *Kampen for tilvaerelsen* (Copenhagen: Gyldendalske Boghandel Nordisk Forlag, 1920), 193–94. For the same connection, see also Dorra, "Munch, Gauguin, and the Norwegian Painters," *Gazette des Beaux-Arts* (Nov. 1976): 175–80.

230. From a letter of the 1930s to his biographer, Jens Thiis, quoted by Reinhold Heller, *Edvard Munch: The Scream* (New York: Viking Press, 1972), 30.

231. Böcklin may not have been aware of Monet's series of similar subjects under different lighting and atmospheric conditions, starting with the Saint-Lazare Station in 1876. And in 1863 Johann-Barthold Jongkind, a precursor of impressionism, had painted two views of Notre Dame under different conditions. See Rewald, *The History of Impressionism* (as in note 198), 114.

232. Mysti... [Louis Montchal], *La Revue de Genève* 2 (1886): 382. Jura Brüschweiler identified the author as Louis Montchal in *Ferdinand Hodler: Anthologie critique* (Lausanne: Rencontre, 1971), 34.

233. Jura Brüschweiler, Chronologie, in the exhibition catalogue *Ferdinand Hodler* (Paris: Musée du Petit Palais, 1983), 21. This is the best recent introduction to the work of the artist. See also Sharon L. Hirsh, *Hodler's Symbolist Themes* (Ann Arbor: University of Michigan Press, 1983).

234. Brüschweiler, 29.

235. The full text was delivered in a lecture before the Society of the Friends of the Fine Arts of Fribourg, Switzerland, Mar. 12, 1897. It is reproduced in its entirety in Brüschweiler, 272–79.

236. The definition is attributed to Plato in several French works on philosophy of the mid-nineteenth century. The closest Plato seems to have come to expressing this idea, however, may be the following: "In the field of deep knowledge, the last thing to be seen, and hardly seen, is the idea of good. When we see it, we see that it is the cause of all things, of all that is beautiful and right. In the world of visible things it gives birth to light and to the lord of light, but in the field of thought it is itself the master cause of reason and all that is true" (*Republic* [as in note 126], 125).

237. Hodler is clearly referring to the linear characteristics and decorative aspirations of art nouveau.

238. Hodler no doubt refers to his concept of parallelism, which for him summarizes the harmony of lines in art, as well as that of the physical and the spiritual in life and their relationship.

239. Hodler here seems to be referring to the law of Chevreul as it applies to values. See note 39, above.

240. The opposition between the blues and violets in the shade and their sunny orange complementary is in keeping with neo-impressionist theory. Reflections, furthermore, are an important component of the overall coloration of an object, according to the neo-impressionists.

CHAPTER 5: THE ARTISTS OF THE SOUL

1. See, in particular, Gustave Soulier, "Les Artistes de l'âme, Armand Point," *L'Art et la vie* (1894): 171–77; Henri Béranger, "Les Artistes de l'âme, Edmond Aman-Jean," *L'Art et la vie* (1893): 31–37; Fernand Weyl, "Alexandre Séon," *L'Art et la vie* (1894): 406–13; Gustave Soulier, "Andhré des Gachons," *L'Art et la vie* (1894): 479–84. Alphonse Germain had already stressed some of the arcane ideals of the new movement in "Le Modernisme et le beau," *La Plume,* Mar. 15, 1891, 115–16, praising both "the luxurious propensities of high society" and "the androgyny of the end of a race" to be evoked by a new art. His article "Alexandre Séon," *La Plume,* supplement, Sept. 1, 1891, 303, highlighted Séon's spirituality by linking him with astrology; and his "Le Désespoir de la Chimère," in the supplement to the same periodical dated June 1, 1892, 244, mourned, with Séon's weeping Chimera in the painting also entitled *Le Désespoir de la Chimère,* the passing of the age of idealism.

Mercure de France, with Camille Mauclair as art critic after Aurier's sudden death, became sympathetic to the new group as Mauclair became hostile toward Gauguin and the Nabis in "Choses d'art," *Mercure de France* 12 (Nov. 1894): 284–86. In "Armand Point," in the same periodical, 9 (Dec. 1893): 331–36, Mauclair singled out the subtlety of that artist, who had, among other things, "painted women forgotten in the frozen islands of desire." The same Mauclair, in "The Influence of the Pre-Raphaelites in France," *The Artist* (Dec. 1901): 169–180, rightly pointed out that some of the same artists, and a few others like Moreau's pupils René Piot, Georges Rouault, and Georges Desvallières, constituted a group of "idealists" influenced by Puvis and Moreau, most of whom followed "the Pre-Raphaelite lead."

2. Charles Blanc, *Les Beaux-arts à l'Exposition universelle de 1878* (Paris: Renouard, 1878), 335.

3. For the impact of the Pre-Raphaelites in France, see Jacques Lethève, "La Connaissance des peintres préraphaélites anglais en France (1855–1900)," *Gazette des Beaux-Arts* (May–June 1959): 315–28.

4. Joséphin Péladan, preface to Dante Gabriel Rossetti, *La Maison de vie,* trans. Clémence Couve (Paris: Lemerre, 1887). True to his nature, Péladan denigrated his hero: "Gabriel Rossetti, in whose work an evolution of lyricism comes to an end and who presents only mawkish characters whose physiognomies are somewhat faded" (xlviii).

5. "Usurped" may be a more appropriate term. Péladan led a group away from the Rose + Croix mystique, an occultist body claiming to continue the tradition established in the seventeenth century by a German mystical fraternity dedicated to

the teachings of the presumably legendary fifteenth-century mystic Christian Ro-zenkreuz. Péladan's group purported to achieve its aims by fostering spiritually ele-vating art. For the development of Péladan's Rose + Croix esthétique (the name he gave his own organization) and its relations with the artistic world, see Robert Pincus-Witten, *Occult Symbolism in France* (New York: Garland, 1976).

6. Joséphin Péladan, "Le matérialisme dans l'art," *Le Foyer,* Aug. 21, 1881, 177–79, and "L'art mystique et la critique contemporaine," idem, Nov. 20, 1881, 387–88.

7. "He himself teaches us that at the origin of his imperial family was a king of Babylon, named Baladan, for which reason he gave himself the title of Sâr, which he believed to mean 'sovereign high-priest,' but which in Chaldean means 'some-thing else,' according to [the scholar of the ancient Middle East Eugène] Ledrain" (Charles Buet, "Joséphin Péladan," *La Plume,* Oct. 1, 1890, 178).

8. Roger Marx, "Les Salons de 1895," *Gazette des Beaux-Arts* (May 1895): 358.

9. Klinger, Fantin-Latour, and Carrière were significant and influential romantic symbolists. Klinger, working in a naturalist idiom, introduced through his choice of subjects conflicting, even jarring, associations that suggest the inconsistencies and ambiguities of the world of dreams. Henri Fantin-Latour first distinguished himself with still lifes and interior scenes revealing a naturalist interest in light and atmo-sphere consistent with his early comradeship with Manet. In 1862 he began to depict imaginary scenes, at once harmonious and vaporous, often drawn from operatic subjects, conceived as dreamlike, evocative meditations. Eugene Carrière painted subtly characterized portraits whose subjects emerge from an artificially thick at-mosphere that makes them dreamlike and mysterious.

10. Marx does not give the source of his quotations.

11. Quoted in René Louis Doyon, *La Douleureuse aventure de Péladan* (Paris: Con-naissances, 1946), 89.

12. Keith Andrews, *The Nazarenes* (Oxford: Clarendon Press, 1964), 72–75; Dorra, "Die französischen 'Nazarener,'" in the exhibition catalogue *Die Nazarener* (Frankfurt am Main: Städelsches Kunstinstitut, 1977), 340.

13. Dorra "Die französischen 'Nazarener,'" 346–48.

14. Joséphin Péladan: "L'art mystique et la critique contemporaine," *Le Foyer,* Nov. 20, 1881, 388.

15. This statement seems to be a rephrasing of Saint-Simon's distinction between "organic" and "critical" periods (see Chapter 2 at note 11).

16. A sculptor by profession, Phidias was in charge of the sculptural work and overall construction program of Athens's Parthenon (448–432 B.C.). The architect was Ictinus.

17. Apelles and Zeuxis were revered painters of ancient Greece; their works are known only from descriptions, although we can extrapolate their manner from the Attic white ground lecythi of the late fifth and the fourth century B.C. Epictetus was a Greek stoic philosopher in Rome; Marcus Aurelius was a stoic philosopher as well as a Roman emperor.

18. An orant is a praying figure in early Christian paintings and sculptures.

19. To Thomas à Kempis, a German monk who lived in the Netherlands, a mov-ing *Imitatio Christi* is frequently, and arguably, attributed. Giacomo da Varaggio was an Italian Benedictine monk whose *Lives of the Saints* acquired great repute; the work eventually became known as *The Golden Legend.* Vincent of Beauvais was a French

Dominican monk whose writings include the *Speculum Majus,* intended to be a survey of all of God's creations.

20. Margaritone was a late-thirteenth-century painter from Arezzo, Italy, notable for his lifelike, though markedly hieratic, figures.

21. The High Renaissance, as we have seen, was disparaged by Christian-revival artists such as the Nazarenes on the grounds that it challenged Christian beliefs by reintroducing the material aspects of antique paganism into artistic and literary productions. Péladan here brings a new element into play: the reliance, not on Greek art, but on the better-known Roman, which he clearly considers that of a lesser culture.

22. The Cenacolo is Leonardo's *Last Supper,* Santa Maria delle Grazie, Milan. The Sistine Chapel, the papal chapel in the Vatican, is decorated in fresco, mostly by Michelangelo; it also contains major earlier works. The Stanze is a series of three ceremonial rooms in the Vatican decorated in fresco by Raphael.

23. The reforming priest Girolamo Savonarola imposed a puritanical way of life on Florence through his fiery oratory. A coalition of his enemies and a mob angered by the severity of his regime succeeded in having him incarcerated, tried by envoys of the Borgia pope, Alexander VI, and burned at the stake. Cesare Borgia, the natural son of Pope Alexander VI, had been made duke of Valentinois (now Monaco) by the king of France, Charles VIII, who was preparing to invade the Italian principalities in connivance with the pope. Taking advantage of the French invasion, Cesare carved out a fief for himself by bravery on the battlefield as well as by murderous intrigue, only to lose it at the death of his father. Péladan was clearly upholding the reforming zeal of Savonarola in contradistinction to the debauchery and corruption of the papal entourage.

24. The Roman poet Ovid evoked with humor and earthy sensuality the irrational and sometimes monstrous loves of Greco-Roman gods. Pan, the amorous god of shepherds, part-goat, part-man, was the offspring of such a union. His impure spirit, according to Péladan, can be perceived in the lofty classical figures carved of marble from the island of Paros. Péladan meant to indict the immorality of pagan times and its resurgence in Europe during the High Renaissance.

25. Joanes was the Spanish painter Vicente Juan Macip. Having decried the High Renaissance (Tintoretto, Veronese) for its voluptuousness, Péladan now accepts, among the great baroque painters, those of still devout Spain.

26. Le Sueur and Brussels-born Champaigne were French baroque painters who specialized in religious work. The Jansenist movement, particularly active in France and Belgium in the mid-seventeenth century, claimed to have found in the writings of Saint Augustine the elements of a theory of predestination. The movement incurred the wrath of the Jesuits and the papacy and was eradicated by French civil authorities under Louis XIV. In praising the stained glass of French cathedrals, Péladan followed the tradition of the Nazarenes and the pronouncements of Saint-Simon in which the Christian Middle Ages remained unsurpassed.

27. François-Marie Arouet was Voltaire's name. Playright, novelist, and pamphleteer, Voltaire was idolized by the liberal, anti-clerical bourgeoisie; his scathing and witty denunciations of the established order did much to pave the way for the 1789 Revolution.

28. The comment on lawyers alludes to the French Revolution, at least two of whose leaders, Robespierre and Roland, were lawyers. Mirabeau, although without

formal legal training, had formidable courtroom talents; and Danton's prerevolutionary title was Avocat (lawyer) au Parlement.

29. Ingres actually wrote: "Have a religious attitude toward your art. Do not believe anything good can be produced, something even vaguely good, if your soul lacks elevation. To adapt yourself to the beautiful, only look at the sublime" (Pierre Cailler, ed., *Ingres raconté par lui-même et par ses amis, pensées et écrits du peintre* [Geneva: Cailler, 1947], 45). Péladan has altered "religious attitude toward your art" into "faith in God." This is all the more reprehensible in that Ingres never showed signs of genuine religious fervor.

30. Francisque Sarcey, Auguste Vacquerie, and Henri de Rochefort were journalists. Vacquerie and Rochefort, in particular, daringly expressed republican views during the Second Empire. Antonio Casanova and José Frappa were both represented in the 1881 Salon. Ernest Renan, an acclaimed religious scholar and philologist of great distinction, wrote a *Life of Jesus* purporting to be, within the limits of the possible, based on historic facts. Georges Ohnet was a celebrated novelist and playwright, whose simplistic and clear-cut plots had philosophical pretensions.

31. Taine, in his *Philosophie de l'art* of 1865 (see the introduction to the excerpt from Jules Laforgue in Chapter 1), purported to establish rational connections between the characteristics of a work of art and its place and time of origin—a notion that must have appeared crassly materialistic to Péladan. Taine himself claimed to be a student of Stendhal's and, beyond Stendhal, his theory has roots in the eighteenth century. See Pierre Arbelet, preface to Stendhal [Henri Beyle] *Histoire de la peinture en Italie* [1817], 2 vols. (Paris: Cercle du bibliophile, 1969), 1:lxxiii, 18. "Casanova" in Péladan's text is a typographical error. Stendhal wrote: If [modern sculpture] were to compete with the Greeks, it would present a *Dancer* by Canova and the *Moses*" (idem, 257). He did not express a preference for Canova. Canova executed at least two versions of *Paris,* and at least two of Paris's head; he gave one head, which Péladan may well have seen, to the French embassy in Rome. Taine's "two volumes" are *Voyage en Italie* [1866], 2 vols. (Paris: Hachette, 1884).

32. "The apostles . . . are vigorous Italians who are moved by their acute passion to mimicry" (Taine, *Voyage en Italie,* 2:407).

33. Taine described Raphael's Virgin as follows: "A beautiful sultana, Circassian or Greek, . . . she bends over her child with the beautiful gesture of a wild animal; and her clear eyes, devoid of thought, freely look ahead" (ibid., 2:176). By eliminating words, Péladan clearly distorted Taine's meaning. Despite his criticism of Aretino's frescoes at the Campo Santo, in Pisa, Taine perceived in his works a beginning of "observation, composition, an attempt to arouse one's interest, and dramatic variety" (idem, 2:73).

34. I could find no evidence in Taine's text of the surprise Péladan mentions. For the passage on Michelangelo, ibid., 1:225. In quoting Taine on Raphael (idem, 1:183), Péladan actually takes fragments from different sentences. As for Taine's summary, the closest statement I could find on the subject of imitation in ancient Greece was in *La philosophie de l'art,* 1:73: "The men of that time observed the nude body in motion, at the baths, in the gymnasia." Taine did not ignore the ideal component: "They corrected, purified, developed their idea of physical beauty." Péladan's quotations—"only exterior form exists" and "one must follow nature to the letter"—I could find nowhere. Another bit of rhetorical dishonesty? I did, however, find "one must look for the healthy body" (*Voyage en Italie,* 1:186).

35. The mention of Fiesole is undoubtedly a reference to Fra Angelico's frescoes at the Dominican cloister there. Aristide Fort was a physician living in Rio de Janeiro whose works on physiology were well known.

36. The Ecole des Beaux-Arts is on the rue Bonaparte. Alexandre Cabanel, with Bouguereau and Gérôme among the most successful artists in France at the time, was also the recipient of numerous official honors.

37. I could not locate any such print by or after Meissonier. Was Péladan suggesting a topic?

38. Fualdès was involved in a sordid murder that took place in southwestern France in 1817.

39. Some Nazarenes were Catholic, others Protestant. Wilhelm von Kaulbach belonged to a later generation than the Nazarenes but some of his large historical works show their influence. The Düsseldorf school, essentially eclectic, produced much religious painting, partly inspired by the Nazarenes.

40. Henri Leys who for many years dominated academic training in Belgium, proudly espoused Nazarene ideals. His hard angular lines were also reminiscent of Dürer, whom the Nazarenes counted among their artistic mentors.

41. Most of these artists were indeed part of a group that played a significant role in the redecoration of French churches, many of which had been neglected since the Revolution. Théodore Chassériau, Hippolyte Flandrin, Paul Chenavard, Victor Mottez, and Jules Ziegler were all pupils of Ingres's. The inseparable Victor Orsel and Alphonse Périn were devoted to Ingres, without having been his pupils. Tymbal's name appears in lists of artists who redecorated churches. Dutch-trained Ary Scheffer had been close to court circles. Alexandre Decamps gained fame primarily as an orientalist. Adrien Guignet followed in Decamps's footsteps. Several of these artists acknowledged their debt to the Nazarenes. See Dorra, "Die französischen 'Nazarener'" (as in note 12).

42. Blaise Desgoffe and Charles Monginot.

43. A play on "mais nous avons changé tout cela," the retort of the false physician Sganarelle to the accusation that he had confused the positions of heart and liver (Molière, *Le médecin malgré lui,* in *Molière: Œuvres complètes,* ed. Georges Couton, 2 vols. [Paris: Gallimard, 1971], 2:246).

44. In another play on words Péladan links the new art, as advocated by the "materialists," with the educational system sponsored by the French government, which was "secularized and compulsory."

45. Monsieur Prudhomme, the creation of the cartoonist Henri Monnier, is a caricature of the self-satisfied, not very bright bourgeois, who innocently, cheerfully, and somewhat pompously displays the shortcomings of his class, including philistinism in artistic matters.

46. *Bodegón* is Spanish for "still life." It was adopted by other languages and its meaning somewhat altered to connote genre pictures devoted to kitchen interiors and utensils and the preparation of food.

47. Caliban and Ariel are characters in Shakespeare's *Tempest.*

48. Renan's *Life of Jesus* (1863), which while retaining the moral message of Scripture examined it critically, was preceded and followed by works, all in German, that also attempted to isolate the physically plausible elements of the life of Christ from the miraculous. The best known is David Friedrich Strauss, *Das Leben Jesu* (Tübingen: Osiander, 1835-36).

49. Félicien Rops, a painter, as well as a prolific printmaker, was essentially a naturalist in execution yet came close to being a romantic symbolist in his bold iconography, which often has erotic overtones. The *Sataniques* is a series of his prints.

50. The coalition of German states led by Prussia had defeated France in 1871. Henri Chapu was a highly skilled sculptor who, while remaining faithful to academic rules, often conveyed quiet emotion in his figures.

51. Péladan was not alone in making such pessimistic pronouncements. His friend Paul Chenavard was known for his gloomy predictions. Furthermore, the notion that Western art had been in decline since the end of the Middle Ages is in keeping with the doctrines of Saint-Simon, who maintained that the world had entered a "critical" period and was therefore in decline and would not enter an "organic," or constructive, period until society had once again united in a common religious faith.

52. See the exhibition catalogue *French Symbolist Painters* (London: Hayward Gallery; Liverpool: Walker Art Gallery, 1972), 97.

53. *Elémir Bourges: Correspondance inédite avec Armand Point,* ed. Gisèle Marie (Paris: Mercure de France, 1962), 20.

54. Gustave Soulier, "Les Artistes de l'âme, Armand Point" *L'Art et la vie* (1894): 171–77.

55. Sfumato is the achievement of a vaporous atmospheric effect in the painting of objects.

56. *Elémir Bourges: Correspondance inédite avec Armand Point,* 55.

57. "E per certo, se si riguarda in queste due arti bene e con sano giudizio, vi si vede cosi smisurata unione et congiunzione insieme d'affinita, che percio si chiama: 'La Pittura, Poetica che tace; Poetica, Pittura che parla.'" According to Edward J. Olszewski, ed. and trans., *Giovanni-Battista Armenini: On the True Precepts of Art* (New York: Burt Franklin, 1977), 328–30, in an essay on the text, Armenini was a mannerist painter in the circle of Pierino del Vaga as well as a theorist.

58. A criticism of the technique of the impressionists.

59. In keeping with the empirical positivist philosophy of Auguste Comte.

60. Probably an occultist concept: "[The secret laws of nature] applicable to terrestrial life and its phases gave birth to the revelation of cycles"; see Papus [Gérard Encausse], *Traité élémentaire de science occulte,* 7th ed. (Paris: Editions Littéraires et artistique, Ollendorff, 1903), 239.

61. Genesis 28:12–15. Jacob dreamed of a ladder reaching heaven and of "the angels of God ascending and descending on it." God then appeared and said, "In thee and in thy seed shall all the families of the earth be blessed." Point undoubtedly intends a parallel between Jacob's divine mission and the artist's act of creation.

62. Mirbeau, "Portrait," *Gil Blas,* July 27, 1886. Reprinted in *Des Artistes* (Paris: Flammarion, 1922), 55, 53.

63. Mirbeau, "Mannequins et critiques," *Le Journal,* Apr. 6, 1893.

64. Mirbeau, "Des lys! des lys!" *Le Journal,* Apr. 7, 1894. His outburst was: "Des lys! . . . des lys . . . de la m——!" Among his other articles on the same topic: "Toujours des lys," *Le Journal,* Apr. 28, 1895; "Botticelli proteste," *Le Journal,* Oct. 4–11, 1896).

65. See text of Chapter 4, at note 185. The identification of Kariste as Meissonier

had been made by Jules Rais in a spirited response to Mirbeau's article, "Les Artistes de l'âme," *Journal des artistes,* Mar. 15, 1896.

66. Julien Leclercq, "Sur la peinture (de Bruxelles à Paris)," *Mercure de France* 10 (May 1894): 75–76.

67. Mirbeau's wordplay is explained in the "author's" response. "Un point, c'est tout" (Period; that's all) implies that an argument has, or should, come to an end.

68. The Batignolles district was one of the peripheral areas of real-estate development during the major reconstruction of Paris completed under the Second Empire. As with many such areas, relatively high rents restricted tenancy to successful women of easy virtue.

69. In 1895 Denis had indeed designed a bedroom for Siegfried Bing's gallery L'Art nouveau that was on display there for two weeks. See Gabriel P. Weisberg, *Art Nouveau Bing: Paris Style, 1900* (Washington, D.C.: Smithsonian Institution; New York: Harry N. Abrams, 1986).

There is another play on words here: *chambre à coucher,* meaning "bedroom," and *à coucher dehors,* meaning "preposterous, likely to drive one crazy."

70. The French expression *fort de la Halle* refers to the hefty laborers who worked in wholesale food markets before mechanization set in. According to tradition, they drank and treated their amorous partners roughly.

71. Joachim Murat, one of Napoleon I's most trusted officers.

EPILOGUE: FORMALIST CRITICISM AND HARBINGERS OF SURREALISM

1. The works include Picasso's *La Vie* (1903), Matisse's *Luxe, Calme et Volupté* (1904–5) and *Joie de vivre* (1906), Derain's *D'après Gauguin* (1906), Picasso's *Demoiselles d'Avignon* (1907), Matisse's illustrations for Mallarmé (1932). And however much cubist works may have been regarded as purely formalist exercises, Robert Rosenblum has adumbrated the associative subtleties of the fractured words that so often appear in them; see his *Cubism and Twentieth-Century Art* (Englewood Cliffs, N.J.: Prentice-Hall, 1976), 90–91. Patricia D. Leighten has devoted an illuminating volume to studying, among other things, the implications of such texts: *Re-ordering the Universe: Picasso and Anarchism* (Princeton, N.J.: Princeton University Press, 1989).

2. Roger Fry, "The French Post-Impressionists," in the exhibition catalogue *The Second Post-Impressionist Exhibition* (London: Grafton Galleries, 1912); reprinted in *Vision and Design* (London: Chatto and Windus, 1923), 242.

3. The term *formalist* here applies to a whole school of criticism that has its roots in such works as Heinrich Wölfflin's *Renaissance und Barock* (Munich: Ackermann, 1888), which established criteria for determining differences between works of the two periods named in its title on the basis of style alone; and in Julius Meier-Graeffe, *Entwicklungsgeschichte der modernen Kunst,* 3 vols. (Stuttgart: Hoffmann, 1904), in which Manet's vigorously painted, colorful, simply rendered, highly lit surfaces are a paragon against which everyone else's works are judged. Most pre–World War II histories of recent art adopt the same formalist stance, particularly Bernard Dorival, *Les Etapes de la peinture française,* 3 vols. (Paris: Gallimard, 1943–). Serious challenges to purely formalist art history were first posed by the iconographic studies of Emile Mâle, which ranged from Romanesque to baroque art. The attention lavished on iconographic problems of past ages by members of the so-called Warburg school of art history, first in Germany and then in Britain and the United States, particularly

by Erwin Panofsky, brought these problems once again to the core of art-historical studies in the 1930s and 1940s.

4. For an outline of the complex developments of the late symbolist period in French poetry, see Michel Décaudin, *La Crise des valeurs symbolistes: Vingt ans de poésie, 1895-1914* (Toulouse: Privat, 1960).

5. Remy de Gourmont, "La littérature. 'Maldoror,'" *Mercure de France* 2 (Feb. 1891): 97-102. The first "chant" of Lautréamont's *Lay of Maldoror* was published anonymously in Paris, in August 1868, by Balitout, Questoy. More "chants," but not all, by the "comte de Lautréamont" were published in 1869 in Brussels by Lacroix Verbroeckhoven, which may have printed as few as ten copies, according to Hubert Juin, preface to Comte de Lautréamont [Isidore Ducasse], *Œuvres complètes,* ed. Hubert Juin (Paris: Table Ronde, 1970), viii. The luxury edition Gourmont saw was issued by Genonceaux (Paris, 1890) and was no more complete. The *Poésies* were published by Gabrie (Paris, 1870).

6. Compare Gourmont's statement with Fénéon's on Seurat's aims: "To synthetize the landscape into a definitive aspect that perpetuates one's sensation of it, that is the task the neo-impressionists have set for themselves." ("Le Néo-impressionnisme," *L'Art moderne* [Brussels], May 1, 1887, 138-39; see the excerpt from Fénéon in Chapter 4).

7. Gourmont, "Le symbolisme," *La Revue blanche* 2 (June 25, 1892): 323-25.

8. Gourmont, "La Création subconsciente," in *La Culture des idées* (Paris: Mercure de France, 1890), 49-51. In a footnote (p. 47) Gourmont cites the scientific sources for his claims: Paul Chabaneix, *Physiologie cérébrale—le subconscient chez les artistes, les savants et les écrivains* (Paris: Baillère, 1897); and Théodule Ribot, *Essai sur l'imagination créatrice* (Paris: Alcan, 1900). Laforgue, after reading Hartmann, had already stressed the importance of the subconscious in poetic and artistic creation but limited its scope when seeing in the unconscious process little more than a source of harmony and a justification for a subjective point of view. See the excerpt from Laforgue, "Pierre Puvis de Chavannes," in Chapter 1.

9. Gourmont, "La Création subconsciente," 69-70.

10. André Breton, "La Situation surréaliste de l'objet (1935)," in *Manifestes du surréalisme* (Paris: Pauvert, 1962), 318-19.

11. Guillaume Apollinaire, preface to Guillaume Apollinaire (poem) and Germaine Albert-Birot (music), *Les Mamelles de Tirésias,* in *Apollinaire: Œuvres poétiques,* ed. Marcel Adéma and Michel Décaudin (Paris: Gallimard, 1956), 865-66. The play was first performed June 24, 1917. Apollinaire had already referred to "a new alliance of painting and dance, the plastic arts and mimicry" as "sur-realist" in program notes to the ballet *Parade,* first performed May 19, 1917 (in *Apollinaire: Œuvres en prose complètes,* ed. Pierre Caizergue and Michel Décaudin, 2 vols. (Paris: Gallimard, 1992), 2:865. The term *sur-réaliste* appeared as a subtitle on the poster for the ballet. It also appeared in the "Program of *Parade*" of 1917 by Guillaume Apollinaire. See L.-C. Breuning, *Apollinaire: Chroniques d'art, 1902-1918* (Paris: Gallimard, 1960), 426-27, 482 n. 1.

12. Apollinaire, "L'Esprit nouveau et les poètes," Nov. 26, 1917, in *Œuvres en prose complètes,* 2:945.

13. Ibid., 2:950.

14. André Breton, "Manifeste du surréalisme (1924)," in *Manifestes du surréalisme* (Paris: Pauvert, 1962), 40.

15. Charles Asselineau, "La Jambe," in *La Double vie* (Paris: Poulet-Malassis and

de Broise, 1858), quoted in *Baudelaire: Œuvres complètes,* ed. Claude Pichois, 2 vols. (Paris: Gallimard, 1975–76), 2:89–90. See also the text of the Prologue at note 25.

16. See the excerpt on van Gogh by Aurier, "The Lonely Ones—Vincent van Gogh," in Chapter 4.

17. See the excerpt on Ensor by Verhaeren in Chapter 4.

18. [Roger Fry,] "The New Gallery," *Athenaeum* 4081 (Jan. 13, 1906): 56–57. The attribution to Fry was made by Jacqueline V. Falkenheim, *Roger Fry and the Beginnings of Formalist Art Criticism* (Ann Arbor: UMI Research Press, 1980), 9. "We confirm to having been hitherto skeptical about Cézanne's genius, but then two pieces [*Paysage* and *Nature morte*] reveal a power which is entirely distinct and personal, and though the artist's appeal is limited, and touches none of the issues of imaginative life, it is none the less complete."

19. See the conscientious and sensitive biography by Frances Spalding, *Roger Fry: Art and Life* (Berkeley and Los Angeles: University of California Press, 1980). See also Denys Sutton, introduction to *Letters of Roger Fry,* ed. Denys Sutton, 2 vols. (New York: Random House, 1972), 1:1–95.

20. Walter Sickert, "The Post-Impressionists," *Fortnightly Review* (Jan. 1911): 79–89.

21. Ibid., 83.

22. Fry, "Post Impressionism," *Fortnightly Review* (May 1911): 860.

23. See Benedict Nicolson, "Post-Impressionism and Roger Fry," *Burlington Magazine* 93 (Jan. 1951): 13.

24. Roger Fry, "Seurat," in *Transformations: Critical and Speculative Essays on Art* (London: Chatto and Windus, 1926), 191. Falkenheim, *Roger Fry,* presents a useful account of the development of Fry's aesthetics. For a convincing attempt to situate Fry in the Bloomsbury group and to link him to later formalist criticism, see Beverly H. Twitchell, *Cézanne and Formalism in Bloomsbury* (Ann Arbor: UMI Research Press, 1987).

25. See the excerpt from Pater, "Poems by William Morris," in Chapter 1.

26. Fry considered Piero della Francesca a "primitive" for belonging to the quattrocento. It is significant that he considered the continuous line that was typical of synthetism—a line that even affected Cézanne in some aspects of his work—an asset.

27. Gauguin equated Cézanne's art with handwriting; see Chapter 4 at note 95. Compare Fry's text also with "the frenzy of the brushstrokes" Verhaeren noted in Ensor's work. Fry, Gauguin, and Verhaeren were aware of the expressive quality of lines and brushstrokes. The surrealists would invest this very graphism with great psychic powers, and such concerns would eventually affect action painting, like that of Jackson Pollock.

28. San Francisco Museum of Art, Harriet Lane Levy Bequest; reproduced in Alfred H. Barr, Jr., *Henri Matisse: His Art and His Public* (New York: Museum of Modern Art, 1951), 352.

29. The closest to this statement I could find was: "[The painter makes the human body] to last a great number of years, and of such excellence that it keeps alive that harmony of proportions which Nature with all its force could not keep. How many paintings of divine beauty of which time or sudden death have destroyed Nature's original, so that the work of the painter has survived in nobler form than that of Nature, his mistress" (*The Literary Works of Leonardo da Vinci,* ed. Jean-Paul Richter

and Irma A. Richter, 2 vols. [London: Oxford University Press, 1939], 1:27, no. 33).

30. Spalding, *Roger Fry* (as in note 19), 164.

31. Fry, in the review of Bell's *Art,* wrote: "Mr. Bell walks into the holy of holies of culture in knickerbockers with a big walking-stick in his hand, and just knocks one head off after another" ("Art. A New Theory of Art," *Nation,* Mar. 7, 1914, 939).

32. Clive Bell, *Art* (New York: Stokes, [1914]), 82. Quotations in the paragraph that follows ("Bell starts out") are from pp. 51–59 of this work.

33. *The Wild Duck* is Henrik Ibsen's drama of 1884.

34. Fry, "Art. A New Theory of Art," 938.

35. Fry, "The Double Nature of Painting," ed. and trans. from the French by Pamela Diamand, *Apollo* (May 1969): 371.

36. Edmund Waller was an English poet, author of the mannered and charming "Go, Lovely Rose."

37. Gourmont, "Le Symbolisme" (as in note 7), 323–25.

38. Antoine Albalat, *La Formation du style par l'assimilation des auteurs* (Paris: Colin, 1902). The book purported to analyze the stylistic niceties of a number of authors, starting with Homer, to help students enrich and refine their own writing style. For Gourmont this imitation was despicable, and he felt that the unintelligent borrowing of the forms of an old civilization was bound to be deadening to new ones.

39. Gourmont plays on words, using the French *trouble* (phonetically close to *triple*), meaning "unclear"; it can even suggest emotional constraint, as in the English word *troubled.*

40. Percy Bysshe Shelley, "A Defense of Poetry" (1821), in *The Complete Works of Percy Bysshe Shelley* [1826–30], ed. Roger Ingpen and Walter E. Peck, 10 vols. (New York: Gordian, 1965), 7:111.

41. Emile Zola, supported by a few friends, took the courageous step in 1897 of challenging the guilty verdict rendered by the military tribunal that tried Captain Dreyfus, wrongfully accused of communicating military secrets to a potential enemy of his country in 1894. Dreyfus was exonerated only in 1906, after nine years in the penitentiary in French Guyana.

42. Gourmont, "Théâtre à idées," *Mercure de France* 15 (Sept. 1895): 343–45.

43. Gourmont: "La dissociation des idées," in *La Culture des idées* (Paris: Mercure de France, 1900), 105–6; first published as "Les Mots et les idées," *Mercure de France* 33 (Jan. 1900): 5–32.

44. The novel referred to is Victor Hugo's *Toilers of the Sea* (*Travailleurs de la mer*) of 1866 (part 2, book 1, vii, according to a footnote in Gourmont's article). Giliatt is the principal character.

45. Alfred Jarry, *Les Minutes de sable mémorial,* dated by Jarry Aug. 11, 1894 (Paris: Mercure de France, 1894), iii–iv. For an analysis of this text, see Michel Arrivé's comments in vol. 1 of Alfred Jarry, *Œuvres complètes* (Paris: Gallimard, 1972–), which Arrivé edited (172 n. 1). Vols. 2 and 3 were edited by Michel Arrivé, Henri Bordillon, Patrick Besnier, and Bernard Le Doze.

46. Jarry, *Œuvres complètes,* 2:849 nn. 1, 2.

47. Victor Basch was a scholar specializing in Kant and other German philosophers who also wrote for the popular press. He held the first chair in aesthetics at the Sorbonne. In an article in *Le Pays,* July 15, 1917, he had written: "The play by

Guillaume Apollinaire is a sur-realist drama, that is, in French, a symbolic drama" (quoted in Apollinaire, *Les Mamelles de Tirésias,* in *Apollinaire: Œuvres poétiques* [as in note 11], 866-67 n. 1).

48. Filippo-Tommaso Marinetti, "Initial Manifesto of Futurism," in the exhibition catalogue by Joshua C. Taylor, *Futurism* (New York: Museum of Modern Art, 1961), 124-25 (originally published as "Le Futurisme," *Le Figaro,* Feb. 20, 1909, 1).

49. Gaston Picard, "M[onsieur] Guillaume Apollinaire et la nouvelle école littéraire," *Le Pays,* June 24, 1917, in *Apollinaire: Œuvres en prose complètes* (as in note 11), 2:989.

50. According to Pierre Caizergue and Michel Décaudin, the editors of *Apollinaire: Oeuvres en prose complètes,* 2:948 n. 1, Apollinaire is referring to the performance of Shakespeare's *Othello* at Paris's Théâtre-Français in 1829, in a translation by Alfred de Vigny. The word *handkerchief* in the pathetic scene of act 5 between Othello and Desdemona gave rise to snickers and protests.

51. Apollinaire was wounded in the head during World War I.

52. According to Caizergue and Décaudin, *Apollinaire: Œuvres en prose complètes,* 2:186, Solomon was apocryphally named as author of Ecclesiastes, in which one reads (1:9) that "there is nothing new under the sun."

53. An allusion to the book of poetry and drawings by Apollinaire's friend Francis Picabia extolling the machine (born out of the efforts of engineers who were usually male), *Poèmes et dessins de la fille née sans mère* (Lausanne: Imprimeries Réunies, 1918).

54. Danaid in Apollinaire's text; there were fifty in the myth.

55. The prophet Ahijah predicted the partial dismemberment of Solomon's kingdom because the king had allowed his foreign-born wives to worship their native gods and had erected monuments to them (1 Kings 11:9-33). Apollinaire contrasts Solomon's indulgence with the monotheistic rigors of Jewish orthodoxy and their promise of future (rather than present) well-being. Apollinaire implies that the type of progress he foresaw for humanity held more in store than the messianic vision of puritanical biblical prophets.

56. The French word *ressort* can mean "mechanical spring" or "machinery that animates living beings, an empire, the world" (Emile Littré, *Dictionnaire de la langue française,* 4 vols. [Paris: Hachette, 1875], 4:1673). The English word *spring,* aside from its mechanical connotation, also means "source," and as such also connotes the life-force.

57. Apollinaire alludes to *Les Mamelles de Tirésias* of 1917. Thérèse, having decided to assume the responsibilities of a man, gets rid of her breasts (toy balloons) and becomes Tirésias. She leaves her husband, who, to support himself, massproduces children. The two are eventually reunited, but she forgoes her breasts. The play ends thus:

> C'est bien plus drôle quand ça change
> Suffit de s'en apercevoir.

> Things are much funnier when they change;
> All that is necessary is to take notice.

58. Another reference to Desdemona's handkerchief. Archimedes claimed that he only needed a platform to raise the world with a lever.

59. Compare to Gourmont's more sarcastic formulation in "The Dissociation of

Ideas," quoted in the introduction to the Epilogue: "Deprived of the truth of commonplaces, people would find themselves defenseless, without support and without food." But then Apollinaire himself is wary of commonplaces and clichés and demands of the poet "a truth that is always new."

60. Apollinaire may have been alluding to the following "Fragment" by the early nineteenth-century German romantic poet Novalis: "Every descent of our sight within ourselves is at the same time an ascension, an assumption, a look toward the reality outside ourselves" (Novalis [Friedrich Leopold Hardenberg], *Les Disciples à Saïs et les Fragments de Novalis,* trans. Maurice Maeterlinck [Brussels: Lacomblez, 1895], 72). Novalis himself may have been influenced by Saint Augustine.

INDEX

Ruskin, John (*continued*)
tion of, 82, 112, 117, 118; and Pre-
Raphaelites, 17–18, 24, 82, 91,
322n34; and relations with James
McNeill Whistler, 67, 328n109; Sick-
ert influenced by, 286
Russian avant-garde art, 288
Rutebeuf (died c. 1285), 151, 152,
339n60
Ruysbroeck, Jan van (1293–1381),
338n48

Saint-Lazare Station, in Paris, 71,
359n231
Saint-Simon, Henri de (1760–1825),
87, 361n15, 362n26, 365n51
Sallis, Rodolphe, 336n18
Salon of 1827, 15
Salon of 1831, 5
Salon of 1846, 5, 6
Salon of 1859, 1
Salon of 1864, 44
Salon of 1879, 98
Salon of 1881, 363n30
Salon of 1882, 357n198
Salon of 1883, 264
Salon de la Rose + Croix. *See* Rose +
Croix movement
Salon de la Société des Artistes Indé-
pendants: of 1884, 157, 255; of 1886,
159; of 1887, 159–60; of 1890, 164;
of 1891, 245–46; of 1895, 255
Salon de la Société Nationale des
Beaux-Arts of 1895, 255
Salon des Artistes Français of 1895, 255
Salon des Champs-Elysées. *See* Salon
des Artistes Français
Salon des Refusés of 1863, 327n101
Salon du Champ-de-Mars. *See* Salon
de la Société Nationale des Beaux-
Arts
Salons: Baudelaire's reviews of, 1, 5, 6;
Cézanne's art in, 357n198; Heine's
review of, 5, 316n19; Hodler's art in,
245–46; Huysmans's reviews of, 98,
331–32n23; later offshoots of, 246,

255, 261; Manet's art in, 327n101;
Roger Marx's reviews of, 255–60;
Moreau's art in, 324n61; official taste
reflected in, 315n1; Péladan's reviews
of, 254, 261–69; Puvis de Cha-
vannes's art in, 323n57; Seurat's art
in, 255; Whistler's art in, 327n101
Sandreuter, Hans (1850–1901), 73,
329n118
Sarcey, Francisque (1827–1899), 265,
363n30
Savonarola, Girolamo (1452–1498),
265, 362n23
Schalcken, Godfried (1643–1706), 221
Scheffer, Ary (1795–1858), 267,
364n41
Schiller, Johann Christoph Friedrich
von (1759–1805), 10
Schlegel, Friedrich von (1772–1829),
10
School of The Hague, 211
Schopenhauer, Arthur (1788–1860), 6,
41, 147
Schuffenecker, Emile (1851–1934),
185–91
Schwabe, Carloz (1866–1926), 252,
256, 257, *258,* 278
Science: and Apollinaire's aesthetics,
310, 311–12; and division of hues,
161–62, 164; and Freud's theory of
unconscious, 284; and geometric
bases of composition, 159, 167–71,
172, 343–45nn; and Gourmont's
theory of subconscious, 367n8; Péla-
dan's condemnation of, 265; and
post-symbolist aesthetics, 282, 283,
284, 293, 310; and Sérusier's aesthet-
ics, 237; and Taine's aesthetics, 48,
194
Secession group, 73, 329n117
Sense perception: in Baudelaire's aes-
thetic theory, 1, 4, 9; in formalist
criticism, 280, 289, 294; in Gauguin's
aesthetic theory, 185, 186; in Kant's
philosophy, 194, 327n94; in Leroux's
aesthetic theory, 9; in post-impres-